藝時代崛起

李仲生
與臺灣現代藝術發展

Pioneers of the Avant-Garde Movement in Taiwan:
From Li Chun-Shan to His Disciples

策展人：陶文岳
Curator: Tao Wen-Yuen

目錄 Contents

序

為落實文化部推動之「重建臺灣藝術史」計畫，國立臺灣美術館近年來積極進行多面向之歸納、梳理，經由展覽、研究、典藏、論壇及學術研討會等形式，建構臺灣美術發展歷程、深化美術的本體價值及脈絡耙梳，對臺灣美術的閱讀與辯證注入新的視角與能量。基於此，「臺灣現代繪畫導師」李仲生，即成為重要之研究目標之一。

李仲生（1912-1984），乃是臺灣 50 年代以降抽象繪畫創作及推動臺灣現代美術發展的重要人物之一，他的創作以自由簡潔的線條及奔放的色彩交疊建構，蘊含著超現實意念及自發性情緒的轉移，以抽象繪畫之型態呈現，為臺灣最早從事抽象繪畫的傑出藝術創作者。而李仲生除了個人之藝術成就之外，更被讚譽為「臺灣現代繪畫導師」，其迥異於一般學院式體制的前衛教學，以咖啡館或茶館一對一獨特授課傳藝方式，啟發了學生個人的藝術潛能及思維，並進而發展出各自獨特的創作風格，培育出日後「東方畫會」、「自由畫會」、「饕餮畫會」、「現代眼畫會」等藝術團體之重要成員；李仲生的諸多學生成為臺灣近代美術歷程中的重要指標人物，影響且帶動著臺灣畫壇的發展。

國立臺灣美術館為探討李仲生及其門生對臺灣美術發展深刻且長遠之影響，特別邀請陶文岳先生精心策劃「藝時代崛起－李仲生與臺灣現代藝術發展」，除展出李仲生精選作品外，並試圖重塑師生間藝術創作之對話。在展覽的結構上，歸納為「1951 年臺北安東街畫室時期」、「1957 年彰化時期」、「李仲生門生作品」三大主題區，並輔以許多珍貴文獻對照展出；參展藝術家包括有「八大響馬」之稱的歐陽文苑、霍剛、蕭勤、李元佳、陳道明、吳昊、夏陽及蕭明賢，以及其他時期門生共 34 位，作品 154 件共同展出。本展透過藝術家們各自精采且獨具一格的創作表現，關注並探討李氏門生在李仲生自由開放的教學引領下，對於臺灣美術脈動與趨勢發展的影響力，並期望透過本次所策劃之展覽，從一種既回望又前瞻的角度，重新檢閱時代藝術思潮、美學路向、創作內涵延異發展的歷史變因及後續的擴散性影響。

本次展覽得以圓滿展出，特別感謝策展人陶文岳先生所投注的大量心力，以及李仲生現代繪畫文教基金會的全力支持，並且謝謝蕭瓊瑞、林宏璋二位教授特賜專論，增益本展在學術探討及研究內容上的深度與廣度。此外，參展藝術家、臺北市立美術館、收藏家、借展單位等的無私支持，慨允出借珍藏作品，使國美館得以藉由精湛之藝術創作，表彰李氏藝術精神的傳承於臺灣美術史發展上的卓越貢獻，在此一併致上最誠摯的謝意。

林志明

國立臺灣美術館 館長

Director's Preface

"Reconstructing Art Histories in Contemporary Taiwan," an ambitious project administered by the Ministry of Culture, has entailed the National Taiwan Museum of Fine Arts (NTMoFA) to engage actively in multi-dimensional induction and collation in recent years, and the fruitful results have been manifested in the museum's diverse activities such as exhibitions, researches, collections, forums and symposiums, through which the course of Taiwanese art history is mapped, the ontological value of art is enhanced, and the associated contexts are clarified, thereby channeling new perspective and energy into the reading and dialectic of Taiwanese art. This is why Li Chun-Shan, known as the "mentor of Taiwanese modern painting," has been one of our crucial research objects.

In the 1950s and after, Li Chun-Shan (1921-1984) was an iconic promoter of Taiwanese modern art in general and abstract painting in particular. His oeuvre was interlaced by simple, untrammeled lines and bold, imbricated coloring, imbued with surreal ideas and qualities of Automatism, and presented in the form of abstract painting, which proved that he was a pioneering abstract painter par excellence in Taiwan. Apart from his artistic achievements, Li also won the kudos as the "mentor of Taiwanese modern painting." His avant-garde arts education differed radically from conventional academic training. His pedagogical approach featuring one-on-one teaching in a coffeehouse or teahouse not only unlocked his disciples' artistic potential but also enlightened their minds, based on which they evolved their respective creative styles. Moreover, Li had nurtured the key members of several artistic groups in Taiwan, such as the Tong Fang Painting Association, the Free Painting Association, the Tao Tie Painting Association, and the Modern Eye Painting Association. Many of Li's disciples have become iconic figures on the trajectory of Taiwanese modern art. They not only have an influential presence in the advancement of Taiwanese painting, but also act as a driving force behind it.

For the purpose of reflecting the profound and enduring influence of Li and his disciples on the development of Taiwanese art, the NTMoFA specifically invited Tao Wen-Yuen to curate the grand exhibition *Pioneers of the Avant-Garde Movement in Taiwan: From Li Chun-Shan to His Disciples* in an elaborate fashion. In addition to offering a superb selection of Li's works, this exhibition is intended to reconstruct the brilliant dialogues between Li and his disciples about artistic creation. With regard to its installation, this exhibition comprises three thematic areas, namely "1951-1955: The Atelier on An-dong Street," "1957-1984: Years in Changhua," and "Works by Li's Disciples." Each area is juxtaposed with a display of precious documents. This exhibition highlights a total of 154 works by Li and his 34 disciples, foremost the "Eight Great Outlaws" (i.e. Oyan Wen-Yuen, Ho Kan, Hsiao Chin, Li Yuan-Chia, Tommy Chen, Wu Hao, Hsia Yang, and Hsiao Ming-Hsien). Through the lens of these artists' inimitable creative styles, this exhibition can help the visitors understand the influence of Li's disciples, under the guidance of Li's free and open pedagogy, upon the dynamism and trends of Taiwanese art. By virtue of this exhibition, we seek to undertake a retrospective and meanwhile forward-looking review of the contemporary strands of artistic thoughts and aesthetic orientations as well as the historical variables of content *différance* and their far-reaching consequences.

The success of this exhibition would have been impossible without the considerable time and effort invested by the curator Tao Wen-Yuen and the unreserved assistance from the Li Chun-Shan Cultural and Educational Foundation for Modern Painting. I am more than grateful to Prof. Hsiao Chong-Ray and Prof. Lin Hong-John for their monographs that deepen and broaden this exhibition in terms of academic enquiry and research. Last but by no means least, my sincere appreciation is extended to Taipei Fine Arts Museum and all the participating artists, collectors and lenders. Their unconditional support and selfless generosity enable the NTMoFA to harness the power of these artistic gems, thereby honoring Li's invaluable contribution to and perpetuating his pioneering spirit in Taiwanese art history.

Lin Chi-ming

Director, National Taiwan Museum of Fine Arts

策展
專文 Curatorial Essay

凝視空間記憶 －
從李仲生影響下的臺灣現代藝術現象談起

策展人｜陶文岳

前言

臺灣的「現代藝術」發軔被定著在 50-60 年代，特別是一個藝術時代的轉變，決不是單向性的發展，它絕對是屬於各方面包含歷史、文化與環境長期累積下的產物。我們可以觀看西方藝術史的發展，一個畫派與主義的流行，最後也會因整體變化的產生而發生變革，沒有持續性的永遠，就如同李仲生所說：「沒有一個畫派能夠永遠的存在，但也沒有一個畫派的優點不被永遠保存下來。」[1] 只有符合歷史文化的潮流，它就像大江入海一樣，匯納百川，最後形成一股更大的力量在推動著，所以歷史就會不斷地更迭推演，時代才會不斷地向前行。

如果翻閱臺灣藝術史發展篇章，20 世紀初期的藝術發展，是依循日本帝展模式，臺灣前輩藝術家受日式教育啓發，接觸繪畫或雕塑創作起因於對藝術的熱愛，而日本在臺的統治社會階層，當一位藝術家在當時是受人尊敬與肯定。當然在那個時代，日本對臺灣政治與教育嚴格控管下，也只有藝術和醫學等少數職業可供選擇。早期的藝術創作較單純，但也因為這樣，長期發展下來缺少多樣化的衝擊，概括來說，臺灣前輩畫家銜接了日本印象派畫風（當時許多日本知名畫家皆留學法國巴黎，受印象派風格影響很深），他們的繪畫創作與觀念來自於寫生與寫實為主，這種「類印象」風格的繪畫在 30 年代開始逐漸形成臺灣當權的主流體制，重要的像「臺展」（1927）、「臺陽美展」（1934）、「省展」（1946）等，一直延續到二次戰後的臺灣。

知名藝評家林惺嶽曾在《雄獅雜誌》為文提到：「戰前臺灣前輩畫家的創作觀念形成經典化及教條化，而對戰後新生代產生支配性的壓力……」[2]。在《臺灣美術風雲 40 年》這本著作裡，他又提到：「臺灣的第一代美術家，表現出優異的天賦與勤奮的鬥志。但缺乏處身逆境的考驗與在荒涼的本土艱苦紮根的歷練。此異於文學的歷史際遇與創作特質，注定了他們在戰後步入嚴重失調的命運。」[3] 而另一股勢力是 1949 年大陸淪陷後隨國民政府撤遷來臺的大部分畫家，也是被歸類於較傳統保守的風格，他們抱持著中國正統地位，透過政治和教育來統御畫壇，這兩股勢力是當時臺灣藝術發展的樣貌。

對於文化與藝術發展而言，每當一個時代發展停滯不前時，總會有扮演先鋒者的角色出現，特別是這種開拓者必須要比一般人擁有洞燭機先的睿智，當然在保守環境中，孤寂必將也隨時考驗著他的信念

1　劉文潭，附：劉文潭〈與李仲生先生談前衛藝術〉，《李仲生文集》（前引書），頁 70。

2　林惺嶽，《雄獅美術》256 期六月份，頁 41，1992。

3　林惺嶽，《臺灣美術風雲 40 年》，頁 47。

與毅力。在臺灣 50-60 年代間，前輩藝術家李仲生（1912-1984）可以說是臺灣「現代藝術」的拓荒者之一。他被後世讚譽為「中國現代繪畫先驅」和「臺灣現代繪畫導師」，正因為他既是優秀藝術創作者，同時也是重要的教育家，屬於傳奇性人物。他的抽象繪畫創作、他的教學方式、以及他的生活背景等，一再的被他所教過的學生和其他藝術家所傳頌著，當然這也是研究他的抽象藝術和教學有趣的地方。

李仲生的創作結合了佛洛伊德的潛意識思想、超現實的意念、自動性技巧與抽象繪畫表現，將個人內心有意識、無意識、潛意識的情緒轉移到畫面空間中，呈現出不造作的線條表現與顏色層疊交錯的構成與內容。而他的教學迴異於一般美術學院的教學，最被人稱讚的就是他獨創的一對一教學法，針對每位學生的質地因材施教。本文正是以他的創作與教學不同時期的發展研究出發，包括：一、李仲生生平、求學與創作經歷。二、1951 年在安東街開畫室時期。三、1957 年移居彰化後自由開班授徒時期。四、後李仲生時期。

李仲生在臺灣的藝術史上，就像一顆茁壯的大樹，為臺灣現代藝術做出了努力與貢獻，他的許多門生也各自發展出個人獨特的風貌與特色，且最後開枝散葉，落實了臺灣現代藝術的果實。這次在國立臺灣美術館特別規劃了「藝時代崛起—李仲生與臺灣現代藝術發展」為主題，展出「臺灣現代繪畫導師」李仲生（1912-1984）以及他的 34 位門生包括：朱為白（1926-2018）、歐陽文苑（1928-2007）、李元佳（1929-1994）、焦士太（1929-）、吳昊（1932-）、夏陽（1932-）、霍剛（1932-）、陳道明（1931-2017）、蕭勤（1935-）、蕭明賢（1936-）、李錫奇（1936-）、許輝煌（1937-）、黃潤色（1937-2013）、鐘俊雄（1939-）、黃志超（1941-）、詹學富（1942-）、謝東山（1946-）、黃步青（1948-）、鄭瓊銘（1948-）、王慶成（1948-）、程武昌（1949-）、郭振昌（1949-）、許雨仁（1951-）、陳幸婉（1951-2004）、曲德義（1952-）、李錦繡（1953-2003）、姚克洪（1953-）、楊茂林（1953-）、陳聖頌（1954-）、曲德華（1954-）、吳梅嵩（1955-）、黃位政（1955-）、林鴻銘（1956-）、陳珠櫻（1962-）等共 35 位藝術家，展出藝術類別含素描、水彩、油畫、陶藝、複合媒材、雕塑、裝置與數位互動等。冀希為李仲生藝術精神傳承的延續和臺灣現代藝術發展，做一個詳實、前瞻性與延伸性的研究探討。

一、李仲生的生平、求學與創作經歷

（一）早慧的藝術創作根基

李仲生於 1912 年出生於廣東韶關，父親李汝梅為前清進士，除了深諳法律並擅長水墨與書法，母親黎錦文更是能詩善文，家中共有兄妹四人，他排行第三，從小受到深厚家學淵源的影響，他很早就顯露了藝術天分，8 歲進入韶關當地的天主教慈幼會勵群小學就讀，畢業後直升勵群中學，都利用課餘時間進行水墨、書法創作，因此很早就打下良好的繪畫創作基礎。

（二）上海學習與接觸現代藝術團體活動

他中學畢業後順利就讀廣州美專時，學校傳統教學模式已不能滿足於喜求新求變的他，剛好聽從在外

經商的堂兄建議，選擇到上海美專求學，上海都會多元豐富的環境開拓了他的心胸與視野，而他在上海美專學習接觸現代藝術的洗禮而眼界大開。1931 年，一次偶然機會碰到前來西湖寫生並參觀的兩位日本畫家太田貢和田坂乾三郎，三人相談甚歡，讓李仲生正視到日本現代藝術的進步與豐富學習環境，於是最後他選擇到日本留學。當然在上海這段求學期間，他的繪畫創作受到當地的藝術家所重視，1932 年，他的兩幅「機械派」風格的油畫獲邀參加了中國最早的前衛藝術團體「決瀾社」[4]，於上海中華學藝術社舉辦的第 1 屆繪畫展覽。

（三）日本留學並大放異彩

1933 年 3 月，李仲生順利的考入東京日本大學藝術系西洋畫科就讀，跟隨日本知名油畫家中村研一習油畫。同年冬天他參觀東京府美術館所舉辦「巴黎‧東京前衛繪畫原作展覽會」，讓他首次親炙西方現代前衛藝術名家原作而大受感動與影響。同樣的李仲生也發現東京日本大學藝術系的繪畫教學與他個人理想差距甚大，於是他利用學校課外時間報名了「東京前衛美術研究所」夜間部研習，與日裔法籍畫家藤田嗣治（1886-1968）結下師徒不解之緣。而日後他在臺灣進行實驗性的教法，無疑是受到藤田嗣治觀念的影響。

藤田嗣治是亞洲在巴黎成名最早的畫家，也是著名的巴黎畫派代表人物之一。藤田的藝術觀點和教法，與一般大學美術老師有極大差異性，他喜歡用反向性的教學來教導學生。因為以往學院派老師比較注重同學中創作完整度和技巧性高的繪畫表現，而他則選擇了學生畫不好的作品，適時給予他們開導鼓勵；因為他認為能從這些作品中看到創作者的真切本心與未來發展特色；相反地，他非常反對沒有創意而只會模仿的作品。從藤田嗣治的教導中，讓李仲生見識到自由、開放、大膽、反學院式的教法，而影響他日後深遠。

李仲生在留日 1933-1937 的這段時間，作品先後入選日本春陽會展、第 21、22（免審查）、23、24 屆，此外他還獲日本外務省贈與「選拔公費獎學金」3 年。他同時也加入日本前衛藝術團體－東京「黑色洋畫會」並參與他們的聯展。此時李仲生的創作已開始揉和抽象與佛洛伊德思想，而顯現出較濃厚的潛意識思想的超現實主義作風。值得一提的是李仲生在創作的傑出表現，在寫作理論上，他也編寫《二十世紀繪畫總論》等著作數十種，深獲日本藝評家外山卯三郎的讚賞，屢屢引用推薦。

（四）中日戰爭與返回中國任教發展

1937 年 8 月，李仲生因中日戰爭爆發返回廣東，最早任教於仁化縣立中學。隨後在中日 8 年漫長的戰爭期間裡，他在 1943 年擔任遷校重慶的國立杭州藝專講師。這段期間仍然利用有限時間和機會參加

4　中國最早提倡現代藝術的繪畫團體「決瀾社」共舉辦過 4 次畫展，首次於 1932 年 10 月 10 日至 17 日在上海愛麥虞限路（今紹興路）中華學藝社舉行，之後，1933 年在上海福開森路（今武康路）世界社禮堂、1934 年 10 月在法租界辣斐德路馬斯南路（今復興中路思南路）577 號之中德聯誼會各舉辦過 1 次畫展，1935 年 10 月又回到中華學藝社大廈舉行第 4 次畫展。李仲生應邀參加 1932 年第 1 屆展覽。

重慶重要的藝術展覽活動，包括「現代繪畫展覽」與「獨立美展」，當時大部分的參展畫家風格很多還未超出「野獸派」的範圍，其中就屬李仲生的畫風最為前衛。特別是「獨立美展」，當時趙無極的畫風還徘徊在「野獸派」之間，李仲生則早已經融入康丁斯基式的抽象繪畫表現與超現實的風格，悠遊在抽象激情的線條表現空間中。

（五）正式投身臺灣現代藝術的寫作與教學

1949 年，李仲生隨國民政府來臺，任職於臺北第二女子中學當美術教員，後又被延攬至政工幹校擔任美術組兼任教授。李仲生看到當時臺灣藝術環境對現代藝術觀念的缺乏，遂積極地投入教學與寫作，他早在 1950 年就與黃榮燦、劉獅、朱德群、林聖揚等人合組「美術研究班」，教授「美術概論」。《新藝術雜誌》的主編何鐵華也是鼓吹藝術新思潮領軍型的人物，結合了包含李仲生在內畫家，還有劉其偉、施翠峰、莊世和等人，在雜誌中介紹和標榜現代美術。何鐵華在「新藝術運動概說」提到：「作為 20 世紀的現代人物的我們，欲達創造新的藝術，必須發動一個中國的新藝術運動，無疑的，這運動是要把因襲傳統的東西剷除，同時把世界的新藝術作品與理論，用批判的方式介紹進來，作暫時鞏固我們的力量」[5]。當時《新藝術雜誌》提供了許多西方藝術的新思想與訊息，包括：野獸主義、立體主義、表現主義、未來主義、抽象主義、超現實主義……等觀念的介紹，對臺灣藝壇影響深遠。

李仲生首先在《新藝術雜誌》的創刊號中發表〈國畫的前途〉，也相繼在《聯合報》和《新生報》等重要的報章刊物上，發表多篇藝術論述，介紹西方現代畫派和日本前衛畫派的文章。另外，李仲生、劉獅、林聖揚、朱德群和趙春翔在中山堂舉行「現代繪畫聯展」（1951），散播現代藝術的創作思想。李仲生在臺灣推廣現代藝術教學是屬於全面性，認為只有主動從理論與創作教學雙管齊下進行，才能徹底改變臺灣畫壇的保守心態，他也相信只要能積極的努力開拓現代藝術，臺灣藝術必將會有另一番新格局。另外他可以說是最早在臺灣開班授徒，倡導現代繪畫的第一人。

二、1951 年在安東街開畫室時期（1951-1955）

（一）安東街畫室的春天

1951 年，李仲生在臺北市東區早期的安東街，找到了一間舊式有閣樓的紅磚平房；當時 8 坪大小的畫室，狹窄簡陋又陰暗潮濕的空間，對他而言，卻宛如現代藝術啟蒙與發生的神聖殿堂，一個可以實現他偉大的前衛藝術理想與教學的聖堂。第一批進入李仲生畫室學畫的學生有歐陽文苑、霍剛、蕭勤、李元佳、陳道明、吳昊、夏陽、蕭明賢等，這 8 位入室弟子也確實沒讓他失望，各個都顯現了現代藝術表現的好身手。（蕭勤最早在 1956 年 7 月以公費留學西班牙，隨後是夏陽、蕭明賢去巴黎，李元佳、霍剛去義大利，歐陽文苑到巴西。他們經常與李仲生通信，報告個人創作、生活與國外最新藝術發展情形。）

5　林惺嶽，《臺灣美術風雲 40 年》，頁 81。

他們還在 1956 年聯合創立了「東方畫會」，雖然李仲生始終未曾參與「東方畫會」的籌組與展出，但創會成員畢竟都是他一手調教出來的學生，在他們心目中，早已認定李仲生為「現代藝術」的精神導師。而李仲生的前衛教學成就能獲致成功與廣為人知，當然與他的學生所組「東方畫會」的發展茁壯與多次對外公開展覽有關。

（二）「東方畫會」是臺灣最早前衛藝術團體之一

「東方畫會」與「五月畫會」並稱為臺灣最早的前衛藝術團體。東方畫會的「東方」之名是霍剛提議的，畫會章程則由夏陽起草，他們於 1956 年 11 月成立。會命名「東方」是因為「太陽都從東方升起，擁有朝氣活力的藝術新力量。而畫友因為生長在東方，多數創作都著重東方精神的表現。」他們標榜的創作精神是「進入新的時代環境，趕上今日世界潮流，吸收和發展新觀念，突破與創造新風格。」如前文所言，李仲生雖未曾參加「東方畫會」，但因為曾教過他們 8 人，所以仍視為精神導師。「東方畫會」於 1957 年 11 月在臺北市衡陽路 109 號新聞大樓 2 樓舉辦第 1 屆展覽，畫展的全名是「第一屆東方畫展－中國、西班牙現代畫家聯合展出」。這個展覽除了展出這八位創始會員的現代繪畫作品外，同時還展出由蕭勤特別從西班牙所引進包含知名畫家達拉茲 Juan José Tharrats（1918-2001）、法勃爾 Will Faber（1901-1987）、阿爾各依 Bouardo Alcoy（1930-1987）等 14 位的西班牙藝術家作品。

「五月畫會」成立的時間是 1956 年 5 月，比「東方畫會」早了 4 個月。「五月」的會名是由李芳枝命名，創始會員有：郭東榮、劉國松、李芳枝、郭豫倫、陳景容、鄭瓊娟等，以廖繼春作為他們的精神導師。「五月畫會」成立的靈感來自於法國巴黎的「五月沙龍」Salon de Mai 而來。他們標舉「革新與反傳統美術，從中國本位出發，回應西方藝術潮流，開創中國現代畫新風格為目標。」於 1957 年 5 月在臺北市中山堂開了第 1 屆的展覽。

基本上在 50-60 年代的臺灣藝術主流大都以臺展為模式發展，整體風格是屬於較傳統保守的繪畫風格。單以東方畫會第一次的抽象畫展來說，造成當時藝壇的衝擊可謂不小。「有些人覺得東方畫會這次的展出作品創新、有趣，但也有人認為內容荒誕不經，甚至有觀眾在展出空間裡，當場將說明書撕碎，粗魯無禮地投擲在參展者身上，並大罵『畫的是什麼東西！』這樣兩極化反應的展覽當然也吸引了報章雜誌的廣為報導。《聯合報》副刊的專欄作家何凡戲稱這是『響馬畫展』，意指此參展的八位畫家就像中國東北的強盜一樣，是到處掠劫的『響馬』，因此『八大響馬』之名不脛而走，並在當時的藝壇掀起一陣旋風。」[6] 知名藝術史家蕭瓊瑞曾提到：「這個『現代繪畫運動』以『抽象』風格為當時主要的訴求，顛覆也解構了日治以來，由類印象主義風格所主導的臺灣畫壇」[7]。

6　陶文岳，《抽象・前衛・李仲生》，雄獅美術，頁53。

7　蕭瓊瑞，《李錫奇與臺灣美術畫廊時代》（李錫奇寫七十・本位・李錫奇），頁172。

這股風潮也影響到其他青年藝術家，他們接受了現代思潮影響，籌組畫會也蔚為一時潮流，像較晚發起的「今日畫會」、「現代版畫會」、「年代畫會」、「心象畫會」……等洋洋灑灑而聲勢壯闊[8]。而「東方畫會」與「五月畫會」的藝術表現並稱為臺灣最早的前衛藝術團體，在 60 年代的臺灣藝壇分庭抗禮，將臺灣現代藝術的發展推向一個高峰。

三、1957 年移居彰化後自由開班授徒時期（1957-1983）

（一）現代藝術的另類播種

李仲生原本在臺北安東街畫室授課，後來為了治療風濕病痛（一說是避開白色恐怖迫害），搬到偏遠的彰化居住並在當地的彰化女中教美術課，卻仍舊像磁石般的吸引許多慕名的學生前來和他習畫。那些喜歡獨力思考不喜受學校傳統教學羈絆的學生仍持續口耳相傳，結果產生了滾雪球般的效應，專程自中南部及高雄地區前來受教的大有人在，甚至於連北部的藝專、師大、文化的在學學生，都甘願花錢坐著平快火車，長時間擺盪到中部和李仲生學現代畫，他們每個月固定到彰化學藝然後帶著滿滿的希望與喜悅回家。

李仲生私下的教學，就屬於現代藝術領域的教學，最為人稱道的就是「精神傳精神」的教學思想，即著名的「一對一咖啡館教學法」。在創作上，他讓學生配合佛洛伊德的潛意識思想，盡情用線條宣洩情感，屬於自動性技巧的素描創作，將內心有意識、無意識、潛意識的情緒慢慢地轉移到畫面空間中，呈現出不造作的線條。李仲生在藝術教學上開明的創作思想，讓現代藝術在臺灣落地生根，這也是他所以被尊稱為「前衛繪畫先驅」的主因。後來的學生也都踏隨著學長的步履，像曲德義、黃步青、李錦繡到了法國，陳聖頌選擇到義大利留學等。這些到國外留學發展的學生，不但經常與李仲生保持聯絡，也隨時為李仲生提供世界最新的藝術資訊，讓他與現代藝術保持著同步發展與瞭解的狀態。

臺灣的 70 年代是屬於衝擊和反省的年代，最主要是 1971 年 10 月 25 日，臺灣退出聯合國，許多邦交國相繼斷交；除了被排出文化、外交、經貿……等國際性組織，更喪失與各國在政治、商務與文化等交流。在國際上種種的失利因素，再加上臺灣經濟已朝向工業化結構轉變，大量人口往城市集中發展，導致傳統產業沒落，農漁業生產受到影響及所得偏低等，這些連串性的社會與民生問題接踵而至。鄉土文學運動率先發軔，像陳映真、黃春明、王拓、王禎和、楊青矗都是當時崛起的青年文學家，也是鄉土運動中最具有代表性的文學家。影響所及，臺灣鄉土藝術抬頭，藝壇保守勢力又重新回歸，開始關懷回歸自我本土社會，並順勢推出新的本土文化運動。

有兩個特例突顯臺灣鄉土運動的高潮，一是 1976 年 3 月 13 日，來自本土的素人畫家洪通在臺北「美

8 自由美協在 1964 年曾在臺北市省立博物館召開盛大的十畫會聯誼會，包括：「五月畫會」、「東方畫會」、「現代版畫會」、「長風畫會」、「今日畫會」、「南聯畫會」、「年代畫會」、「心象畫會」、「自由美協」及「集象畫會」，形成中國現代畫會的一次大結合，不但顯示了強大的聲勢，也肯定了現代藝術全面性地生根。郭繼生主編，《當代臺灣繪畫文選》，頁 163。

新處」[9] 展出，在報紙與媒體爭相報導下，洪通的素人繪畫特質如造神般地被打響知名度，可惜的是後來缺乏推動文化與延續歷史傳承的養分與動力，也未能真正持續深耕本土藝術，當鄉土藝術熱潮逐漸散去後，背後又少了人為的支持與炒作，洪通如驚鴻一瞥的驚艷於藝壇，隨後很快的殞落消逝。

「李仲生曾針對一九七○年代的臺灣藝術環境做一個解析與評論，他認為在當時並沒有真正藝術評論的制度，大部分坊間評論的文章充斥著外行人討論著內行人的事，像洪通的繪畫就是最顯明的例子。但以他的觀點看，他認為這位素人畫家的作品只是表現出純真的一面，但那不屬於嚴肅的藝術創作，報紙卻大肆的炒作新聞，這可以當成社會新聞來處理，但不應該出現在藝術界中討論，而且，寫藝術評論不是一件容易的事，要做一個夠資格的評論家，如果僅是玩弄幾句藝術理論的術語，或是寫寫似是而非的空泛談論，就好像盡到評論家的任務，這是不夠的。實際上當一位稱職的藝評家，必須具備藝術、哲學、美學、藝術評論及創作技巧等多方面的修養。」[10]

另一位來自民間的神像雕刻家朱銘，同樣在 1976 年 3 月，於國立歷史博物館舉辦首次個展的盛會與洪通展覽相比並不遑多讓。朱銘專以臺灣鄉土創作為主，融合傳統木雕與現代雕塑精神，富含生命力量。他雕刻的特質，粗獷中兼具細膩美感質地而令人回味；其中又以水牛為主題創作的〈同心協力〉，更受到藝文界人士的熱烈迴響與好評，成為 70 年代臺灣鄉土運動的重要代表和象徵。

四、後李仲生時期

（一）永遠臺灣的藝術先驅

1979 年，時年 67 歲的李仲生從彰化女中退休，同時在臺北的「版畫家畫廊」和「龍門畫廊」舉辦畫展，才辦了生平第一次個展，卻也是生年的唯一兩次畫展。他於 1982 年獲頒中華民國畫學會第 19 屆「繪畫教育類」金爵獎，以表彰在繪畫教育上數十年貢獻。遺憾的是在兩年後卻因肝硬化及大腸癌而辭世，葬於彰化花壇李仔山公墓。一輩子獨來獨往奉獻給創作與教育的李仲生，被弟子們尊稱為「教師中的教師，藝術家中的藝術家」也是當仁不讓的「中國現代繪畫先驅」。

（二）藝術的火苗不熄－「李仲生現代繪畫文教基金會」成立

1985 年 12 月 11 日，「李仲生現代繪畫文教基金會」正式登記成立，由吳昊擔任基金會董事長，詹學富擔任基金會秘書長。持續地推動李仲生生前的遺願，推動臺灣現代藝術發展。1989 年李仲生基金會主辦了第 1 屆「李仲生基金會現代繪畫獎」，頒發成就獎給旅外多年的知名藝術家蕭勤。創作獎則由陳幸婉獲得。李仲生基金會在 2014 年 7 月重新改選董事會，由黃步青擔任基金會董事長，詹學富續任基金會秘書長。從 1989 年到 2018 年，李仲生基金會共舉辦了 15 屆的藝術獎評選，支持鼓勵臺

9 「美新處」是臺北「美國新聞處」的簡稱。

10 陳小凌，〈李仲生訪談錄 -- 抽象世界的獨裁者〉，《李仲生文集》（前引書），頁 144。

灣年輕藝術家，也持續深耕臺灣現代藝術發展而努力推廣。事實也證明被評選獲獎的藝術家們皆持續地發展藝術創作，堅持藝術創作的道路。

後記

80-90 年代臺灣藝術環境發生了很大的改變，在李仲生世逝 3 年後，1987 年 7 月 15 日，臺灣正式宣布「解嚴」。少了政治長期控管與限制，原本禁錮自由的藝術創作領域突然獲得釋放，讓臺灣藝術才能朝向多元性風格發展的主因，臺灣藝術發展百花爭鳴時代由此來臨。這些時空因素與現象的發生串聯匯集，造就了臺灣藝術創作領域嶄新的另一頁篇章。

而臺灣北中南美術館也相繼成立，「臺北市立美術館」率先成立於 1983 年，然後是 1988 年成立於臺中的「臺灣省立美術館」（現為「國立臺灣美術館」），「高雄市立美術館」成立於 1994 年。先後舉辦了許多重要大型的國內外藝術展覽，臺灣的美術館南北串連帶動藝術朝向專業化發展。另外私人畫廊和「替代空間」與「閒置空間」也相繼成立，其中像臺北「伊通公園」成立於 1988 年的秋天，「二號公寓」成立於 1989 年（1994 年暫停活動，後轉型為「新樂園」），兩個並稱為臺灣最早創立的藝術「替代空間」。而「閒置空間」如臺北的「華山藝文特區」（1999 年）與「松山文創園區」（2010 年），高雄的「駁二藝術特區」（2006 年）、花蓮的「花蓮文化創意產業園區」（2007 年）……等，這些來自臺灣各地的民間與官方藝術機構相繼的成立與發展，共同構築起臺灣藝術環境新世紀的到來。

21 世紀，臺灣在科技網路便捷、全球化的架構下，藝術發展環境大不同於以往，各式各樣的當代藝術表現五花八門，而藝術關注的議題不再是「傳統與現代」、「保守與前衛」之爭，對於臺灣藝術未來發展趨勢，無論是朝國際化的理想前進或是繼續深耕本土，藝術家如何重新界定創作的態度和理念，如何調整回歸屬於自己時代與歷史的藝術定位，或許才是重點。回顧以往相比，與李仲生早年篳路藍縷，艱辛的推廣現代藝術是不可同日而語，也正因為如此，此次由國立臺灣美術館所舉辦的藝術特展更顯珍惜難得，也是做為臺灣現代藝術發展的時代見證。

The Evocative Imagery of an Art Giant: A Review of the Modern Art Development in Taiwan under the Influence of Li Chun-Shan

Curator | Tao Wen-Yuen

Introduction

In Taiwan, "modern art" tends to be dated from the 1950s and 1960s. It is noteworthy that the paradigm shift in the art world does not enjoy a straightforward linear development. Its causes have been diverse. Historical, cultural and environmental factors have all impacted upon it at different moments in the long run. Similarly, in occidental art history, the trendiest painting school or art movement has been changing in tandem with the macrocosm. There is no such thing as eternality. Just like what Li Chun-Shan said, "No painting school is permanent, yet its merit is immortal."[1] All things merge with the tide of history, generating an unstoppable momentum that keeps times changing.

In terms of Taiwan's art history, the Imperial Academy of Fine Arts Exhibition dictated the art development in Taiwan throughout the early 20th century. Enlightened by Japanese education, senior Taiwanese artists engaged in painting or sculpture out of their burning passion for arts. Being an artist was a noble profession revered by the elite class. It is not surprising at all, because, at that time, the Japanese colonial regime had absolute control over Taiwan's politics and education, leaving only a few professions (e.g. arts, medical science) available for Taiwanese people. The artistic creation in that period was relatively pure and simple, and therefore seemed to lack diversity along the course of its development. Generally speaking, senior Taiwanese painters followed the style of Japanese Impressionism (many prominent Japanese painters pursued advanced training in Paris, which was why Impressionism had a marked influence on them). Their paintings were mostly sketching from nature and realistic portrayal. Such a "quasi-Impressionist style" started to move into the mainstream in the 1930s, and remained so till the post-war period in Taiwan. Stellar examples include the Taiwan Fine Arts Exhibition (1927), the Tai Yang Art Exhibition (1934), and the Taiwan Provincial Fine Arts Exhibition (1946).

In his article written for *Hsiung Shih Art Monthly*, famous art critic Lin Hsing-Yueh pointed out that "the creative ideas of senior Taiwanese painters who flourished in the pre-war period turned into canonical and dogmatized shackles on the younger generation in the post-war era."[2] In his book *Forty Years of Taiwan's Fine Arts*, Lin further mentioned that "the first generation of Taiwanese artists possessed prodigious talents and displayed great fighting spirit, but they lacked the experiences of the trials and tribulations of adversity and the mental sophistication developed from arduous, root-taking efforts in the bleakness of their homeland. Distinct from those in the literary world, their career paths and creative ethos foreordained their severe disorientation in the post-war era."[3] Another influential force was the group of Chinese painters who retreated to Taiwan together with the Nationalist government after the fall of Mainland in 1949. Their oeuvres embodied traditions and inherent conservatism. Posing as strict defenders of Chinese orthodoxy, they controlled Taiwan's art world by means of politics and education. The early development of Taiwanese art ergo manifested itself in the legacies of senior Taiwanese painters and those migrated from China.

1 Liu Wen-Tan, "Discussing Avant-garde Art with Li Chun-Shan," in *A Collection of Articles by Li Chun-Shan*, p. 70.

2 Lin Hsing-Yueh, *Hsiung Shih Art Monthly*, no. 256, June 1992, p. 41.

3 Lin Hsing-Yueh, *Forty Years of Taiwan's Fine Arts*, p. 47.

Years of cultural or artistic stagnation always bring forth wise and farsighted pioneers. In an environment where conservative values triumph, however, loneliness is a natural concomitant of their original spirit, which puts their faith and perseverance to the test. Li Chun-Shan (1912-1984) who flourished in the 1950s and 1960s could be construed as one of the pioneers of Taiwan's modern art. The later generations hold Li in deep reverence as the "groundbreaker of Chinese modern painting" and the "mentor of Taiwanese modern painting," because he was not only an artist par excellence but also an influential educator, a legendary figure in Taiwan's art world. His abstract paintings, pedagogic strategy, as well as his social and cultural milieus have been eulogized by his disciples and other artists, which is why we can find great delight in studying his abstract art and teaching.

His oeuvre welded together surrealist ideas, Automatism, abstract painting, and Sigmund Freud's account of the unconscious mind, channeling his personal supra-consciousness to create engrossing compositions characterized by unpretentious lines and imbricated layers of colors. Li's mentorship was different from traditional academic training, distinguishing itself by his pedagogical approach of teaching in line with the disciple's ability, which was exemplified by his celebrated one-on-one teaching method. Based on the different stages of Li's artistic creation and teaching, this article proceeds in four parts: (1) an overview of Li's life, training and career; (2) the period of running an atelier on An-dong Street after 1951; (3) the years of teaching in Changhua after 1957; and (4) the post-Li Chun-Shan era.

Li was an artistic icon in Taiwan's art history. He devoted a lifetime to the promotion of Taiwanese modern art, based on which his disciples have not only evolved their respective creative styles, but also flourished with remarkable fruits. Against this background, the National Taiwan Museum of Fine Arts elaborately orchestrated *Pioneers of the Avant-Garde Movement in Taiwan: From Li Chun-Shan to His Disciples*, a grand exhibition that gives prominence to the works by a total of 35 artists, foremost Li Chun-Shan (1912-1984), the mentor of Taiwanese modern painting, together with his disciples, including Chu Wei-Bor (1926-2018), Oyan Wen-Yuen (1928-2007), Li Yuan-Chia (1929-1994), Chiao Shih-Tai (1929-), Wu Hao (1932-), Hsia Yang (1932-), Ho Kan (1932-), Tommy Chen (1931-2017), Hsiao Chin (1935-), Hsiao Ming-Hsien (1936-), Lee Shi-Chi (1936-), Syu Huei-Huang (1937-), Huang Run-Se (1937-2013), Chung Chun-Hsiung (1939-), Dennis Hwang (1941-), Jan Syue-Fu (1942-), Hsieh Tung-Shan (1946-), Hwang Buh-Ching (1948-), Cheng Chiung-Ming (1948-), Wang Ching-Cheng (1948-), Cheng Wu-Chang (1949-), Kuo Jen-Chang (1949-), Hsu Yu-Jen (1951-), Chen Hsing-Wan (1951-2004), Chu Teh-I (1952-), Li Jiin-Shiow (1953-2003), Yao Keh-Hong (1953-), Yang Mao-Lin (1953-), Chern Shen-Son (1954-), Chu Teh-Huah (1954-), Wu Mei-Song (1955-), Hwang Wey-Jeng (1955-), Lin Hung-Ming (1956-), and Chen Chu-Yin (1962-). The works displayed in this exhibition encompass a riotous profusion of forms ranging from drawing, watercolor, ink-wash and oil painting to ceramics, mixed-media, sculpture, installation and digital interaction. Embracing such a rich diversity of works by these admirable artists, we expect to address the perpetuation and development of Li Chun-Shan's spirit of art in a thorough, forward-looking, and extensive fashion.

1. Li's Coming-of-age Chronicle, Training and Career Highlights

1-1. An Early Bloomer of Art

Li Chun-Shan was born in Shaoguan, Guangdong province, China in 1912. His father Li Ru-Mei was a palace graduate (*jinshi*) of the Qing Dynasty in Imperial China, who was not only well-versed in law but also skilled at ink-wash painting and calligraphy. His mother Li Jin-Wen was also capable of poetry and proficient at prose. Li Chun-

Shan had three siblings: two elder brothers and a younger sister. Being erudite through parental teaching and influence, he was an early bloomer of art. Enrolled in the SDB Li-Chun Elementary School at the age of eight and then the Li-Chun High School with an exemption from the entrance exam, his diligent practice at ink-wash painting and calligraphy after school laid an excellent foundation for his painting career.

1-2. Learning and Enlightened by Modern Art Event in Shanghai

After high school, Li Chun-Shan was enrolled in the Guangzhou Fine Arts School without a hitch. As a person craving innovation and revolution, however, he no longer felt satisfied with the traditional training offered by this school. Instead, he transferred to the Shanghai Fine Arts School at the suggestion of his cousin who was a businessman. The all-embracing, bustling Shanghai metropolitan area and the baptism of modern art at the Shanghai Fine Arts School collectively opened up new horizons for Li. In 1931, Li by sheer chance encountered Ōta Mitsugi and Tasaka Kenzaburō, two Japanese painters who visited and sketched from nature at the West Lake. The three hit it off immediately, which informed Li of Japan's congenial environment for modern art development, and prompted him to pursue advanced training in Japan later. Local artists highly valued Li's paintings created during the time when he was studying in Shanghai. In 1932, at the invitation of the Jue-Lan Society,[4] the earliest avant-garde artist group in China, Li presented two of his "machine-style" oil paintings at the first painting exhibition hosted by the Shanghai Chinese Art Association.

1-3. Studying Abroad in Japan and Shining with Extraordinary Talent

In March 1933, Li passed the exam with flying colors and was hence enrolled in the Department of Fine Arts, Nihon University, Japan. Majoring in Western painting, he sat at the feet of eminent Japanese oil painter Nakamura Kenichi. In the winter of the same year, Li went to the exhibition titled *Original Avant-garde Paintings from Paris and Tokyo* organized by the Tokyo Metropolitan Art Museum, where he was enlightened by direct contact with masterpieces of Western modern art for the first time and was therefore extremely touched and profoundly influenced. Again, Li felt that there is a world of difference between the university's training and his aesthetic ideal. As a result, he undertook extracurricular activities at the Institute of Avant-garde Art in Tokyo, where he forged an indissoluble bond with acclaimed Japanese-French painter Foujita Tsuguharu, a pivotal figure who inspired Li's experimental teaching method he adopted in Taiwan.

Fujita was the first Asian painter who shot to fame in Paris and later became one of the iconic figures of the Paris school. He and conventional art professors were worlds apart in their aesthetic views and pedagogic strategies. Professors of academism tended to emphasize the integrity and skillfulness embodied in students' works, while Fujita contrarily set great store by flawed works, so that he could instruct and encourage students in due course

4 The Jue-Lan Society, the first artist group dedicated to modern art promotion in China, had held a total of four painting exhibitions. The first was hosted by the Shanghai Chinese Art Association on 10-17 October 1932, the second at the auditorium of the Shanghai World Society in 1933, the third at the Sino-German Association in October 1934, and the fourth back to the Shanghai Chinese Art Association again in October 1935. Li was invited to present his works at the first exhibition of the Jue-Lan Society.

since he discerned their genuine commitment to and sui generis potential for artistic creation. He was vigorously opposed to the works of mere imitation without any hint of creativity. Li learned from Fujita about what a free, open, and bold pedagogic strategy is, and the latter's spirit of anti-academism had exerted a profound and enduring influence on the former as well.

Li stayed in Japan from 1933 to 1937, during which his works had been nominated for the 21st, 22nd (exempted from review), 23rd and 24th Shunyo Art Exhibition. He also won a three-year scholarship offered by Japan's Ministry of Foreign Affairs. Moreover, he was invited to join the Tokyo-based avant-garde artist group — Black Western Painting Society, and staged joint exhibitions in collaboration with the other members. At that time, Li had evolved a creative style that blends abstraction with Freud's theory, manifesting itself in a surrealist fashion with a conspicuous feature of subconscious mind. Apart from his illustrious career as a painter, Li was also a very prolific writer of dozens of important books such as *An Introduction to the Paintings of the 20th Century*. Japanese art critic Toyama Usaburō not only rhapsodized over Li's writings, but also frequently cited and recommended them.

1-4. The Second Sino-Japanese War and Li's Homecoming as a Teacher

Li returned from Japan to Guangdong in August 1937 owing to the outbreak of the Second Sino-Japanese War. After his homecoming, he taught firstly at the Ren-Hua County High School, and then at the National Hangzhou School of Art (relocated to Chongqing in wartime) after 1943. During the war years, he continued to partake in prestigious art events held in Chongqing, such as the Modern Painting Exhibition and the Independent Art Exhibition. While the majority of the participating artists still confined their creative style to Fauvism, Li had stood out from the crowd as an avant-garde painter. Particularly in the Independent Art Exhibition when Zao Wou-Ki's painting style still lingered over Fauvism, Li had already incorporated Wassily Kandinsky's surrealist abstraction into his works, wandering in the spaces constructed with abstract lines of passion.

1-5. Dedicating to the Writing and Teaching of Modern Art in Taiwan

Moving to Taiwan with the Nationalist government in 1949, Li firstly taught fine arts at the Taipei Second Girls' High School, and was then recruited as an adjunct professor of fine arts at the Political Warfare Cadres Academy. In view of the paucity of modern art education in Taiwan, Li devoted himself to the teaching and writing of modern art on this island. Since 1950, Li had taught the course of "Introduction to Fine Arts" at the Academy of Fine Arts that he founded in collaboration with Huang Rong-Can, Liu Shih, Chu Teh-Chun, and Lin Sheng-Yang. Ho Tieh-Hua, chief-editor of *Art Nouveau* and a bellwether figure in advocating new art thoughts, had invited several painters including Li Chun-Shan, Max Liu, Shih Tsui-Feng, and Chuang Shih-Ho to introduce and promote modern art through this art journal. In his article "A Summary of the New Art Movement," Ho wrote that "a nationwide new art movement is a necessary commodity, if we, as modern actors in the 20th century, are going to create new art. This movement is undoubtedly aimed at weeding old patterns and existing models, and meanwhile introducing foreign works and theories of new art to our fellow countrymen through our critical lens, transforming them into the force that supports

our common cause."[5] At that time, *Art Nouveau* became a channel of communication through which the public were granted access to ideas and knowledge of Western art, e.g. Fauvism, Cubism, Expressionism, Futurism, Abstractionism, and Surrealism. This is by no means an exhaustive list.

Li published the article titled "The Prospects of Traditional Chinese Paintings" in the inaugural issue of *Art Nouveau*, and authored many pieces of art criticism of Western modern painting and Japanese avant-garde painting for influential journals and newspapers such as the *Taiwan Shin Sheng Daily News*. Besides, the *Joint Exhibition on Modern Paintings* (1951) was held at the Zhongshan Hall by Li Chun-Shan, Max Liu, Lin Sheng-Yang, Chu Teh-Chun and Zhao Chun-Xiang, advocating the philosophies behind modern art creation. Li employed a two-pronged strategy (theory and creation) for his effort in promoting modern art education in Taiwan, because only such a comprehensive approach can revolutionize Taiwan's art world ruled by principles of traditional conservatism. He was of the opinion that the active promotion and exploration of modern art will eventually induce a refreshing change in Taiwan's art world. In sum, Li was the first mentor and advocate of modern art in Taiwan, if you will.

2. The Atelier on An-dong Street (1951-1955)

2-1. The Flourishing Atelier on An-dong Street

In 1951, Li found a brick bungalow with a garret located on An-dong Street in the Taipei Eastern District and established his atelier in a space of 26.5 m2 there. Small, simple, dim and humid notwithstanding, it was a sacred place for modern art enlightenment as far as he was concerned, a holy temple for him to achieve his ideal of teaching avant-garde art. The first generation of Li's disciples include Oyan Wen-Yuen, Ho Kan, Hsiao Chin, Li Yuan-Chia, Tommy Chen, Wu Hao, Hsia Yang, and Hsiao Ming-Hsien. Each of them has an impressive record of achievement in modern art that met Li's expectation. (Hsiao Chin obtained the government scholarship for overseas study and went to Spain in July 1956, followed by Hsia Yang [Spain], Hsiao Ming-Hsien [Paris], Li Yuan-Chia [Italy], Ho Kan [Italy], and Oyan Wen-Yuen [Brazil]. They'd been corresponding with Li Chun-Shan, informing him of their respective works, lives and the latest art trends in foreign countries.)

They also founded the Tong Fang Painting Association in 1956. Having no direct link with the founding and exhibitions of the Tong Fang Painting Association though, Li has been enshrined as the spiritual mentor of modern art by the eight disciples. That Li's avant-garde pedagogy was successful and well-known could be deemed as a consequence of the thriving of the Tong Fang Painting Association and the brilliant joint exhibitions staged by his disciples.

2-2. Tong Fang Painting Association: One of the Pioneering Avant-garde Painting Syndicates in Taiwan

The Tong Fang Painting Association and the Fifth Moon Group were equally famous as the earliest avant-garde artist

5 Lin Hsing-Yueh, *Forty Years of Taiwan's Fine Arts*, p. 81.

groups in Taiwan. The former was founded in November 1956. The term "Tong Fang" was adopted at the suggestion of Ho Kan, and the charter was drafted by Hsia Yang. According to Ho, "Tong Fang evokes the imagery of the rising sun, implying vitality and dynamism of new art. Coming of age in the Eastern world, the members' tend to create their works by putting a premium on the oriental spirit." They advocated a four-fold creative spirit: ushering in a brand new era, keeping abreast of global trends, internalizing and developing new ideas, as well as blazing a new trail in terms of their artistic style. As aforementioned, Li had been enshrined as their spiritual mentor because they had sat at his feet even though he was not a member of the association. In November 1957 on the second floor of the Taipei News Building (No. 109, Hengyang Rd., Zhongzheng Dist., Taipei City), the association's members staged the First Tong Fang Painting Exhibition by Chinese and Spanish Modern Painters. Apart from the modern paintings by the eight founding members, this exhibition also featured the magnum opuses by a total of 14 Spanish painters introduced by Hsiao Chin, such as Juan José Tharrats (1918-2001), Will Faber (1901-1987), and Bouardo Alcoy (1930-1987).

Named by Li Fang-Zhi, the Fifth Moon Group was founded in May 1956, four months earlier than the Tong Fang Painting Association. The founding members of the group include Guo Dong-Rong, Liu Guo-Song, Li Fang-Zhi, Guo Yu-Lun, Chen Jing-Rong, and Zheng Qiong-Juan, with Liao Chi-Chun as their spiritual mentor. This group's establishment owed its inspiration to the Paris-based Salon de Mai. Their objectives were three-fold: pursuing revolutionary and avant-garde art, responding to occidental art trends with China-centered approaches, and evolving new styles for Chinese modern painting. The members presented their first joint exhibition at the Zhongshan Hall in Taipei in May 1957.

All through the 1950s and 1960s, the Taiwan Fine Arts Exhibition had been the model for the artistic mainstream in Taiwan, characterized by a relatively conventional, conservative painting style. This was why Taiwan's art world was stunned by the Tong Fang Painting Association's first joint exhibition in that period. "Some visitors found the exhibits innovative and fascinating, while others criticized them for being absurd and ludicrous, and still others even tore the brochures to pieces and threw them onto the participating artists at the exhibition venue, and meanwhile bawled the artists out that "What the hell are you painting!" These highly polarized opinions naturally attracted massive media coverage of this exhibition. Ho Fan, a supplement columnist from the *United Daily News*, jokingly termed it "a painting exhibition by outlaws," implying that the eight painters are a dead ringer for the plundering bandits in Northeast China, thenceforth the reputation of the "Eight Great Outlaws" got round Taiwan's conservative art world rapidly and caused a great sensation."[6] Renowned art historian Hsiao Chong-Ray also mentioned that "the appeal of this 'modern painting movement' lies in its 'abstract' style, which not only subverted but also deconstructed the quasi-Impressionism that had dominated Taiwan's art world since the Japanese colonial period."[7]

This craze for modern art also swept other young artists, who regard establishing painting societies as the trendiest

6 Tao Wen-Yueh, "Abstraction · Avant-garde · Li Chun-Shan," *Hsiung Shih Art Monthly*, p. 53.

7 Hsiao Chong-Ray, "Lee Shi-Chi and the Age of Art Gallery in Taiwan," in Lee Shi-Chi, *70 · Orientation · Lee Shi-Chi*, p. 172.

activity under the influence of modern thoughts, hence the founding of the Contemporary Painting Society, the Modern Printmaking Association, the Times Painting Society, the Imagery Painting Society, etc., displaying a myriad of creative styles and the sheer exuberance of modern art.[8] The Tong Fang Painting Association and the Fifth Moon Group stood as equals as pioneering avant-garde painting syndicates in Taiwan. The development of Taiwan's modern art peaked in the 1960s due to their collective promotional effort.

3. The Years of Teaching in Changhua (1957-1983)

3-1. An Alternative Seed-sowing Approach to Modern Art

To alleviate the pain inflicted by rheumatism (also reportedly to flee from political persecution [the White Terror]), Li stopped running his atelier in Taipei and moved to Changhua, teaching fine arts at the Changhua Girls' Senior High School. Although Li moved to a relatively remote area, many students who admired him still came to ask for his advice about painting, as if he was a powerful magnet for them. This phenomenon was passed on by word of mouth among students who preferred independent thinking and were eager to shake off the shackles of traditional art education, which had a snowball effect that plenty of such people from around the country went to Changhua specifically for the purpose of learning from Li. Even some students of the National Taiwan Academy of Arts, the National Taiwan Normal University and the Chinese Culture University in Taipei were willing to spend time and money, travelling by local express to Changhua in order to learn modern painting from Li. They went to Changhua on a monthly basis, and returned home from a rewarding journey every time.

Categorized in the field of modern art, Li's mentorship distinguished itself by his pedagogical approach of "spirit perpetuation," exemplified by his celebrated "coffeehouse-based one-on-one teaching method." He encouraged his disciples to express their sentiments with lines as much as they can by blending Freud's account of the unconscious mind into Automatism, channeling their personal supra-consciousness to create engrossing compositions characterized by unpretentious brushstrokes. Li's open-minded, enlightening approach to arts education allowed modern art to put down roots in Taiwan. This was the main reason he obtained the honorific title of "the pioneer of avant-garde painting." Many junior disciples studied abroad following in the senior ones' footsteps. Chu Teh-I, Huang Buh-Ching and Li Jiin-Shiow went to France, while Chern Shen-Son to Italy. They'd been corresponding with Li Chun-Shan, keeping him informed of the latest art trends in foreign countries, just like the senior disciples did.

The 1970s was a decade of bitter blow and agonizing introspection for Taiwan. The United Nations General Assembly Resolution 2758 passed on 25 October 1971 was the most severe jolt, followed by many countries

8 In 1964 at the Taiwan Provincial Museum, the Free Art Association convened a special meeting of ten major painting societies, including the Fifth Moon Group, the Tong Fang Painting Association, the Modern Printmaking Association, the Chang-Feng Painting Society, the Contemporary Painting Society, the Southern Union Painting Society, the Times Painting Society, the Imagery Painting Society, the Free Art Association, and the Ji-Xiang Painting Society. It was an important landmark in the history of Chinese modern painting, which not only demonstrated a growing influence of these syndicates, but also stood as testimony to the fact that modern art has put down roots in China. See Guo Ji-Sheng, ed. *A Collection of Articles on Contemporary Taiwanese Painting*, p. 163.

refusing to maintain diplomatic ties with Taiwan. Apart from being removed from international governmental organizations on cultural, political and trade issues, Taiwan's interaction with foreign countries in terms of politics, commerce and culture was also severely undermined. Taiwan was suffering consecutive defeat in international affairs, and what made things worse was a concatenation of social and livelihood problems caused by industrialization and urbanization (e.g. the decline of traditional industries, household income, agriculture and fishery). The nativist literature movement emerged first out of concern for this precarious situation. Chen Ying-Zhen, Huang Chun-Ming, Wang Tuoh, Wang Zhen-He and Yang Ching-Chu were budding writers in that period as well as the iconic figures of the movement. The consequence had become apparent in the rise of Taiwanese nativist arts and the return of artistic conservatism, which prompted Taiwan's art world to focus on the Taiwanese society and seize the opportunity to launch new nativist cultural movements.

The Taiwanese nativist movement peaked with two landmark events. The first was the exhibition by Taiwanese naïve artist Hung Tung at the United States Information Service in Taipei on 13 March 1976. Given extensive press coverage, Hung was soon apotheosized and gained high visibility for the peculiar feature of his naïve paintings. Unfortunately, the absence of necessary nutrients and momentum for cultural and historical perpetuation impeded the development of nativist arts. As the popularity of nativist arts gradually waned, along with the general lack of public support and media hype, Hung's success was just a flash in the pan, a brilliant shooting star streaking through the night sky and then disappearing without trace.

"Li Chun-Shan once analyzed and commented on Taiwan's art environment in the 1970s. He thought that there is no such thing as a real system of art criticism, and pieces showing that amateurs exceed their place and meddle in connoisseurs' affairs were rife at that time. Hung Tung's exhibition was a classic instance. In Li's opinion, this naïve artist did nothing but expressed his innocence. It wasn't much authentic art as such, yet it received plenty of media hype. It could be an item of local news, but shall not be discussed as an art event. On top of that, writing art criticism is not as easy as it looks. It is far from enough to simply juggle with terms of art theories or formulate specious, empty arguments if one wants to be a qualified art critic. As a matter of fact, a competent art critic should be literate in art, philosophy, aesthetics, art criticism and creative skills."[9]

The second landmark event was the debut solo exhibition by Chu Ming, a Taiwanese deity-statue sculptor, at the National Museum of History in March 1976. The sensation it caused bore comparison with that by Hung's painting exhibition. Specializing in Taiwanese folk sculpture, Chu's oeuvre showed a perfect fusion of traditional wooden sculpture and modern spirit, radiating an aura of awe-inspiring vitality. He chiseled in a rough, uninhibited fashion without compromising the delicacy and aesthetics of his works, evoking all kinds of associations for the viewers, foremost the piece titled *In One Heart* featuring a water buffalo that took art critics and practitioners by storm. This piece was then enshrined as an icon of the Taiwanese nativist movement in the 1970s.

9 Chen Xiao-Ling, "An Interview with Li Chun-Shan—A Dictator in the World of Abstraction," in *A Collection of Articles by Li Chun-Shan*, p. 144.

4. The Post-Li Chun-Shan Era

4-1. The Eternal Pioneer of Taiwanese Art

No sooner did Li retire from the Changhua Girls' Senior High School at age 67 in 1979, than he staged his first solo exhibition at the Printmaker Art Gallery and the Lung Men Art Gallery in Taipei. These were also the only two painting exhibitions all through his life. In 1982, he was bestowed with the 19th Jinjue Award by the Calligraphy and Painting Association of China for his lifetime commitment to painting education. Much to our regret, Li died of liver cirrhosis and colorectal cancer in 1984. He was buried in the Lizishan public cemetery in Huatan Township, Changhua. As a maverick who devoted his lifetime to artistic creation and arts education, Li was addressed by his disciples distinctively as "the teacher of teachers and the artist of artists," and absolutely measured up to the legendary reputation as the "pioneer of Chinese modern art."

4-2. Li as the Inspiration that Keeps the Torch of Art Aflame
The Li Chun-Shan Cultural and Educational Foundation for Modern Painting

On 11 December 1985, the Li Chun-Shan Cultural and Educational Foundation for Modern Painting was formally established with Wu Hao as the chairman and Jan Syue-Fu as the secretary-general. To fulfill Li's final wish, the foundation is dedicated to promoting the development of Taiwan's modern art. The foundation set up its first modern painting award in 1989, conferring the award of lifetime achievement to famous expatriate artist Hsiao Chin, while the award of creation went to Chen Hsing-Wan. The foundation's board of directors was re-elected in July 2014, with Hwang Buh-Ching as the chairman and Jan Syue-Fu re-appointed as the secretary-general. Since its initiation in 1989, the foundation's modern painting award has entered its 15th year, committed to the cause of encouraging young Taiwanese artists on the one hand and supporting the development of Taiwan's modern art on the other. It has proved that each of the award-winning artists has spent his/her entire career in artistic creation.

Epilogue

The 1980s and 1990s were a period of great change in Taiwan's art environment. The Taiwan martial law order was lifted on 15 July 1987, three years after Li's demise. Taiwan's art world thus converted to pluralism after attaining liberation from suffocating political control and censorship. Such a congenial development ushered in an era in which numerous schools of art contend with one another. These historical factors and events collectively wrote a brilliant chapter in the history of Taiwanese art.

This period also witnessed the successive establishment of major art museums around Taiwan. The Taipei Fine Arts Museum was the first (1983), followed by the Taichung Fine Arts Museum (1988) (now the National Taiwan Museum of Fine Arts) and the Kaohsiung Fine Arts Museum (1994). They've served as the venues for many prestigious international exhibitions, and their reciprocal connections have become a driving force behind the professionalization of art. A multitude of commercial galleries, alternative spaces and revitalized urban spaces also emerged in rapid succession. For examples, the IT Park was founded in the autumn of 1988, and the Apartment No. 2 in 1989 (ceased functioning in 1994, now the SLY Art Space), known as the two earliest alternative spaces in Taiwan. Revitalized urban spaces include the Huashan 1914 Creative Park (1999), the Pier-2 Art Center (2006),

the Hualien Cultural and Creative Industries Park (2007), and the Songshan Cultural and Creative Park (2010). The establishment and development of these private and governmental artistic institutions collaboratively bring Taiwan's art world a fresh look and new energy in the 21st century.

Thanks to the convenient and fast services of technologies in the globalized world, the conditions for artistic development nowadays have been radically different from those in the past. In addition to the riotous profusion of forms in contemporary art, "tradition/modernity" and "conservatism/avant-garde" are no longer the subjects of debate. With a vision for the future of Taiwanese art, be it inclined to internationalization or localization, the key issues are perhaps how artists re-define their attitudes and ideas about creation, and how they re-position themselves in a greater historical context. By way of comparison, all the hardships that Li endured throughout his undertaking of promoting Taiwan's modern art proved to be an invaluable experience for the later generations. In this sense, the grand exhibition—*Pioneers of the Avant-Garde Movement in Taiwan: From Li Chun-Shan to His Disciples*— organized by the National Taiwan Museum of Fine Arts not only offers a rare and precious opportunity to the visitors, but also bears testimony to the development of Taiwan's modern art.

專論 Essays

李仲生傳奇與藝時代的崛起－
臺灣現代藝術發展的一頁重要篇章

文｜蕭瓊瑞

「臺灣現代藝術導師」李仲生（1912-1984），在 1984 年 7 月過世時，具名在治喪委員會名單上的學生，計有 69 人；而這些學生的藝術成就，構成臺灣戰後現代藝術史最重要的一個側面，也印證了藝術史家所言：李仲生的私人教學及影響，幾乎超越一所專業的美術學校。[1]

國立臺灣美術館 2019 年推出的「藝時代崛起－李仲生與臺灣現代藝術發展」特展，由年輕藝術學者陶文岳策展，計邀請 34 位學生，加上李氏本人作品，重新檢視這段臺灣現代藝術史上最具傳奇色彩、也最為膾炙人口的一頁篇章，值得深入討論與闡發。

李仲生長達 34 年的在臺教學生涯，可以 1955 年的離開臺北、南下彰化為界，劃分為前後兩個階段，前段才僅 6 年，後段則長達 28 年；但臺北這 6 年的教學，卻培養出日後推動臺灣「現代繪畫運動」最重要的團體「東方畫會」；而南下後的教學，則又先後催生了「自由畫會」（1977-）、「饕餮畫會」（1981-）、「現代眼畫會」（1982-）等團體，以及造就出許多不在這些團體之內的傑出子弟，確是臺灣藝術史上未曾有過、未來也很可能不會再有的傳奇。

一、東方畫會時期

1951 年春天，也是李仲生自廣東來臺的第二年，他和同是中國大陸來臺的藝術家黃榮燦（1916-1952）、劉獅（1913-1997）、朱德群（1920-2014）、林聖揚（1917-?）等人，在臺北市漢口街開設了一個「美術研究班」。[2] 這是一個以推動「現代藝術」為目標的私人補習班，模仿日本的名稱，所有的私人教學都稱作「研究班」；但在那個艱困的時代，開班授徒似乎也是這些美術家增加收入的一個管道。

不過，美術班在一期 3 個月之後，便因招生困難而停辦；倒是李仲生對這些失學青年的教學熱忱不減，便將部份願意繼續學習的學生，轉往他在安東街新設的畫室兼教室，繼續教學；而這個「安東街畫室」，也就成了日後「東方畫會」的發源地。

1 蕭瓊瑞〈李仲生的學生們－戰後臺灣現代繪畫發展的一個切面〉，李仲生與臺灣現代繪畫之發展學術研討會，中國杭州：中國美術學院主辦，臺中：國立臺灣美術館、財團法人李仲生現代繪畫文教基金會協辦，2006.11.1。

2 詳參蕭瓊瑞〈戰後初期臺灣畫壇私人畫室之成立〉，《五月與東方－中國美術現代化運動在戰後臺灣之發展（1945-1970）》，頁 71-79，臺北：東大書局，1991.11。

「安東街畫室」的學生，主要來自兩個系統：一是服務於空軍的軍中青年，包括：歐陽文苑（1929-）、吳昊（原名吳世祿，1931-）、夏陽（1932-）；一是仍在臺北師範學校（簡稱「北師」）就讀的李元佳（1929-1994）、陳道明（1931-2018）、霍剛（原名霍學剛，1932-）、蕭勤（1933-）、蕭明賢（原名蕭龍，1936-）……等人，這些人正是 1926 年年底組成「東方畫會」、而在 1927 年的首展中被稱為「八大響馬」的主軸性人物。[3]

事實上，早在 1955 年年中，學生們便有組織畫會的構想，並向老師提出，沒想到這位曾在報章雜誌上大力鼓吹、呼籲政府應支持臺灣畫壇組織美術團體以便推動美術運動的精神導師[4]，卻在聽聞學生即將組成畫會的消息時，嚇得全身發軟，跌坐在地上；甚至幾天後，便不辭而別，放棄在政工幹校（後改政治作戰學校、今國防大學政治作戰學院）的教授一職，離開臺北，前往彰化員林家商任教。[5]

不過，學生組成畫會的意念，並未因老師的離去而動搖；1956 年 7 月，蕭勤以西班牙提供的獎學金，率先前往巴塞隆納留學，並在 1957 年的首屆東方畫展，引進西班牙畫家，如：達拉茲（Juan José Tharrats, 1918-）、法勃爾（Will Faber, 1901-?）……等人，藉由這個以反共聞名的國家的藝術家的參與，來消除臺灣社會、特別是政府當局對於「現代藝術＝共產主義」的疑慮。類似的作法，在此後的多屆展出中持續進行；同時，也將東方畫會會員的作品，引介到歐洲展出。這在臺灣現代藝術的發展上，是極具意義的作為；東方畫會的展出，也為臺灣「現代藝術運動」正式拉開了序幕。[6]

這批李仲生最早的學生，幾乎都是從帶著潛意識的抽象風格入手，但在日後的發展中，則並不完全走向抽象，如：吳昊跨越版畫、油畫兩界，以帶著歡愉、華麗的色彩，創作出大批和鄉土、民俗相關的作品[7]；夏陽則追隨蕭勤之後，先到義大利、再轉往巴黎，最後在紐約以帶著晃動的超寫實風格，及被稱作「毛毛人」的手法，在現代都會與傳統文化間進行詼諧式的思辨[8]。

但整體而言，東方畫會中的這批李氏弟子，在創作上基本還是以抽象式的風格為主軸，其中尤以蕭勤、霍剛最具代表性。

蕭勤的父親蕭友梅（1884-1940）是中國第一位留學德國的音樂家，也是上海音專創辦人；出自良好

3　詳參〈八大響馬與東方畫會之成立〉，前揭《五月與東方－中國美術現代化運動在戰後臺灣之發展（1945-1970）》，頁 90-124。

4　李仲生〈美術團體與美術運動〉，《新藝術》1 卷 3 期，臺北：廿世紀社，1951.1。

5　蕭瓊瑞〈來臺初期的李仲生（1949-1956）：教學生活〉，《現代美術》22 期，頁 45-53，臺北：臺北市立美術館，1988.12。

6　詳參前揭蕭瓊瑞《五月與東方－中國美術現代化運動在戰後臺灣之發展（1945-1970）》。

7　詳參蕭瓊瑞〈無悔的歡愉－做為一個生活藝術家的吳昊〉，《吳昊四十年創作展》，頁 21-32，臺北：臺北市立美術館，1994.12；及蕭瓊瑞〈吳昊的「生之喜悅」〉，《吳昊》（展覽專輯），臺北：帝門藝術中心，1999.8。

8　蕭瓊瑞〈冷眼世情‧笑看人生－夏陽的藝術特質〉，《夏陽－觀‧遊‧趣》，頁 18-26，臺北：臺北市立美術館，2018.10。

的家世背景，蕭勤卻有一個悲慘的成長經歷：5 歲時父親不幸過世，10 歲時，母親也蒙主寵召，留下唯一的妹妹，卻有精神上的宿疾。15 歲時，隨姑媽來到臺灣，就讀臺北師範；22 歲那年去了西班牙。動盪、飄泊的生命歷程，也成就了蕭勤獨特的藝術思維與風格；他曾自述：自己的藝術正是父親的人文主義加上母親的宗教影響，一方面是哲理的、分析的、實證的，二方面是玄學的、神秘的、綜合的。不論是自由流動的線條，或一度走向硬邊的結構，蕭勤的創作始終是一種對生命、宇宙的永恆好奇與探討。[9]

霍剛早期的作品，運用一種自由想像的連續性線條，發展出具有潛意識特色的圖像，勾引觀者產生一種具夢幻、灰沈的聯想，可視為霍剛的「灰色時期」。1964 年的出國前往義大利，並定居米蘭，是霍剛創作風格決定性轉變的關鍵點。色彩完全脫離灰、黑的主調，轉為紅、藍、紫的構譜，而且都是帶著一些粉調的中間色；而在構成上，也由空靈的、幾何性的趣味，取代了之前筆觸行走、不定形的作風。

在霍剛此後長達一甲子的創作中，正是透過純粹的形色組構，營造出一種看似設計，其實充滿人文性與精神性的藝術創作。色彩營構氛圍、形式提供情節；尤其在形式當中，線條的方向、圓的大小，或三角形的排列，都具有高度示意性的功能；充滿了一種似乎有事正在發生、或有話要說的謎樣特質。這種特質正是音樂的、也是詩的特質。[10]

至於歐陽文苑、陳道明，和蕭明賢，也都是以抽象的手法創作，早期均有相當突出的表現，蕭明賢甚至還得過 1957 年巴西聖保羅雙年展的「榮譽獎」，但較可惜地，他們一度在藝壇上消失，晚年才再恢復創作。

較為特別的是李元佳，與其說他走的是抽象風格，不如說是觀念藝術。從早期的墨點或細線畫，到後來移居英國，自設美術館，成為當地觀光景點，都可以窺見這位藝術家別樹一幟的創作理念與作為。[11]

李仲生的教學強調「精神性」，他認為：沒有「精神性」，抽象藝術就容易流為設計的圖案。這些東方畫會的學生，可說正是實踐了乃師的理念與主張，也成為臺灣 1950、60 年代「現代繪畫運動」最重要的一群推手。

二、安東街畫室外的學生

李仲生來臺初期的臺北教學，除安東街畫室的東方畫會諸子外，他在復興崗政工幹校的學院教學中，也影響一批軍校子弟，焦士太（1929-）可為代表。

9　詳參蕭瓊瑞〈宇宙過客－蕭勤的心靈逆旅〉，《榮源－蕭勤七十回顧展》，臺北：大未來畫廊藝術有限公司，2006.4。

10　詳參蕭瓊瑞〈幾何的詩情－霍剛 2015 新作選〉，《原點‧解析－霍剛的東方抽象語法》，臺北：采泥藝術，2016。

11　參見前揭蕭瓊瑞〈李仲生的學生們－戰後臺灣現代繪畫發展的一個切面〉。

焦士太，生於江蘇邳州，少年時期，曾隨私塾教師學過國畫。1949 年來臺，1953 年入復興崗政工幹校；師從李仲生研習畫論，深受李氏「潛意識自動性技法」觀念啟發。1965 年之後，全力投入抽象繪畫的探討。

兼擅文思的焦士太，也曾以筆名「大漠」發表許多藝術評論，特別是在屬於軍中刊物的《勝利之光》，對當時的軍中藝文青年，乃至一般社會大眾，均有相當影響；尤其是對臺灣現代繪畫導師李仲生的推崇與介紹，更是當年臺灣藝壇媒體的先行者。[12]

焦士太之外，另有李錫奇（1938-）、朱為白（1929-2019）也都是屬於較早的一批學生。

出生金門的李錫奇，有畫壇「變調鳥」的美稱；所謂的「變調鳥」，便是對媒材、風格、形式的不斷嘗試與創新。也是臺北師範藝術科畢業的李錫奇，沒能趕上學長們拜師李仲生的時潮；但日後，他和李仲生的接觸，以師禮敬待李仲生，李仲生也公開接受這位並未真正入門的弟子為學生。

李錫奇是臺灣現代藝術運動中，第一個以反傳統、反繪畫性，及反格律化的行動，來完成一種既是傳統、又具繪畫性、也充滿格律化趣味作品的人。他既是臺灣「現代版畫會」的創始藝術家、東方畫會的成員，也是臺灣 1960 年代中期最早以現成物來從事複合美術創作的藝術家之一。

1970 年代末期，李錫奇在個人創作外，開始投注大量心力於現代藝術的推廣與介紹，先後主持版畫家畫廊（1978-）、一畫廊（1983-）、環亞藝術中心（1985-），以及三原色畫廊（1987-）等，許多重要藝術家的在臺首展，乃至生平首展，都是在這些畫廊中舉辦，包括：趙無極、李仲生，及大陸畫家黃永玉、石虎、劉萬年、舒春光 …… 等等，這是李錫奇對臺灣戰後美術運動的另一貢獻。

1990 年，李錫奇結束長達 12 年的畫廊經營後，有機會前往湖北荊州美術館參觀，乍見楚文化的魅力，也展開了他後期的「漆畫」創作階段，巨大尺幅，特殊的媒材、多變可拼貼的手法，在在形塑他成為一代巨匠的地位與形象。[13]

另一位也是從版畫切入抽象藝術創作而深具成就的是朱為白。朱為白雖然不是「現代版畫會」創始會員，卻在 1965 年加入「現代版畫會」，同時，也早在 1958 年，即參加第 2 屆「東方畫會」的展出；甚至在 1978 年之後提供私人畫室，與李錫奇成立「版畫家畫廊」、「三原色畫廊」，提供現代版畫及現代藝術展出的平臺，是臺灣現代繪畫運動中、後期極具特色的藝術家。

12　參見蕭瓊瑞〈抽象繪畫的先行一代〉，《藝術家》515 期，頁 106-119，臺北：藝術家雜誌社，2018.4。

13　詳參蕭瓊瑞〈本位‧變異‧超越－李錫奇的藝術歷程〉，《臺灣美術全集（31）：李錫奇》，臺北：藝術家雜誌社，2016.3。

朱為白，原名武順，和霍剛同為南京人，出身三代的裁縫世家。1949 年隨軍赴臺，公餘接受李仲生的教導。1954 年，在臺北結識霍剛、蕭勤等東方畫會諸子，1958 年成為第 2 屆畫展的參展者，也是東方畫會創始會員之外，最早入會的成員。

除了具有民俗風情的版畫外，朱為白也投入「挖貼」藝術的探討，憑著他三代縫紉匠師的背景，將這項手法發揮到極致。他擅長運用黑、白、紅等單色棉布或麻布為媒材，以利刃取代畫筆，在作品表面，劃出一道道割痕，再加上多層襯托、折疊等手法，使畫面產生豐富的層次效果與空間深度，超越了一般繪畫作品的平面性；在極簡和質樸的風格中，呈現了中國傳統道家老、莊的哲學內涵與韻味。[14]

黃潤色（1937-2013）是李仲生南下後，最早接觸、且在創作上深具個人特色的一位藝術家。1962 年受邀加入東方畫會，成為畫會首位女性成員，也是臺灣在抽象繪畫表現上最具特色與成熟風格的第一位女性藝術家。

黃潤色的抽象繪畫，一開始就展現一種流暢、優雅的曲線結構，加上同色系的豐富色韻變化，以及巨大的寬幅表現，在恢宏的氣度中，又有細膩、含蓄的氣質。以流暢的弧線，組構出一種充滿神秘、又富生命律動的畫面，有時襯在幾近白色的空曠背景前，引人進入一種無限想像的靈視世界。[15]

較黃潤色年輕兩歲的鐘俊雄（1939-），比黃潤色更早 3 年接受李仲生的指導，進入輔仁大學英語系就讀那年（1957），也正是東方畫會推出首展的一年，鐘俊雄便已投入李仲生門下，展開對現代藝術的追求。

鐘俊雄的作品，始終是多變且多元的，時而水墨、時而油彩、時而拼貼、時而肌理，他經常跳脫純粹技巧的層次，企求有所表現。因此鐘俊雄的創作風格，始終無法以單一的面貌拘限，他的創作，帶著頑童的心理，一日數變，別人既無法預測，自我也不願拘限。

鐘俊雄的多才多藝，讓他的表現領域複雜多樣，除油彩、版畫之外，他更在 1967 年加入「中華民國雕塑協會」。初期以木雕為主，帶著一些禪意的抽象表現；之後，以鐵雕為主，90 年代創作大量作品，在「百分之一公共藝術」政策實施後，也有多次公共藝術創作的參與。[16]

1941 年出生於廈門鼓浪嶼世家的黃志超，年少時期即從祖父的書法藏品，獲得藝術的啟蒙。1950 年自廈門渡海赴臺，先居臺北，後遷嘉義，再回臺北，這樣的遷徙，讓他更全面地接觸不同社會的臺灣，

14　參見蕭瓊瑞〈純粹與深邃－當代臺灣抽象藝術經典展〉，《當代臺灣抽象經典展》畫冊，頁 10-51，臺北：采泥藝術，2017.3。

15　參見蕭瓊瑞〈抽象思維的擴張與傳播〉，《藝術家》517 期，頁 100-113，臺北：藝術家出版社，2018.6。

16　同上註。

同時也與席德進相識，並拜師吳學讓；後經鐘俊雄介紹，成為李仲生門下，獲得現代藝術創作的思維與門徑。

1971 年，他應邀赴美訪問，自此長居美國。美國時尚的色彩，尤其是剛剛問世的壓克力彩，加上紐約街頭百態和社會氛圍，讓他的創作，歷經一次徹底的翻轉；放下了已然成名的蠟染風格，開始投入版畫的創作；不久，便回到純粹的手繪圖畫，畫面變得更為豐富自在，而女人、山水、馬……，也成為他抒發情感、寄寓心靈的語彙。這些看似童趣的造型，其實是來自潛意識自動流露的書法線性構成，而渲染、漸層的色面，則有著中國古代山水空間的轉換；一顆不安的靈魂，恰恰刻意追尋一個可居、可遊的人間桃花源，那正是古老中國一個狂簡、脫俗的另類文人傳統，遠從魏晉的山林居士，到明清之際的徐渭、唐寅、陳老蓮、八大等畫家的真情率性。

而黃志超則在這當中，更加入了純真與幽默、多彩與情色的元素，形成了不可代替的 20、21 世紀的另類文人風範。[17]

也是以「人」的本位出發的詹學富（1942-），也是彰化員林人，從臺灣師大美術系二年級前後，進入李仲生畫室學習，前後 9 年之久；樸質堅毅的個性，表現在其創作手法，也是擇一而終。他採取李氏意識流的創作手法，以延續性的線條、色面，構成各種極具象徵意涵與情慾反思的女體造型。這種捨去學院法則，也拋開現實自然法則的造型方式，完全交由本能、潛意識的流動主導，形成的女性結構，暗含諸多可解與不可解的象徵意涵。而其原色的色彩，突顯強烈對比的效果，賦予畫面一種緊密、俐落的視覺張力。

三、從「自由畫會」、「饕餮畫會」到「現代眼」

1977 年，已經是李仲生南下之後的第 23 個年頭，「東方畫會」的活動，已因成員的陸續出國而瀕臨停息的狀態；此時，那些在李氏南下後陸續接受啟蒙的學生，開始有了延續學長作為、重新組成畫會、推動繪畫運動的想法。首先組成的團體，就是「自由畫會」。李仲生為他們的首展寫了介紹文，肯定他們將成為東方畫會之後，另一個能夠承當承先啟後責任的前衛藝術團體。[18]

自由畫會的創始會員計有：黃步青（1948-）、程武昌（1949-）、曲德義（1952-），和李錦繡（1953-2003）等 4 人。

黃步青出生彰化鹿港，1969 年仍就讀臺灣師大美術系期間，就前往李仲生畫室學習。1977 年，師大美術系畢業後，即帶頭組成自由畫會。這段期間，他的創作，仍以繪畫為手法，以帶著照相寫實般的

17　詳參蕭瓊瑞〈玩家・童趣・文人情－黃志超的色線人生〉，《今藝術》288 期，頁 72-75，臺北：典藏今藝術，2016.9。

18　見〈自由畫會〉首展請束序文。

手法，描繪臺北街頭往來人群。

1981 年，他和同學、也是妻子的李錦繡（1953-2003），雙雙赴法留學，以 6 年時間（1987），取得法國巴黎大學造型藝術碩士。這段期間，他的創作手法大幅改變，媒材、技法都深具實驗性與創造性，如：將手掌沾彩拓印，留下深深的掌紋，然後再用鉛筆畫上精細寫實的蟬影；又如：採用油性粉筆，透過擦拓、拼貼的手法，來捕捉裸女的身形；或是以炭筆、壓克力直接在紙上自由的揮洒；似乎李仲生強調潛意識的教學影響，也在此時浮現出來。1988 年，他就是帶著這樣的風格回到臺灣，並進入成功大學建築系任教。

1989 年，黃步青開始走入裝置的階段，也展開海邊拾荒的工作。許多從山上沖刷入海的原木，或被拋棄的舊家具、瓶子、洋娃娃、衣服模特兒……等，形成他極具視覺震撼力的裝置創作，帶著高度的儀式性與生命思維，是臺灣裝置藝術，迄今最具代表性的藝術家之一，也曾代表臺灣參加威尼斯雙年展。[19]

1953 年出生在嘉義市一個油漆匠師家庭的李錦繡，1972 年負笈北上，成為國立臺灣師範大學美術系的學生。大二升上大三那年，她和黃步青，一起前往彰化員林拜師李仲生，藝術創作自此進入深具精神性的內在世界，以一種帶著潛意識、自我分析式的流動造型，描繪身邊的家人、同學和風景。

1983 年，她追隨夫婿黃步青之後，赴法留學，1987 年返臺。在繁忙的教學、家居生活中，李錦繡始終未曾鬆懈個人的創作。返臺初期，她延續留法時期對空間、光線的探討，同時，也返回嘉義故鄉，和前輩書法家陳丁奇（1911-1994）學習書法，融和東、西方思維於一爐。

90 年代之後，李錦繡的創作思維，逐漸轉向內心澄徹的追求，也就是所謂「透明自在」的「我的存在」。2003 年不幸因病去世。[20]

自由畫會另一創始會員曲德義（1952-），是黃步青、李錦繡在臺灣師大美術系的學長（1976 年畢），在臺灣師大美術系三年級時（1974），入李仲生畫室學習，展開其帶著潛意識特質的純粹抽象表現探討。1977 年首屆「自由畫會」之後，即赴法留學（1978），同時在法國國立高等藝術學院（1979-1984）及國立高等設計學院（1981-1983）學習，並以俄國絕對主義藝術家馬勒維奇（Kazimir Severinovich Maleyich,1878-1935）的研究作為碩士論文的主題；而在創作上，也走上結合李仲生的心象抽象（熱抽）與馬勒維奇色面構成（冷抽）的個人風格。

身為華人，卻出生在韓國，來臺就讀臺師大美術系，之後又留學法國，這種多元的文化背景，充份展

19　詳參蕭瓊瑞〈走出荒蕪‧堅持拾荒－反思文明的黃步青〉，《今藝術》234 期，頁 144-146，臺北：典藏今藝術，2012.2。

20　詳參蕭瓊瑞〈粉色人生‧素淡風情－李錦繡的藝術魅力〉，《藝術家》499 期，頁 382-383，臺北：藝術家出版社，2016.12。

現在曲德義的創作行動中：通過潑、刮、塗、抹、流、磨等技法，及一再地堆疊或減去，呈現了飽滿鮮明的色彩交錯融合，猶如頑童般瀟灑恣意地挑戰自我。曲德義對色彩的掌握及材質間衝突的美感呈現，總是有獨到的見解，在畫面的色彩與空間感的塑造層面，不斷提出別於既往的大膽嘗試。畫作多表現出正負空間相互交錯的平面，創造出視覺空間的跳躍性，色彩間的融合及使用層層乳膠堆疊產生的曖昧地帶，加上藝術家在法國學習到的特殊打磨技法，平和地讓不同圖層在二維空間中交錯並置、相互印證，在視覺上掀起一股莫名的騷動。[21]

自由畫會創始會員中唯一非臺灣師大系統的程武昌（1949-），是黃步青鹿港的同鄉，程武昌未曾進入學院，卻是李氏南下後最早追隨學習、且持續時間最久的少數幾位學生中的一位。他早期以東方文人水墨的毛筆，進行一些極具生物性繁衍特質的造型表現，捕捉某種潛意識的「真實」，素樸、低彩、幾近素描的手法。80 年代中期之後，則加入一些較具油漬相斥般效果的肌理變化，紅、藍的色彩，仍讓人有一種神秘的聯想。李仲生稱他是「作畫最勤的一位」。他在 1969 年，進入李仲生畫室學習，1971 年入選國際青年美展，1976 年個展於臺北美國新聞處；1977 年自由畫會成立後，他是最忠實的參展同仁，並在 1979 年成立「程武昌現代畫室」，李仲生為其畫室題名；李氏 1984 年去世後，他在同年成立「中國前衛藝術中心」，矢志延續乃師志業，傳授前衛藝術思想，並在 1987 年與學生組成「龍頭畫會」，推出「中國第一屆前衛藝術展」，是對「前衛藝術」極具熱情與使命感的李氏弟子。[22]

自由畫會一直展出到 1988 年的第 8 屆，展出場地已由臺中轉往臺北市立美術館。期間陸續加入的會員，也都是李仲生的學生，而在此次國美館「藝時代崛起」展出名單中的，計有：許輝煌（1937-）、鄭瓊銘（1948-）、謝東山（1946-）、王慶成（1948-）、陳幸婉（1951-2004）、曲德華（1953-）、陳聖頌（1954-）、吳梅嵩（1955-）、黃位政（1955-）等人。

年齡最長的許輝煌，也是彰化鹿港人，臺中師範（今國立臺中教育大學）畢業。在校期間，即曾參加多項競賽畫展，並獲佳績；1964 年入李仲生畫室，遂終生投入現代繪畫之探索。

許輝煌的創作，基本上是從潛意識的自動性技巧出發，以線聯線、以形造形，追求一種非形象的精神世界，具有夢幻、虛凌的視覺特質，色彩鮮麗、筆觸細、綿密，透露其探究生命、奧秘的痕跡。

許輝煌在中部地區，長期從事兒童畫教學，也對現代藝術的推廣，具一定貢獻。[23]

而 1969 年入門的謝東山（1946-），臺灣師大美術系畢業（1969），之後取得美國德州理工大學的藝

21　詳參蕭瓊瑞〈低限‧冷抽九人展〉，《低限‧冷抽－九人展》（畫展專輯），頁 6-17，臺北：采泥藝術，2018.9。

22　參見蕭瓊瑞〈李仲生南下後的第二波影響（二）〉，《藝術家》524 期，頁 178-189，臺北：藝術家出版社，2019.1。

23　參見前揭蕭瓊瑞〈抽象思維的擴張與傳播〉，頁 100-113。

術批評博士學位。

早年的創作，尤其是參加自由畫會期間，是以一種印刷圖像拼貼的方式為手法；近年來，走向一種具超現實意味的古典寫實畫風，給合中西圖像，仍具後現代的特色。[24]

長居臺中的鄭瓊銘和出生雲林的陳聖頌，也是臺灣師大美術系的同班同學。鄭瓊銘於 1979 年進入李仲生畫室，陳聖頌則更早於 1976 年。

鄭瓊銘的創作，是以墨、炭、粉彩、油彩等多媒材，進行一種細密重疊的線性組構。早期的作品，比較接近潛意識的心象抒發，基本上是從周邊環境的感受切入，採半自動性的技法，任由畫筆隨性奔竄，以不同強弱、粗細的線條，譜構出疏密有緻、且深具動感的畫面。視角開闊，猶如俯瞰的大地圖，摻雜多次元的空間交錯，有時甚至以油彩畫在立體的方盒當中；90 年代之後，關懷自然生態的用心更為明顯，畫面隱約中有自然、土地的影子，綿密素樸中散發一種人文的溫度。[25]

陳聖頌出生雲林北港，和曲德義、鄭瓊銘均為臺灣師大美術系 1976 年畢業；1977 年入李仲生畫室，1981 年起加入自由畫會展出，1983 年留學義大利，入國立羅馬藝術學院就讀，1988 年畢業，一度長居義大利。

陳聖頌早期的色彩，以黑、白、灰為基調，事實上，那既是一種空間關係的結構，也是一種色彩的凝煉；之後，多了一些黃、褐的色彩，顯然地是來自大地與自然、尤其是樹木的元素。堅實、內斂、緊密，畫面一如藝術家的個性。近年來，他從南臺灣海邊、原野的視覺特質中找尋靈感，在純粹的色彩線條構成中，呈現了一種屬於土地與生命的情感與眷戀。[26]

和鄭瓊銘同齡的王慶成，曾隨政戰學校的金哲夫學習，並參與政戰體系出身畫家組成的「六六畫會」。1976 年進入李仲生畫室後，拋棄以往描形寫實的作風，以自動技法進行創作，打破傳統強調和諧、安定的畫面構成，刻意造成多重影像的不協調，頗有日後紐約「壞畫」（Bad Panting）的先聲。[27]

如果說，文前所提李錦繡的創作，是超越生死、淡看人生的一種自在與飛揚；那麼，同樣英年早逝的陳幸婉（1951-2004），則是在作品中舖陳了死亡的悲壯與生命的無常。

24　參見前揭蕭瓊瑞〈李仲生的學生們－戰後臺灣現代繪畫發展的一個切面〉。

25　參見前揭蕭瓊瑞〈李仲生南下後的第二波影響（二）〉，《藝術家》524 期，頁 178-189。

26　同上註。

27　同上註。

陳幸婉是知名前輩雕塑家陳夏雨（1917-2000）的女兒。1969年入國立藝專美術科西畫組，1972年畢業後，一度擔任教職。1979年，辭去教職，全力創作。1981年，拜入李仲生門下，受其觀念啟發，開始進行大量自動性技法的素描練習，並在畫面加入石膏、紗布等媒材，以增加肌理與量感，在刮、貼、畫……的行動中，展現一種帶著美麗與頹廢的畫面特質。

1990年，陳幸婉參與國際藝術家交換計劃，赴瑞士巴塞爾駐居創作半年，也開始了她以水墨在紙上創作抽象繪畫的系列。顯然她深受李仲生強調「墨水」而非「水墨」的思想影響，跳脫中國文人水墨講究墨韻濃淡變化的拘限，以自動性技法，將純黑的水墨，在畫面上形成一種時而爆發、時而流洩、時而旋轉、時而噴灑……的多樣性構成，成為她終生探索不厭、且傑作倍出的系列。

1999年，面臨父親健康惡化、感情傷逝，及921大地震……等等內外變故的衝擊，加上之後眼疾的困擾，作品逐漸以水墨創作為主。2004年，以乳癌驟逝於巴黎，享年53歲。[28]

年輕陳幸婉3歲的曲德華出生於韓國，1977年自臺灣師大美術系畢業，1977至78年進入李仲生畫室學習；之後遊學法國巴黎，就讀巴黎東方文化語言學院及羅浮宮學院（1979-1982），再遊學澳洲（1982-1992），其間也進入澳洲雪梨城市藝術學院研究所研習雕塑，並取得創作碩士學位（1984-1989）；2000年，再取得澳洲國立大學坎培拉藝術學院視覺藝術碩士。

曲德華以線性構成的雕塑作品，早在1989年澳洲雪梨的畢業展中即已形成；而這種對空間結構的敏銳感知，甚至延伸到整個展場空間的佈署，特別是在紅、黑、白等線條密集結的支持下，形成量體既大，感覺卻虛靈的神秘空間。

2009年之後，更將燈光引入，成為和這些線性雕塑，形成一種光影交錯、虛實相生的「浮光」、「漾影」的迷人效果。這些立方體的造型物，由於觀者觀看角度的改變，或光線投影角度的改變，會產生無窮的趣味變化，在虛實緊密之間，引人進入一種超越視覺趣味的靈視想像。

曲德華的作品，在綿密、精準的鐵線組構中，不但不會給人冰冷、枯燥的感覺，反而令人感受到一種如詩般的優雅氛圍，似虛又實、舉重若輕，光影穿透、多組呼應，力量滲及整個空間，是臺灣少數以抽象雕塑為專業的傑出女藝術家。[29]

臺灣藝專畢業的吳梅嵩（1954-），其創作帶著強烈的視覺思辨性，一如他的《桌、椅、語錄》系列，畫面中雖有、椅的形象，但描繪桌、椅並非他的目標，也非目的，而是透過那些孤獨存在的桌、椅，

28　詳參前揭蕭瓊瑞〈李仲生南下後的第二波影響（一）〉，《藝術家》523期，頁178-191。

29　同上註。

去捕捉、呈現這個「物象」在幽闇的空間中，存在的實境與意義。那是一種心靈的探索與冥思，而在媒材和手法上，時而平面、拼合的畫布、時而實物的裝置與擺設。[30]

黃位政（1955-）也是以人物為題材，但極盡誇張與變形之能事，以突顯人性愚蠢、暴力、貪婪的本質，作品深具社會批判與警世意味，也是臺灣解嚴前後現代藝壇的一把響號。

臺中師專（今臺中教育大學）畢業（1975）的黃位政，在畢業的前1年（1974），進入李仲生畫室學習，奠定其從事現代藝術的基礎。1983年通過教育部自費留學考試，前往法國留學（1986），自法國國立高等美術學院畢業（1986）。

黃位政早期的作品，仍以李氏潛意識的素描造型為基調，創作了許多深具超現實主義風格的油畫作品。之後，焦點轉向以人物身體為元素的《原慾》系列。由性轉往政治，或說結合性與政治，成為黃位政在解嚴前後創作的主題；其作品中人物的糾纏、角力、謾罵，既是一種爭衡，也是一種解脫。其作品具有強烈的個人日記與時代見證的雙重意涵，人物的扭曲變形，也是心靈的扭曲變形。黃位政批判性極強的作品，是一種精神的自剖與社會的寫照，令人不愉快，卻如此真實直接。[31]

自由畫會組成後的第4年（1981），又有「饕餮畫會」的成立。「饕餮」是中國上古青銅器上的紋飾，相傳這種怪獸生性好吃，什麼都吃！取名「饕餮」，正是要仿傚「饕餮」精神，凡事吸收，勇於學習。如果說：「自由畫會」是由臺灣師大校友為主軸組成的團體，那麼明顯的「饕餮畫會」就是由國立臺灣藝專（今國立臺灣藝術大學）校友所組成。「饕餮畫會」的成員，此次參與展出的，除前提曾參與自由畫會的吳梅嵩外，另有許雨仁與姚克洪。

許雨仁（1951-）也是在符號與自然、抽象與心象之間穿梭、拉扯，媒材上也由濃重的油彩，轉為虛凌、簡拙的墨筆。許雨仁，是畫壇的一朵奇葩。出生臺南佳里的他，從小看到書本就會頭暈，卻奇蹟地在1971年考上國立臺灣藝專，就讀美術科國畫組。在藝專求學的5年中，臺北故宮和彰化的李仲生，分別提供他對傳統的認識與現代藝術的啟蒙。

從早期筆觸填滿的油畫作品，到近期幾乎空無幾筆的水墨長軸，許雨人的創作事實上始終不離現實的生活；但也始終不限於現實的生活。他以細筆直線，顛覆現代水墨所謂「革中鋒的命」的主張，從頭到尾都用中鋒，也只用中鋒；他挑戰傳統中國文人水墨對直線、直角的禁忌，他的畫面經常出現直線、直角，甚至只有直線、直角。他的水墨，有墨無水，卻喜愛用墨線表現水的流動與無限。許雨人的抽象繪畫，是生活的，也是觀念的；或有現實的影子，卻是潛意識的呈現；他是城市中的野人、鄉野中

30　參見前揭蕭瓊瑞〈李仲生南下後的第二波影響（二）〉，《藝術家》524期，頁178-189。

31　同上註。

的哲士；為臺灣 60 年代之後的現代水墨，乃至臺灣抽象繪畫發展，開拓了一個嶄新的面貌。[32]

至於姚克洪，藝專畢業後，前往美國加州洛杉磯 Rio Hondo 學院進修陶藝。之後再入紐約市立大學藝術研究所主修陶藝和繪畫，並取得 MFA 學位。此後，即以多媒材成為創作主要手法。

姚克洪也是一位多才多藝、廣泛學習、多元表現的藝術家。作品蘊含深刻的人文思維，結合詩的玄想與人和環境、歷史、日常之間的隨機關聯及隱喻，呈顯一種極富文學與哲思的作品，是對母土、故鄉的一種遙念。[33]

1982 年，饕餮畫會成立後的第 2 年，一群李仲生南下後教學培養的學生，包括：前提黃潤色、詹學富、鐘俊雄、陳幸婉等，公推甫由臺北移居臺中的資深現代藝術前輩陳庭詩為會長、鐘俊雄任總幹事，正式成立「現代眼」畫會；之後陸續加入、仍屬李氏學生的黃步青、李錦繡、林鴻銘、鄭瓊銘、曲德華……等，乃至非李氏弟子的其他現代藝術創作者；成為 80 年代之後，中部地區最重要的前衛藝術團體，也是李氏南下教學影響力的一次總集結與總展現。

1950 年次的林鴻銘，彰化人，1974 年入李仲生畫室，1989 年加入「現代眼」聯展。他的抽象創作，徘徊於抽象與超現實風格之間，具有強大的爆發力，恰和超現實風格的靜謐、神秘形成對比。[34]

「現代眼」畫會成立的兩年後（1984），李仲生即以 73 歲之齡辭世。3 年後（1987），其弟子程武昌，立志承繼乃師精神、發揚現代藝術，邀集李氏晚期學生，組成「龍頭畫會」，其中出生臺中的陳珠櫻（1962-），在短期的國小教師生涯後，1987 年前往法國巴黎國立高等藝術學院進修，1991 年取得學位；1995 年再完成巴黎第八大學「藝術與新科技影像」碩士學位，在新媒體的創作上，頗具表現，曾返臺個展於臺北市立美術館。

在李氏南下後的教學行動中，事實上也有一些未曾參加學生團體，但在創作上也深具成績者，郭振昌及楊茂林可為代表。

由於是彰化人，郭振昌早在高中時期（1968）即前往李仲生畫室學習，前後 5 年之久（1968-1973），直到文化大學美術系畢業（1973）。

郭振昌的個人經歷頗為特殊，他曾任職知名印刷廠，擔任高階主管，卻毅然辭職，全力投入創作；他

32　詳參蕭瓊瑞〈李仲生南下後的第二波影響（三）〉，《藝術家》525 期，頁 150-163，臺北：藝術家出版社，2019.2。

33　同上註。

34　同上註。

的繪畫，大力擷取各種民間藝術的造型，如：古代神話人物、八家將，年畫、民俗版畫、神佛畫像，結合當代社會的各種印刷品、現成物，如廣告美女、獎章、珠飾……等等，構成一種色彩艷俗、造型狂野的複合性畫面。內容往往是對臺灣各種社會現象的諷刺及影射，畫面巨大而氣勢撼人，成為臺灣解嚴後重要的當代藝術表現之一。[35]

也是彰化人的楊茂林（1953-），1973 年進入李仲生畫室學習，當時還是個高中生。1977 年文化大學美術系畢業後，與同學組成「101 現代藝術群」，以歷史反思、政治嘲諷、社會批判的創作角度，獲得廣大注目。1985 年，文化大學校友擴大組成「臺北畫派」，楊茂林擔任第 1 任會長。1991 年，以突出的創作成果，獲得第 1 屆雄獅美術創作獎。

楊茂林的創作，結合各種圖像，包括古代失敗的英雄、解嚴前後臺灣議會打架的人物，乃至寓言故事中的驢子、胡蘿蔔，還有之後尋找臺灣歷史的熱蘭遮城記事、圓山記事中的歷史人物與動、植物的百合花、雲豹等，近期則更引入東西洋漫畫人物系列的各種卡通、玩具造型。[36]

楊茂林後現代式的表現類型，是否有直接來自李仲生教學的啟發或影響，或許還有待深入探究；但李仲生強調從傳統中擷取創作養份的教學思想，顯然成為學生創作傾向中的一個大項，則無疑義。

四、結論

在檢視李仲生學生們的藝術創作與成就的同時，有論者曾經提出：李仲生在臺灣藝術史上的地位，完全是建立在學生的成就上；換句話說：是學生的成就造就了李仲生在臺灣美術史上的地位；因此，他作為一位美術教育家的貢獻，實遠大於本身作為一位創作者。

然而衡諸目前典藏在國美館的李氏大批創作，不論是素描或是水彩畫、油畫，上述的說法，顯然是一種嚴重的偏頗與完全忽略事實的論斷。從此次展出的師生作品觀察，李仲生除了作為一位成功的現代藝術導師，在其個人創作上，至少也可以略舉如下的幾個特點：

（一）十字形的構成。畫面大致以幾何形中心為焦點，形成一種十字形的構圖。所謂的十字形構圖，往往既富由內向外爆發的張力，也具由四方向中心凝聚的動力，而予人以一種平衡與縱切拉扯的宗教莊嚴感。

（二）豐富的肌理。不以意境聯想為取向的創作，如何賦予觀者可游、可思、可感的內涵，便是以多樣

35　參見前揭蕭瓊瑞〈李仲生的學生們－戰後臺灣現代繪畫發展的一個切面〉。

36　詳參蕭瓊瑞〈後二二八世代與二二八－從建碑到美展的思考〉，《凝視與形塑－後二二八世代的歷史觀察》（展覽專輯），頁 8-21，臺北：臺北市立美術館，1998.2。

性技法所構成的豐富肌理來引發視覺的探索、追蹤與品味。在李仲生的作品中，隨處可見他如何透過刮、塗、擦、染、印……的種種技法，形成複雜的視覺穿梭與游移。

（三）線面的交錯與加、減畫法的互用。在李仲生的作品中，一般抽象表現主義經常運用的甩點手法反而罕見，而是著重快速有力的線條與層次多變的色面，在層層堆疊的色彩與筆劃中，更相對地使用刮痕的減式筆法，在相互對照與彼此拉扯的對應中，形成一種猶如思維辨證的哲學對話。

總之，相對於與他同時代的趙無極（1921-2013）、朱德群等被西方藝壇標舉為「東方抒情抽象」的感性表現，李仲生的抽象創作，毋寧是呈顯一種更具節制與思維的建築性構成。儘管李氏本人一再宣稱自己的創作是一種強調潛意識流露的「超現實主義的抽象」；但我們應可肯定：所謂的「潛意識」，只是創作起動初始時的一種「畫因」與「動能」，最後所謂「心象」的構成與呈顯，實則具備更多思辨、辨證、覆蓋、揭露的綿密過與特質。因此，面對李仲生的抽象作品，與其去深究作品所蘊藏的個別「心象」表徵，不如回到畫面本身，去細細品味其形、色、線、面……等交錯、對應的諸多趣味與精神性。這是李仲生個人創作的獨特成就與貢獻，既深刻地影響了他的學生，甚至影響了臺灣現代藝術發展長達半世紀的「藝時代崛起」。

The Rise of the Legend of Li Chun-Shan and the Era of Art:
An Important Chapter in the Development of Avant-Garde Art in Taiwan

Hsiao Chong-Ray

When Li Chun-Shan (1912-1984), renowned as the "The mentor of Taiwanese modern painting," passed away on July 1984, 69 names among the list of funeral committees were Li's disciples. These disciples were representing figures of the art scene of post-war Taiwan, as well as a realization of what art historians have stated: the private teachings and influence of Li Chun-Shan exceeds that of an entire professional art school.[1]

In 2019, the National Taiwan Museum of Fine Arts presents the special exhibition, *Pioneers of the Avant-Garde Movement in Taiwan: From Li Chun-Shan to His Disciples*, curated by the young art researcher, Tao Wen-Yuen. The exhibition showcases not only the works of 34 artists who have studied under Li Chun-Shan but Li's own artworks, re-examining this exciting and remarkable chapter in the history of modern art in Taiwan, which is worthy of in-depth discussion and elucidation.

Looking into Li Chun-Shan's 34-year teaching career in Taiwan, it can be divided into two phases by the year of 1955, at the time when Li left Taipei and moved to Changhua – no more than six years in Taipei as the first phase, while twenty-eight years in Changhua as the second. Li cultivated important figures of the Tong Fang Painting Association throughout his years in Taipei, which were instrumental for the modern art movement in Taiwan. Li's teachings in the south of Taiwan gave birth to art groups including the Free Painting Association (1977-), Tao Tie Painting Association (1981-), and Modern Eye Group (1982-), as well as other outstanding artists that do not belong to any groups. This scene can definitely be deemed as a legend that has never been seen in the modern art history of Taiwan, and it is likely that it will not be there in the future.

1. The Years of the Tong Fang Painting Association

It was the spring of 1951, the second year that Li Chun-Shan arrived in Taiwan from Guangdong, he gathered together the artists who also traveled to Taiwan from Mainland China – including Huang Rong-Can (1916-1952), Liu Shih (1913-1997), Chu Teh-Chun (1920-2014), Lin Sheng-Yang (1917-?), and opened a "research class of fine arts" at the junction of Hankou Street in Taipei.[2] The main objective of founding this private extracurricular class was to promote modern art. The title of the class was extracted from Japanese style, from which all private classes were referred to as "research classes." However, during difficult moments of that time, launching classes and giving tutelage were common methods for artists to gain extra income.

1 Hsiao Chong-Ray, 'The Disciples of Li Chun-Shan: A View of the Modern Painting Scene in Post-War Taiwan,' Li Chun-Shan and the Development of Modern Art Painting in Taiwan Conference, Hangzhou, China: Hosted by the China Academy of Art, Taichung: Co-organized by the National Taiwan Museum of Fine Arts and Li Chun-Shan Foundation, November 1, 2006.

2 See Hsiao Chong-Ray, 'The Establishment of Private Painting Studios in the Early Years of Post-War Taiwan,' *The Fifth Moon and Tong Fang: The Modernization of Chinese Fine Art in Post-Wat Taiwan*, (1945-1970), p.71-79, Taipei: Dongda Publishing, November 1991.

Unfortunately, after the first three-month session, the class was forced to shut down on account of difficulties in recruiting disciples. Notwithstanding this, Li Chun-Shan's enthusiasm towards those youngsters remained unchanged. Subsequently, Li transferred those disciples who were still willing to learn to his newly-established atelier on Andong Street; hence this "Andong Street Atelier" became the cradle of the Tong Fang Painting Association.

The disciples at the "Andong Street Atelier" were derived from two groups – the ones who served in the air force, including Oyan Wen-Yuen, Wu Hao (originally named Wu Shih-Lu), and Hsia Yang; and the others who were still enrolled at the National Taipei Teacher's College (now the National Taipei University of Education), such as Li Yuan-Chia, Tommy Chen, Ho Kan (originally named Ho Xue-Gang), Hsiao Chin, and Hsiao Ming-Hsien (originally named Hsiao Long). These figures were not only the founding members of the Tong Fang Painting Association, an art group that formed at the end of 1926, but also referred to as "the Eight Great Outlaws" during the first exhibition in 1927.[3]

In fact, those disciples had already had some ideas about forming a painting association as early as mid-1955, and presented the idea to Li. However, they did not expect that their teacher, a leader who had voiced his ideology through publications to convince government to support art groups in Taiwan,[4] was petrified when he heard the news. Li even took leave without prior notice, abandoning his teaching post at the School for Political Warfare Officers (the Political Warfare College, later known as Fu Hsing Kang College), and leaving Taipei to start a new position at National Yuanlin Home-Economics and Commercial Vocational Senior High School in Changhua.[5]

Despite Li's departure, the determination of forming a painting association remained unchanged in those disciples' minds. In July 1956, Hsiao Chin left for Barcelona to study further with the scholarship provided by the government of Spain. He then introduced Spanish artists such as Juan Jos'e Tharrats (1918-) and Will Faber (1901-) during the first exhibition of the Tong Fang Painting Association in 1957. By inviting the artists from a country known for its resistance against the communists, Hsiao attempted to eliminate any concerns of equating modern art with communism from Taiwanese society and the government. Similar strategies were applied continuously throughout the later exhibitions. At the same time, works by members of the Tong Fang Painting Association were also showcased in Europe. All of these incidents were significant tipping points for the development of Taiwanese modern art; indeed, we could say that the Tong Fang Painting Association exhibition introduced a new era of modern art movements in Taiwan.[6]

The artists, who were the early disciples of Li Chun-Shan, started their artistic creations with subtle abstract styles, but they did not all become full-blown abstract painters. For instance, Wu Hao concentrated on both print and oil painting, creating numerous joyful, glamorous works inspired by rural land and folk culture.[7] As for Hsia Yang, he followed the footsteps of Hsiao Chin, traveling to Italy, Paris, and finally New York, where he became the pioneer of the "Fuzzy People" technique with his quivering, surrealistic styles, and creating a new perspective – between

3 See 'The Establishment of the Eight Great Outlaws and Tong Fang Painting Association,' *The Fifth Moon and Tong Fang: The Modernization of Chinese Fine Art in Post-Wat Taiwan (1945-1970)*, p.90-124.

4 Li Chun-Shan 'Fine Art Groups and Fine Art Movements,' volume 1 issue 3, Taipei: 20th Century Publishing, January 1951.

5 Hsiao Chong-Ray, 'The Early Years of Li Chun-Shan in Taiwan (1949-1956): Teaching and Life,' issue 22, Modern Art, p.45-53, Taipei: Taipei Fine Arts Museum, December 1988.

6 See Hsiao Chong-Ray, *The Fifth Moon and Tong Fang: The Modernization of Chinese Fine Art in Post-Wat Taiwan (1945-1970)*.

7 See Hsiao Chong-Ray, 'Pleasure without Regret: Wu Hao, the Life Artist,' *Wu Hao Forty Years Exhibition*, p.21-32, Taipei: Taipei Fine Arts Museum, December 1994, and Hsiao Chong-Ray, "Wu Hao's 'Joy of Life,'" *Wu Hao* (exhibition album), Taipei: Dimensions Art Center, August 1999.

modern urbanism and traditional culture through humor.[8]

Overall, this group of disciples of Li Chun-Shan was known for their abstract style of paintings, with Hsiao Chin and Ho Kan as representing figures.

Hsiao Chin once stated that his art was influenced by his father's humanistic thinking and his mother's religious beliefs; one was philosophical, analytical, and empirical, while the other was metaphysical, mysterious, and complex. Whatever free-moving lines or stiff structure, they all express Hsiao's curiosity and exploration of life, universe, and eternity.

Throughout the sixty years or so of Ho Kan's artistic career, his works are known for their pure color and simple form that may be seem as design-like but are in truth filled with humanistic and metaphysical concepts. The works give mysterious impression as if about to convey an on-going incident or speech, a quality that is both musical and poetic.

As for Oyan Wen-Yuen, Tommy Chen, and Hsiao Ming-Hsien, their early works not only reveal outstanding qualities but also have abstract characteristics. Different from others, Li Yuan-Chia's works were more conceptual rather than abstract.

Li Chun-Shan's teaching approaches and methodology emphasize the "spiritual." He stated that without the spiritual, abstract art would merely become design patterns. Those disciples from the Tong Fang Painting Association applied the methods of their mentor, and became the forces of the modern art movement in Taiwan during the 1950s and 60s.

2. Disciples Outside the Andong Street Painting Studio

During the early years when Li Chun-Shan taught in Taipei, apart from the disciples of Tong Fang Painting Association from the Andong Street atelier, Li was also a significant influence to a group of military students at Fu Hsing Kang College, with Chiao Shih-Tai as the representing figure.

Chiao Shih-Tai studied under Li Chun-Shan and was deeply inspired by Li's "subconscious automatic technique," devoting to exploring abstract painting.

Lee Shi-Chi is dubbed as the "changing bird," referring to Lee's continuous experiments and innovation with different media, styles, and forms. Lee is the pioneer of the modern art movement in Taiwan, and also the first one to challenge tradition, creating works that resisted rules but were at the same time inspired by conventions, paintings, and regulations.

Chu Wei-Bor excelled in applying black, white, and red cottons or linen cloths as mediums, and he replaced paintbrush with knife, creating cuts that were further accentuated or enhanced to present layers and spatial depth. These works not only break through two-dimensional boundaries but also convey traditional Daoist philosophy of

8 Hsiao Chong-Ray, 'Viewing the World and Life with Cool Detachment: The Artistic Temperament of Hsia Yang,' *Hsia Yang: Journey to Art*, p.18-226, Taipei: Taipei Fine Arts Museum, October 2018.

Laozi and Zhuangzi through minimalism and simplicity.

As Li Chun-Shan's first female disciple, Huang Run-Se is an outstanding abstract artist in Taiwan. Huang's works are characterized by their fluid, graceful curve structures and the rich variation of synchronized color arrangements. Her works are generally shown in large-scale, with meticulous, subtle qualities added to the grandeur of the art pieces.

The works of Chung Chun-Hsiung are ever-changing and filled with variety. Chun created not only ink paintings but also oil paintings and collage. He sometimes even experimented with different textures. Chun's works have a playful quality, which are unpredictable and unrestrained.

Dennis Hwang's seemingly childlike designs were in truth formed with flowing calligraphic lines from his subconscious, while the gradient colors were inspired by the changing of space in traditional Chinese landscapes. He would add a sense of innocence and humor, vibrancy and eroticism into his works, forming an unparalleled artistic style of the twentieth and twenty-first century.

Jan Syue-Fu abandons standard art techniques and the rules of naturalism, hands over the creative control to instinct and the flow of subconscious, creating female figures that imply ineffable symbolic meaning. As for the primary colors in his works, they create a contrast that reveals intense visual sensations.

3. From the Free Painting Association, Tao Tie Painting Association, to the Modern Eye Group

By 1977, Li Chun-Shan had spent twenty-three years in Southern Taiwan. Activities of the Tong Fang Painting Association were at a standstill due to the absence of members who traveled abroad. In the meanwhile, Li's other disciples – the ones received his tutelage when Li moved to the south – followed the footsteps of Li, initiating new painting associations to promote painting movements. The first group they formed, was the Free Painting Association. Li Chun-Shan especially wrote an introduction for their first exhibition, praising their effort of forming an avant-garde art group that continued the legacy of the Tong Fang Painting Association.[9]

Members of the Free Painting Association include Hwang Buh-Ching, Cheng Wu-Chang, Chu Teh-I, and Li Jiin-Shiow.

Hwang Buh-Ching's creative method changed extensively throughout his time in Paris, which showed the impact of Li Chun-Shan's emphasis on the subconscious in media and technique. These techniques were transformed into impressive installation works that conveyed rich ceremonial concepts and contemplations on life. Hwang remains one of the most representative artists that concentrates on installation works in Taiwan.

Since Li Jiin-Shiow began her apprentice to Li Chun-Shan, her works conveyed an in-depth spiritual exploration of the inner world, with designs that were inspired by the subconscious and self-analysis. After the 90s, the creative concept of Li Jiin-Shiow turned inwards, showing a "transparent content" of the "existence of the self." Li passed away in 2002 due to an illness.

9 See the introduction article of the invitation of the 'Free Painting Association Exhibition.'

Chu Teh-I's arrangement of color and sense of space continuously reveal his bold, new experiments of creativity. Chu's works generally show two-dimensional images with intertwining spaces that represent the vibrancy. The ambiguous areas created by different merging colors and layers of latexes as well as the unique polishing technique that the artist learned in France, perfectly place different layers of images in a harmonious composition, which complement each other and create stunning effects.[10]

Cheng Wu-Chang's early works were created with oriental calligraphic ink brushes, which not only conveyed forms that remind viewers the biological reproduction but also captured the humble, low-saturated qualities of the subconscious, almost identical to sketch methods. After the mid-80s, Cheng started to incorporate textures that resemble oil stain separation, while the red and blue hues inspire mysterious associations. Li Chun-Shan praised Cheng as the "most diligent at painting."

By 1988, the location of the 8th Free Painting Association exhibition had moved from Taichung to Taipei Fine Arts Museum. Most of the artists who joined the association throughout the years were the disciples of Li Chun-Shan. The listed artist in the Participants of the Avant-Garde Movement in Taiwan: From Li Chun-Shan to his Disciples exhibition arranged by the NTMoFA include Syu Huei-Huang, Cheng Chiung-Ming, Hsieh Tung-Shan, Wang Ching-Cheng, Chen Hsing-Wan, Chu Teh-Huah, Chern Shen-Son, Wu Mei-Song, Hwang Wey-Jeng, among others.

The works of Syu Huei-Huang are inspired by automatism of the subconscious technique. By connecting lines and shapes, Syu pursues a spiritual world unrestricted by form, and creates works that have a dreamy, ethereal quality. The vibrant colors and delicate, meticulous lines all convey the traces of exploring life and the mysterious.

The early works of Hsieh Tung-Shan, especially the pieces that were created during his time as a member of the Free Painting Association, were collage works by using printed images. Hsieh's recent works convey a style that mixed with surrealism and classic realism, integrating both oriental and occidental images, which provide viewers a post-modern impression.

The closely-woven and layered linear structure within the works of Cheng Chiung-Ming were created by using various media – including ink, charcoal, pastel, and oil painting. After the 90s, his works began showing a more obvious concern for the ecology, with noticeable traces of nature and land and an interest in humanity.

The works of Chern Shen-Son are inspired by the earth and nature, particularly the element of trees. The sense of steadiness, introversion, and density in his works, is just like the personality of him. In recent years, Chern has searched for the inspiration from landscape and seashore of southern Taiwan, portraying sentiment towards the land and life through lines composed of pure colors.[11]

Wang Ching-Cheng creates works by utilizing the technique of automatism, which breaks with traditional methods that value harmony and stability in composition. He intentionally created incoordination, resonant of the "Bad Paintings," which were displayed in New York several years later.[12]

10 See Hsiao Chong-Ray, 'Minimalism · Cold Abstraction – Contemporary Abstract Art in Taiwan,' *Minimalism · Cold Abstraction – Contemporary Abstract Art in Taiwan* (exhibition catalogue), p.6-17, Taipei: Chini Gallery, September 2018.

11 Ibid.

12 Ibid.

If the works of Li Jiin-Shiow express a carefree transcendence towards life and death, then the works of Chen Hsing-Wan (1951-2004), who also died at a relatively young age, portray the solemnness of death and the uncertainty of life.

Chen Hsing-Wan was deeply influenced by Li Chun-Shan's concept of ink paintings, which break with the conventional restrictions in traditional Chinese literati ink paintings. She utilized the technique of automatism to create explosive and flowing, spinning and spraying composition with pure black ink, which then became her most renowned series of works. Chen passed away in Paris in 2004 at the age of 53 due to breast cancer.[13]

Added with light, Chu Teh-Huah's steel mesh sculptures create a contrast between light and shadow, resulting in enchanting and mesmerizing effects. Chu's works reveal a graceful, poetic atmosphere. The ambiguous presentations of reality and illusion, weight and weightlessness, as well as light and shadow, fill the entire space. Chu Teh-Huah is undoubtedly one of the few outstanding female abstract sculptors in Taiwan.[14]

The works of Wu Mei-Song are characterized by their intense visual speculative quality. By depicting the objects alone in dark spaces, the artist attempts to contemplate existence and its meaning. Wu's works are an exploration of the mind. As for media and techniques, Wu interchanges between using two-dimensional canvas collages with installations and object arrangement.[15]

The works of Hwang Wey-Jeng are kind of personal records of life and witness of the times, as the distortion of human figures in his works also represents the deformity of human mind. Hwang's works inspire critical thinking, reflection and dissecting society, which make the viewers discomfort but convey direct and blunt messages.[16]

In 1981, the fourth year of the establishment of the Free Painting Association, the Tao Tie Painting Association was also founded. "Tao Tie" are patterns on ancient Chinese bronze ware. According to Chinese legends, Tao Tie loves to eat and can devour anything. By naming the association "Tao Tie," the painting association asserted that members would be able to absorb and learn all things. If the Free Painting association was mainly formed by alumni of the National Taiwan Normal University, then the Tao Tie Painting Association would be grouped chiefly by the alumni of National Taiwan Academy of Arts (today's National Taiwan University of Arts). The members from the Tao-Tie Painting association whose works are participated in this exhibition, apart from Wu Mei-Son as mentioned above, also include Hsu Yu-Jen and Yao Keh-Hong.

The abstract paintings of Hsu Yu-Jen depict life and are conceptual at the same time, portraying reality while conveying the subconscious. Hsu is kind like a wildling in the city and a philosopher of the fields; his works open up a new chapter for modern ink paintings of the 1970s as well as the abstract paintings in Taiwan.[17]

13 See Hsiao Chong-Ray, 'The Second Wave of Li Chun-Shan's Influence After Traveling to the South (One),' issue 523, Artist Magazine, p. 178-191.

14 Ibid.

15 See Hsiao Chong-Ray, 'The Second Wave of Li Chun-Shan's Influence After Traveling to the South (Two),' issue 524, Artist Magazine, p. 178-189.

16 Ibid.

17 See Hsiao Chong-Ray, 'The Second Wave of Li Chun-Shan's Influence After Traveling to the South (Three),' issue 525, Artist Magazine, p. 150-163, February 2019.

The works of Yao Keh-Hong not only convey profound humanistic thinking that combined abstract poetry with the metaphors and relations of human beings, environment, history, and daily life, but also express literary and philosophical reflections as well as a longing for the homeland.[18]

In 1982, the second year of the establishment of the Tao Tie Painting Association, a group of Li's disciples who he mentored in the south of Taiwan – including Huang Run-Se, Jan Syue-Fu, Chung Chun-Hsiung, and Chen Hsing-Wan – established the Modern Eye Group, with senior modern art artist Chen Ting-Shih as the head of the association, and Chung Chun-Hsiung as the officer. Those who participated later in the group include Li's other disciples such as Hwang Buh-Ching, Li Jiin-Shiow, Lin Hung-Ming, Cheng Chiung-Ming, and Chu Teh-Huah, as well as some other modern artists. The Modern Eye Group became the most important avant-garde art group in central Taiwan in the 80s, which can be regarded as a collective representation of Li's influence in the art scene.

The abstract works of Lin Hung-Ming are a mixture of abstraction and surrealism, with dramatic expressions that contrast the serene and mysterious qualities of surrealist art.[19]

In 1984, two years after the establishment of the Modern Eye Group, Li Chun-Shan passed away at the age of 73. Three years later, Li's disciple Cheng Wu-Chang, dedicated to passing down the legacy of his mentor of promoting modern art, gathering others who apprenticed to Li in his late years, and forming the Dragon Head Painting Association. Chen Chu-Yin's artist career in new media is widely acclaimed.

Even though some of Li Chun-Shan's disciples who he tutored in the south of Taiwan did not participate in any art groups, they also became outstanding artists, such as Kuo Jen-Chang and Yang Mao-Lin.

J.C. Kuo's paintings were primarily inspired by designs in folk art. Kuo creates large colorful and wild images which generally be seen as satire or reflection upon phenomena of Taiwanese society. The works of Kuo are regarded as one of the most important artistic expressions in post-martial law Taiwan.[20]

Yang Mao-Lin expresses his artistic creations by combining different images, fables, and stories – including historical figures from the Fort Zeelandia and the Yuanshan chronicle, as well as animals, plants, lilies, and cloud leopards. Yang's recent works have started to portray cartoon figures from Eastern and Western comic books.

4. Conclusion

While examining the artistic creations and performances of the Li Chun-Shan's disciples, one of the researchers claimed that the importance of Li in Taiwanese modern art history is completely founded on the achievements of the disciples. In other words, the outstanding performances of the disciples make their mentor as a renowned figure, or we can say that the contribution of Li as an art educator is far greater than as an artist.

Looking into the selection of works of Li Chun-Shan showcased in the NTMoFA, however, the sketches, watercolors,

18 Ibid.

19 Ibid.

20 See Hsiao Chong-Ray, 'The Disciples of Li Chun-Shan: A View of the Modern Painting Scene in Post-War Taiwan.'

and oil paintings, reveal that the comment mentioned above fails to acknowledge the truth. Apart from his contribution as an outstanding mentor in modern art, we can see from the displays in this exhibition that Li's artworks have the following qualities:

1) A cross-shaped composition: The works have a geometric center point that forms a cross-shaped composition which expresses an outward, explosive quality and the gathering of energy to the center at the same time. This composition gives viewers a sense of balance and grace akin to religious experiences.

2) Rich texture: By using a variety of different techniques to create rich textures that allow visual explorations, Li has created a world for viewers to contemplate and reflect without encouraging associations. Techniques including scraping, painting, rubbing, dyeing, and stamping are seen across his works, forming complex visual effects.

3) Interchange of intertwining lines and planes as well as subtraction painting methods: The "Fling Dot Method," which is commonly seen in abstract expressionism, can be rarely seen in the works of Li Chun-Shan. Instead, Li's works depict fast, strong lines and color blocks. Among the multi-layered colors and brushstrokes, the scraping subtraction method creates tensions that allow philosophical reflections and debate.

Overall, compared with his contemporary Zao Wou-Ki (1921-2013), Chu Teh-Chun, and other artists whose works have been identified by the Western art world as "Eastern Lyrical Abstraction," the abstract works of Li Chun-Shan display a more reserved concept and composition. Although Li has repeatedly stated that his works are "abstract surrealism" that emphasize the flow of the subconscious, we can be certain that the "subconscious" is merely an "element of painting" and "motif" at the beginning of the creative process. The formation and presentation of mental imagery require the process and characteristics of speculation, dialect, concealing, and revealing. Therefore, instead of inspecting the metal imagery hidden within the abstract work, viewers can focus on the canvas, appreciating the mixture of forms, colors, lines, and planes, as well as the novelty and spiritual qualities that it evokes. The prominent achievements and contributions of Li Chun-Shan's had not only deeply influenced the artist careers of his disciples, but also had great impact on the rise of the modern art scene in Taiwan for nearly a half century.

李仲生的教育轉向

文｜林宏璋

前言

蟄居中部 23 年，作為「現代繪畫導師」的李仲生一直到 1979 年才在龍門畫廊與版畫家畫廊舉行個展，在後者展出 1954 到 68 年作品，而龍門展出是 70 年代近 10 年間抽象表現油畫。在當時，作為前衛繪畫的「傳教士」李仲生學生們，包含「東方畫會」等藝術家，在國際上早就取得一定地位，因此，這些「創作」以展覽公開發表方式呈現，當時是相當轟動。而起因在於該年民生報記者陳小凌為李仲生所製作報導專題〈抽象世界的獨裁者〉披露於媒體上，不少畫廊還競相爭取展出李仲生展覽機會。然而，對於具有高度藝術倫理的李仲生而言，展覽本身不應該成為一個商業功利機制，為了釐清這層關係，李仲生還特別寫了一篇〈我在臺北舉行畫展的經過〉，說明了辦首次展覽不是「商業炒作」，而他本人還特別交代自己近年創作活動，參與國內、外群展，以及教學、寫作、擔任評審等文化場域介入，雖然居住在中部，絕對不是「退隱避世」於藝術系統，而是為了長年風濕之健康因素；在平日休閒，雖然居住在彰化，也固定到臺中當時繁榮自由路上俱樂部、歌廳、咖啡廳過「布爾喬亞」風情生活。這些總總日常活動，如李仲生所言是「⋯一直在創作」階段，與生命歷程扣在一起的藝術實踐，包涵著繪畫、教學、寫作等等，雖然是展演情境下作品的「缺席」（absence）—相對與在龍門畫廊以及版畫家畫廊展出的「顯現」（presence），以及在 20 年代的平面作品「呈現」（presentation）—指向了李仲生作為一個「創作者」所關切藝術實踐具體面相以及實質美學政治之意義。

因而，本文寫作是在於將「李仲生的首次個展」以症候（symptom）方式閱讀其作品／工作（work）在顯現與消失之間的意義，因為，其所注重「獨特性」（uniqueness）的教學中，李仲生不改畫、更不會往自己作品讓學生看，作為模仿及參考對象。對於學生而言，老師平面繪畫作品是從「消失」中「消失」造就了學生獨特性，以一種複數的「單奇性」（singularities）標示其在作為創作主體潛能，如同德希達（Jacques Derrida）在〈繪畫裏的真理〉（*The Truth in Painting*）中指出「作品邊緣」（*parergon*）與作品之間的辯證關係[1]。個展過後 5 年，李仲生病逝於臺中榮總；他單身在臺，播種成千上百從事藝術工作者，開始了臺灣的現代繪畫運動，其中也包含李仲生在圍繞「前衛主義的知識生產框架」在員林、上海、東京、巴黎、紐約等「地方（*loci*）」所形成之多元現代性及文化轉譯（cultural translation）。

1 作品邊緣（parergon）的概念，Derrida 思考在審美物件，其座落、框架與簽名等作為本真作品的附屬及補充。見 Jacques Derrida, "The Truth In Painting," trans. Geoffrey Bennington, Chicago: University of Chicago Press, 1987, p.63

語言、思想與時代

1979 年民生報的訪談結尾，李仲生回應了記者提問其創作核心理念：「在鄉下懶得走動，也疏於走動，我的作品風格是揉合了佛洛伊德思想與抽象思想的，富『精神語言』與『心理語言』的現代前衛作風。」[2] 在這個簡短回應中，一方面指出其繪畫作品中風格與抽象繪畫及立體派的發展，同時也與超現實主義對應，這當然是歷史前衛主義透過在亞洲不同文化觸媒與藝術機制之傳播與生產，標示李仲生創作將「形式」考量作為解決藝術問題方式。另外極為重要的，針對同一時代臺灣藝術工作者，李仲生的藝術觀特別強調反視覺性「思想」、「語言」等「論述實踐（discursive practice）」之能力展現，不管是「精神語言」 或是「心理語言」，其論述形式是將「說不可說（to say the unsayable）」並且將原本語言中思辨與邏輯的明確狀態，以解構方式呈現，不僅僅是他繪畫中所呈現語言狀態，也呈現在他獨特寫作評論以及教學的樣態。基本上，除了是一種言說推演的能力展現，更是一種「移置」語言關係，透過再現過程超越其語言框架「之外」可能，在李仲生語言／思想的論述實踐是一種轉換及替換原本規範框架方式，指涉於「他處」，並進一步改變認知事物的既定關係，李仲生在 1979 這一年在《雄獅藝術》發表〈論現代藝術〉一文中，就開宗明義的說出：

「畫本來就是視覺語言，又稱為繪畫語言，更有稱為國際語言的。不論是視覺語言、繪畫語言、還是國際語言，都跟平常嘴巴說話的語言不同。尤其是『現代繪畫語言』，已經發展到即使一定要說明一個肉眼所見的現象世界時，也不一定有條理去敘事一件事；而毋寧更需要暗示或者象徵一個肉眼所看到的心像世界。」[3]

超越次序、邏輯、推演可能、以及固定因果再現的藝術語言性，是一個「說不可說」、「再現不可能再現」的論述實踐，如同李仲生的宣稱反對強調秩序組織「拉丁精神」[4]。這樣的藝術語言是一個「詩性」媒介，其敘述是在開放感知作用，將「不可見的」作為「可見」，作為一種以「直觀（intuition）」精神世界；或者一種將藝術作為外在世界「現象學還原（epokhé）」[5]，是一個干擾日常慣常的自然、中性態度藝術策略，將原本的判斷、信仰暫時懸置。在 68 歲時，橫跨在哲學、美學、倫理學層面的李仲生的藝術世界以及日常生活習性，指向一個「內在精神」世界的凝視，李仲生宣稱「精神的真實性」是經由對於顯示可見世界道德抽離，如他宣稱「形象永遠存在！抽象不會消失」。這種對於所感轉換必須是一個特定之時空組態，牽涉到個人與一個「時代」（epoch）的對應與互動。李仲生的藝術信仰，不僅僅回應出他當時的時間性，更對原本的書寫進行思考，尋求對應，甚至企圖回到藝術「精神」世界，超越其時代性以在「此時此地」限制，操演性的確定「個人」實踐。

2　吳昊主編，《現代繪畫先驅李仲生》，臺北：時報文化，1984，頁 207。

3　蕭瓊瑞主編，《李仲生文集》，臺北：臺北市立美術館，1994，頁 31。

4　同註三，197 頁。

5　現象學的還原是一個回歸事物本質的哲思方法，不等同於 reduction，另一種說法為 suspension of disbelief，作為一種對於現實狀態的暫時懸置，也因此常常在以前的翻譯會為「存而不論」。Edmund Husserl, "Logical Investigations", trans. J.N. Findlay, New York: Rutledge, 1970, xxxvi.

而透過「還原（epokhé）」對「時代（epoch）」回應其「個人性」李仲生為何？1912 年出生的李仲生，在年輕時候歷經中國與日本現代主義以及前衛藝術洗禮，在 1932 年上海期間參與「決瀾社」以及發生在上海展覽，在這時候歐洲的歷史前衛主義正是超現實主義盛行時代，而之前從 1906-24 之間從野獸、達達、未來主義、包浩斯等已經進入尾聲；即便在俄國構成主義，也在列寧的主導下逐漸消失。換言之，歷史前衛藝術成為至少在歐美藝術慣常的表現，在各地畫會、沙龍、藝文組織進入機構化狀態。在上海，對藝術以及現實政治「求新求變」之渴望在決瀾社宣言中，對應著「前衛之後」的革命激情：

要用新的技法來表現新時代的精神，20 世紀以來，歐洲的藝壇間實現新興的氣象，野獸群的叫喊，立體派的變形，達達的猛烈，超現實主義的憧憬…20 世紀的中國藝壇，也應該出現一種新興的氣象了。讓我們一起起來吧！用了狂飆一般的激情，鐵一般的理智，來創造我們色、線、形交錯的世界吧！

上海之後，李仲生留學日本大學藝術系（1932-37），除了與中國藝術家組成「中華獨立美術協會」、「獨立繪畫研究所」，也加入日本前衛沙龍及畫會「日本二科會第九室」以及「東京前衛美術研究所」，留歐經驗藤田嗣治（Tsuguharu Fujita）以及東鄉青兒（Togo Seiji）這些都曾與李仲生互動。在這段期間中，日本引介歐洲前衛繪畫作品，並且曾在 1932 年東京都美術館舉辦「巴黎—東京前衛繪畫原作展覽會」，李仲生也有機會看到展覽，而當時在東京，他的同學韓國現代繪畫金煥基（Whanki Kim）也同時孕育了以抽象繪畫為主的創作觀，並在日後影響韓國藝術發展。在當時日本政治氛圍下，透過文化轉譯的「前衛」，是一個去政治意識形態的美學運動，同時也是在不再營造如伯格（Peter Burger）對「中產階級的震驚（shock of the bourgeoisie）」，更不是一種針對藝術機制的批判（值得指出「前衛」是日文翻譯 Avant Garde 的漢字）[6]。在日本李仲生展出油畫作品〈甲板〉呈現了具有詩意的超現實語境，畫面有如基里柯（Giorgio de Chirico）的詭譎場景：既非室內，也不是室外；不是路上／也是海上；是甲板上／也是桌子；而前景的瓶子長著有如動物尾巴影子，在語言及圖像的雙重曖昧指涉中，李仲生試圖走出在「歷史前衛主義」之外亞洲可能性。

在日本時期為期 5 年的時間，李仲生吸收了在日後所強調「佛洛伊德思想」抽象畫面美學表現，或者如其自稱「抽象的超寫實主義」。918 事變後返中，李仲生投身軍旅，其後也有機會在重慶國立藝專與李可染、關良等共事，然而當時動盪政治情勢，對任何藝術工作者而言當然不是很好發展情境，更何況以「前衛」信徒自居的李仲生。

教育轉向

到了臺灣之後，李仲生之前作品因戰亂大多遺失，在北投政治作戰學校參與了短暫的教學，從 1951 年開始以私人授課的方式在臺北安東街開設畫室，他教學方法是有如蘇格拉底的詰問，因材施教一對一教學，以對話方式展開，語言成為老師與學生之媒介，語言成為他們溝通藝術的方式，換言之，經

6 Peter Burger, "Theory of Avant Garde," trans. Michael Shaw, Manchester: Manchester University Press, 1984, p.60

由作品的參照，語言仍是論述之媒介。有時候也根本不在畫室中，也許是因為這樣的溝通，更不用憑藉畫作、圖像參照。吳昊回憶：「李仲生上課的地點有時在空軍總部附近的防空洞，有時在火車站，常常談到天亮，就隨便睡在防空洞和火車站[7]。」在這個階段的弟子們，成為「東方畫會」主要份子。

1955 年，李仲生搬到員林任職於員林家職，1957 年到彰化女中，李仲生從此有兩個不同「老師」的身分，一個是基礎藝術教育的老師，另外則為倡導現代藝術、啟迪專業藝術工作者的傳道者。學生們往往坐車到彰化，上課地點，不是在他家裏，學生也不會到他居處，而是在彰化的西餐廳、冰果室進行一個蘇格拉底式的對話性教學，也會看學生帶來作品；換句話說，學生不會看到老師作品，而學生之間彼此亦不相識；每個人都應當有自己的藝術之路，不受「他人」的影響。李仲生曾經說到：「像別人有用嗎？每個學生都應該當他自己，像我就更沒用了。」在他的教育理念中，返回到自身的個人性藝術語言，是現代繪畫的道路：

那麼這條未走過的路要怎麼走呢？主要的方法是拿著畫筆，不想什麼，不在一張畫裏要求得到什麼，完全自由放鬆的去畫。換句話說，在初步的階段，根本不與其要得到什麼，然後才可以得到什麼…而建立起自己內面的世界，同時也打進現代藝術的精神世界，發自人性內心深處的那面真實接觸。[8]

這種個人的真實性（authenticity）的追求，是對獨創性的要求；在李仲生現代主義的美學觀中，有從個人內在世界（inwelt）通往集體外在世界之對話。另一方面，也有著如超現實主義自動性技法途徑，從解放原本自我對於藝術的意圖性（intentionality）。而這種「動機」（motif）是建立在藝術家（主體）與藝術作品（客體）劃上等號狀態，也從這裏去建立出「藝術次序」，可以回到一個純粹審美原初狀態。在他著名的〈畫因淺說〉中，他提出一個「心之所向」的創作論：

所謂畫因，如果把由畫家的心所選擇自然心態的想法，有畫面所獲得的自然形象，稱之為「自然對象」…因為他是在畫面所吸收和感受的形態，故嚴密的說，那非得是「畫面對象」不可。只要是純粹的繪畫，繪畫動機的「畫因」，必為「畫面對象」無疑，那畫面與自然比較，顯然畫面遠較自然是吾人有藝術次序之感，可以充分想像美的「還原」這一回事。[9]

李仲生的繪畫觀，經過他教學指出了一個不強調技法、「返求諸己」的藝術策略。對他而言，繪畫的訓練在於「素描」，他不只一次強調素描的重要性。「素描的訓練，是一個對於作品『真實性』的起源，同時也是個人作風的骨幹。」[10] 素描，對李仲生而言，是一個思想的研究與培養，同時也

7　這裏所指的防空洞是龍江街的日治時代的防空洞，約 40 坪大小，當時由藝術家歐陽文苑管理。吳昊主編，《現代繪畫先驅李仲生》，臺北：時報文化，1984，頁 80。

8　蕭瓊瑞主編，《李仲生文集》，臺北：臺北市立美術館，1994，頁 127。

9　同前註，頁 21。

10　值得指出作風一詞，李仲生以 metamorphose 翻譯。這篇文章一直到 1992，李仲生並沒有出版這篇文章。同前註，頁 76。

是藝術語法的訓練，也因此他不是以 Drawing（素描）這個名詞稱呼，他說明著他認為素描就是去除色彩的繪畫，是為了以更為純粹的方式進行的藝術思考：「素描一語原為素畫的意思，素描常常是單色畫（monochrome）以探求繪畫的根源」。[11] 素描對李仲生而言標示藝術根源的文法書寫（Grammatology）。

一方面是創作純粹性，另一方面則為必須從傳統及學院中解放，李仲生在教學上從不教學生墨守成規，同時也提倡「反學院主義」、「反傳統繪畫」[12]。曾經是李仲生的學生謝東山，曾經以「教學法上的兩難」，討論一對一教學方式，培養獨特創作作風的問題性：針對受過正規美術教育的，無法「完全」拋棄學院的包袱；而針對未曾受過正規美術教育的人，亦無所適從，其效果十分有限， 甚至不可能有預期的結果。但，對於李仲生而言，能由一個未經預期之意外（contingency）發生，正是藝術以及藝術工作者存在狀態真實性的顯現。而在謝東山文中的「正規」（normality），也許正是講求適才適性、因人而異的李氏「差異性教育」所試圖規避。而這種教學方式，非常接近以言談方法，所進行如「心理分析」般的教學，在「非正規」的教室中—咖啡廳、餐廳等進行教學，是在於能藉此激發出創造異端，具有差異性藝術。在這個意義上，李仲生的教學，更接近「educate」在字源上意義：「e」為「引出」，而「duco」 為「帶領」，因此，「教育」是經由老師帶領，引領出學生原本就應該被開發， 本身具有的潛力，這個過程必須經由老師與學生共同協力完成。

李仲生的教育方法，接近宗教改革期間法國教師約瑟夫・賈寇托（Joseph Jacotot）「普遍教育」（universal teaching）的理念。法國哲學家洪席耶（Jacques Rancière）在〈蒙昧的老師：關於知識解放的五堂課〉（The Ignorant Schoolmaster: Five Lessons in Intellectual Emancipation）記載了寇托特殊教育實踐，他相信：人的智性是平等（equality）。因此，教育在於引領出學生的潛能， 是而這種潛能能夠探索「未知」與「無知」。在當時賈寇托讓學生能學習老師不會的事物，如語言、繪畫、及音樂等科目。在學習過程中，賈寇托甚至設計出了讓學生體認他們必須自主學習的儀式。賈寇托在夜裡將學生帶往只點有兩根蠟燭的狹窄空間中，並在黑暗中對他們說：「我必須教給你們的是，我沒有任何事情可以教給你們」[13]。洪席耶認為：「普遍教育」是一種知識的「解放方法」（emancipatory method）」實現一個人與人之間社會法則，廢除師生之間的等級與差別，從無知到「知」的過程是政治權力作為一種平等顯現，同時也是社會集體解放。與其相對，正是講求一致性、規範性、測量性的「社會方法（social method）」（或者，如李仲生之語具有日耳曼民族性的「拉丁精神」），因社會機制性以及其等級制是不平等區分的開始，作為一種「倫理次序」的結構反應，在師生互動過程中，學生總處在被動位置，即便正規藝術教育，也依然是一個早在課堂倫理中安置妥當角色。這意味著規範教育有著既定等級制度與位階，老師扮演著「啟蒙」學生角色，因為這種等級與位階的給定，學生

11　同前註，頁 79。

12　同前註，頁 198。

13　Jacques Rancière, "The Ignorant Schoolmaster: Five Lessons in Intellectual Emancipation," trans. Kristin Ross, Stanford: Standford University Press, 1991, p.15

自主性處在「尚待啓蒙」不平等位置。因此，解放方法的「普遍教育」教學法（pedagogy），是一個從社會理念所開始啓迪人智性與潛能的民主精神的體現。民主（demo-cracy），其字源之本意，是讓原本不可參與社會平凡人民（demos）以平等方式參與社會。在這個意義下，讓原本具有潛能、未被啓迪的學生經由「談話性教學」而獲得解放一樣，這是民主藝術話語，如同確立人與人之間美學權利（aesthetic right）平等。在李仲生的「有教無類」重視獨特性開發教學方式中，不僅僅是藝術烏托邦，也是社會烏托邦之政治企圖：人的平等是經由創造力在一種不斷實踐動態平衡中實現的個人性，這會是一個實現不斷邁向烏托邦進程，因此所有等級制、階級化、社會區分及差別是為了最終要實現平等狀態；這是一種美學權力的起點與終點，也是一個未竟未盡的烏托邦；在這個基礎點上，藝術與教育成為社會人「賦權」（empowerment）」社會策略。

李仲生從未在現實政治上作過多的表述，但黃榮燦與陳澄波的事件，也許是他對現實政治沈默的原因；甚至對抽象繪畫的政治成份也極為小心，夏陽在東方畫展開始之前，曾到彰化請教老師，而李仲生還是勸「最好不要開」。[14] 李仲生對現實政治上「沈默」並不代表其在藝術的美學政治立場退卻。相反的，他的創作以及他對於經由語言「意會」教育觀，是有其政治立場，是一個在「後設政治」（meta-politics）層次展開的藝術著重思想、語言之「論述實踐」。

但李仲生的「沈默」還有另一個意義，本身繪畫創作被筆記本子上的速寫及書寫所取代；在臺灣的李仲生，尤其是到了員林之後，將本身創作「轉向（turn）」到啓蒙學生。李仲生志業轉向為具有創造性教學以及論述寫作，包涵在各式種種「自主教學」、「差異性學習」以及「解放教育」等知識生產與藝術研究。因此，「轉向」與其是一種位置及發展陳述，還不如說是個人驅力（drive）朝向一種與公眾對話。可以說，李仲生實驗是一個「非正規」教育行動（pedagogical action），一方面是批判當時現行教育體制，以及對當時藝術系統不滿（臺展以及傳統水墨作品）；同時也是透過寫作以及引介對於社會公眾對話方式，其參與過程中是智性改變，也是一個啓蒙過程。可以說，李仲生「教育轉向」將師生之間溝通互動與協力，以不設定既定目標開放教育模式、利用同課堂空間移轉以及從工作室出走，轉換為師生們共同成長過程，是一個廢除師生等級制開放性論述空間。特別是針對教學對象與教程（curriculum）的差異性，有著跨越在哲學、美學、藝術史、倫理學等學科整合，在「一對一」暫時性對等而私密溝通狀態下進行智性溝通與交流，老師及學生具有共同平等的起點開始，同樣作為創作者，必須面對空白畫布，「拿著畫筆，不想什麼，不在一張畫裏要求得到什麼…」，這是一個在師生間美學平權共同學習，讓「可感知」與「不可感知」原本既定分野在創作當下可被重新界定、理解與配置。可以說，李仲生的「教育轉向」是一種集體實踐，指向當時社會潛在結構作為一個能動跨越，以及對時代「認識論滑動」（glide in epistemology）」。

透過「論述實踐」的化主體關係，以重新調配美學平權，這尤其在李仲生寫作中，牽涉到創作面相時，更為明顯。例如談論現代繪畫抽象時，以京劇舞台場景設計所濃縮物理及心理空間作為理解「抽象」

14　吳昊主編，《現代繪畫先驅李仲生》，臺北：時報文化，1984，頁 86。

美學概念，敘述性的濃縮與「歷史前衛主義」之抽象概念大異其趣；或者在對於超現實評述中，將「超」（sur-realism）作為日文「迫真性」的定義。李仲生的「前衛」以及「現代主義」不是一個歐美定義下標準化的產物，而是將「前衛」藝術以在地化的個人創作性的表述[15]。李仲生個展之後的寫作，更是不諱言自己是以「鄉居」的邊陲視野，平起平坐評論國際藝術發展以及各國的「前衛運動」，甚至也包含著對全球的藝術系統如雙年展、藝術學校、藝文機制調查[16]。

身為創作者、教育者及評論家身分的李仲生，是以一種照料者身分開啟照料他者（學生）以及照料藝術的途徑，以平等、分享的態度共同前進的藝術觀，更是一個不斷在實現中美學平權。藉著照料自我與他人開啟的自我與世界關係，李仲生的藝術創作、教學與寫作是一場解放智性的實驗，框架在二戰氛圍下的留學經驗、以及冷戰時期白色恐怖的臺灣，以「轉向」方式所進行的情感勞動（affection labor）生產，這個藝術實踐所面臨的抉擇與行動，也許是在困頓現實情境之下，找到個人出口以及介入業已受體制化意識型態的「實踐」策略。

15　這篇文章《論現代繪畫》，原本刊登在 1975 年的雄獅美術。其中大部分談到一個中國情境寫意的抽象可能。舉例的京劇的戲碼為「宋江殺妻」但實為「宋江殺惜」（閻婆惜）。同前註，頁 168-169。

16　這篇文章原登載 1980 的民生報，其中對於「The Armory Show」有不少的討論，起因在於 Harold Rosenberg 與紐約客（New Yorker，1963）發表的 The Armory Show: the Revolution Reenacted。李仲生參考了許多法、日文、英文資料，也經由紐約、日本以巴黎的友人及學生所轉寄的資料，進行的研究，許多考證以及對特定的翻譯，那時定居彰化李仲生總是以實事求是的態度考證與論理，這些寫作上是非常不容易成果，同時也註記了在全球流通藝術知識是如何生產。同前註，頁 25-63。

The Education Turn of Li Chun-Shan

Lin Hong-John

Preface

By the time he had his first solo exhibition at the Long Men Art Gallery and the Printmaker's Art Gallery in 1979, Li Chun-Shan, the "Mentor of Modern Painting," had spent 23 years in the middle of Taiwan. The exhibition at the Printmaker's Art Gallery showcased works created between 1954 and 1968 while the exhibition at Long Men Art Gallery displayed Li's oil paintings in the style of abstract expressionism created across ten years in the 70s. As a "missionary" of Avant-Garde painting at the time, the disciples of Li Chun-Shan, including artists from the Tong Fang Painting Association, have long been acclaimed by the international art world; therefore, it was no surprise that exhibited together, the works would cause a sensation. It all started when Min-Shen Daily News reporter Chen Hsiao-Ling wrote a special report on Li Chun-Shan titled "The Dictator of the Abstract World,"; many art galleries fought for the opportunity to organize an exhibition of the works of Li Chun-Shan. However, Li valued art ethics and believed that exhibitions should not be targeted towards gaining profit. To clarify his stance on the issue, Li even wrote an article titled "About my Taipei Exhibitions" to explain that his first solo exhibition was not arranged to create commercial hype, and listed his recent activities including participating in group exhibitions both domestic and abroad, teaching, writing, and joining the examination board of art events. Li's choice to move to middle Taiwan was not to retreat from the art world but was because of Rheumatism. Although Li lived in Changhua, he frequented the clubs, karaoke, and cafés on the lively ZiYou Road, living the life of a Bourgeois. According to Li, these daily activities were "part of the creative process," and the creative process was tightly connected with life. Compared with the "presence" of works at the exhibitions at the Long Men Art Gallery and the Printmaker's Art Gallery and the "presentation" of two-dimensional works in the 20s, the "absence" of works in activities such as drawing, teaching, and writing still expressed Li's concerns as an artist and his ideas in practicing art and the political meanings in aesthetics.

Therefore, this article examines the meaning of the presence and absence of the works/work of Li Chun-Shan by viewing Li's first solo exhibition as a symptom. Throughout Li's teaching that emphasizes uniqueness, Li Chun-Shan does not edit his work and never shows his works to his disciples to imitate. For Li's disciples, the absence of the mentor's works contributes to their uniqueness, encouraging the disciple's protentional through "singularities." This is similar to "parergon," the dialectical relationship between works mentioned in Jacques Derrida's *The Truth in Painting*[1]. Li Chun-Shan passed away in Taichung Veterans General Hospital five years after his solo exhibition. Throughout his years that he spent alone in Taiwan, Li cultivated hundreds and millions of professionals working in the art world and pioneered the Modern painting movement in Taiwan, which includes the variety of modernism and cultural translation of "loci" including Yuanlin, Shanghai, Tokyo, Paris, and New York, which is centered around the "framework of Avant-Garde knowledge production."

1 The concept of the "parergon" was proposed by Derrida when contemplating the aesthetic process and viewing the setting, framework, and signature as attachment and addition to the work itself. See Jacques Derrida, "The Truth In Painting," trans. Geoffrey Bennington, Chicago: University of Chicago Press, 1987, p.63.

Language, Thought, and Era

At the end of the 1979 Min-Shen Daily News interview, the reporter inquired about Li Chun-Shan's creative concept, to which Li replied: "I felt lazy about walking around and have failed to do so during my time in the countryside. My works are inspired by the integration of the thoughts of Freud and Abstractionism; they are filled with a modern Avant-Garde style of the "language of the spirit" and "language of the mind."[2] This short reply on the one hand points to the development of style, abstract painting, and Cubism in his works, and on the other hand hints to Surrealism, and, of course, is a reflection of how Historical Avant-Garde has spread and produced through the different cultural catalysts and art systems of Asia, and shows how the works of Li view "form" as a solution to the questions in art. Another important aspect is that compared with his contemporary art workers in Taiwan, the artistic concept of Li Chun-Shan emphasizes the expression of anti-visual discourse practices such as "thought" and "language." Li's method is "to say the unsayable," presenting the thought process and logic of language through deconstruction, which reveals not only the language status of his paintings but also his unique methods in writing reviews and teaching. Apart from being an expression of the ability to deduce through words and speech, Li's method is basically a sort of language displacement, exploring the possibilities outside the framework of langue through the process of re-presentation. The discursive practice of Li's language/thought involves changing and replacing the original framework and points to "elsewhere" while further transforming the relationship between the perceived. Below is a quote of Li Chun-Shan's article "Criticism of Modern Art" published in the 1979 issue of "Lion Art Magazine:"

Paintings are visual languages or painting languages; some even refer to paintings as an international language. Whether visual, painting, or international language, paintings are different from verbal communication. The "language of modern painting" in particular has developed to the point that even when describing the physical world that is perceived by vision, it does not require organized description; instead, it uses hints or metaphors to refer to mental imagery that is perceived by the eye.[3]

This artistic language which transcends sequence, logic, the possibilities of deduction and fixed causal relationships is a discursive practice of "saying the unsayable" and "re-presenting the in-representable," just as Li Chun-Shan's objection of emphasizing sequence and the importance of a "Latino spirit."[4] This type of artistic language is a "poetic" medium which describes the process of opening the sensory receptors transforming the "invisible" into the "visible" to proceed towards a spiritual world of "intuition." This method also views art as epokhé of the external world[5]. An art strategy that interferes with the nature and neutral attitude of daily life and suspends previous judgments and beliefs. At the age of 68, Li's art world and daily life crossed the boundaries of philosophy, aesthetics, and ethics, and began to focus on the gaze of the "inner spirit." Li believes that the "reality of spirituality" lies in the ethical distancing from the visible world, just as his statement that "the form will exist for eternity! Abstractionism will never disappear." This sense of transforming the sensations are specific combinations of space and time that involves the individual and his or her interaction with the epoch. Li Chun-Shan's artistic beliefs not only respond to the timing of his situation, but also contemplates and searches for a respond to his writing, attempting to return to the spiritual world of art and breaking through the restrictions of "here and now," which were limitations of his time, and realizes that practice of the self.

2 Editor-in-chief Wu Hao, *Li Chun-Shan: The Pioneer of Modern Painting*, Taipei: China Times Publishing, 1984, p.207.

3 Editor-in-chief Hsiao Chong-ray, *Collected Works by Li Chun-Shan*, Taipei: Taipei Fine Arts Museum, 1994, p.31.

4 Ibid, p.197.

5 *Epokhé* is a philosophical method of returning to the essence and is different from reduction. *Epokhé* is also referred to as "suspension of disbelief," which temporarily suspends reality. It is often translated as " 存而不論 " in Chinese. Edmund Husserl, "Logical Investigations", trans. J.N. Findlay, New York: Rutledge, 1970, xxxvi.

What does this response towards epoch through *epokhé* reveal about the individuality of Li Chun-Shan? Born in 1912, Li Chun-Shan was deeply influenced by the Modernism and Avant-Garde art of China and Japan when he was young. Li joined the Storm Society in 1932 and had an exhibition in Shanghai. This was the time when Surrealism was popular in the Historical Avant-Garde of Europe, while Fauvism, Dadaism, Futurism, and Bauhaus was coming to an end after prevailing throughout 1906-24. Even Constructivism in Russia was gradually fading under the leadership of Vladimir Lenin. In other words, Historical Avant-Garde art became the prevailing artistic style in Europe and was institutionalized in various painting association, art salons, and cultural organizations. In Shanghai, the Storm Society's statement expressed their desire for change in art and politics and their passion for an Avant-Garde revolution:

The spirit of the new era requires new techniques. Since the 20th century, a new kind of atmosphere is spreading across the art world in Europe: the roar of Fauvism, the distortion of Cubism, and the longing of Surrealism…the art world of 20th century China should also have a breath of fresh air. Let's come together and create a world of colors, lines, and forms with a fiery passion and a will of iron!

After Shanghai, Li Chun-Shan studied as the Nihon University College of Art (1932-37). Apart from forming the Chinese Independent Art Association and the Independent Painting Research Institute with other Chinese artists, Li also joined Japanese Avant-Garde salons and painting association "The ninth gallery in the Nikakai" and "Tokyo Avant-Garde Art Fine Art Research Institute." Tsuguharu Fujita and Togo Seiji, both of whom studied in Europe, were acquaintances of Li Chun-Shan. Throughout this period, European Avant-Garde art was introduced to Japan; Tokyo Metropolitan Art Museum arranged the "Exposition of Avant-Garde Artists Paris–Tokyo" in 1932, an exhibition that Li visited. While Li was in Tokyo, his Korean classmate Whanki Kim also focused on abstract painting and became an influential force in the art scene of Korea. During the time, the cultural translated "Avant-Garde" was an aesthetic movement that wished to remove political ideology; it no longer wished to create the "shock of the bourgeoisie" that was proposed by Peter Burger, nor was it a kind of resistance against the art system (it is worth mentioning that "前衛" were the Kanji characters used in the Japanese translation of Avant-Garde)[6]. Li unveiled his oil painting *Deck*, which conveys a poetic style of surrealism that portrayed eerie qualities akin to the works of Giorgio de Chirico; it was neither a portrayal of an interior or exterior, neither on the road nor at sea, and was the deck and table at the same time. The vase in the foreground has a shadow of an animal-like tail. *Deck* is Li's attempt at exploring the Asian possibility of "historical Avant-Garde" using the ambiguity of language and imagery.

The five years that Li Chun-Shan spent in Japan was when he encountered the abstract aesthetic expression of Freud, which became an emphasis in the later works; Li referred to these works as "Abstract Surrealism." After the Mukden Incident, Li returned to China and joined the military. Li later became acquainted with figures including Li Keran and Guan Liang at Chongqing National Art Institute. However, the political turmoil did not create an ideal environment for those who worked in the arts, especially for the likes of Li Chun-Shan, who considered himself as the believer of Avant-Garde.

A Turn in Education Method

By the time Li Chun-Shan arrived in Taiwan, most of his previous works were lost due to war. After teaching for a brief period at the Political Warfare College in Beitou, Li started giving private lessons at his Taipei Andong Street Painting Studio in 1951. Li's teaching method involved one-on-one Socratic questioning catered to individuals. This

6 Peter Burger, "Theory of Avant Garde," trans. Michael Shaw, Manchester: Manchester University Press, 1984, p.60

method proceeded as dialogue with language acting as the medium of communicating art between teacher and student. In other words, by referring to the works of art, language remains the vessel for discourse. Some of these sessions were conducted outside the painting studio and therefore does not require physical works or images. Wu Hao recalls: "Our lessons with Li Chun-Shan were sometimes in a dugout near the air force headquarters, sometimes they were at the train station. We would often talk till dawn and sleep in the dugouts or at the station[7]." Li's students during this period became the central members of the Tong Fang Painting Association.

In 1955, Li Chun-Shan moved to Yuanlin and started teaching at National Yuanlin Home-Economics and Commercial Vocational Senior High School, and later began teaching at National Changhua Girls' Senior High School in 1957. During this time, Li started to have two teaching identities, one was a teacher of basic art education, and the other was an advocate for modern art and a missionary who inspired professional artists. Students would often take the train to their lessons in Changhua, which was not at where Li lived but at western restaurants and ice dessert stores. In these sessions, the students would engage in Socratic dialogue with Li and Li would look at the works of his students. In fact, the students would not see the works of their teacher, and the students would not know each other; every person was on their own journey and not influenced by others. Li Chun-Shan once stated: "What use is there to resemble the works of another? Each student should be themselves. It would be even more useless if their works resemble mine." Li Chun-Shan believed that the return to the artistic expression of the self was the way forward for modern art:

So how does one advance on this path? The primary method entails picking up a paintbrush, and then, without excessive thinking and forgetting about was one wishes to achieve from the painting, the painter must paint in utmost freedom. In other words, this initial stage achieves without anticipating results; it is about constructing the inner landscape, entering the spiritual world of modern art, and exploring authenticity in the depths of the mind.[8]

This emphasis on authenticity is a quest for originality. Li's aesthetics on Modernism is a dialogue between the inner world (*inwelt*) and the outer world. This method is also like the automatic technique used in Surrealism, a liberation from the intentionality of the self. This motif is established on equating the artist (subject) with the artwork (object); this enables an "art sequence" that returns to a pure state of artistic judgment. In his well-known article "A Brief Introduction to the Painting Drive," Li proposed a creative method based on the "will of the heart:"

The painting drive refers to when the painter follows the original intentions of the mind. These intentions form "natural objects" onto the image...since these forms are produced by absorbing the sensations from the image, strictly speaking, they should be referred to as "painting objects." All pure acts of painting is a result of the "painting drive" and must be "painting objects." Compared with nature, the painting has more of an "art sequence," which allows one to contemplate on the "reversion" of beauty.[9]

Li Chun-Shan's outlook on painting is expressed through his teaching, which, rather than focusing on techniques, emphasizes the artistic strategy of "search for the self." For Li, painting training entail sketching; Li has more than once stressed the importance of sketching. "The training in sketching is a focus on the origin of the 'reality' of the

7 The dugout mentioned here refers to the Japanese era dugout on Longjiang Street. The dugout is approximately 132m^2 and was managed by artist Oyan Wen-Yuen at the time. Editor-in-chief Wu Hao, *Li Chun-Shan: The Pioneer of Modern Painting*, Taipei: China Times Publishing, 1984, p.80.

8 Editor-in-chief Hsiao Chong-ray, *A Collection of Articles by Li Chun-Shan*, Taipei: Taipei Fine Arts Museum, 1994, p.127.

9 Ibid, p.21.

work and the core of a person's metamorphose."[10] For Li, sketching was a form of research and cultivation of the mind, at the same time training for artistic terminology; this was why Li did not refer to the act as "drawing." Li believed that sketch was painting without color, a purer method of conducting artistic thinking: "In Chinese, the work sketching means pleain painting. Sketches often explore the root of painting through monochrome."[11] For Li Chun-Shan, sketches are a form of grammatology of art.

Apart from a pure state of creating, another is the liberation from tradition and educational institutions. Li Chun-Shan's teaching never asks students to follow the rules; instead, he is an advocate of "resisting against educational institutions" and "resisting against traditional drawing[12]. Hsieh Tung-Shan, who was once a student of Li Chun-Shan, once described the one-on-one teaching method which aims to inspire originality as a "teaching dilemma;" it would be impossible for those who received proper training in fine art to "completely" abandon their training, and those without training would not know what to do. The results of this method are therefore limited and may even meet previous expectation. However, for Li Chun-Shan, this contingency is exactly the true appearance of art and the state of art workers. The "normality" in Hsieh's article is what Li seeks to avoid through his method that is specially designed to suit the different qualities of the individual. Li's teaching method is very similar to the psychoanalytical method of teaching, which is conducted by conversation. The "unorthodox" teaching locations, such as cafes and restaurants, were to encourage difference between individuals. Li's teaching method is close to the original meaning of the word "educate:" "e" means "to induce' while "duco" means "to guide." "Education" is led by the teacher to induce the potential of the student; the process must be completed by the cooperating between student and teacher.

Li's teaching method is similar to Joseph Jacotot, a French educator during the Reformation, and his method of "universal teaching." French philosopher Jacques Rancière documented Jacotot's unique teaching method in *The Ignorant Schoolmaster: Five Lessons in Intellectual Emancipation*. Jacotot believed that human beings are equal in intellect; therefore, the purpose of education is to encourage the student's potential to explore the unknown and to mend the ignorance. Jacotot was even able to guide students to learn subjects that the teacher has no knowledge of, such as language, painting, and music. Jacotot designed a ritual for students to realize that they would have to acquire knowledge on their own by taking the students into a dark, narrow space at night that is lit with only two candles. Jacotot would say to them: "I must teach you that I have nothing to teach you.[13]" Rancière believed that general education was an emancipatory method of knowledge that realizes the social principle of interpersonal relationship and abolishes the difference and rank between student and teacher. The process of transformation from the unknown to knowing is an equalization of political power and a collective liberation of society. The opposite is the "social method" (or, in Li Chun-Shan's Germanic description of the "Latino Spirit) which emphasizes consistency, regularity, and measurability, because social structures and hierarchy is the source of inequality. As a response to moral hierarchy, students are often placed in a passive position in teacher-student interactions, which is also the case in art education. This entails that normative education involves fixed regulations and hierarchy, where the teacher is responsible for enlightening the student. This setting of this system conveys that the student is placed in the inferior state as the "unenlightened." Therefore, the liberating "general education" pedagogy is a form of human enlightenment inspired by social concepts. The meaning of the word democracy (demo-cracy) is to allow ordinary people who were originally not allowed to participate in society to engage as equals. "General education" allows

10 It is worth noting that Li Chun-Shan used "metamorphose" when referring to style. This article was not published until 1992. Ibid, p.76.

11 Ibid, p.79

12 Ibid, p.198

13 Jacques Rancière,"The Ignorant Schoolmaster: Five Lessons in Intellectual Emancipation," trans. Kristin Ross, Stanford: Standford University Press, 1991, p.15

students with unrealized potential to be liberated through "conversational education," an expression of art democracy which in a way establishes the aesthetic right among people. Li Chun-Shan's "teaching without discrimination" which focuses on unveiling the individuality of students is not only an art Utopia but also a social Utopia with political attempts: the equality of an individual is personality realized through the continuous practice of creativity. This is an ongoing attempt to reach Utopia; therefore, the different stages, hierarchy, and social categorization exist to achieve equality. This is a beginning and ending of aesthetic power, an ongoing and unfinished Utopia. This is the foundation upon which art and education become a social strategy of empowerment.

Li Chun-Shan has never expressed personal opinions on politics. The reason behind Li's silence may be the incidents of Huang Ron-Can and Chen Cheng-Po. Li is also cautious about the political characteristics of abstract paintings. Before the Tong Fang Painting Association exhibition, Hsia Yang visited Li Chun-Shan in Changhua, during which Li suggested that "It would be better not to open the exhibition."[14] Li Chun-Shan's silence towards politics does not mean that the artist took a retreating position regarding the politics of aesthetic. On the contrary, Li's artworks and view on education expressed his stance towards politics, a "discursive practice" in "meta-politics" that emphasizes thought and language.

Li Chun-Shan's "silence" has another meaning: he replaced painting with sketching and writing in his notebook. After Li arrived in Taiwan, especially during his years in Yuanlin, he "turned" from creating artworks to teaching students. Li's turn towards creative teaching and discourse writing includes various knowledge production and art research including "self-directed teaching," "differential learning," and liberating education." Rather than viewing this "turn" as a position and developmental statement, one should instead understand it as a personal drive directed at public dialogue. In other words, Li was experimenting an "unorthodox" "pedagogical action" which on the one hand critiques the existing education system and expresses his dissatisfaction toward the art system of the time (the Taiwan Fine Art Exhibition and traditional ink paintings), and on the other hand forms a dialogue with society through writing. This process is a transformation of intellect and enlightenment. In other words, Li Chun-Shan's "educational turn" transforms the teacher-student relationship into a process of growing together through conversation and collaboration, in addition to a teaching method that does not set goals but instead abandons the classroom and studio. The differentiation between the student and curriculum integrates philosophy, aesthetics, art history, ethics, and other subjects. The "one-on-one" method creates temporary equality and allows intimate communication that leads to intellectual exchange, putting the teacher and student on the same level. As creatives, both the student and teacher have to face the blank canvas, "picking up a paintbrush, and then, without excessive thinking and forgetting about was one wishes to achieve from the painting…". Li's method creates an equal relationship between the student and teacher, allowing the "perceivable" and "unperceivable" to be redefined, re-understood, and rearranged through the creative process. Li's "education turn" is a force of collective practice directed at the underlying social structure and a "glide in epistemology" of his time.

The reallocation of power of aesthetic through the discursive practice of the subject relationship is apparent in Li's writing, particularly when touching upon the creative process. For instance, when discussing modern abstract painting, Li interprets the aesthetic concept of "Abstractionism" through the condensed physical and psychological space in the stage design of Beijing opera, contrasting the narrative and concentration with the abstract concept of "historical Avant-Garde." Another example is Li's application of the Japanese concept of verisimilitude in the definition of Surrealism (sur-realism). Li Chun-Shan's understanding of "Avant-Garde" and "modernism" is not a standard product of European and American standards; instead, Li views "Avant-Garde" as an expression of personal artistic

14 Editor-in-chief Wu Hao, *Li Chun-Shan: The Pioneer of Modern Painting*, Taipei: China Times Publishing, 1984, p.86.

creativity.[15] In the article that was published after his solo exhibition, Li Chun-Shan does not deny that his views are equal-footing voices with the development of international art generated from a "rural" perspective and even involves observations on global art institutions such as biennales, art schools, and art systems.[16]

As an artist, educator, and critic, Li Chun-Shan looks after others (students) as a nurturer, developing artistic concepts through sharing between equals. By looking after others, Li forms a relationship between the self and the world. Li's artworks, teaching, and writing are experiments of liberating the intellect. Influenced by the experience of studying abroad during World War Two and White Terror in Taiwan, The choice and act of Li's affection labor art practice through the "education turn" may very well be a strategy of discovering personal outlet and acting against institutionalized ideology during times of difficulty.

15 The article *On Modern Painting* was originally published in Lion Art Magazine in 1975. *On Modern Painting* talks about the possibility of Chinese Abstractionism. The example give in the article was *Song Jiang Kills his Wife*, but was actually *Song Jiang kills Yan Poxi*. Ibid, p.168-169.

16 This article was originally published in Min-Shen Daily News in 1980. The extensive discussion on *The Armory Show* was a response to Harold Rosenberg's article "The Armory Show: the Revolution Reenacted" in the New Yorker (1963). Li Chun-Shan referenced many resources in French, Japanese, and English and examined, researched, and translated materials sent by friends and students in New York, Japan, and Paris. At the time, Li was living in Changhua and always approached subjects with a truth-seeking attitude. These impressive writings also documented how art knowledge was produced and circulated around the world. Ibid, p.25-63.

李仲生	Li Chun-Shan		
朱為白	Chu Wei-Bor	黃步青	Hwang Buh-Ching
歐陽文苑	Oyan Wen-Yuen	鄭瓊銘	Cheng Chiung-Ming
李元佳	Li Yuan-Chia	王慶成	Wang Ching-Cheng
焦士太	Chiao Shih-Tai	程武昌	Cheng Wu-Chang
吳昊	Wu Hao	郭振昌	J.C. Kuo
夏陽	Hsia Yang	許雨仁	Hsu Yu-Jen
霍剛	Ho Kan	陳幸婉	Chen Hsing-Wan
陳道明	Tommy Chen	曲德義	Chu Teh-I
蕭勤	Hsiao Chin	李錦繡	Li Jiin-Shiow
蕭明賢	Hsiao Ming-Hsien	姚克洪	Yao Keh-Hong
李錫奇	Lee Shi-Chi	楊茂林	Yang Mao-Lin
許輝煌	Syu Huei-Huang	陳聖頌	Chern Shen-Son
黃潤色	Huang Run-Se	曲德華	Chu Teh-Huah
鐘俊雄	Chung Chun-Hsiung	吳梅嵩	Wu Mei-Song
黃志超	Dennis Hwang	黃位政	Hwang Wey-Jeng
詹學富	Jan Syue-Fu	林鴻銘	Lin Hung-Ming
謝東山	Hsieh Tung-Shan	陳珠櫻	Chen Chu-Yin

李仲生
Li Chun-Shan

李仲生被讚譽為「臺灣現代繪畫導師」，他既是優秀藝術創作者，同時也是著名的教育家。他的創作結合了佛洛伊德的潛意識思想、超現實的意念、自動性技巧與抽象繪畫表現，將個人內心有意識、無意識、潛意識的情緒轉移到畫面空間中，呈現出不造作的線條表現與顏色層疊交錯的構成與內容。

他私下的教學，是屬於現代藝術領域的教學，最為人稱道的就是「精神傳精神」的教學思想與方式，即著名的「一對一咖啡館教學法」。李仲生的前衛教學成就能獲致成功與廣為人知，當然與他的門生包含最早安東街畫室（創始東方畫會的八大響馬），還有他後來到彰化的教學有關，每位門生皆有所才與發展，共同構築起臺灣對現代藝術的發展與影響力，而李仲生是他們心目中現代藝術的精神導師。

Held in deep reverence as "the mentor of Taiwanese modern painting," Li was not only an artist par excellence but also a great educator. His oeuvre welded together surrealist ideas, Automatism, abstract painting, and Sigmund Freud's account of the unconscious mind, channeling his personal supra-consciousness to create engrossing compositions characterized by unpretentious lines and imbricated layers of colors. Categorized in the field of modern art, Li's mentorship distinguished itself by his pedagogical approach of "spirit perpetuation," exemplified by his celebrated "coffeehouse-based one-on-one teaching method." That Li's avant-garde pedagogy was successful and well-known could be deemed as a consequence of his teaching activities in Changhua and the sparkling performance of his disciples (incl. the Eight Great Outlaws who founded Tong Fang Painting Association and sat at Li's feet at his atelier on An-dong Street). Each of his disciples has an impressive record of achievement. Sharing the common experience of being mentored by Li and venerating him as a beacon of pioneering spirit, they've collectively exerted profound and enduring influences on the development of Taiwanese modern art.

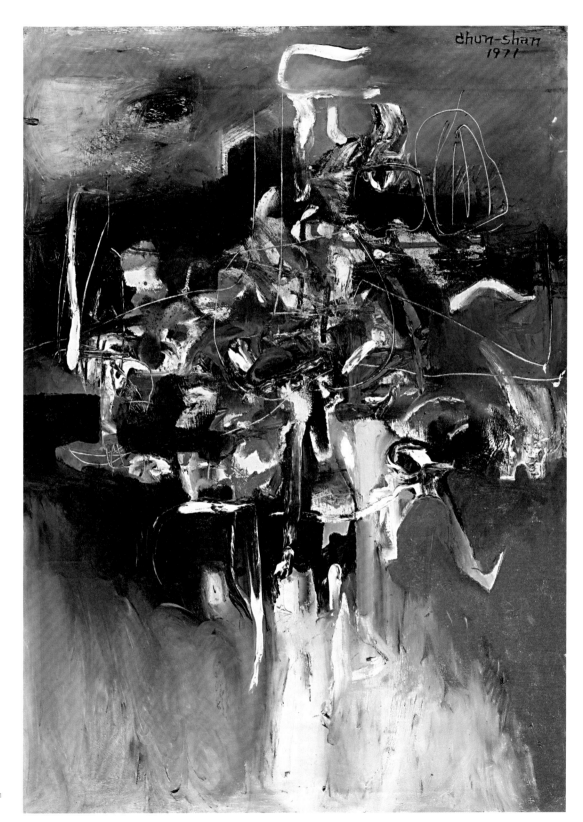

李仲生
〈抽象畫〉
1971
油畫
94.2 x 68.3 公分
國立臺灣美術館典藏

Li Chun-Shan
Abstract Painting
1971
Oil painting
94.2 x 68.3 cm
Collection of National Taiwan
Museum of Fine Arts

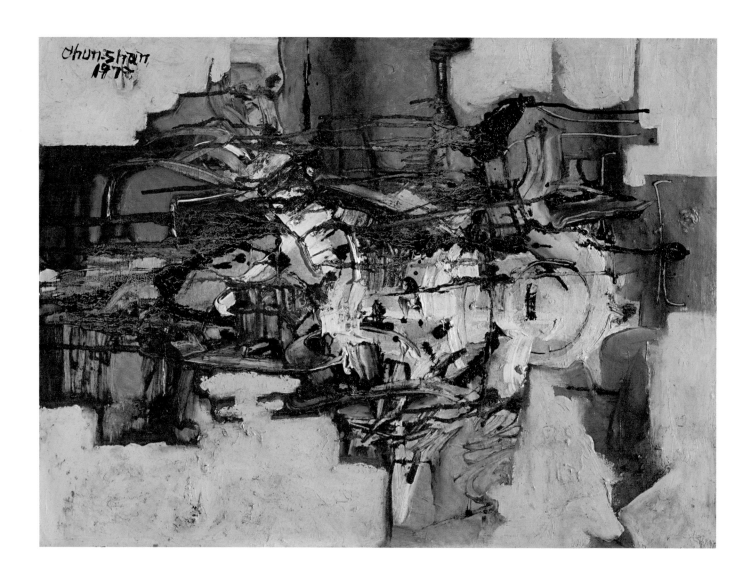

李仲生 Li Chun-Shan
〈作品021〉 *Work No.021*
1972 1972
油畫 Oil painting
53.5 x 73 公分 53.5 x 73 cm
國立臺灣美術館典藏 Collection of National Taiwan Museum of Fine Arts

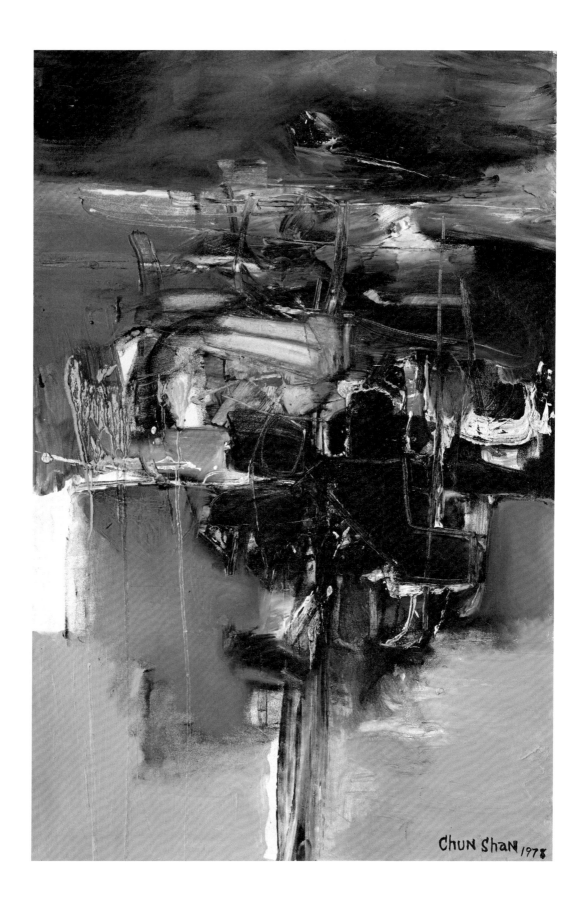

李仲生
〈作品025〉
1978
油畫
90.5 x 60 公分
國立臺灣美術館典藏

Li Chun-Shan
Work No.025
1978
Oil painting
90.5 x 60 cm
Collection of National Taiwan
Museum of Fine Arts

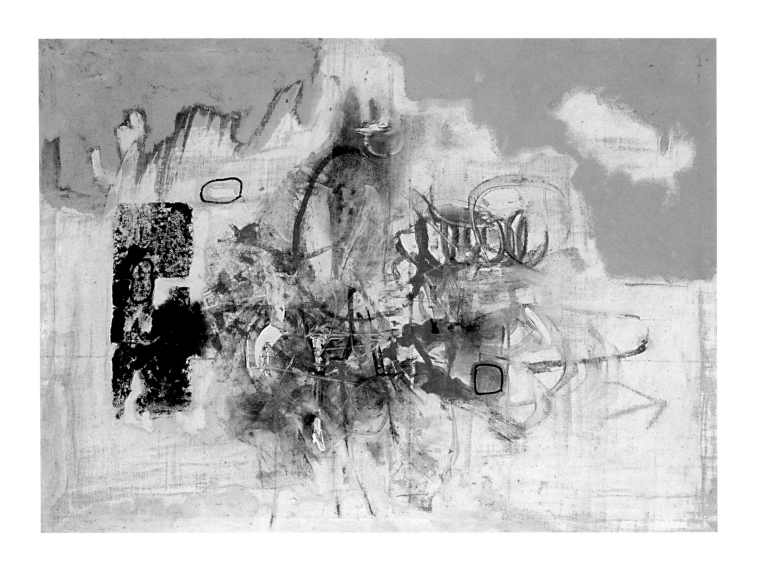

李仲生
〈作品032〉
年代不詳
油畫
65 x 91 公分
國立臺灣美術館典藏

Li Chun-Shan
Work No.032
Undated
Oil painting
65 x 91 cm
Collection of National Taiwan Museum of Fine Arts

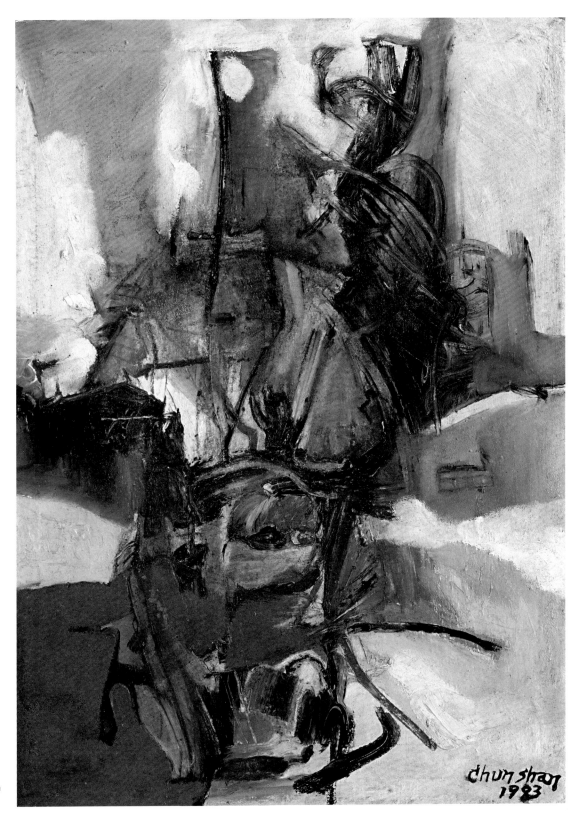

李仲生
〈作品057〉
1983
油畫
73 x 53 公分
國立臺灣美術館典藏

Li Chun-Shan
Work No.057
1983
Oil painting
73 x 53 cm
Collection of National Taiwan
Museum of Fine Arts

朱為白
Chu Wei-Bor

朱為白認為「圓是宇宙萬物之間的定率，都是以圓為規，從宇宙星辰，到萬物多數以圓為準。創作先有獨特的觀念，後有觀念的實現。生死無老少，生命若沒有價值，同草木一樣，所以生命隨著歷史成長才有其價值與意義。」他早期的創作追求天人合一的境界，在天地人的領域中實驗與創作，中期的作品以黑白單色系創作為主，使用東方媒材表現並融合西方創作精神，晚期的作品較激進溫暖喜悅，誠如他一再強調的培養善心、善念、做善事，作品自然散發出溫柔的關懷與力量。

As far as Chu was concerned, "circle is the law of the universe, by which everything, be it a distant star or any other forms of existence, goes. In terms of artistic creation, the formulation of original ideas always precedes their respective materialization. Life is full of uncertainty, and it is valuable and meaningful only after weathering the storms of history, otherwise it will be little more than a picayune plant." Chu's early works revolved around the union of heaven and human beings, manifesting the spirit of experiment in the realm composed of heaven, earth and humanity. The striking expressive power of black and white featured prominently in his mid-career works, demonstrating a perfect fusion of oriental materials and occidental techniques. He converted to a more radical approach in his twilight years, giving his late works a magical aura of warmth and joy, since treating others with benevolence and virtuousness had been an essential part of his philosophy of life, which was exemplified by the natural touch of tender care and gentle power radiated from these works.

朱為白　　　　Chu Wei-Bor
〈招財〉　　　*Ushering in Wealth and Prosperity*
1991　　　　　1991
複合媒材、綿　　Mixed media, cotton
87 x 106.5 公分　87 x 106.5 cm
家屬自藏　　　Courtesy of the Artist's Family

朱為白　　　　　　Chu Wei-Bor
〈網路（一）〉　　　*Network - I*
1996　　　　　　　1996
複合媒材　　　　　Mixed media
104 x 132 公分　　　104 x 132 cm
家屬自藏　　　　　Courtesy of the Artist's Family

朱為白　　　　　Chu Wei-Bor
〈網路（二）〉　　*Network - II*
1996　　　　　　1996
複合媒材　　　　Mixed media
133 x 104 公分　133 x 104 cm
家屬自藏　　　　Courtesy of the Artist's Family

歐陽文苑
Oyan Wen-Yuen

根據霍剛老師的訪談中，歐陽文苑是最早和李仲生老師學畫，所以算是李老師的大弟子，當然很早就接觸了現代藝術。

歐陽文苑悠遊在油畫與水墨的創作表現裡，他擅長描繪死亡的意象、生命的榮枯藉由動植物的符號來表現，具有悲劇性主題和戲劇性張力。「席德進曾給予他『相當有個性』的評介：『他擅長描繪死亡、枯樹、魚骨等悲劇性主題，尤其因對漢代石刻的研究，形成粗野樸實、蒼勁淒涼的畫風；席德進認為他的作品頗能傳達現代人的感受。』」[1] 而「劉國松曾經形容他的作品是『人間性的、苦痛的、悲哀的，乃至絕望的。』」[2] 歐陽文苑的水墨創作，大膽自由、渾厚激盪，兼具墨韻與線條構成表現，也有融入漢代石刻拓印的結構象徵，深具東方美學的意涵。

1、2　引用自蕭瓊瑞，「五月與東方－中國美術現代化運動在戰後臺灣之發展（1945-1970）」，東大圖書公司，頁211。

Regarded as the most senior disciple of Li Chun-Shan according to the interview with Ho Kan, Oyan has *a fortiori* engaged in modern art long since. Immersing himself in a world interlaced by oil and ink-wash paintings, Oyan is skilled in depicting the cycle of life and death by using flora and fauna as creative symbols, with a special focus on tragic stories surrounded by dramatic tension. "Xi De-Jin commented that Oyan Wen-Yuen was quite a personality: 'He delineated tragic subjects such as death, dead trees and fish bones with all the dexterity of an artist. His rough, guileless painting style featuring forceful, poignant brushstrokes bears the distinctive signature of his rigorous research on the stelae of the Han Dynasty, which was why Xi thought that modern people's innermost feelings find expression in Oyan's works" [1]. On the other hand, "Liu Kuo-Sung described Oyan Wen-Yuen's works as 'earthly, agonizing, sorrowful, and even desperate'" [2]. Oyan's ink-wash paintings render themselves resounding and overwhelming with bold and untrammeled brushstrokes. Their compositions not only ooze the charm of ink, but also incorporate the structural symbols of Han stele rubbings, hence a superb incarnation of oriental aesthetics.

1, 2　Cited in Xiao Chiung-Rui, *The Fifth Moon Group and the Tong Fang Painting Association: The Modernization of Chinese Fine Arts in Post-war Taiwan (1945-1970)*. Tung Da Books, p. 211.

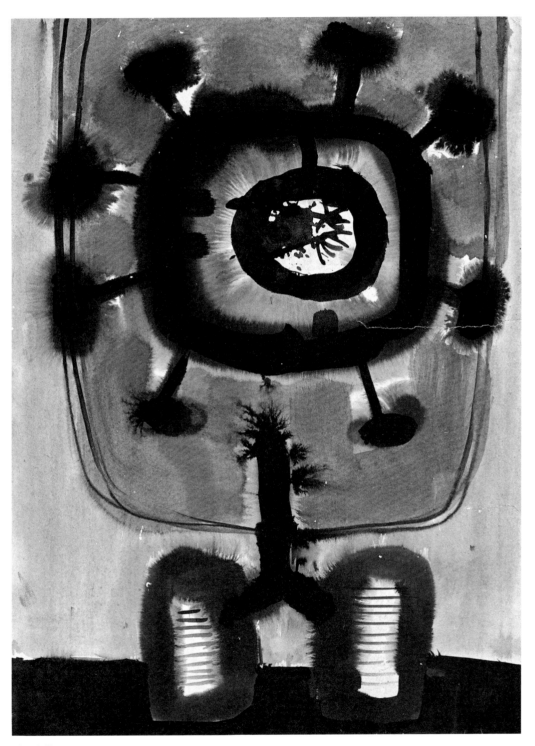

歐陽文苑　　　　Oyan Wen-Yuen
〈無題〉　　　　*Untitled*
1965　　　　　1965
油畫　　　　　Oil painting
99 x 78 公分　　99 x 78 cm
家屬自藏　　　　Courtesy of the Artist's Family

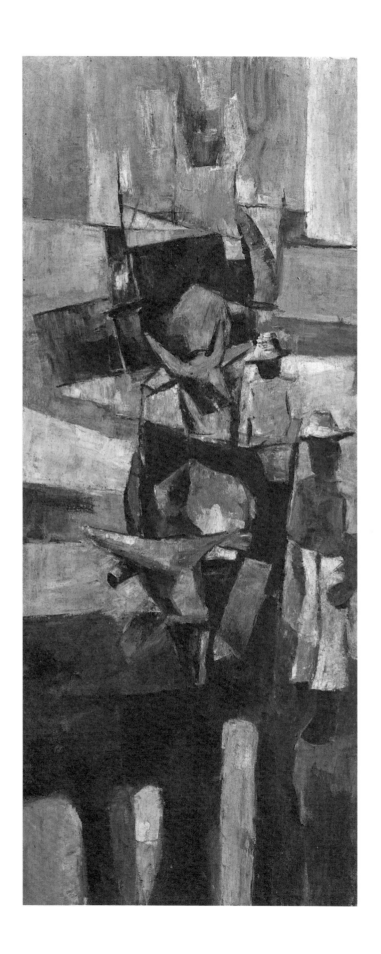

歐陽文苑
〈無題〉
年代不詳
油畫
86 x 36 公分
家屬自藏

Oyan Wen-Yuen
Untitled
Undated
Oil painting
86 x 36 cm
Courtesy of the Artist's Family

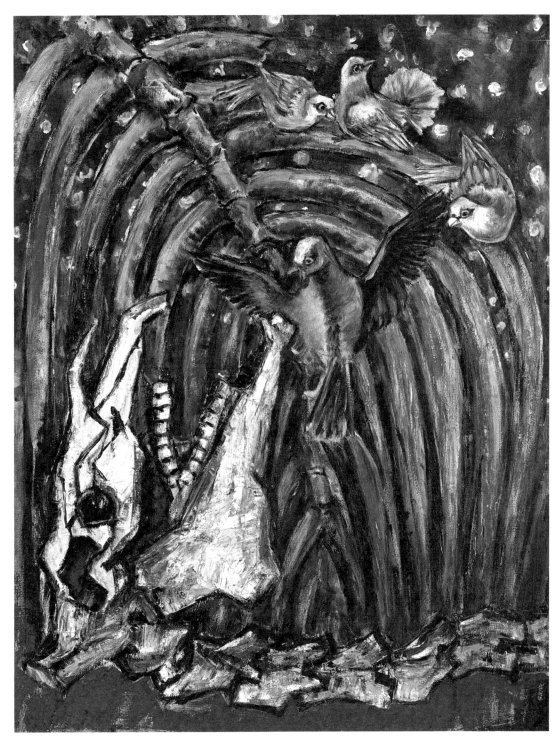

歐陽文苑　　Oyan Wen-Yuen
〈無題〉　　*Untitled*
年代不詳　　Undated
油畫　　Oil painting
67 x 86 公分　　67 x 86 cm
家屬自藏　　Courtesy of the Artist's Family

李元佳
Li Yuan-Chia

李元佳身為臺灣初期抽象畫與觀念藝術的前衛開拓者之一，他接受了臺灣現代繪畫導師李仲生創作與觀念教學的啓發與薰陶，脫離了傳統保守與創作束縛，開創了個人創作的特色。他從 1959 年即以畫布上的「點」作為創作內容，他創作的「點」深具禪意與詩意，既是繪畫創作的最小單元，同樣的也可作為內在測量宇宙時空的意涵。李元佳的創作多元而豐富，包含水墨、油畫、單色繪畫、甚至觀念藝術到攝影與複合媒材等，他並以行動與實驗來創作，傳達出深厚的哲學與美學思維。

As one of the early pioneers of abstract painting and conceptual art in Taiwan, Li transcended the conservative confines of deep-rooted traditions and managed to evolve his *sui generis* style of art with his indebtedness to Li Chun-Shan, the mentor of Taiwanese modern painting, from whom the former directly drew nurture and inspiration. Since 1959, Li Yuan-Chia had employed "dots" on canvas as his creative medium, ingeniously transmuting his works into a realm of Zen and poetic delight. These "dots" not only functioned as the smallest units in the artist's paintings, but also implied the measurement of his inner universe. As a prolific artist, Li Yuan-Chia's oeuvre encompassed a riotous profusion of art forms and genres ranging from ink-wash, oil and monochrome painting to conceptual art, photography and mixed media. He engaged in performance and experiment as well, in which his profound philosophical and aesthetic thoughts found vivid expression.

李元佳
國立臺灣美術館展場一景

Li Yuan-Chia
An installation view of
National Taiwan Museum of Fine Arts

焦士太
Chiao Shih-Tai

已達 90 高齡的焦士太，他的活力依舊如年輕人一般，不僅思路清晰、記憶良好，創作也是生猛有力，橫跨水墨和油畫兩個領域。當然他的另一項專長就是寫作，可以說是右手拿畫筆，左手寫作的人，既是畫家也是評論者，在李仲生的門生中，也算是一位奇葩。焦士太是一個喜歡自省的藝術家，他的繪畫創作，特別是抽象畫已歷經 40 餘年的創作生涯，無論是理論的實踐，亦或創作表達的方式，皆已達到獨特的見解與特色。他自己提到抽象創作的三個階段：「一、意象的自然。二、抽象的自然。三、心象的自然。」他的線條、色彩與造型三者互相糾結交纏，隨他的心性而動。有時也融入一些意象與半具象的圖騰符號，接近超現實感的《夢幻歲月》的系列創作。

焦士太
〈天地玄黃〉
1987-88
油畫
130 x 486 公分
藝術家自藏

Chiao Shih-Tai
The Beginning of the Universe
1987-88
Oil painting
130 x 486 cm
Courtesy of the Artist

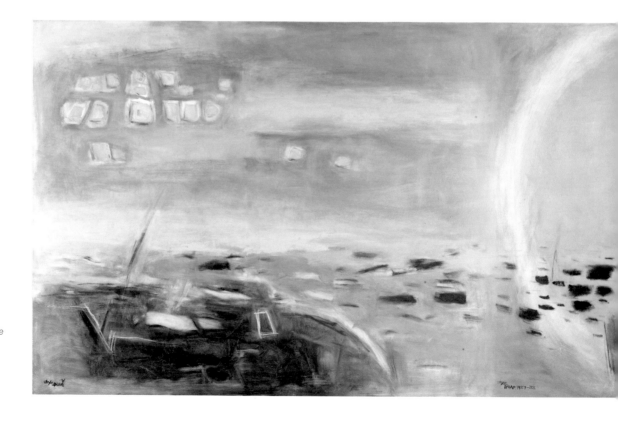

Even at the age of 90, Chiao is every bit as energetic as the young. Apart from retaining his reasoning power and prodigious memory, he also excels in ink-wash and oil paintings that are nothing if not full of life. Writing is one of his specialties, which makes him an artist-critic who paints with his right hand and writes with left. Regarded as a legendary figure among Li Chun-Shan's pupils, Chiao tends to create his works through thoughtful introspection. His oeuvre, abstract paintings in particular, has been evolved over a span of more than four decades. He has stood out from the crowd whether in terms of theory application or way of expression. The artist summarized the creation of his abstract works in three phases: (1) unaffected imagery; (2) unsophisticated abstraction; and (3) unpretentious mind. The brushstrokes, colors and shapes in Chiao's oeuvre ergo become an entangled relational trinity that dances to his emotion's tune. Some of his works incorporate with semi-representational totems and symbols, of which *Years of Dream and Fantasy*, a quasi-surrealist series, is the very epitome.

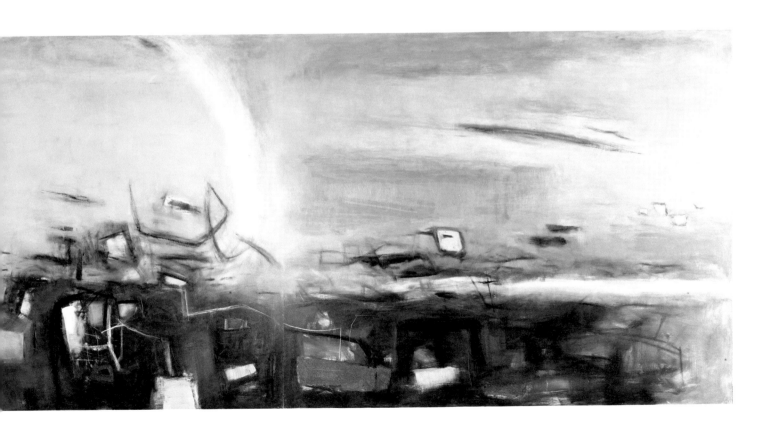

吳昊
Wu Hao

吳昊特別強調線條的重要性，這些靈感得自於東方「水墨工筆白描」的技法，正是他繪畫創作的秘笈寶典。「中學西用」的黑色細線，作為上色前的色彩區隔；如果少了這些線條，畫面結構就容易渙散掉。他的作品參雜中國民間圖騰與吉祥圖案造型，得自於母親精湛的傳統刺繡技藝的影響。他又歷經國共內戰，烽火交替歲月的洗練；年僅 16、7 歲的吳昊便隨著表嫂眷屬一起來臺，因生活困苦而入伍。從這些酸甜苦辣的人生經歷中，吳昊選擇了童年裡最美好的回憶來創作，透過洗練俐落的筆調勾勒描繪眾多繁複的花卉與靜物，這些造形意象豐饒的構圖，充滿了年節喜慶味道，雋永而耐人尋味。

Wu is an artist who sets great store by the expressive power of lines. Owing its inspiration to the oriental "elaborate-style line drawing," the line-based technique in his paintings has been an artistic *tour de force*. The black fine lines drawn in an occidental style with an oriental spirit as the core serve as the demarcation before coloring. The composition will inevitably become disorganized without them. With his indebtedness to his mother's consummate skill at embroidery, Wu's oeuvre shows an eclectic mix of Chinese folk totems and auspicious patterns. Weathering the storms of the Chinese Civil War, a real baptism of fire, Wu migrated to Taiwan with the family of his cousin-in-law when he was a teenager, and enlisted in the army due to penury. Despite the vicissitudes of his life, Wu's oeuvre gleams at his sweet childhood memories, depicting a riotous profusion of delicate flowers and still lives with deft brushstrokes. A festive atmosphere of the New Year pervades these mesmerizing compositions as meaningful as thought-provoking.

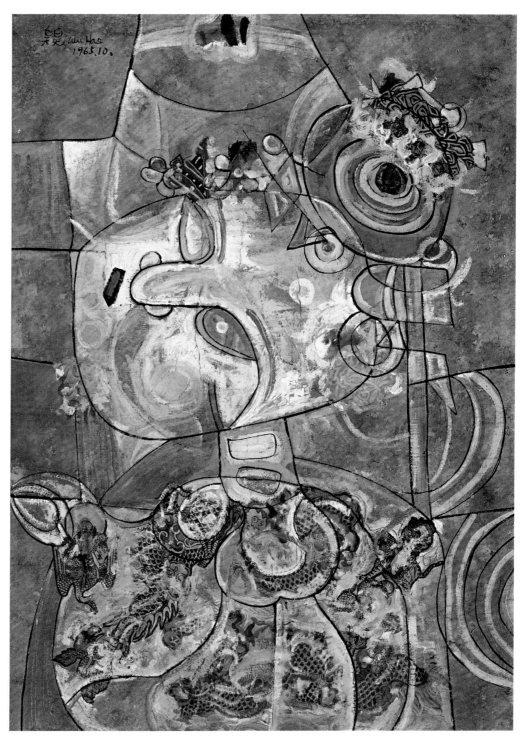

吳昊
〈戲〉
1965
油畫
73x 53.5 公分
國立臺灣美術館典藏

Wu Hao
A Drama
1965
Oil painting
73 x 53.5 cm
Collection of National Taiwan Museum of Fine Arts

吳昊　　　　　　　Wu Hao
〈鼓舞〉　　　　　*Drum Dance*
2002　　　　　　2002
油畫　　　　　　Oil painting
104 x 104 公分　104 x 104 cm
私人收藏　　　　Private Collection

吳昊
〈賽馬〉
2011
油畫
128 x 128 公分
形而上畫廊提供

Wu Hao
Horse Racing
2011
Oil painting
128 x 128 cm
Courtesy of Metaphysical Art Gallery

夏陽
Hsia Yang

夏陽早期以描繪「毛毛人」繪畫的風格著名，這是他在 1963 年底巴黎期間創作出來。他所描繪的「毛毛人」，線條粗細狂亂，在現實空間中並存並融，除了表達時間快速中的暫存現象外，也顯現一種當世存在價值中的混亂思緒，讓人不得不思考隱喻在圖像背後的意義，令人印象深刻。1968 年他到美國紐約生活且定居，正逢美國流行「照相寫實繪畫」風潮，他也即刻融入了這股潮流裡，再利用原有的毛毛人加上寫實的背景，那種晃動的形體與影子，很快地豎立起自己的風格，也成功的打入紐約藝術圈。夏陽說：「真正的藝術交流是本國的藝術家把文化的觸鬚伸展到國外，但自己創作的本體，依然繫於國內。」他於 2002 年移居上海生活，當一位專職的藝術家，創作至今且活力充沛。

Hsia has been known for his "fuzzy people" painting style developed in Paris around the end of 1963. The brushstrokes that shape these "fuzzy people" are rather irregular with a touch of untrammeled spirit, yet they blend in harmoniously with the physical space, which not only presents the fleeting moments in time, but also reveals a state of chaos regarding their *raison d'être* in the contemporary world. Portrayed in an impressive way, Hsia's "fuzzy people" also prompt the viewers to contemplate the implications behind his paintings. The artist settled down in New York in 1968, at the time when the trend of photorealistic painting was emerging. Following this trend, and harnessing the powers of "fuzzy people" and his training in realistic painting, Hsia rapidly evolved his own style featuring vague figures and silhouettes as if they are jolted, which in turn helped him establish a visible presence in New York's art world. "A genuine artistic exchange entails an artist to expand his cultural horizons abroad and ensure the ontology of his oeuvre to root domestically," so said the artist. Hsia moved to Shanghai in 2002 and has been a professional, zestful artist to date.

夏陽
〈凱蒂〉
1972
油畫
182.5 x 241.5 公分
國立臺灣美術館典藏

Hsia Yang
Katty
1972
Oil painting
182.5 x 241.5 cm
Collection of National Taiwan Museum of Fine Arts

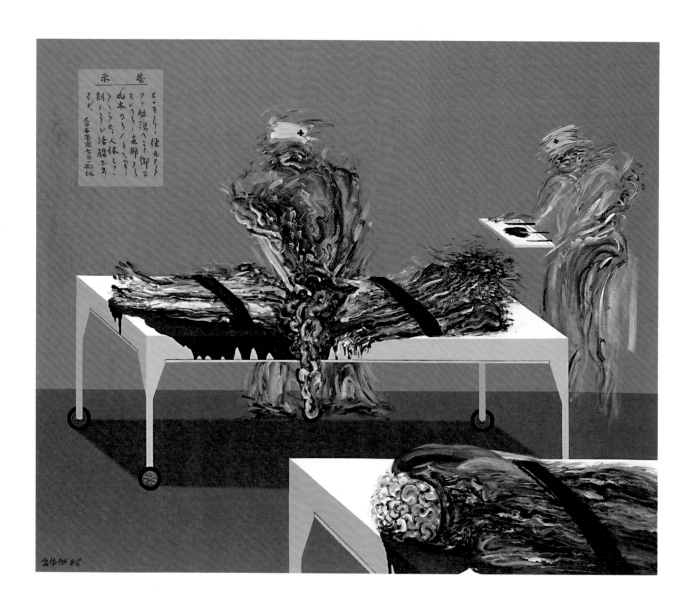

夏陽
〈日本國醫生〉
1988
複合媒材
153 x 183.2 公分
國立臺灣美術館典藏

Hsia Yang
Japanese Surgeon
1988
Mixed media
153 x 183.2 cm
Collection of National Taiwan Museum of Fine Arts

夏陽
〈穿牛仔褲的人〉
1985
複合媒材
228 x 117 公分
國立臺灣美術館典藏

Hsia Yang

A Guy Wearing Jeans

1985

Mixed media

228 x 117 cm

Collection of National Taiwan Museum of Fine Arts

霍剛
Ho Kan

霍剛說：「東方常說留白，西方強調極簡，用最少的表現最多，用最淺的表達最深，如同野獸派的健將馬諦斯所說：『畫面上沒用的就是有害的』，所以畫面上沒用的，我不畫，我儘量求簡來探索，追求畫境，同時朝向生命本質邁進並發展，這是我心境未來的追求。」他喜歡那種畫面單純、乾淨、理性，充滿理性與挑戰精神的創作。為了區隔出與西方藝術家不同的創作，他將東方的金石與文字拆解，提煉出屬於個人的靈感情懷世界，同時注重線條對稱表現，使用薄塗法將畫面平塗，他想要將東方寧靜的空靈感與空間放入，另闢一條蹊徑。近年來他回國定居，接連在臺灣辦了幾個重要的個展與聯展而備受藝壇矚目。

According to Ho, "blanks are usually left in oriental works of art, and minimalist ideas are their occidental incarnation, both are adopted to present more with less and deep with shallow. 'Everything that is not useful in the picture is, it follows, harmful.' so said Henri Matisse, an iconic figure of Fauvism. Following this principle, none of the elements in my paintings are useless. I explore and pursue artistic conception in a way as simple as possible, and meanwhile model my painting style upon the nature of life, which is also the ultimate escape for my frame of mind." Ho appreciates artworks that have a simple, clean, and rational composition with an aura of revolutionary zeal. To differentiate his oeuvre from those by western artists, Ho masterfully disassembles oriental bronze inscriptions and characters, from which he draws great inspiration and creative drive. Setting great store by simple lines and pleasing symmetry, he applies a delicately thin coating of pigment on the canvas, trying to blaze a trail by injecting oriental tranquility, ethereality, and spatiality into the composition via these simple, painterly layers that leave a tantalizing halo around his paintings. He moved back to Taiwan a couple of years ago, and has become a high-profile artist for he partook in some prestigious joint exhibitions and staged several solo shows that received hordes of accolades.

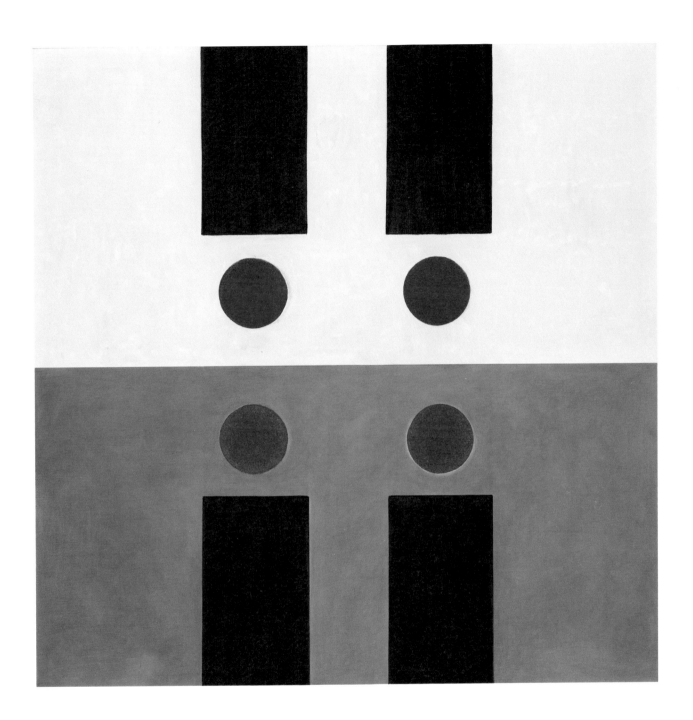

霍剛
〈承合之3〉
2011
油畫
100 x 200 公分 x 2件
私人收藏

Ho Kan
Continuity 3
2011
Oil painting
100 x 200 cm x 2pcs
Private Collection

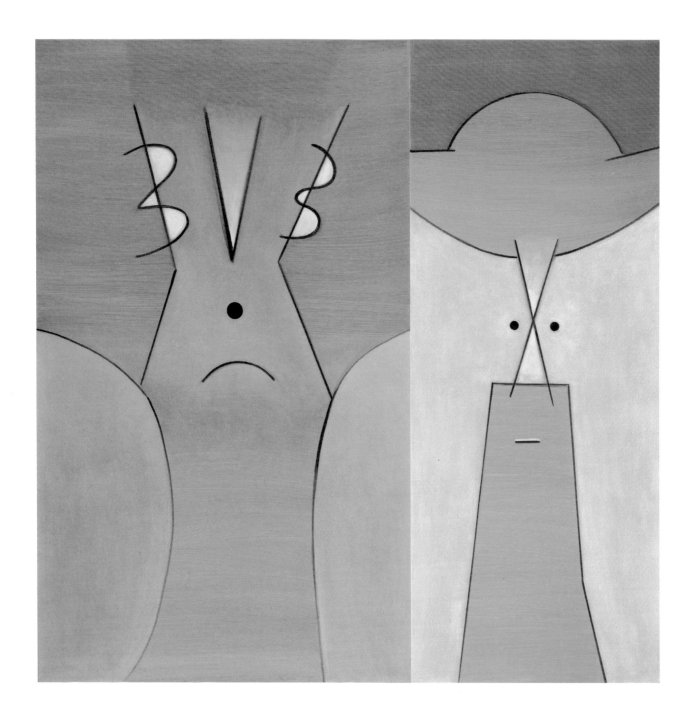

霍剛
〈承合之5、承合之2〉
2011
油畫
200 x 120 公分、200 x 80 公分
私人收藏．

Ho Kan
Continuity 5, Continuity 2
2011
Oil painting
200 x 120 cm, 200 x 80 cm
Private Collection

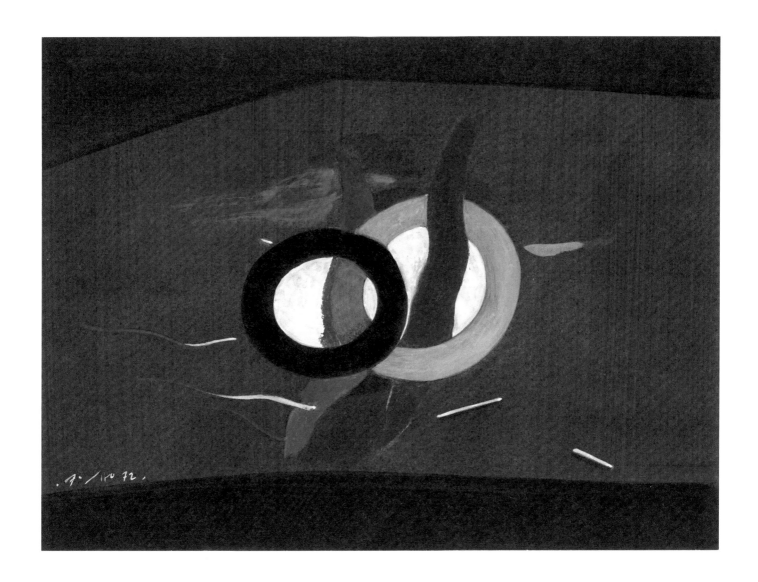

霍剛　　　　　　　Ho Kan
〈無題〉　　　　　　*Untitled*
1972　　　　　　　1972
油畫　　　　　　　Oil painting
30 x 39.5 公分　　30 x 39.5 cm
私人收藏　　　　　Private Collection

陳道明
Tommy Chen

李仲生在安東街畫室教出的第一代門生中，他們各自發展出個人的創作特色，有的傾向於具象風格表現，有的則發展出抽象風格的繪畫創作，而陳道明就是最早發展出抽象畫的畫家。

同是「東方畫會」健將的蕭勤就曾多次提及：「陳道明是中國第一位嘗試抽象繪畫的畫家。」[1] 陳道明的抽象畫重視肌理實驗與結構表現，不定型的繪畫特性讓他的畫充滿了氣韻流轉、起伏生動的自然意象，色彩運用柔美抒情，富東方詩意的美感表徵。他雖曾中斷過繪畫發展，但沉潛多年後又重拾畫筆，創作依然有脈絡之連貫性與張力之表現，令人印象深刻。「陳道明曾自我闡明：『我們語言所不能達到的，或很多語言沒辦法訴說的，就拿抽象的符號來作為一種敘述的語言…』。」[2]

1 引用自蕭瓊瑞，「五月與東方－中國美術現代化運動在戰後臺灣之發展（1945-1970）」，東大圖書公司，頁 221。
2 引用自石瑞仁藝評文章－「表面儘是文章，方寸俱現性情－陳道明的藝術耕耘」。

Sitting at the feet of Li Chun-Shan at his atelier on An-dong Street, all the first generation of his disciples have evolved their own signature creative styles. Some prefer figurative representation, while others abstraction. Tommy Chen is exactly the first abstract painter among them. Hsiao Chin, one of the iconic figures of the Tong Fang Painting Association, has repeatedly mentioned that "Tommy Chen is the first Chinese artist who attempts to create abstract painting" [1]. Chen's abstract paintings put a premium on the expression of texture and structure. Their mercurial quality is evocative of the natural imagery brimming with ethereal flavors and rolling undulations. Besides, their coloring is as gentle as lyrical, conveying poetic beauty in an oriental fashion. Career break notwithstanding, Chen resumed after years of hunkering down without compromising his later works' contextual coherence and aesthetic tension, which is nothing if not impressive. "'Where there is something indescribable, use abstract symbols to narrate it,' Tommy Chen said" [2].

1 Cited in Xiao Chiung-Rui, *The Fifth Moon Group and the Tong Fang Painting Association: The Modernization of Chinese Fine Arts in Postwar Taiwan (1945-1970)*. Tung Da Books, p. 211.
2 Cited in J.J. Shih, "Let Meanings Alight on Paper and True Nature Belie in Frame: Tommy Chen's Illustrious Career as an Artist."

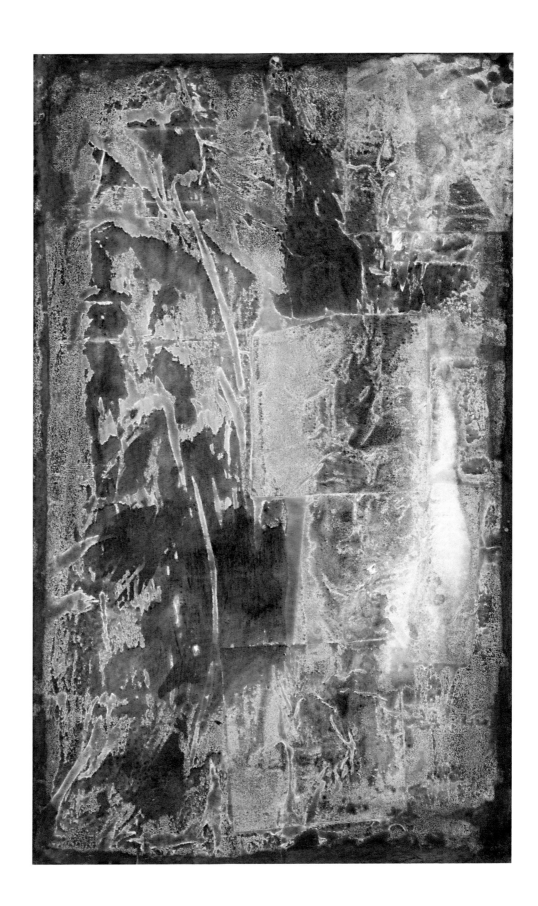

陳道明
〈2007冬〉
2007
壓克力顏料、畫布
145 x 89 公分
誠品畫廊提供

Tommy Chen
2007 Winter
2007
Acrylic on cavas
145 x 89 cm
Courtesy of Eslite Gallery

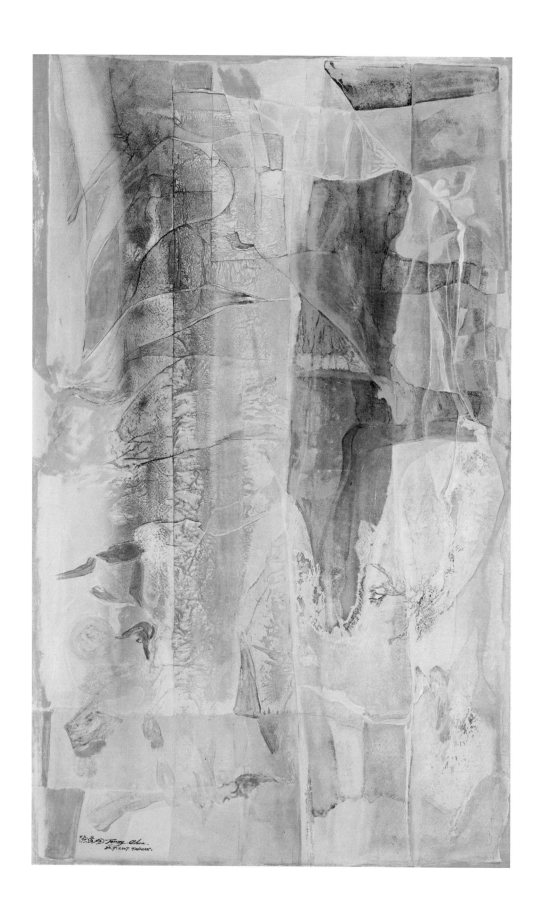

陳道明
〈20072007〉
2007
壓克力顏料、畫布
145 x 90 公分
誠品畫廊提供

Tommy Chen
20072007
2007
Acrylic on cavas
145 x 90 cm
Courtesy of Eslite Gallery

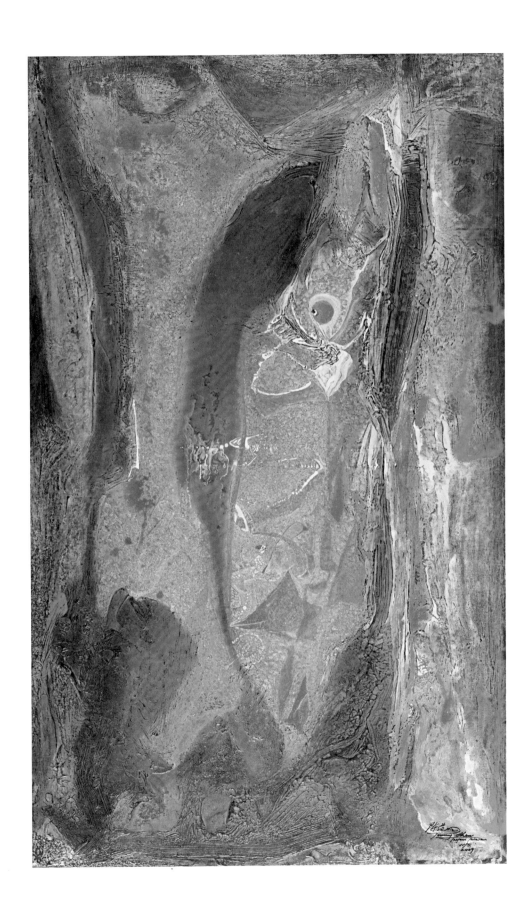

陳道明
〈11052009〉
2009
壓克力顏料、畫布
145 x 97 公分
誠品畫廊提供

Tommy Chen
11052009
2009
Acrylic on cavas
145 x 97 cm
Courtesy of Eslite Gallery

蕭勤
Hsiao Chin

如果說「五月畫會」中的精神代表人物是劉國松，「東方畫會」無疑就是以蕭勤莫屬，也是東方畫會中重要的「八大響馬」之一，他後來長期旅居在義大利，早期不像現在網路科技的發達，只能藉由書信往返，或定期於臺灣藝術雜誌發表，將國際現代藝術的發展訊息傳達到國內，影響臺灣的現代藝術深遠。蕭勤於留義大利期間開始展露出他的藝術長才，1961 年發起「龐圖 PUNTO 國際藝術運動」（又譯作「點」），1978 年又再創辦「太陽（SURYA）國際藝術運動」，1989 年並發起「國際炁（SHAKTI）藝術運動」等。先後參與了這些前衛藝術運動，讓他成為活躍於當時國際藝壇的藝術家。蕭勤的作品融入了東西方的實驗精神；簡單的說，創作以簡馭繁，又由繁雜中收併於意念中，介於道家與禪宗的哲學思想體系，還原於本我的精神自覺。當然藝術家的創作離不開生命本源的探討，這個過程就像他畫中的一道道線條，都是起始探尋的道路，讓物象回歸到原點，又由原點牽引出悟性，營造出混沌、空靈與大氣磅礴的氛圍。

When it comes to a spiritual leader, Liu Kuo-Sung is to the Fifth Moon Group what Hsiao Chin is to the Tong Fang Painting Association. The latter is also a member of the so-called Eight Great Outlaws. Hsiao has resided in Italy for a long period. At the time when the Internet was yet to come, he had no choice but to send correspondence or regularly publish articles in Taiwanese art magazines if he wanted to introduce the latest trends of international modern art to Taiwan. The difficulties notwithstanding, the artist still exerts a profound and enduring influence on Taiwanese modern art. During his stay in Italy, Hsiao began to reveal his outstanding talent. He initiated several international artistic movements such as PUNTO (1961), SURYA (1978) and SHAKTI (1989). These avant-garde movements helped him establish an enlivened presence in the international art world. Besides, his oeuvre embodies the experimental spirit of both the oriental and occidental arts, simplifying the complicated through a convergence of portmanteau ideas. His creative philosophy shows an in-between state of Taoism and Zen Buddhism, orientating itself towards his basic, instinctual drives of id. Obviously, every stroke of Hsiao's brush bears his signature of probing into the origin of life and charting different paths of exploration for the natural state of everything, from which the power of enlightenment is derived and an innocent, ethereal and humbling atmosphere is created.

蕭勤　　　　　　　　Hsiao Chin
〈度大限-121〉　　　*Passage through the Great Threshold-121*
1992　　　　　　　　1992
壓克力顏料、紙　　　Acrylic on paper
180 x 198 公分　　　180 x 198 cm
國立臺灣美術館典藏　Collection of National Taiwan Museum of Fine Arts

蕭勤
〈炁-136〉
1983
墨水、壓克力顏料、畫布
124.6 x 200 公分
國立臺灣美術館典藏

Hsiao Chin
Chi-136
1983
Ink and acrylic on paper
124.6 x 200 cm
Collection of National Taiwan Museum of Fine Arts

蕭明賢
Hsiao Ming-Hsien

蕭明賢的創作以抽象表現為主，他早期作品喜歡以單純的線條為創作表現重點，類似建築線條的結構體，具書法結構性特色與筆觸表現特質，作品傾向扁平化與留白空間形成強烈視覺對比。1957 年他榮獲巴西聖保羅第四屆國際雙年展「榮譽獎」的作品即是此類型的呈現。中期作品重視抽象線條書寫性表達，創作朝向奔放與宣洩的自由揮灑，填滿色彩的背景空間，往往與畫中主角的黑色抽象線條纏繞互動，這是心情書寫的抽象表現，抽象線條與筆觸豪邁靈動，隨心性而舞，穿透畫面交融與開合。近期作品貼近接近東方性與「道」的概念，理性與感性並融，往往在畫面上呈現像五線譜的音樂線條，在其上有類似書法筆觸的放逸揮灑，具音樂性節奏表現，有時創作啓動，連手掌也玩興沾上墨色即席拓印，形成有趣且激情的創作畫面，讓人感受他那分創作的原動力與熱情。

Abstract paintings are the staple of Hsiao's oeuvre. His early works feature simple yet one-of-a-kind brushstrokes reminiscent of building contours with a touch of calligraphic aesthetics. These works are also characterized by their flattened compositions and the blanks that provide a dramatic contrast. His entry that earned him the "Honorary Award" of the 4th São Paulo Art Biennial in 1957 epitomizes the batch of works created during his early career. Hsiao's mid-career works give prominence to free-style abstract *écriture* which is nothing if not bold and unrestrained. Saturated with colors, the background appears to be inextricably intertwined with the black lines that shape the protagonist's contour, which is a highly abstract articulation of the artist's innermost feelings. These uninhibited brushstrokes dance to Hsiao's tune and convey a sense of spirituality, intersecting with one another across the composition with charming deftness. Hsiao's recent works highlight oriental qualities and Taoist conception of the Way, embodying a marvelous fusion of sense and sensibility. Quasi-calligraphic brushstrokes are presented freely in the stave-like lines evocative of flowing melodies, imbuing the composition with rhythmic vitality. Sometimes he takes childlike delight in making art improvisation by adding inked palm-prints to the composition, thereby giving it a playful aura of passion. It can be argued that Hsiao's original impetus and unbridled enthusiasm for artistic creation find vivid expression in these captivating abstract paintings.

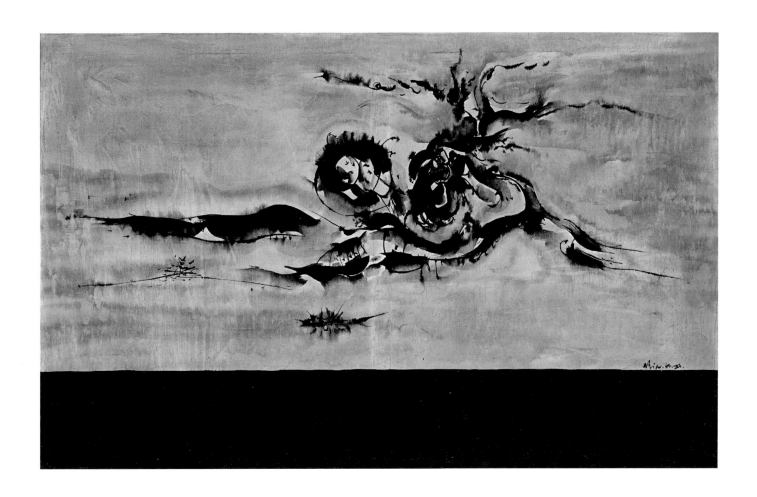

蕭明賢　　　　　　Hsiao Ming-Hsien
〈形象A〉　　　　　*Image A*
1963　　　　　　　1963
複合媒材　　　　　Mixed media
74 x 117 公分　　　74 x 117 cm
國立臺灣美術館典藏　Collection of National Taiwan Museum of Fine Arts

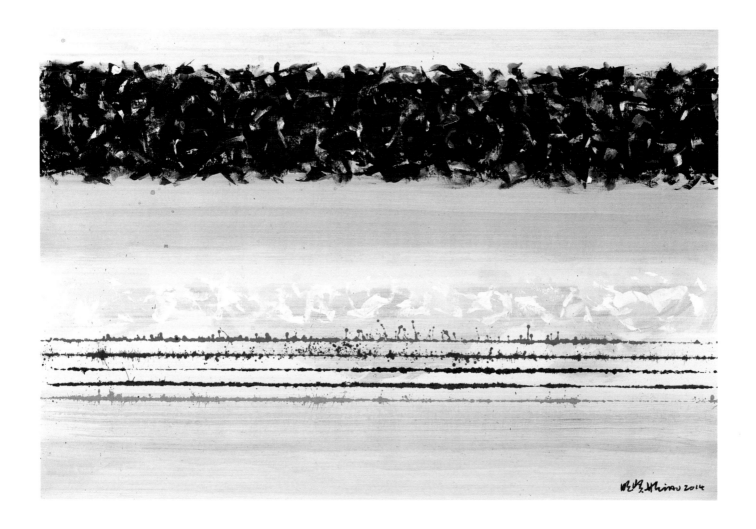

蕭明賢　　　　　　Hsiao Ming-Hsien
〈時空的記憶-2〉　*Memories of Time and Space-2*
2014　　　　　　　2014
油畫　　　　　　　Oil painting
82.5 x 122 公分　　82.5 x 122 cm
采泥藝術提供　　　Courtesy of Chini Gallery

蕭明賢
〈祈望〉
1963
油畫
115 x 53 公分
藝術家自藏

Hsiao Ming-Hsien
To Pray
1963
Oil painting
115 x 53 cm
Courtesy of the Artist

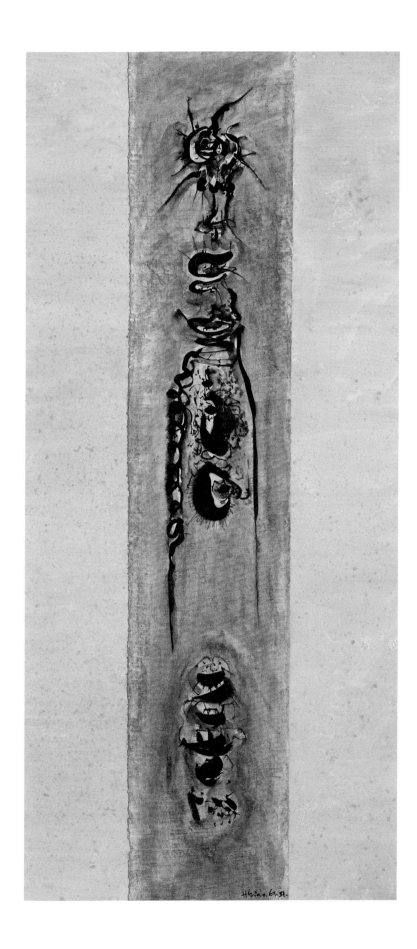

李錫奇
Lee Shi-Chi

李錫奇有臺灣「變調鳥」的稱謂，這是知名詩人楚戈所說，形容這位藝術家的創作就像「變調鳥」一樣，多元變化且豐富。相較其他李仲生的學生，李錫奇雖然後來也被歸於李仲生門下，但其實他並未真正受教於李仲生，相反的兩人更像是因藝術之緣而結交。他在臺灣藝壇的表現也和其他藝術家的發展不同，充滿了許多變數和異數。1958 年，他發起並參與了臺灣第一個「現代版畫會」，1963 年加入「東方畫會」，成為「臺灣現代繪畫導師」李仲生中後期的重要弟子。從 1978-1990 年曾先後開過四家畫廊，前後引薦許多知名海外華裔藝術家回臺展覽。李錫奇在創作上迭創新意，橫跨版畫、水墨、漆畫、複合媒材、裝置等領域，屬於風格多變的藝術家，早期版畫具象形式，中後期以抽象創作為主。他一直以中國文化與歷史為「本位」，作為創造原動力。

Lee was dubbed the "Variegated Bird of Art" by famous poet Chu Ko for his painting style which is every bit as ever-changing and tantalizing as a variegated bird. Construed as one of Li Chun-Shan's disciples yet distinct from them, the artist has never received instructions from Li. Rather, it seems more like the two artists formed an indissoluble bond with each other because of art. Lee's mercurial performance also renders him one-of-a-kind in Taiwan's art world. He co-founded the Modern Printmaking Association—the first association for printmaking in Taiwan—in 1958, and joined the Tong Fang Painting Association in 1963, thenceforth becoming an iconic figure among Li Chun-Shan's disciples. He had run four galleries successively between 1978 and 1990, hosting many attractive exhibitions by renowned overseas Chinese artists. As a brilliantly inventive artist who keeps evolving his creative style, Lee has his oeuvre in a riotous profusion of forms ranging from printmaking, ink-wash, lacquer painting, mixed media, and installation. His early prints are representational, while those in his mid- and late-career tend to be abstract. The Chinese culture and history have always been the orientation and creative drive throughout his prolific career.

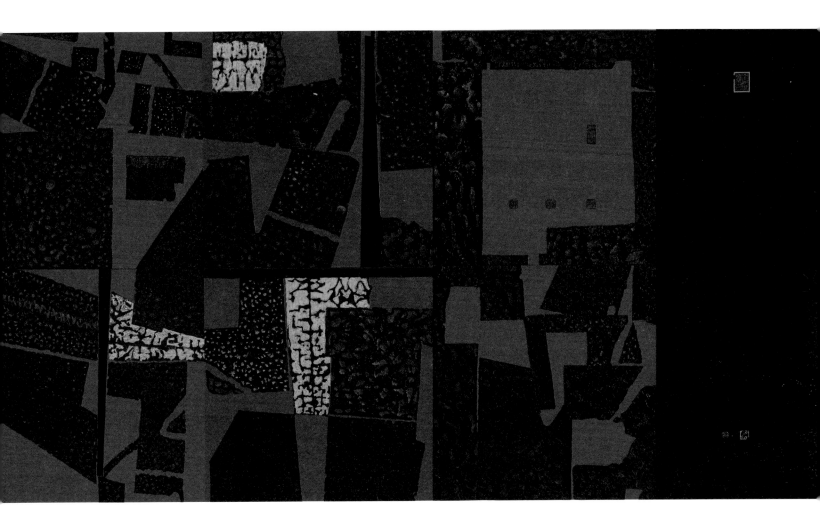

李錫奇
〈本位 新發之十四〉
2005
複合媒材
200 x 380 公分
國立臺灣美術館典藏

Lee Shi-Chi
Orientation Sprouting from the Root -14
2005
Mixed media
200 x 380 cm
Collection of National Taiwan Museum of Fine Arts

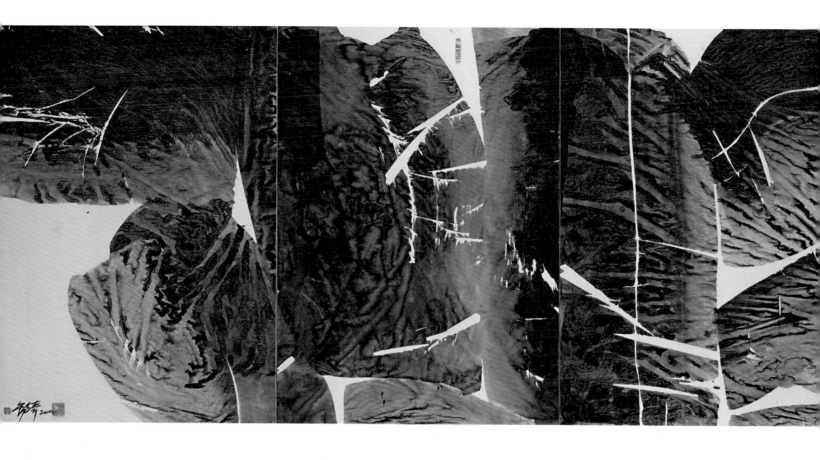

李錫奇
〈墨語0208〉
2002
水墨
109 x 236.6 公分
國立臺灣美術館典藏

Lee Shi-Chi
Voices of Ink 0208
2002
Ink on paper
109 x 236.6 cm
Collection of National Taiwan Museum of Fine Arts

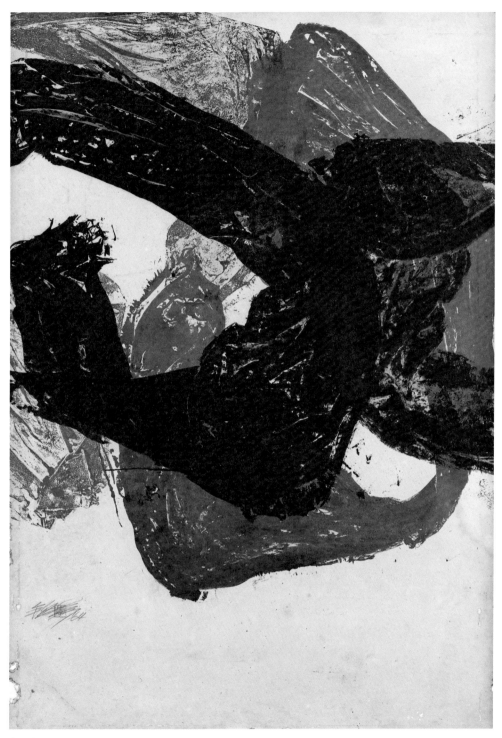

李錫奇
〈作品之二〉
1964
複合媒材（降落傘布拓印）
77 x 52 公分
李錫奇藝術中心提供

Lee Shi-Chi
Parachute Series No.2
1964
Rubbing on parachute canvas
77 x 52 cm
Courtesy of Shi Chi Lee Gallery

許輝煌
Syu Huei-Huang

許輝煌說：「筆是我的眼、筆是我的口、筆是我的耳、筆是我的心。油彩是我的生活，我用筆畫出我的心靈世界。我用我的畫說出我的感覺，讓我的生命自然流露。」在創作精神上，他以前衛藝術的新素描為表現重點與視野，將中國傳統東方精神與西方超現實主義結合，並融入佛洛伊德潛意識的學說，試圖再創造一個異象新空間。而在材質的表現上，他以油畫表現為主，運用筆觸和肌理，有時畫面呈現光滑細膩、有時粗糙質感、有時又大膽渲染和潑彩，剛柔並濟的運用。他創造的新空間裡，非敘事性、非文學性、非主題性，充滿了衝突與矛盾的潛意識、繽紛流動的色彩、扭曲變奏的造形、虛實相映的純粹抽象表現之繪畫。

"My brushes are my eyes, mouth, ears and heart incarnate, and my *raison d'être* lies in oil paints. I depict my mind and vent my feelings through my brushes, in which my life trajectory finds natural expression," so stated Syu Huei-Huang. Focusing his horizons on avant-garde drawing, the artist not only integrates oriental spirit with occidental surrealism, but also incorporates Sigmund Freud's account of the unconscious mind into his painting style, seeking to fabricate an unprecedented wonderland of art. Coupling strength and gentleness, the majority of his works are oil paintings containing various brushstrokes and textures that present diverse tactile qualities; some are exquisite and glossy, others are coarse and craggy, and still others are wildly rendered with a splash-effect. In the wonderland he masterfully crafted, myriads of non-narrative, non-literary and non-thematic things merge with conflict- and contradiction-laden sub-consciousness. These purely abstract paintings are intersected by the real and the virtual, characterized by all the colors in profusion and all the shapes in deformation.

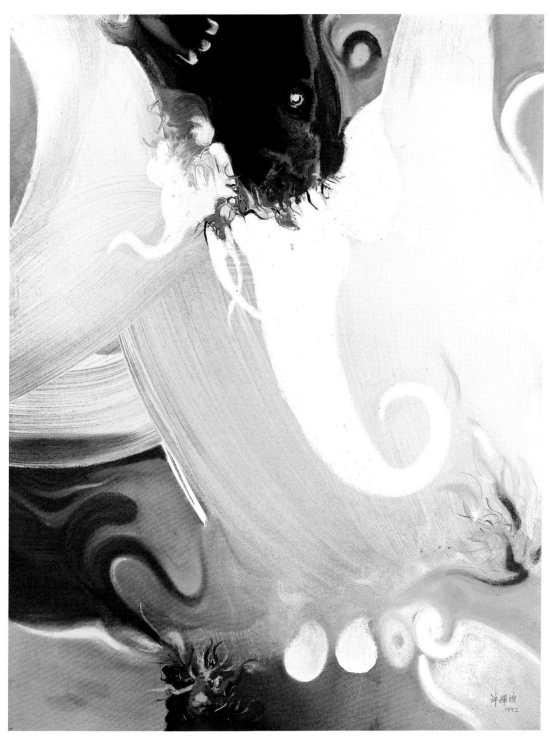

許輝煌
〈心象世界 I〉
1992
油畫
120 x 94 公分
藝術家自藏

Syu Huei-Huang
Mental Imagery - I
1992
Oil painting
120 x 94 cm
Courtesy of the Artist

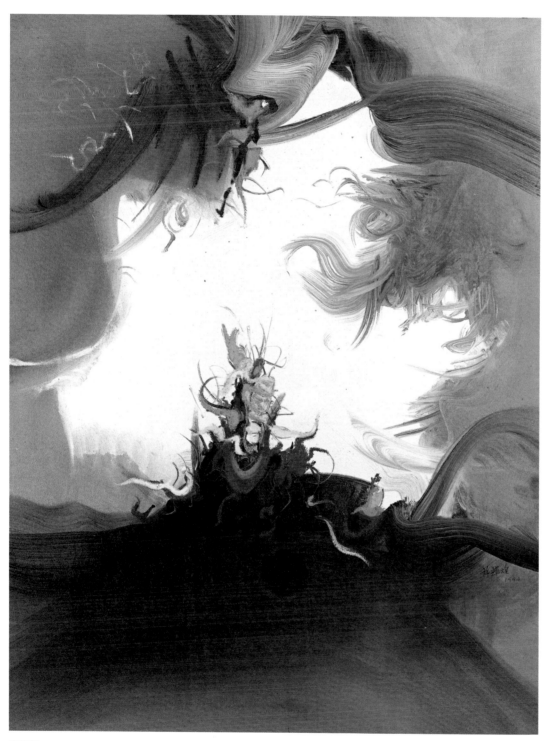

許輝煌
〈心象世界 II〉
1994
油畫
120 x 94 公分
藝術家自藏

Syu Huei-Huang
Mental Imagery - II
1994
Oil painting
120 x 94 cm
Courtesy of the Artist

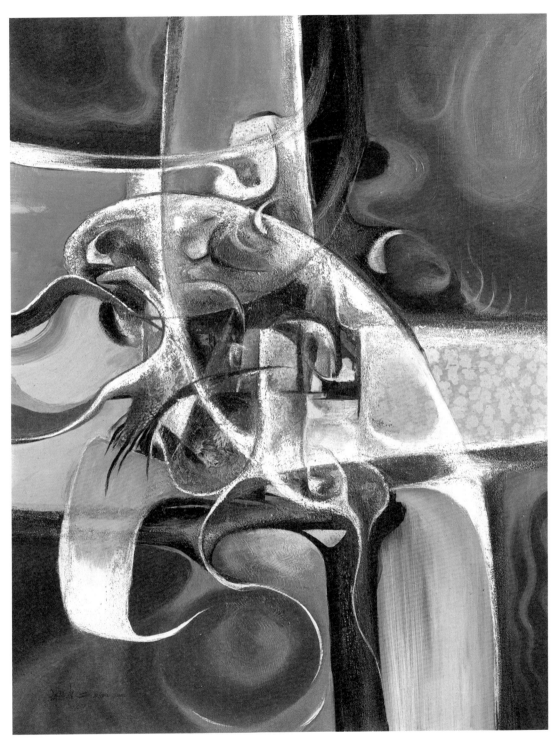

許輝煌　　　　Syu Huei-Huang
〈心象世界 III〉　　*Mental Imagery - III*
2004　　　　　2004
油畫　　　　　Oil painting
120 x 94 公分　120 x 94 cm
藝術家自藏　　Courtesy of the Artist

黃潤色
Huang Run-Se

在李仲生眾多門生中，女性門生算是少數，但每位後來皆發展出個人獨特的風格，黃潤色就是其中頗令人矚目的一位。她最早師從楊啓東學水彩畫，後來 1960 年才轉向李仲生學習創作。

黃潤色從李氏的教學中找尋到自己個人的特色，從而自由大膽發揮，嘗試了超現實神祕的結構與具線條造型內涵的創作。黃潤色早年時曾自述：「我一向酷愛細、幽而又充滿神祕性的線條，我的畫以線條為主幹，由少而多，由簡單而複雜，畫至自己感覺滿足為止，然後以接近我自己個性的寒色調子，透過直覺的意念表現內心的感情和思想。」

她的創作帶有女性的優雅與神祕特質，作品在理性結構分析中，線條延伸或纏繞重疊呈現深邃的幾何空間，又似心象世界的獨白。

Having established their respective creative styles, females constituted a small minority but a force to be reckoned with among Li Chun-Shan's disciples, and Huang was one of these high-profile female artists. She was originally apprenticed to Yang Chi-Tong for watercolors, and then learned to create other forms of art from Li after 1960. Huang managed to develop her personal style from Li's mentorship, and began to freely experiment on surreal, mystic structures and line-based contents thenceforth. "I'm always fascinated with thin, subtle lines that radiate a mystical aura. My paintings revolve around lines of all stripes, manifesting a gradual accumulation from less to more and from simple to complex. I will not stop drawing until I feel satisfied. Then I apply cool tones that match my personality to intuitively voice my deep sentiments and ideology," so described Huang herself. The artist's oeuvre on the one hand displayed women's mystically charming elegance, and on the other hand seemed to be her inner monologue, for it presented fetching geometric spaces interlaced by sprawling or intertwined lines apart from rational, analytical structures.

黃潤色
〈作品08-B〉
2008
油畫
110 x 110 公分
國立臺灣美術館典藏

Huang Run-Se
Work 08-B
2008
Oil painting
110 x 110 cm
Collection of National Taiwan Museum of Fine Arts

黃潤色
〈作品Y〉
1985
油畫
124 x 124 公分
臺北市立美術館典藏

Huang Run-Se
Composition Y
1985
Oil painting
124 x 124 cm
Collection of Taipei Fine Arts Museum

黃潤色
〈作品87-M〉
1987
油畫
124 x 124 公分
臺北市立美術館典藏

Huang Run-Se
Composition 87-M
1987
Oil painting
124 x 124 cm
Collection of Taipei Fine Arts Museum

鐘俊雄
Chung Chun-Hsiung

鐘俊雄的創作多元而豐富，從早期跟李仲生學畫時期，他已發展出結合素描與水墨韻味的超現實風格的繪畫，他的創作充滿許多實驗精神，且不拘泥於各種材質的實驗，從紙、畫布、木板、現成物等的複合媒材創作等，他都喜歡運用嘗試。

其中最重要的一點，他特別強調他的畫始終充滿童趣，為了保有這種臺灣味，有時複合媒材的創作還加入稻草與稻殼在創作裡，他顏色的靈感得自於廟宇的色彩，是從臺灣味道發展出來的東方性精神。這些元素皆是他一再思考創作的問題，且是永無止盡的探索與實驗。另外除了繪畫創作之外，他也創作雕塑，包含公共藝術的大型雕塑與裝置。

Chung is a prolific artist who creates works in different art forms, and has developed a surrealist painting style that perfectly blends the charm of drawing and ink-wash as early as the time when he sat at the feet of Li Chun-Shan. Embodying the spirit of experimentation, Chung does not so much confine his oeuvre to a single creative medium as unflaggingly experimenting on different ones, such as paper, canvas, wood slab, ready-made and so on. Most importantly, he lays particular emphasis on childlike delight, insofar as to incorporate straw and paddy into his mixed media works at times as a way to preserve the Taiwanese flavor. The temple-inspired coloring of his works faithfully reflects the oriental ethos evolved from such flavor. These elements are not only at the core of Chung's concern but also the targets of his indefatigable exploration and experimentation. Apart from paintings, Chung also creates sculptures, including large-scale sculptural works and installations for public art projects.

鐘俊雄　　　　　Chung Chun-Hsiung
〈2010-9B〉　　　*2010-9B*
2010　　　　　　2010
複合媒材　　　　Mixed media
100 x 100 公分　100 x 100 cm
藝術家自藏　　　Courtesy of the Artist

鐘俊雄
〈2012-2B〉
2012
紙上貼繪
194 x 65 公分
藝術家自藏

Chung Chun-Hsiung
2012-2B
2012
Collage on paper
194 x 65 cm
Courtesy of the Artist

鐘俊雄
〈1966A〉
1966
油畫
101.5 x 81.5 公分
藝術家自藏

Chung Chun-Hsiung
1966A
1966
Oil painting
101.5 x 81.5 cm
Courtesy of the Artist

黃志超
Dennis Hwang

黃志超以水墨創作的線條與色彩運用，融入造型成為他的創作特色。他說：「我受中國傳統文化很深，蘇東坡是我崇拜的畫家，另外我也嚮往畫家徐渭和八大的放逸揮灑，從東方水墨進入，結合民間廟宇藝術的靈感色彩與造型變化，我在畫中營造空氣感，讓畫面不修飾充滿活力，追求享樂與世俗感官人生。」這種觀點想法從他繪畫創作上就可強烈感受到，他創作許多關於山水、女人和馬的主題，用色大膽自由、線條強烈，造型童趣、拙稚，不管是水墨或是彩墨，充滿節奏與韻律，形成他個人獨特的繪畫風格。

Hwang's oeuvre is characterized by blending ink-wash lines and coloring into the composition. He explained, "Traditional Chinese culture has profoundly influenced my thinking. I adore Su Shi as a master artist, and long for the gracefully unrestrained styles of Xu Wei and Zhu Da, two famed painters in Chinese art history. Treating oriental ink-wash painting as the point of departure, I incorporate the temple art's spiritual quality displayed through its colors and shapes, so as to give my works a sense of refreshment, or, an aerial perspective, thereby making the composition burst with vitality and implying a lifestyle of pursuing hedonic pleasure and profane sensory delight." Hwang's paintings perfectly exemplify this account. Landscapes, women and horses have arisen frequently as the subjects of his oeuvre. Applying colors in a bold, unconfined manner and vigorous brushstrokes with great expressive power, his paintings, be they ink-wash or colored ink, collectively indicate a *sui generis* style that not only oozes an aura of simplicity and childlike delight, but also evokes an alluring feeling of musical pulse and rhythmic motion.

黃志超
〈天上人間〉
1971
蠟染、棉布
87 x 54.5 公分
藝術家自藏

Dennis Hwang
Heaven and Earth
1971
Dye on cotton
87 x 54.5 cm
Courtesy of the Artist

黃志超
〈九曲洞（一）〉
2011
複合媒材畫布
87.5 x 130 公分
藝術家自藏

Dennis Hwang
Tunnel of Nine Turns
2011
Mixed media on canvas
87.5 x 130 cm
Courtesy of the Artist

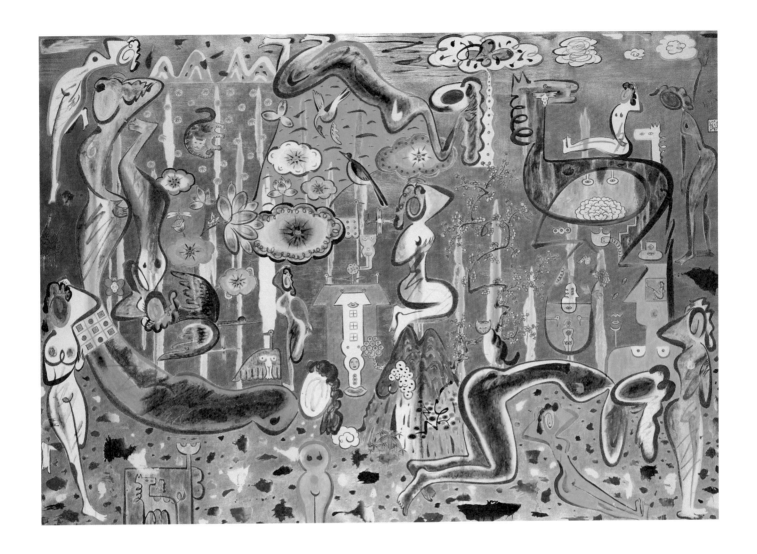

黃志超
〈群女圖〉
2008
複合媒材畫布
150 x 185 公分
藝術家自藏

Dennis Hwang
Image of Women
2008
Mixed media on canvas
150 x 185 cm
Courtesy of the Artist

詹學富
Jan Syue-Fu

詹學富畫筆下的女人姿態多樣，或坐或臥，以細線條勾勒出半具象的造型變化，自由的表達出他內心的感覺；我們可以看到畫中山形結構的變化、或是幾何形體的介入、亦或是平塗的色塊組構等，依照潛意識的萬般變化逐一的融入超現實的畫面裡。詹學富說：「繪畫創作是個最可自由的耕地，去除學院法則及現實自然的限制，轉由本能非理性的自由伸張，千萬變化於焉產生。可臻自由自在繪所欲繪，無限開闊的繪畫領域。」他創作的女人不是具有綺麗的容顏與姣好的身材，更多的是柔軟平整的肉塊組織，這種眾生相，源自於畫家的奇幻巧思與顏色層次的互動對話。

In Jan's paintings, the women figures are gracefully attractive be they sitting or reclining. The artist tends to draw semi-representational shapes with thin lines as the way to vent his innermost feelings unreservedly. It is easily discernible that, in the artist's paintings, whether the variation of mountain ridges, the intervention of geometric patterns, or the painterly colors all dance to the tune of his volatile subconscious, harmoniously blending in with the surreal compositions. Jan claimed, "Nowhere can grant us greater freedom than the arable field of painting. I break away from academic principles and transcend the physical confines of reality, turning to non-rational, instinct-driven emancipation, hence countless changes in my paintings. Thus, I can draw whatever I like with a carefree spirit, braving the uncharted territory of art." The women figures in Jan's paintings feature not so much charming mien and tempting physique as clusters of smooth and tender flesh. Such a way of expression originated from the constructive interaction and dialogue between the layers of paints and the artist's admirable ingenuity.

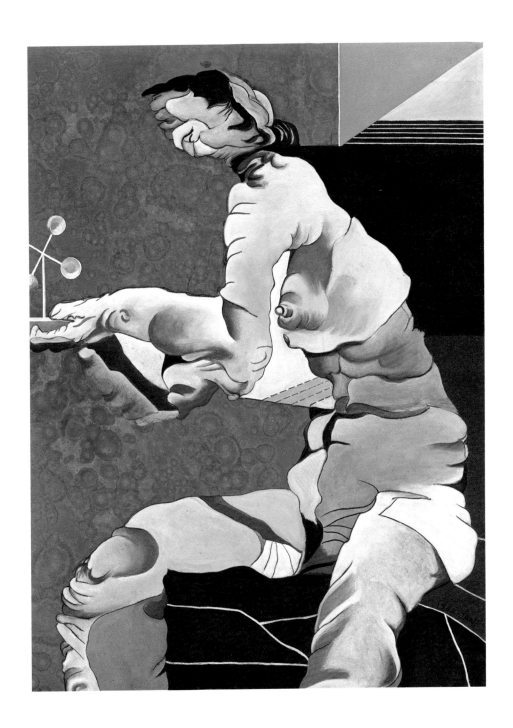

詹學富
〈獨女 B〉
1982
壓克力畫布
100 x 73 公分
藝術家自藏

Jan Syue-Fu
Single Girl B
1982
Acrylic on cavas
100 x 73 cm
Courtesy of the Artist

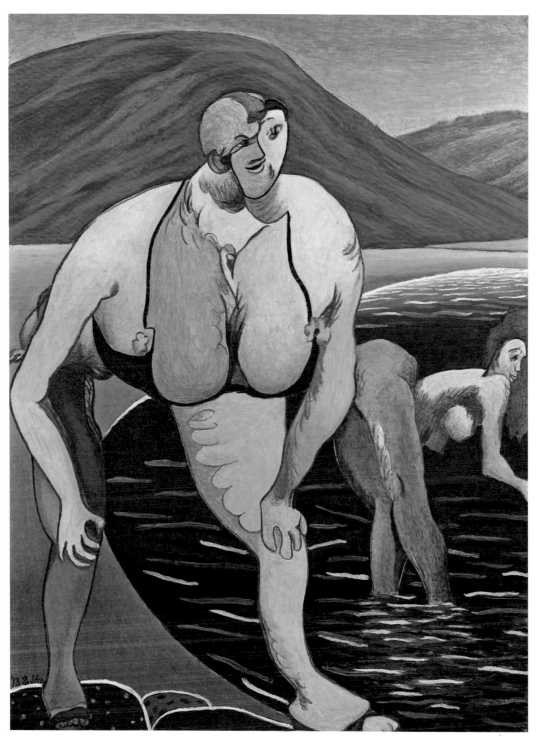

詹學富 Jan Syue-Fu

〈戲水〉 *Water Playing*

2013 2013

油畫紙板 Oil on paper

120 x 89.6 公分 120 x 89.6 cm

藝術家自藏 Courtesy of the Artist

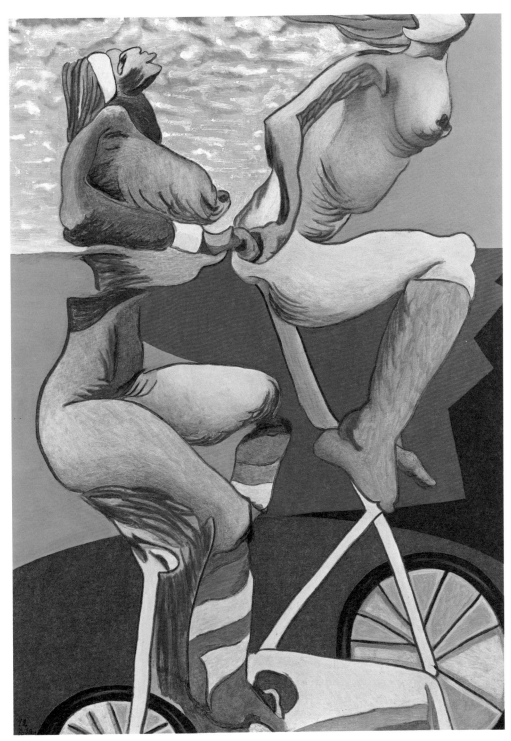

詹學富　　　　　Jan Syue-Fu
〈騎單車表演〉　　*Bike Show*
2012　　　　　　2012
油畫　　　　　　Oil painting
122.5 x 87 公分　122.5 x 87 cm
藝術家自藏　　　Courtesy of the Artist

謝東山
Hsieh Tung-Shan

在李仲生教的學生裡，創作佔了大多數，但能夠右手畫畫，左手持筆的人，謝東山無疑是最貼近這樣的藝術家與藝評家。他的繪畫喜歡以裸女入鏡，我們看到這些裸女隨興的倘佯在自然的風景中，那像是再造一個現代的神話故事。

他說：「以裸女為題材畫了20年，在美國留學時就開始進行，裸女畫接近古典故事情節，繪畫就是好玩，隨心境而走。」謝東山的繪畫創作依照他的心境而走，但對一位有意識想法的藝術家而言，他的創作還是有別於傳統模特兒的寫生繪畫，畫面上縈繞在一種風俗與社會性的道德議題探討。

對謝東山來說，裸女畫不僅是他後現代觀念的再現延伸，除了天體營的場域能容許外，在現世的社會生活中，是不存在於這樣的生活場域，更源自於烏托邦的理想，潛意識中的欲念。

Most of Li-Chun-Shan's disciples excel in artistic creation, yet none of them are as competent as Hsieh Tung-Shan in being an artist-critic. Naked women feature strikingly in his paintings, spontaneously wandering around natural scenery, which is nothing short of a modern incarnation of classical mythology. "I've pursued the subject of nudity for two decades since the time when I was studying abroad in the United States. Nude paintings carry the mythological implications in the classical tradition. I paint by following my heart, in which I take spiritual delight," Hsieh stated. It is noteworthy that Hsieh is an artist teeming with creative ideas, and his oeuvre is obviously different from general nudes, for the composition lingers on issues regarding social custom and morality. As far as Hsieh is concerned, his nude paintings not only originate from his utopian ideal and subconscious desire, but also serve as the representation and extension of his postmodern vision that, within the scope of contemporary society, can be fulfilled in no other place than in naturist domains.

謝東山
〈西洋繪畫的起源〉
2013
油畫
194 x 130 公分
藝術家自藏

Hsieh Tung-Shan
The Genesis of Occidental Painting
2013
Oil painting
194 x 130 cm
Courtesy of the Artist

謝東山
〈林中湖〉
2011
油畫
162 x 130 公分
藝術家自藏

Hsieh Tung-Shan
Lake in the Forest
2011
Oil painting
162 x 130 cm
Courtesy of the Artist

黃步青
Hwang Buh-Ching

黃步青是一個喜歡思考的藝術家，感性理性兼之，在大學時就想當藝術家，才執著去巴黎念書，想在巴黎當藝術家。他喜歡收集有造型的物件和歲月老東西的習慣，1981 年到巴黎留學後，這些都融入了創作領域與之結合，然後 1987 年又回到臺灣這塊土地繼續他的創作道路。他說：「個人的創作一直有一個理想，用純粹極個人的藝術語彙，來探討我賴以生活的這塊土地，這可以回溯以往在創作上用報紙擠壓的形式，做了一個系列作品，後來用臺灣蒺藜子做成發展裝置的媒材語彙，後來的大型裝置，例如威尼斯雙年展與英國文化奧運的展覽，皆以此媒材來創作。」現階段黃步青以鐵焊的大型裝置作為發展重心，他希望能夠再創作開發一陣子，能發展出更獨特的雕塑和裝置語言形式。

Huang Buh-ching is an artist who loves to think, and is both sentimental and rational. He was already aspired to become an artist when he was in college, and he was possessed with studying abroad in Paris, so he could become an artist in Paris. He had the habit of collecting objects with unique designs and vintage items, and after he went to study in Paris in 1981, all these things were incorporated into his creative works. Then, in 1987, he returned home to Taiwan to continue his creative journey. He said: "I have always had a dream about personal creation. I want to explore this soil I live on through extremely pure and personal artistic vocabularies. This dream can be traced back to my past creative format of crushed newspaper, as I created a collection of such works. Later, I used Taiwanese puncture vine as the medium and vocabulary to develop installations. My more recent large installations, such as the ones exhibited at the Venice Biennale and the UK Cultural Olympiad, were all created with this medium." Currently, Huang is focusing on developing large installations of welded iron parts. He hopes to continue creating and exploring further for some time to develop more unique languages and formats of sculpture and installation.

黃步青　　　　　　Hwang Buh-Ching
〈洋子橋〉　　　　　*Yangzi Bridge*
1977　　　　　　　1977
油畫　　　　　　　Oil painting
92 x 117 公分　　　92 x 117 cm
藝術家自藏　　　　Courtesy of the Artist

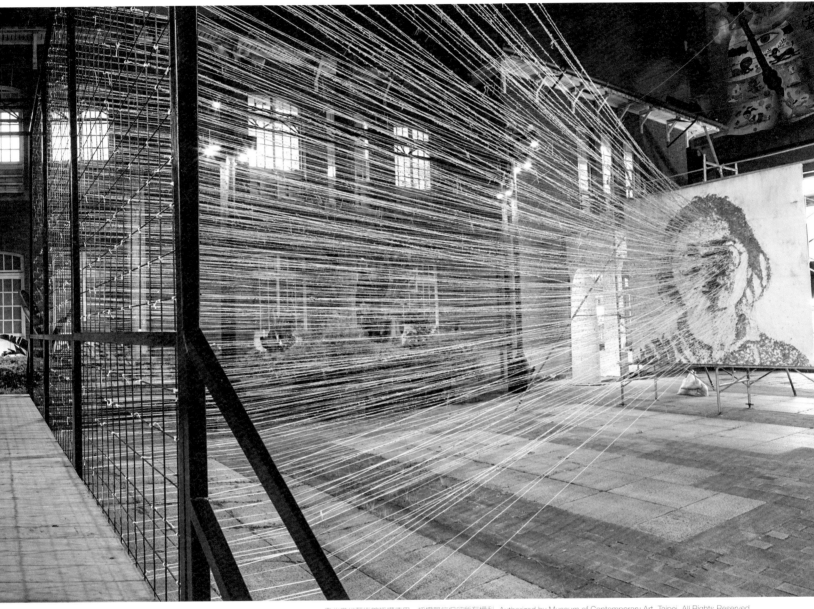

黃步青

〈雙凝〉

2018

綿線、蒺藜草種子、複合媒材

尺寸依場地而定

臺北當代藝術館展出場景

Hwang Buh-Ching

Gaze

2018

Cotton rope, cenchrus echinatus seeds, mixed media

Dimensions variable

Installation view at Museum of Contemporary Art, Taipei.

鄭瓊銘
Cheng Chiung-Ming

鄭瓊銘的創作與環境有關，他關懷鄉土，作品名稱皆以當地的地名結合，因為他看到現代周遭環境已被開發利用，環境改變很大，許多景物已消失不復返。希望以創作的精神為家鄉留下最美好的回憶。鄭瓊銘以他慣有的獨特風格，最純粹的鉛筆、炭筆、炭精筆與油彩畫筆，一點一滴地用點、用線、用面的方式塗抹並記錄下環境的轉變，他是跟著這塊土地的變化在奔跑，與時間競賽。陸續發展出許多系列的創作，包括:《草皮 · 皮草系列》(1990):草皮是自然的生成，皮草則是人造的自然產物，是他有感而發觸景深情的創作，引喻原始自然與人造自然間的糾葛不清，雖然兩者的外形相類似，但其實充滿了矛盾和對立。另外還有《臺灣系列》(1991~1992):以住家窗外的大片農田為觀察主軸，因為經年累月的反覆耕作、生長、收成、荒蕪、翻動等的循環過程，心中有所感觸之作。《自然圖像系列》(1993)和近期的《新自然系列》皆是源於對周圍環境的感受再出發，對自然環境與現實環境中的強烈感受，皆是記錄下他內心情感寫照。

Cheng articulates his environmental and nativist concerns through his works whose titles contain the names of their "birth places." Witnessing today's drastic environmental changes caused by undue development and exploitation, and lamenting the familiar scenes gone forever, the artist believes that artistic creation is the best way to record his most treasured memories of his hometown. Following his consistent approach, Cheng uses pencils, charcoals, charcoal pencils and oil pastels in a straightforward manner, incrementally turning dots into lines and planes, thereby portraying the environmental changes in his eyes. He is in a race against time to record the changes of this land, which ends up as many art series such as *Grass and Fur* (1990): the grass is natural (*res naturales*) while the fur artificial (*res non naturales*). This art series was created from his heart, implying the entanglement between Mother Nature and artificial nature. Despite their similarity in appearance, the two parties stand in a contradictory, antithetical relationship to each other. His *Taiwan* series (1991-1992) revolves around the vast farmland seen out of his residence's window, a series that owes its inspiration to the artist's deep feelings evoked by his observations on the agrarian cycle over the years. Cheng's *Natural Image* series (1993) and the latest *New Nature* series both address his perception and impression of his immediate surroundings. In sum, the artist shows a full range of emotions in his portrayals of Mother Nature and the real world.

鄭瓊銘　　　　　　　　Cheng Chiung-Ming
〈臺灣系列之一〉　　　*Taiwan Series I*
1993　　　　　　　　　1993
素描　　　　　　　　　Sketch
75 x 106 公分　　　　　75 x 106 cm
國立臺灣美術館典藏　　Collection of National Taiwan Museum of Fine Arts

鄭瓊銘
〈自然圖象〉
1994
素描
73.3 x 105 公分
國立臺灣美術館典藏

Cheng Chiung-Ming
Image of the Nature
1994
Sketch
73.3 x 105 cm
Collection of National Taiwan Museum of Fine Arts

王慶成
Wang Ching-Cheng

王慶成說：「當藝術家比較自由自在，雖然走的辛苦，卻怡然自得。我的創作來自心靈上的靈感表達，從素描的元素中找尋我的創作靈感，不同的點、線、面表現刺激下形成作品的構成。堅持自己的創作風貌，它雖是抽象，看畫的人只能意會不能言傳，但那卻是我自己深入內心的獨白。」王慶成的創作以抽象表現為主，他沒有學院的拘束，運用素描的點、線、面為創作的要素，結合複合媒材的多重表現手法，從超現實的幻想意象中去發揮，用色自由大膽，不拘形式、混沌的造型充滿了激情的創作展現。

"Being an artist is much freer and easier for me, and I feel happy and comfortable with all the hardships it entails along the way. Veraciously mirroring my frame of mind and owing its inspiration to the fundamental elements of drawing, my oeuvre is mainly composed of the interplay among various dots, lines and planes. I keep being true to my creative style. Abstraction notwithstanding, these perceivable yet inexplicable contents perfectly delivered my inner monologue in a dynamic fashion," Wang Ching-Cheng said. The artist's abstract works transcend the traditional confines of academic training, showing an entrancing mix of basic elements of drawing and multiple techniques of mixed-media art, which superbly outlines a surreal world of fantasy. Every stroke of Wang's brush bears his signature of bold, unshackled coloring, and every innocent chaos on the canvas is imbued with the artist's genuine passion.

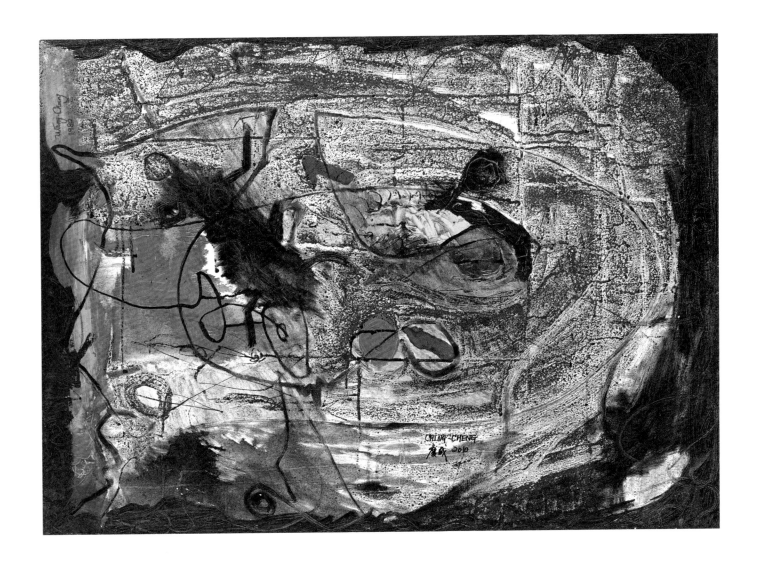

王慶成　　　　　Wang Ching-Cheng
〈無題〉　　　　*Untitled*
2010　　　　　2010
油畫　　　　　Oil painting
70 x 96 公分　　70 x 96 cm
藝術家自藏　　Courtesy of the Artist

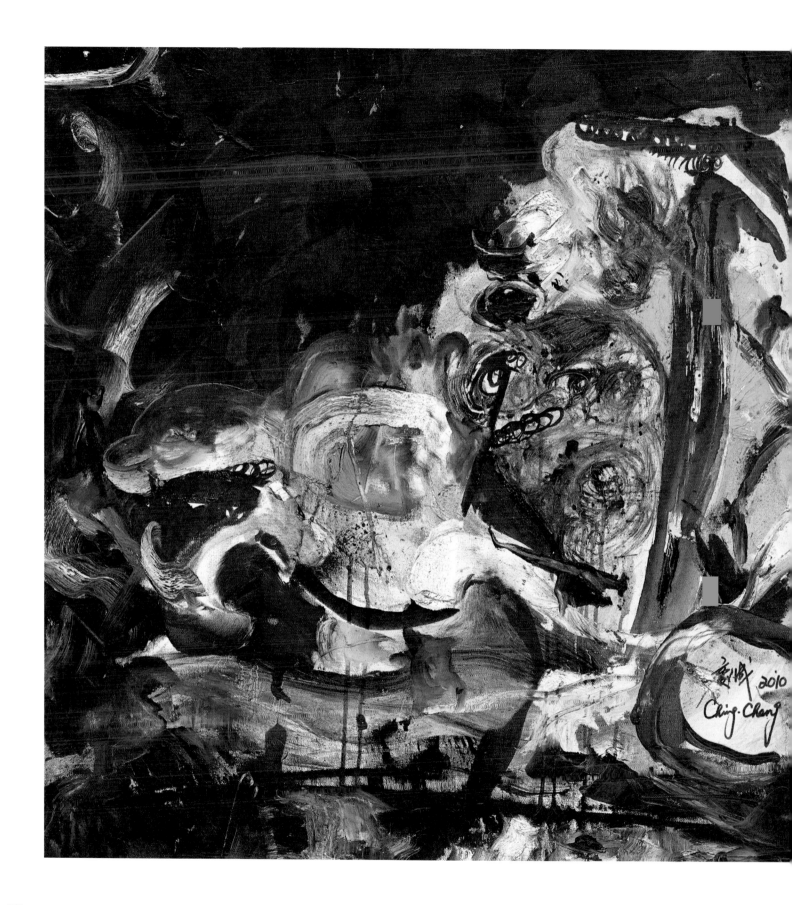

王慶成　　　　　Wang Ching-Cheng
〈無題〉　　　　*Untitled*
2010　　　　　2010
油畫　　　　　Oil painting
72 x 100 公分　72 x 100 cm
藝術家自藏　　Courtesy of the Artist

程武昌
Cheng Wu-Chang

程武昌的創作以平面的抽象為主，那是抽象的線條與造形悠遊在精神空間，源於他內心的潛意識、超意識的幻想與生活體驗，大膽繪畫塗鴉與自動性技法表現。他想回歸一種人類最基本的創作法則，一切始於造形，虛擬於幻覺，讓線條原生再現。程武昌希望：「我的創作理想就是把人類精神空間構造呈現，創作表現當下的現實與理想的感覺相符合。」他不斷地在創作的過程中尋回自我，同時也在抽象的揮灑表現中，完成再造的經驗。

Cheng's oeuvre consists mainly of graphic abstractions that feature enigmatic lines and shapes dancing in the spiritual world. His subconsciousness and supra-consciousness are the fountainheads of these beguiling elements presented with daring scribbles and Automatism. The artist longs to return to the most fundamental principle of creation. Everything originates from figurative formation and merges into visual illusion, ergo the proto-lines re-emerge. "My creative philosophy is about representing the spiritual dimension of human beings, thereby aligning my aesthetic ideal with the reality at the very moment of artistic creation," Cheng stated. He continuously rediscovers himself in the creation of his works, and meanwhile reforms himself through the free abstraction.

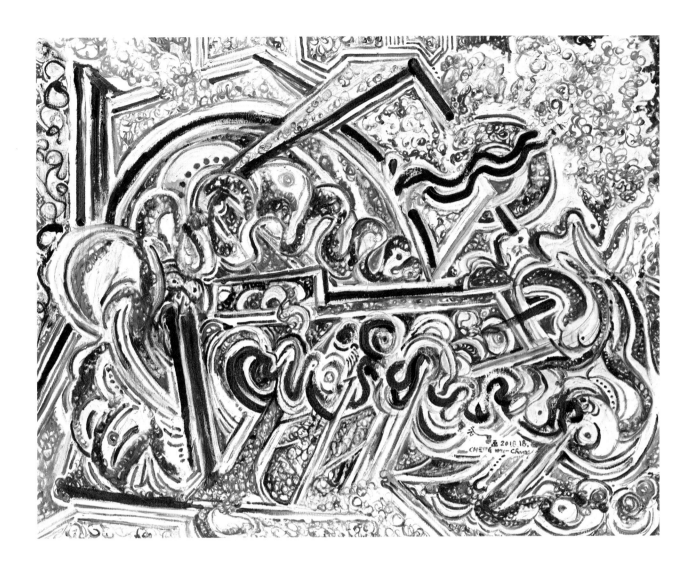

程武昌
〈人類的理想-藝術新世界〉
2018
油畫
91x117 公分
藝術家自藏

Cheng Wu-Chang
An Ideal Brave New World of Art
2018
Oil painting
91 x 117 cm
Courtesy of the Artist

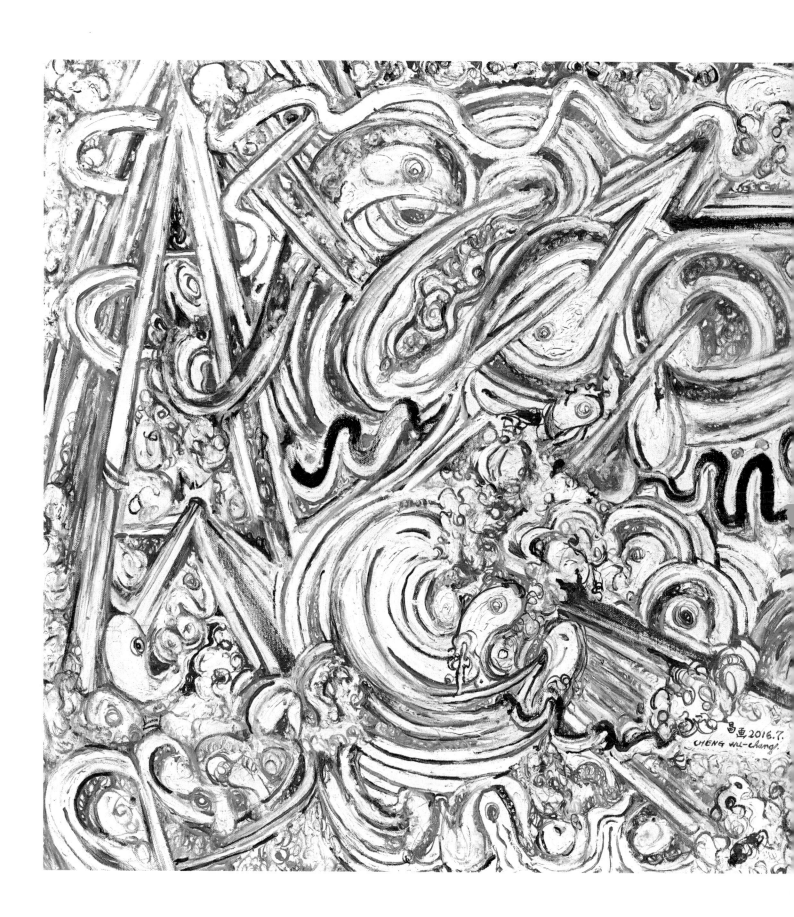

150

程武昌
〈人類的理想-藝術新世界〉
2016
油畫
91 x 117 公分
藝術家自藏

Cheng Wu-Chang
An Ideal Brave New World of Art
2016
Oil painting
91 x 117 cm
Courtesy of the Artist

郭振昌
J.C. Kuo

如果說要從藝術家作品中挑選代表深具臺灣味的藝術家，那麼郭振昌絕對會是首選藝術家。他創造了「臺灣圖像美學」，最特別的像臺灣民俗宗教信仰中，原本屬於陣頭戲的八家將，他擷取這些民間地方宗教俗艷的色彩、線條與符號，運用到他的繪畫創作裡，創造了郭振昌式的圖像風格。作為臺灣戰後當代藝術的第一代藝術家，郭振昌的繪畫創作辨識度極高；他喜歡運用粗黑的線條創作來表現，色彩豐富、人物造型誇張艷俗，從傳統民俗元素的運用到當代圖像與符號的多元拼貼等，個人風格特色非常明顯。這種融入臺灣在地文化圖像，強而有力運用東西方技法並融的視覺衝突造型的展現，應該說是他對臺灣民俗文化、宗教與社會的深入研究探討的心得。1976~1977 年，以為期 2 年的時間進行臺灣民間藝術傳統的調查研究，此研究案同時讓他的畫風吸收了臺灣在地性元素，從原本早期抽象風格轉變為「生活寫實」的風格。

No artists' works can convey so strong Taiwanese flavor as those by J.C. Kuo, who invented the "image aesthetics of Taiwan". He applies the colors, lines and symbols extracted from Taiwanese folk beliefs and myths to his paintings, in which those of Ba Jia Jiang – eight generals of the godly realm – serve as a stellar example. His unique painting style has been evolved against this background. Kuo belongs to the first generation of post-war Taiwanese contemporary artists, and his oeuvre is recognizably distinguishing among the others'. He prefers to depict colorful, hyperbolic and kitsch figures with thick lines. His characteristic signature finds expression in the use of traditional folk elements and the collage of contemporary images and symbols. Such a captivating fusion of Taiwanese cultural images and the visual contrast between the oriental and occidental techniques in his oeuvre is tantamount to a manifestation of his personal observations and thoughts on Taiwanese folk culture, religion and society. Between 1976 and 1977, Kuo carried out a two-year field survey into Taiwanese folk art traditions, which in turn immersed himself in a nativist ambience of Taiwan, and eventually prompted him to convert his painting style from abstraction to realism.

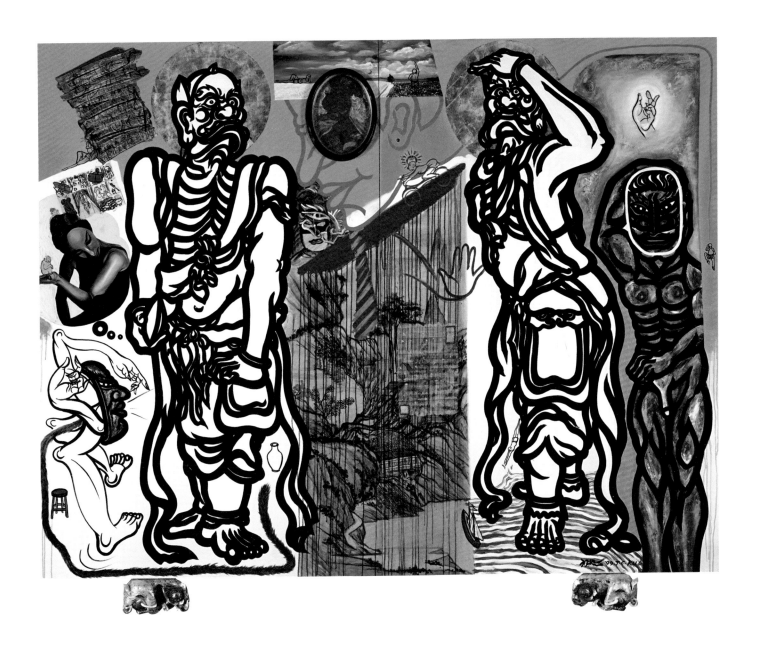

郭振昌　　　　　　　　　　J.C. Kuo
〈順風千里〉　　　　　　　　*God Speed You*
1999　　　　　　　　　　　1999
複合媒材　　　　　　　　　 Mixed media
200 x 260 x 15 公分　　　　 200 x 260 x 15 cm
國立臺灣美術館典藏　　　　 Collection of National Taiwan Museum of Fine Arts

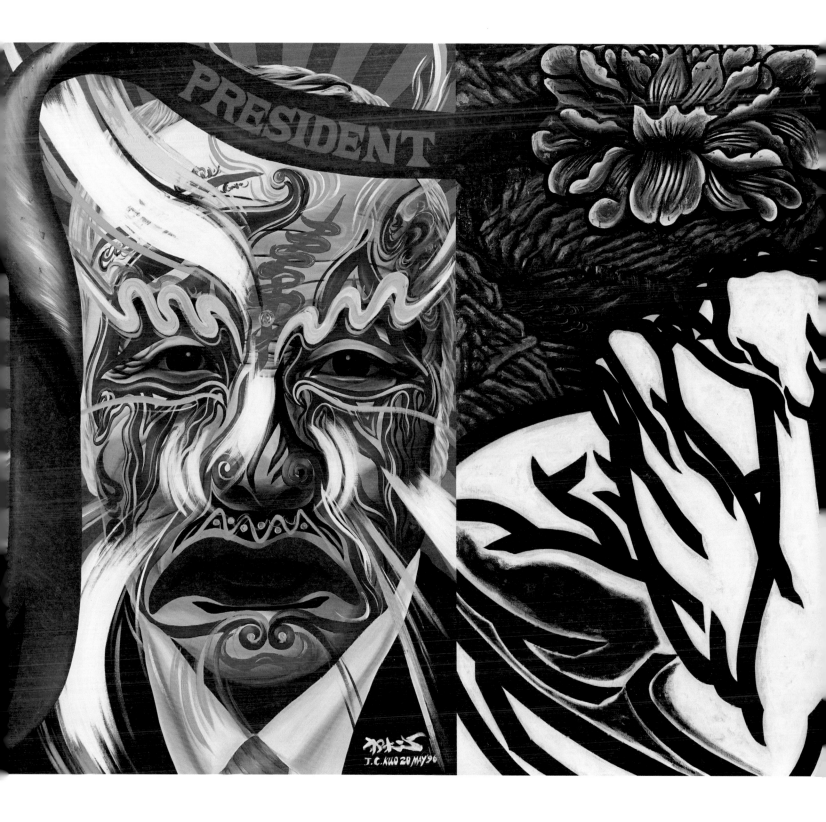

154

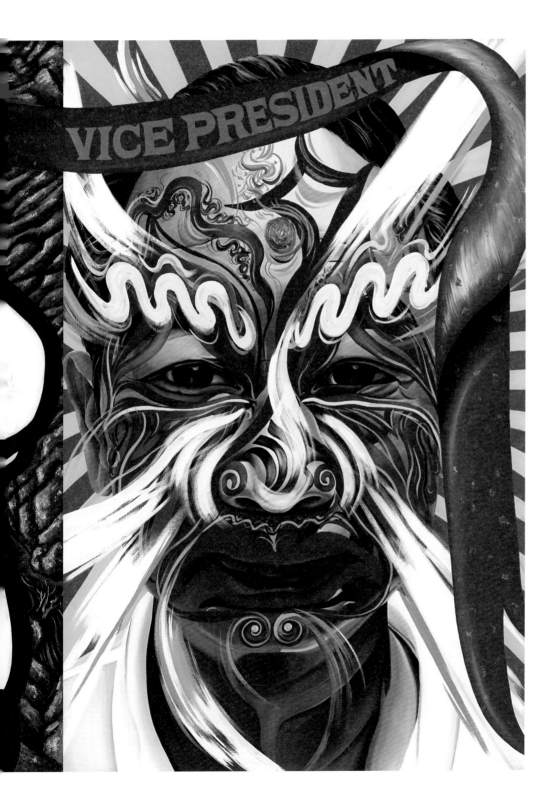

郭振昌
〈95'-96'記事:總統.副總統〉
1996
油畫
200 x 390 公分
國立臺灣美術館典藏

J.C. Kuo
'95-'96 Chronicles: President & Vice President
1996
Oil painting
200 x 390 cm
Collection of National Taiwan Museum of Fine Arts

許雨仁
Hsu Yu-Jen

許雨仁早期創作油畫，他的油畫注重肌理表現，以個人的觀點出發，反映生活與環境的壓抑，畫面繁複具精神性的表現張力。現在的水墨創作反而朝向單純簡練而乾淨，兩者之間的差異性非常大。許雨仁說：「我的留白和抽象藝術家表現的不一樣，我們常說道家講『無』，佛家談『空』，畫畫都從留白開始，我從『沒有』到加入留白的創作過程，這個靈感的啓發是來自於臺灣921大地震時，我去玉山測量，發覺自然的造山運動力量的強大能量，那種自然移動的改變與轉變，令我感覺很大的震撼，也引發後來創造出斷點斷線皴法的表現方式。」他運用畫面的結構形式包含水平垂直、斜角、斜線等的現代構圖法。那些斷斷續續的線，在淺淡墨色表現下，似乎承接了某種精神的指引座標，引領我們去索驥、去探訪，進入一個瀕臨白色的大空間中遊走。

Oil painting comprises the majority of Hsu's early works. His oil paintings emphasize the expressiveness of texture, strongly reflecting the stifling atmosphere that surrounds his life from his personal perspective, hence dramatic tension around the sophisticated compositions. His later ink-wash works are instead characterized by the simplicity, succinctness and cleanness of their brushstrokes and compositions, which is different as night and day from his oil paintings. Hsu explained, "Abstract artists and I differ in the art of leaving blanks. I tend to do so by applying the mutually accommodating concepts of "creatio ex nihilo" and "consummation out of void" embraced by Taoism and Buddhism. My approach of leaving blanks owes its inspiration to my experience of making measurement up the Mount Jade in the aftermath of the Jiji earthquake, when I was thoroughly shocked by the powerful nature manifested in orogeny, the drastic deformation of the Earth's lithosphere caused by lava flow or plate tectonics at convergent margins, which also gave rise to my signature technique of discontinuous wrinkling brushstrokes." Featuring the elements of modern composition like horizontal, perpendicular and diagonal lines as well as oblique angles, the artist's discontinuous wrinkling brushstrokes, along with their varying shades of ink, seem to indicate a set of coordinates, a navigation beacon that guides us across the almost boundless white space, the empty nothingness from which the artist's spirit is consummated.

許雨仁
〈彩筆系列之三〉
2007
油畫
240 x 100 公分
私人收藏

Hsu Yu-Jen
Color Painting Series No.3
2007
Oil painting
240 x 100 cm
Private Collection

許雨仁
〈彩筆系列之四〉
2007
油畫
240 x 100 公分
私人收藏

Hsu Yu-Jen
Color Painting Series No.4
2007
Oil painting
240 x 100 cm
Private Collection

許雨仁
〈彩筆系列之十三〉
2016
複合媒材、畫布
89 x 75 公分
私人收藏

Hsu Yu-Jen
Color Painting Series No.13
2016
Mixed media on canvas
89 x 75 cm
Private Collection

陳幸婉
Chen Hsing-Wan

陳幸婉作為李仲生最得意的女門生之一，她在藝術上的創作表現力無疑是驚人的，她的創作充滿了實驗性的精神，從最早得到臺北市立美術館首屆新展望獎開始，就在臺灣藝壇颳起了陳幸婉式的旋風，當然她的創作很個人、毫無修飾與猶豫、直接單純的藝術本質、忠實的呈現出她內在與外在的藝術表現。

陳幸婉創作的內容很廣泛，舉凡水墨、油畫、複合媒材、立體作品到裝置等，各種素材經由她手中重新提煉出美學深度與視覺圖像的不同意涵，充滿飽和張力與爆發力，且具有一種視覺的侵略性。

陳幸婉的創作歷程從 70 年代晚期至 2004 年之間，她也藉由不斷的旅行與駐村，充實她的創作內容，雖然在 2004 年創作的巔峰中，因病驟逝，但無疑在臺灣美術史書寫上，她創作的生命軌跡成為永遠不可抹滅的紀錄。

As one of Li Chun-Shan's most favorite female pupils, Chen undoubtedly had awe-inspiring artistic creativity that rendered her oeuvre highly experimental. The "Chen Hsing-Wan Phenomenon" had thus arisen in Taiwan's art world since she won the 1st New Horizons Award established by the Taipei Museum of Fine Arts. Chen's oeuvre was one-of-a-kind, unsophisticated, unwavering and simple in nature, and this was just part of its charm that faithfully demonstrated the artist's intrinsic and extrinsic properties. Her works encompassed a riotous profusion of forms ranging from ink-wash painting and oil painting to mixed media and installation. Aesthetic profoundness and new connotations of visual images were extracted from the materials she applied, showing saturated tension with a touch of visual aggressiveness. Chen's career as an artist spanned nearly three decades. She also continued to enrich the soil of her oeuvre by virtue of travel and residency programs. She was at the peak of her career when she unexpectedly died of illness. Nevertheless, she will go down in Taiwanese art history as a female artist held in great reverence.

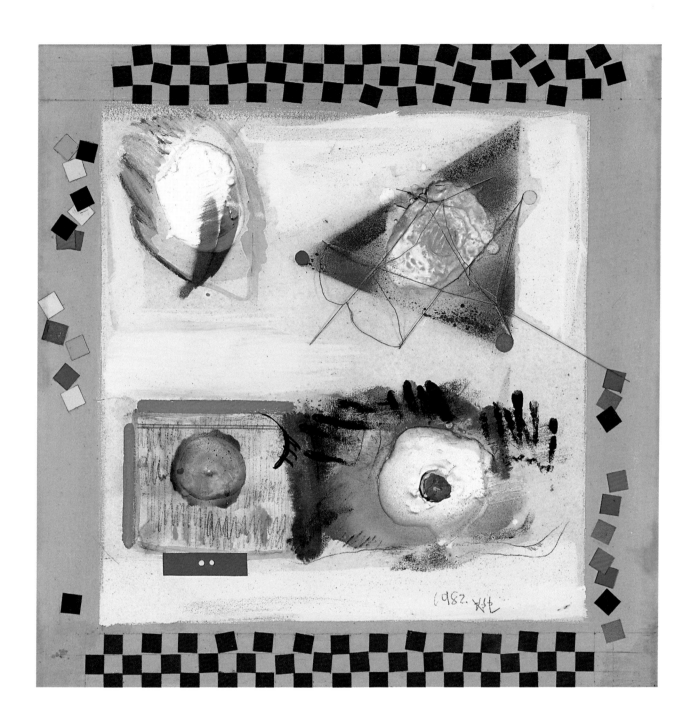

陳幸婉
〈作品 8206〉
1982
複合媒材
83 x 83 公分
科元藝術中心提供

Chen Hsing-Wan
Work 8206
1982
Mixed media
83 x 83 cm
Courtesy of Ke-Yuan Gallery

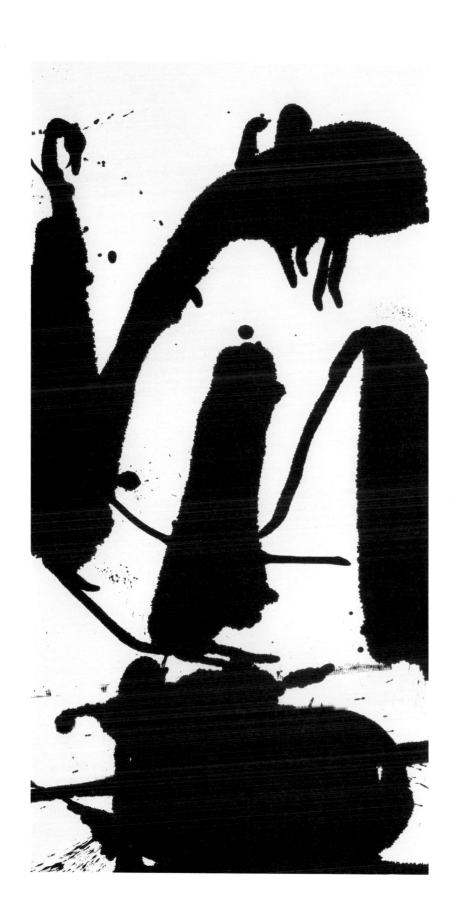

陳幸婉
〈作品AC199〉
1994
水墨紙本
137 x 70 公分
科元藝術中心提供

Chen Hsing-Wan
Work AC199
1994
Ink on paper
137 x 70 cm
Courtesy of Ke-Yuan Gallery

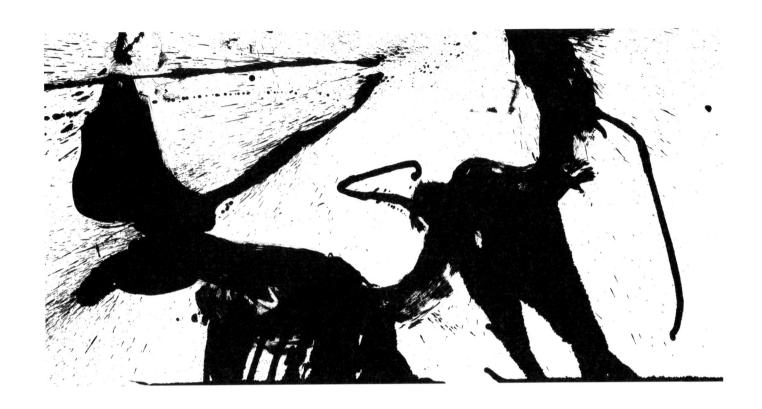

陳幸婉
〈90 T 20〉
1990
複合媒材
68.6 x 135.3 公分
國立臺灣美術館典藏

Chen Hsing-Wan
90 T 20
1990
Mixed media
68.6 x 135.3 cm
Collection of National Taiwan Museum of Fine Arts

曲德義
Chu Teh-I

曲德義說：「我一直試圖找尋繪畫的某種可能性，打破畫作尺寸的規格限制。因為正常的繪畫創作抒情抽象與幾何抽象都在現有的尺寸畫布規格中，我會再增加另一張畫布。表面上是依循抽象繪畫的傳統，但另外增加的部分，除了打破既有的形式之外，也融入了個人想法與當代的特質。」

在臺灣的 80 年代末期，曲德義就以冷冽極限的幾何形象融入潑灑的抽象表現形式成名。他的抽象繪畫不同於傳統認知的抽象表現形式，最主要他將屬於「冷抽象」領域的幾何抽象與「熱抽象」領域的潑灑表現並置於同一畫面裡，他的作品往往在現有的單幅作品中，又再增加入另一幅作品，形成並置的畫面，在其間構築起形與色的綜合創作表現，造成畫面的對比、衝擊與矛盾的視覺現象，可以說他的繪畫兼具理性與感性的創作。

"Paintings, be they lyrical or geometric abstractions, are generally confined to the existing sizes of canvas, hence my continual exploration of new possibilities of painting, seeking to shake off the shackles of canvas dimensions. To achieve this objective, I tend to add an additional canvas to my work. Ostensibly this approach follows the tradition of abstract painting, but the extra dimensions not only transcend the rigid confines of established formality, but also incorporate my personal ideology and contemporary quality," Chu argued. The artist's abstract paintings break away from the form as we conventionally recognized. Since the late 1980s, Chu has been known for seamlessly blending minimalist geometry into free abstraction. New possibilities are ergo created through such ingenious juxtaposition in a single composition: on one side stand geometric patterns of cold abstract, and on the other stand splash-like brushstrokes of hot abstract, amidst which the interplay between shapes and colors manifests itself, giving the visual effect of stark contrast as interesting as contradictory. Accordingly, it can be argued that Chu's paintings present an eclectic mix of sense and sensibility.

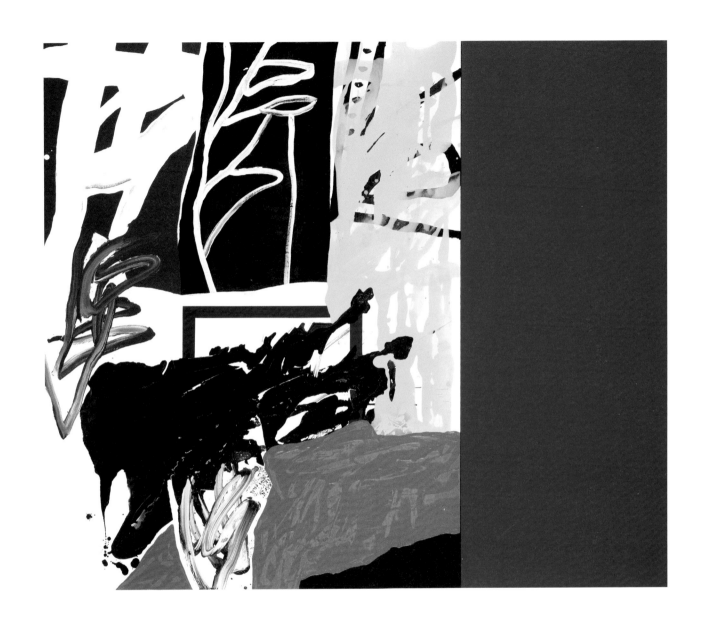

曲德義
〈對立／綠D9805〉
1998
油畫
146 x 171.5 公分
國立臺灣美術館典藏

Chu Teh-I
Confrontation / Green D9805
1998
Oil painting
146 x 171.5 cm
Collection of National Taiwan Museum of Fine Arts

曲德義
〈無物之象 D1507〉
2015
油畫
162 x 195 公分
國立臺灣美術館典藏

Chu Teh-I
Image of Nothingness D1507
2015
Oil painting
162 x 195 cm
Collection of National Taiwan Museum of Fine Arts

曲德義
〈形形色色 E1309〉
2013
壓克力畫
260 x 195 公分、260 x 98 公分
國立臺灣美術館典藏

Chu Teh-I
Colors Forms / E1309
2013
Acrylic paint
260 x 195 cm, 260 x 98 cm
Collection of National Taiwan Museum of Fine Arts

李錦繡
Li Jiin-Shiow

李錦繡在師大美術系四年級時，喜愛以人為題材，帶有非合理性的思維，佛洛伊德潛意識精神性的表現手法，將人的身形體態描繪扭曲變形，抽離具象，自畫像是明顯的例子；畢業後畫了許多以家族合照為題材的畫作，人與人之間常以黑色塊來聯繫，帶有些許的淒冷和脆黑；1983 年到法國巴黎深造，人依然是她的最愛，在巴黎期間不再孤寂，時常融入都會人群裡，可見現代建築與環境刺激元素，像是金屬反射或是透明穿透性呈現在畫作裡，非常精彩。回國後，其畫風也更加多樣廣泛，風景也常入畫，家庭的空間擺設也信手拈來入畫，生活化卻又很深刻。（黃步青 代述）

When she was a senior in the Department of Fine Arts, National Taiwan Normal University, Li stuck to the subject of human figures and presented them through her innovative technique with an intriguing touch of non-rational thinking and Freudian psychoanalysis. The physiques in her works were deliberately distorted insofar as to flout the physical law, of which her self-portrait was the epitome. Subsequently, family portraits became the staple of her works after graduation. The figures were often interlinked by black blocks, conveying a faintly sorrowful and gloomy impression. Human figures remained her favorite subject when she pursued advanced training in Paris in 1983. Changing completely from her normal practice of seeking solitude, the artist tried to blend herself with the metropolitan glamour and excitement as much as possible in this period, exemplified by the brilliant integration of her ensuing observations on the traits of modern architecture – such as light reflecting off metallic finishes and transparency of clear glass – into her works. Li evolved a more pluralistic painting style after returning to Taiwan. Not only that landscapes came up as her subject, but also that home décor was picked up by her at random, rendering her paintings amiable and approachable while rich in philosophical implications.

李錦繡　　　　　　Li Jiin-Shiow
〈自畫像〉　　　　　*Self-portrait*
1976　　　　　　　1976
油畫　　　　　　　Oil painting
116 x 92.5 公分　　116 x 92.5 cm
家屬自藏　　　　　Courtesy of the Artist's Family

李錦繡
〈都會形影〉
1985
壓克力、紙
177 x 115.5 公分
家屬自藏

Li Jiin-Shiow
Appearance of the city
1985
Acrylic on paper
177 x 115.5 cm
Courtesy of the Artist's Family

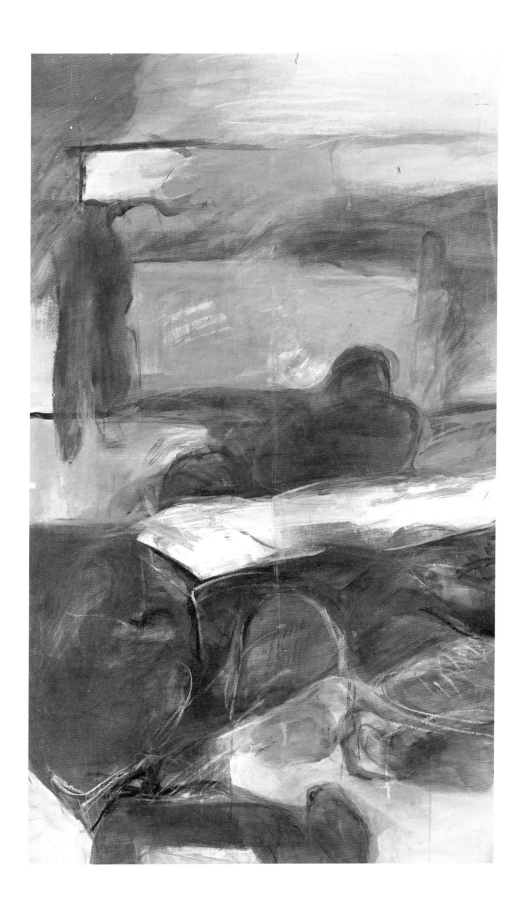

李錦繡
〈金色世界〉
1985
壓克力、紙
144 x 86 公分
家屬自藏

Li Jiin-Shiow
Golden World
1985
Acrylic on paper
144 x 86 cm
Courtesy of the Artist's Family

姚克洪
Yao Keh-Hong

姚克洪做現代陶藝，源自於與土的互動，和泥拉坯的過程，就像一棵樹的成長經驗與過程。如何把那種存在的「看不見的真實」，和內心潛意識表現銜接上陶土創作，這當然不容易，其實這些皆來自於他生活中的體認、感動與感悟，因為不管是處在精神領域還是一般生活事務之中，創作的形式與結構，都具備土的純粹和簡潔特性。姚克洪的陶藝創作充滿了詩意的氛圍，營造某種抽象的架構與秩序，它既如心靈的基礎原形，亦是藝術被純化後的特質、物件、光與影的編織。或許他能聽見來自陶土內部最深沉的呼喚，然後就像空山迴響，不斷地敲擊在他的內心深處，真的探測到那「看不見真實」之土的精神意象。

Yao's modern ceramic works come from his intimate interaction with clay and the process of throwing, which is a dead ringer for the trees nurtured by water and time. The reason Yao can make invisible truth and subconscious mind visible through ceramics, a task undoubtedly as difficult as delicate, is because his oeuvre is mainly inspired by the revelations, emotional warmth and epiphanies he ever had in his quotidian existence, which is also why clay's simplicity and succinctness find expression in the form and structure of Yao's ceramic works, be they representing his inner spirit or humdrum routines. His ceramic works conjure up a poetic vision on one hand, and bring a certain abstract framework and order on the other. They not only approximate the prototype of human mind, but also weave objects, light and shadow into the quality of purified art. Perhaps the artist is indeed able to hear the deepest call from the clay, a call producing echoes that reverberate through his heart, in which his mental imagery of invisible truth dwells.

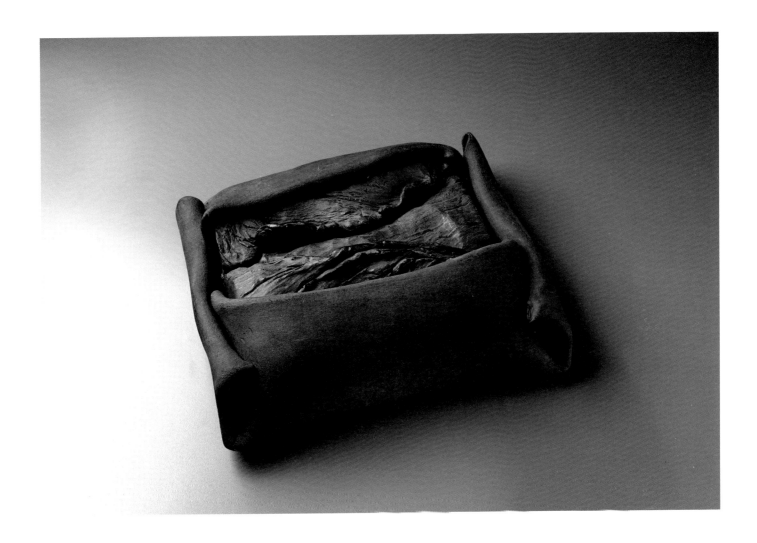

姚克洪
〈山河歲月、暫住的漂流陸塊〉
1998
陶
36 x 29.5 x 13 公分
藝術家自藏

Yao Keh-Hong
Ages of the Mountain and River, the Temporary Land Block in Flowing
1998
Ceramic
36 x 29.5 x 13 cm
Courtesy of the Artist

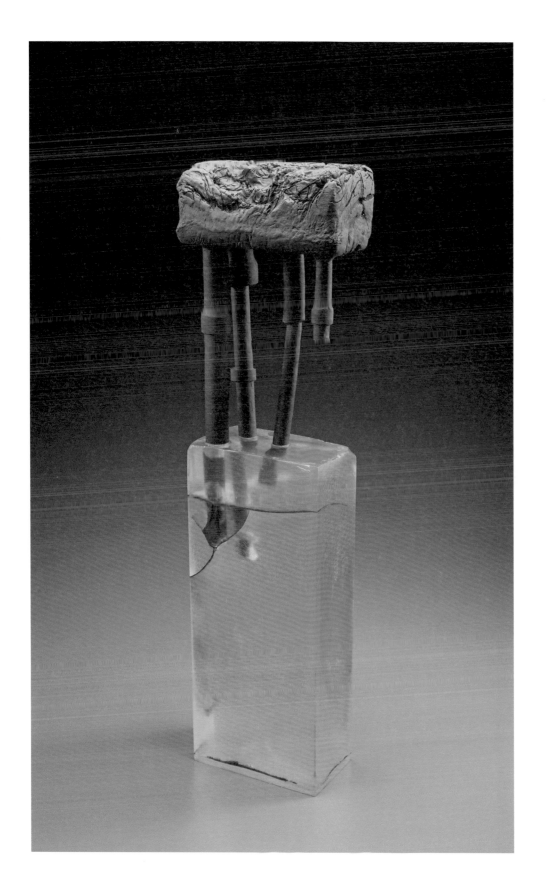

姚克洪
〈站在永恆的惡華之上〉
1997，2018修
陶、塑脂
21.5 x 12 x 75.5 公分
藝術家自藏

Yao Keh-Hong
Standing on the Eternal Evil Flower
1997, 2018 refix
Ceramic, poly
21.5 x 12 x 75.5 cm
Courtesy of the Artist

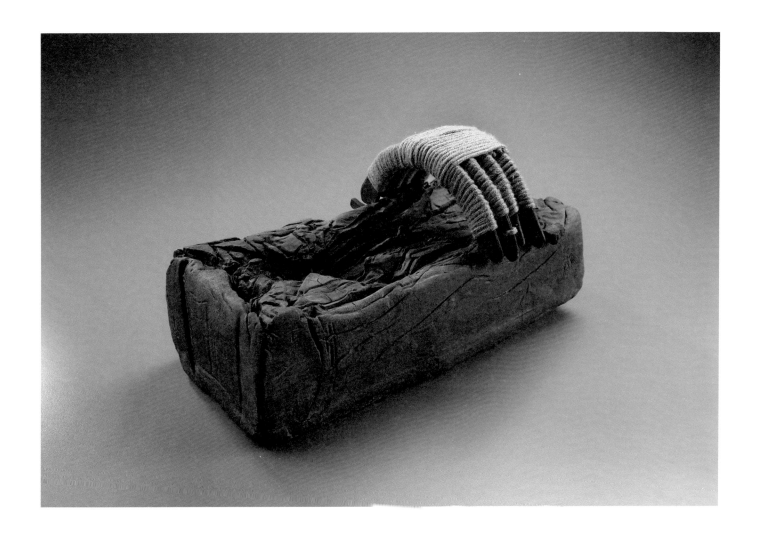

姚克洪
〈必要的招喚（儀式之一）〉
2002
陶、纖維
23.5 x 21 x 43 公分
藝術家自藏

Yao Keh-Hong
Necessary Summoning. (Ceremony No.1)
2002
Ceramic, fiber
23.5 x 21 x 43 cm
Courtesy of the Artist

楊茂林
Yang Mao-Lin

楊茂林年少時就很早熟，他使用自己的語彙詮釋政治與歷史，當臺灣 80 年代政治解嚴的前後期，楊茂林在藝壇嶄露頭角，他主動挑釁政治議題、突破禁忌與社會威權，以時事與政治批判作為創作發展的主軸。他的繪畫尺幅巨大，創作表現充滿力度與張力。到了 90 年代，他又用「MADE IN TAIWAN」（臺灣製造）做為創作議題，試圖以臺灣過往的殖民史背景作為主軸呈現，兼具批判、諷喻和探討，也樹立了個人的創作特色。到了 21 世紀，他從平面繪畫直接跳級到雕塑的創作，結合超人公仔與宗教圖騰創造出另類的雕塑。現在，他又進行《黯黑的放浪者》系列的創作，從平面繪畫到立體雕塑表現，造型各異的深海魚，展現瑰奇異怪的身形，又帶有孤寂之美感，延展出另類當代的藝術視覺語彙。

Yang is an early bloomer able to put his own interpretation on politics and history when he was young. Around the lifting of martial law in the 1980s, he stood out as a brilliant artist who bravely touched upon sensitive political issues, violated social taboos, and rebelled against authorities, keeping his works revolving around current events and political criticism. His large-scale paintings glow in strength and tension. "MADE IN TAIWAN" came up as the subject of Yang's works in the 1990s. The artist sought to criticize, allegorize and investigate Taiwan's historical background as a colony, thereby giving his works an inimitable quality. Sculpture ushered Yang's career in a new phase in the 21st century, featuring alternative sculptural works made from the amalgamation of the action figure of superman and religious totems. Currently the artist is occupied by *Wanderers of the Abyssal Darkness*, a new art series encompassing paintings and sculptures that vividly portray the peculiar attractiveness of abyssal fishes by setting them in a beautiful sense of utter desolation. An alternative vocabulary of visual arts ergo emerges before the viewers' eyes.

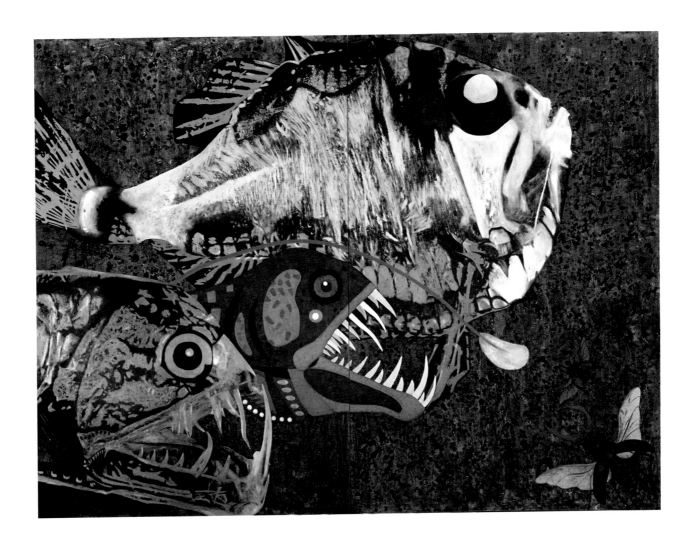

楊茂林
〈黯黑的放浪者・奧茲斧頭號 EX L1807〉
2018
油彩、壓克力顏料、畫布
218 x 291 公分
藝術家自藏

Yang Mao-Lin
Wanderers of the Abyssal Darkness · The Ex Oz Hatchetfish L1807
2018
Oil, acrylic on canvas
218 x 291 cm
Courtesy of the Artist

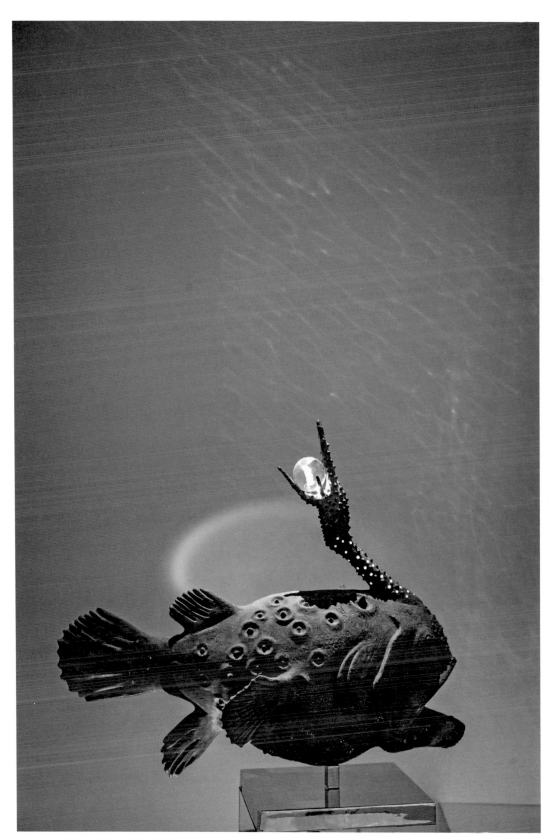

楊茂林
〈奧茲富貴鮟鱇號〉
2015
銅、不鏽鋼、水晶、LED
96 x 51 x 100 公分
藝術家自藏

Yang Mao-Lin
The Wealthy Oz Anglerfish
2015
copper, stainless steel, crystal, LED
96 x 51 x 100 cm
Courtesy of the Artist

楊茂林
〈奧茲桶眼號－悠遊狀〉
2013
銅、不鏽鋼、琉璃、樹脂、LED
51 x 112 x 91 公分
藝術家自藏

Yang Mao-Lin
The Oz Barreleye -Surfing
2013
Copper, stainless steel, luili, resin, LED
51 x 112 x 91 cm
Courtesy of the Artist

陳聖頌
Chern Shen-Son

陳聖頌大學時就想當藝術家，也因為如此，畢業後教完書就出國到義大利留學，在羅馬前後旅居了 13 年。回國後陸續創作，2003 年參加高雄市立美術館創作論壇，舉辦個展，還做多媒材的實驗表現，之後就開始思考個人創作蛻變問題，他重新思考繪畫創作應往哪裡走怎麼走，從 2003~2005 年，一步一腳印的努力才走到今天這樣的繪畫樣貌。陳聖頌說：「探討油畫『純粹性』的問題在於回歸油畫，試著放鬆放軟，之前是走強勢文化，強烈的筆觸表現，現在則思考屬於東方精神的內斂。有些思維，從東方走到西方，現在從西方走回東方，現在對道家思想去體會，希望能呈現這種東方精神。」陳聖頌的抽象，創作只大的尺寸，遊走在畫觸與內心的情感釋放，遠望如天際的穹蒼，或如平野蒼茫的大地，創作以心印心，橫豎揮灑中見真情。

Chern aspired to be an artist as early as he was an undergraduate. As a result, no sooner did he graduate from college and was discharged from his obligation of teaching, than he pursued advanced training abroad in Italy. After residing in Rome for 13 years, Chern returned to Taiwan and started to create his own works thenceforth. The year of 2003 proved a turning point in his career. Apart from partaking in the creative forum hosted by the Kaohsiung Museum of Fine Arts, the artist also staged his solo exhibition and performed a multi-media experiment. Afterward, the question as to how to evolve his painting style had occupied his mind. The artist's steady and serious effort devoted between 2003 and 2005 to this endeavor manifested itself in his paintings that give the viewers great visceral thrills. Chern stated, "Shifting the focus back onto oil painting per se is the key to pursue the 'purity' of oil painting. I used to adopt powerful, intensive brushstrokes, but now I try to soften my way of expression, re-orientating my painting style towards the oriental ethos of balance and harmony. Previously my thinking evolved from the oriental to the occidental, and now it sways back from the occidental to the oriental. Now I'm striving to understand the Chinese philosophy of Taoism, expecting my works to embody the oriental ethos in general." Chern's innermost feelings are set free by the unrestrained brushstrokes in his large-scale abstract paintings. Admiring these works from a distance, we may find them bearing more than a passing resemblance to the blue dome of heaven or vast territories on the earth. His deepest reflection is mirrored in his enthralling paintings, and his sincere feelings in his untrammeled brushstrokes

陳聖頌　　　　　Chern Shen-Son
〈無題〉　　　　　*Untitled*
1980　　　　　　1980
素描　　　　　　Sketch
29.7 x 42 公分　　29.7 x 42 cm
藝術家自藏　　　Courtesy of the Artist

陳聖頌　　　　　　　Chern Shen-Son
〈冬韻之一〉　　　　　Winter Rhythm - II
2015　　　　　　　　2015
油畫　　　　　　　　 Oil painting
180 x 140 公分　　　 180 x 140 cm
藝非凡美術館提供　　 Courtesy of Mezzo Art Gallery

陳聖頌　　　　　　Chern Shen-Son
〈冬韻之一〉　　　*Winter Rhythm - I*
2015　　　　　　2015
油畫　　　　　　　Oil painting
180 x 140 公分　　180 x140 cm
藝非凡美術館提供　Courtesy of Mezzo Art Gallery

曲德華
Chu Teh-Huah

曲德華說：「我從小就夢想當藝術家，早期創作較傾向於超現實主義的創作表現，訴說視覺上的結構與空間感覺，現在則是追求作品的透明度、線形間的微妙變化、光與影的互動，呈現極簡主義的特色。」她現在創作使用大量的「鋼絲網」，這是建築上常使用的材料。「鋼絲網」的方形格子狀結構，構築起《格子空間系列》的雕塑和裝置作品。曲德華創造的雕塑與裝置藉由光影互動呈現視覺、錯覺、幻覺與錯視紛雜並呈的現象，這些層層格子網狀造型結構縱橫其間，在視覺上彼此交錯交織，又相互穿透空間。事實上，光與影穿梭在幾何線性造型的裝置空間中遊走，包容光影的透明、虛實、隱藏和變幻並存，恰恰如實的反映了現實生活的狀態與環境轉換。

"Being an artist is my aspiration from childhood. My early works featured surrealism, highlighting expressive visual structure and the sense of space. Now I seek to give my works a certain degree of transparency, setting great store by the subtle variation of line and shape as well as the interplay between light and shadow, so as to make them exude an aura of minimalism," Chu explicated. The artist's works are primarily made of wire-mesh, a common building material. It can be said that her lattice series comprising sculptures and installations revolves around the checked structure of wire-mesh, providing the viewers with numerous mesmerizing optical illusions. These works are intersected by layers of lattices that run through one another, hence a marvelous, kaleidoscope like visual effect. Light and shadow meander among these enchanting lines and geometric shapes, showing an amalgamation of different attributes such as transparency, hollowness, solidity and fluctuation, which honestly reflects the vicissitudes of our real lives and the changes in our living environment.

曲德華
〈2017幻化1〉
2017
不鏽鋼網、銠漆
210 x 210 x 35 公分
藝術家自藏

Chu Teh-Huah
2017 Transformation One
2017
Steel, mesh
210 x 210 x 35 cm
Courtesy of the Artist

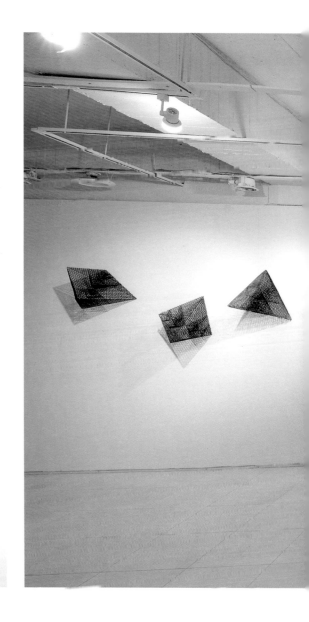

曲德華
〈2014方形〉
2014
不鏽鋼網、銬漆
56 x 56 x 56 公分
藝術家自藏

Chu Teh-Huah
2014 Square
2014
Steel, mesh
56 x 56 x 56 cm
Courtesy of the Artist

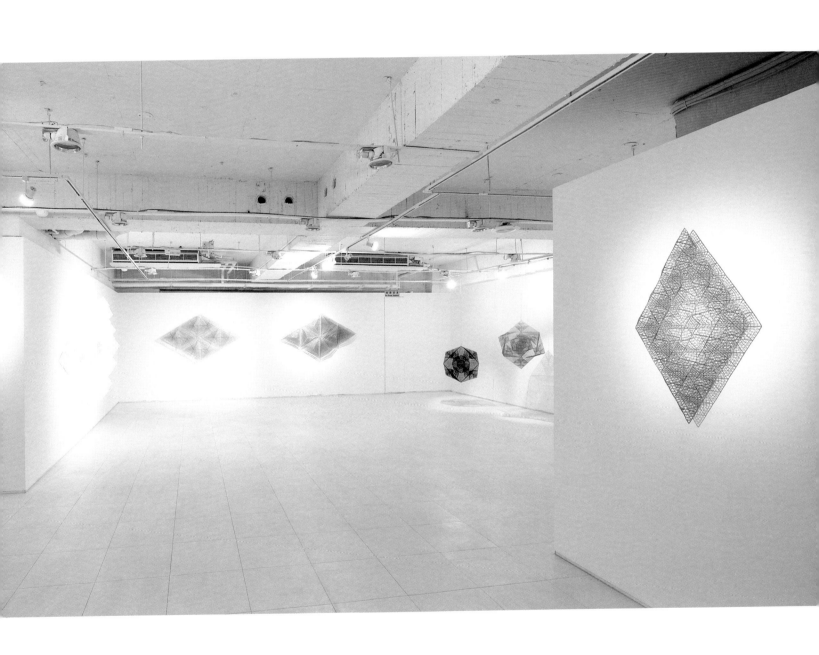

大象藝術空間展出場景　Installation view at Da Xiang Art Space

吳梅嵩
Wu Mei-Song

吳梅嵩的創作具有多元面向的形式，實驗性強，包含平面繪畫、立體與裝置等。早期的作品以繪畫塗鴉的創作為主，線條自由大膽表現。中期的作品深具隱喻與象徵性的手法呈現，例如他以生活中最簡易常見的桌椅為創作符號，延伸了《椅子系列》的創作。椅子作為視覺的圖像符號，有顏色的堆疊與塗鴉，他化繁為簡，利用抽象的背景與椅子形成某種情感的投射與視覺張力。近期作品則悠遊在平面繪畫的自由創作裡，複合媒材綜合運用，他大開大闔的顏色自由揮灑、符號性線條與造型不拘泥的融入繪畫創作，深具隱喻和私密性的個人創作特色。

Wu's oeuvre is highly experimental, and its appeal is manifold. Paintings with free and bold brushstrokes were the staple of his early works. In his mid-career works, the artist converted to a more metaphorical and symbolic approach. For example, he transformed daily-life objects such as tables and chairs into creative elements, thereby giving birth to his *Chair* series. Employing chair as a visual symbol, along with the imbricated pigment and graffiti, Wu not only created aesthetic richness through informed simplicity, but also projected his feelings and built dramatic tension between the chair and the abstract background. His recent works instead featured a fascinating fusion of mixed media and freestyle paintings, characterized by brilliant coloring, symbolic lines and inventive shapes without rigidly adhering to formalities. His personal creativity thus finds expression in such a unique, metaphor-laden style.

吳梅嵩　　　　　　Wu Mei-Song
〈倘佯樹海〉　　　　*A Stroll in the Forest*
2017　　　　　　 2017
複合媒材　　　　　 Mixed media
116 x 90 公分　　　116 x 90 cm
藝術家自藏　　　　 Courtesy of the Artist

吳梅嵩
〈漂鳥・風景拼圖〉
2017
複合媒材
116 x 182 公分
藝術家自藏

Wu Mei-Song
Stray Birds in the Forest
2017
Mixed media
116 x 182 cm
Courtesy of the Artist

吳梅嵩
〈海邊拾貝〉
2017
複合媒材
116 x 90 公分
藝術家自藏

Wu Mei-Song
Gathering Seashells on the Beach
2017
Mixed media
116 x 90 cm
Courtesy of the Artist

黃位政
Hwang Wey-Jeng

創作對黃位政而言，是他對生命探索的歷程，也是修行的獨行路。往往在旅途中不斷遇見的人、物、風景，最後都成為他創作的豐富來源，也讓他見證了生命的歷程與意義。

其中特別是「人」，一直是黃位政探討的創作議題，他提到「東西方藝術史的發展，不管是平面繪畫或是三度空間的立體雕塑，以『人物』作為創作的題材不勝枚舉，可以說『人』一直是許多藝術家的最愛。」

黃位政關心人忕，特別與「身體」有關，他使用超現實的意境結合自動性技法的表現來創作。他畫的人體是有扭曲的、有變形的、有簡化的，綜合人生百態之歡、慾、悲、苦、離、合等，這些清一色單色系的人體被拋逐於平面構圖的空間中，呈現出詭奇虛擬交替的時空境地。

As far as Hwang is concerned, artistic creation is an exploratory journey to be savored each step of the way, and it can be *sādhana* as well, a spiritual exercise aimed at achieving the ultimate expression of his life in the real world. His artistic practice has been nurtured by the people, things and landscapes he encountered along the way, which has also made him a witness to the cycle and meaning of life. Hwang has devoted constant attention to people-related issues. According to him, "the works addressing the subject of 'human figures' throughout the development of oriental and occidental arts have been too numerous to mention individually, be they graphic paintings or 3D sculptures. It can be argued that 'human figures' constitute a theme that many artists favor the most." Hwang concerns for human beings, the human body in particular, creating his works by means of the integration of Automatism and surreal artistic conception. In his paintings, some of the figures' bodies are distorted, others are deformed, and still others are simplified, staging the vicissitudes of life in the human comedy. These monochromatic human bodies are scattered on the composition, luring the viewers into a peculiar world of reveries interlaced by reality and virtuality.

黃位政　　　　　　　Hwang Wey-Jeng
〈競合之際〉　　　　　*Co-opetition*
2013　　　　　　　　2013
壓克力畫　　　　　　Acrylic paint
150 x 200 公分　　　150 x 200 cm
藝術家自藏　　　　　Courtesy of the Artist

黃位政
〈兩人〉
1986
綜合素材
150 x 110 公分
藝術家自藏

Hwang Wcv-Jeng
Couple
1986
Mixed material
150 x 110 cm
Courtesy of the Artist

黃位政
〈身體風景組曲〉
2001
壓克力、墨、粉彩
140 x 240 公分
藝術家自藏

Hwang Wey-Jeng
Body Scenery Suite
2001
Acrylic, ink, pastel
140 x 240 cm
Courtesy of the Artist

林鴻銘
Lin Hung-Ming

林鴻銘說：「藝術創作一直是個人的，可以是自由自在，任自己的思想與觀念自由揮灑表現出來，同時也可以不拘於媒材種類，只要可以掌控具應用自如即可，至於形式那就看個人喜好，也可以不在意別人的看法，是自由、不拘束、不侷限一定形式與材質，可隨心所欲加以變化，組合呈現當時內心感受，而不受干擾或限制盡情發揮內在情感。」林鴻銘的繪畫創作構圖奇特，與他創作環境有關聯。他的創作以人為主，反映當下感受到的生活狀態與內心世界。他擅長創作大畫，當這些巨大作品呈現在觀者眼前，能量的張力是非常強大，也造成視覺的震撼，從某個角度來說也是畫家自身的創作爆發力。

Lin claimed, "Creating works of art is always personal. It can be done by liberating our thoughts and ideas, or by having a fluent command of diverse creative media. It can also take on any form *ad libitum* regardless of others' opinions. We can make variations or different combinations by following our heart's desires rather than confining to any specific material, so as to convey our true feelings as much as we like in an undisturbed and unshackled manner." The peculiar compositions of Lin's paintings have many to do with his creative environment. Human figures have maintained a remarkable hold on his oeuvre, vividly portraying his living conditions and innermost self. The artist excels in creating colossal paintings that always humble the viewers with stunning expressive power and frisson of visual excitement, which is also indicative of his enormous explosiveness in terms of artistic creation.

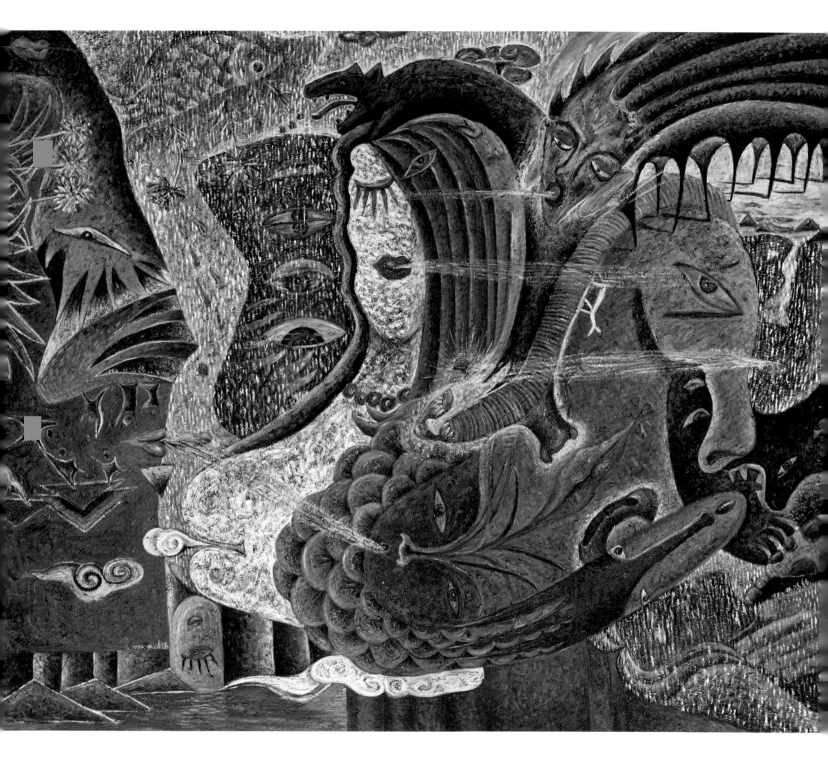

林鴻銘
〈傾訴〉
1994
油畫
260 x 486 公分
國立臺灣美術館典藏

Lin Hung-Ming
Pouring the Heart Out
1994
Oil painting
260 x 486 cm
Collection of National Taiwan Museum of Fino Arts

陳珠櫻
Chen Chu-Yin

陳珠櫻的創作早期源自於潛意識裡的「自發性」，以原始的岩礦素材、自由流動的彩墨線條，發展出她個人獨特表現的抽象與童真符號；游離在捉摸不定的幻想圖像，樸實率真的繪畫語彙，表達她內在千變萬化的心象世界。

陳珠櫻後來的創作隱含一種意圖，欲讓藝術家的想像世界活現，把繪畫元素賦予靈魂，她轉入了電腦程式設計，創造類人工生命機制的衍生藝術－3D 電腦動畫影片，呈現另一種生機盎然、奇幻不絕的虛擬生物宇宙的造化。她進而開發一系列具有自主系統的互動性作品－數位藝術生命互動磁場 (Enactif digital art)，藉由身體的感知與觀眾親身的體驗，企求藝術的幻想大地能夠實際體現。

創作對她而言，「即放下一切，方能銜接幻想世界，開啟生命空白處：刹那的『發、現』，是藝術初喜之心！當『發、覺』湧入心靈，是生命會心的『奇點』（singularity）。」

Subconscious spontaneity is the origin of Chen's early works. Treating ore and flowing color ink as the point of departure, the artist established her *sui generis* style characterized by symbols of abstraction and child like innocence. In her oeuvre, simple and candid painting vocabulary is intermingled with elusive images of fantasy, reflecting the constant permutation of her mental vision. Chen's later works are intended for making her imaginary world vivid and realistic through ensoulment. As a result, she converted to 3D computer animation, a practice of generative art where the artist uses computer programs to create quasi-artificial life mechanisms, which presents the unceasing torrents of exuberance and imagination of a virtual universe comparable to nature's greatest marvels. She subsequently developed the "Enactif digital art," a series of interactive works equipped with automatic systems, seeking to materialize the reveries of art via the viewers' personal experiences and physical perceptions. Artistic creation to Chen is "to let go of all perplexities, so that she can link up with the imaginary world and explore new possibilities for her life. Serendipitous discoveries make clear her original intention behind artistic creation, and the moments of epiphanies, or the influx of inspiration, cast a knowing look at her life's singularity."

陳珠櫻
〈首1（精神裡的自動性繪畫）〉
1991
炭筆及混合媒材於卡紙
35 x 27 公分
藝術家自藏

Chen Chu-Yin

Head 1 (Drawing from Psychic Automatism)
1991
Charcoal and mixed materials on cardboard
35 x 27 cm
Courtesy of the Artist

陳珠櫻
〈體感互動繪畫－無限軀體〉
3D電腦影像即時互動裝置
2018
尺寸因場地而異

技術助理：LY Ponnara, HOYAMI Jean-Claude
感應器贊助：巴黎路米埃聯合大學
　　　　　　藝術・科技與數位人文卓越實驗室

Chen Chu-Yin
Enaction Drawing - The Infinite Body
An interactive installation of real time 3D computer graphics
2018
Dimensions variable

Technical assistant: LY Ponnara, HOYAMI Jean-Claude
Sensor Sponsor: ComUE Université Paris Lumieres
EUR ArTeC – Labex Arts-H2H

年表　Chronological Table

李仲生與門人年表

製表｜陶文岳

1912　1歲

11月11日，生於廣東省仁化縣韶關市中信路13號自宅（身分證登記為民國2年廣東省仁化縣）。
父李汝梅（字友仁）深諳法律，擅長書法（習王羲之）、水墨畫（宗米芾），母黎錦文，亦能文善詩。
兄妹共4人，李仲生排行第3。

李仲生身分證登記為民國
2年11月11日廣東省仁化縣。
（圖片提供／李仲生基金會）

1920　8歲

入天主教慈幼會勵群小學。（依李氏遺稿為1921 [民國10年] 入小學）

1926　14歲

小學畢業，入天主教慈幼會勵群中學（校長羅神父），課餘隨父習國畫。
[依李氏遺稿為1927（民國16年）小學畢，入中學]

1928　17歲

入廣州美專，從校長司徒槐學習寫實素描，接受學院派古典素描技巧訓練。

1930　19歲

受堂兄贊卿鼓勵，赴上海，入上海美專附設繪畫研究所西畫科習藝。
（1930-1932年於上海美專附設的繪畫研究所開始接觸與了解西方的新古典主義、野獸派、立體派、機械派。）

1931　20歲

結識前來西湖寫生、並到上海美專參觀的日本油畫家太田貢、田坂乾三郎，受其鼓勵決心赴日深造。

1932　21歲

10月，參加中國第一個提倡現代藝術的繪畫團體「決瀾社」在上海中華學藝社舉行的第一次繪畫聯展，以兩幅「機械派」風格的作品參展。
偕廣東同學也是決瀾社會員梁錫鴻，由上海匯山碼頭乘日本郵輪「諏訪丸」東渡日本。先入日本東亞高等豫備學校日文專修科及川端畫學校，
學習語言及勤練素描。

1933　22歲

3月，入東京日本大學藝術系西洋畫科，隨知名油畫家中村研一習油畫、雕刻家山本豐市學習以動態為主的裸體素描，並隨松原寬習哲學、
坪內逍遙習戲劇、菊池寬習文學。同年稍後，入「東京前衛美術研究所」夜間部研習，指導老師有藤田嗣治、阿部金剛、東鄉青兒、峰岸義一，
同學有齋藤義重、山本敬輔、桂雪子、金煥基（韓籍）等。
冬，參觀東京府美術館舉辦「巴黎・東京前衛繪畫原作展覽會」，首次親炙西方現代前衛藝術名家原作，大為感動並深受其影響。

1934　23歲

春，以〈盛裝〉具象寫實油畫作品正式入選日本「春陽會展」。
秋，以〈構成〉超現實主義油畫作品，獲選第21屆日本「二科會」於第九室前衛藝術專室展出。該室出品畫家有：吉原治良、東鄉青兒、
齋藤義重、岡田謙三、小野里行信、金煥基等人。
獲日本外務省贈與「選拔公費獎學金」3年。
在東京和梁錫鴻、方人定、李東平和趙獸等留日西畫家共同組織「中國獨立美術學會」。

1935　24歲

作品〈靜物〉免審查入選第22屆「二科會」，於前衛藝術專室第九室展出。
加入前衛藝術團體－東京「黑色洋畫會」，該會由齋藤義重、山本敬輔、小野里行信、山本直武、高橋迪章、李仲生等人組成。此時，其作
品開始揉和抽象與佛洛伊德思想，而有較濃厚的潛意識思想的超現實主義作風。藝評家福澤一郎在其出版的《前衛繪畫》一書中，評論「黑
色洋畫會」與「新造型畫展」為日本前衛運動史上極為重要的兩翼。
編寫《二十世紀繪畫總論》等著作數十種，深獲日本藝評家外山卯三郎的讚賞，屢屢引用推薦。

1936 **25 歲**

（昭和 11 年 3 月），自日本大學藝術系西洋畫科畢業，獲文學士學位。
作品〈逃亡的鳥〉入選第 23 屆「二科會」，於前衛藝術專室第九室展出；
該作並被編入上海良友圖書公司出版，倪貽德著的《藝苑交遊記》中。

李仲生日本大學藝術系西洋畫
科畢業證書，獲文學士學位。
（圖片提供／李仲生基金會）

1936 年李仲生入選第 23 屆
「二科會」作品〈逃亡的鳥〉。
（圖片提供／李仲生基金會）

1937 **26 歲**

6 月，提出包括〈春 A〉、〈春 B〉、〈魔術之創造〉…等 6 件超現實風格油畫作品，參加「第
15 屆黑色洋畫展」。
8 月，因中日戰爭爆發返回廣東，任教於仁化縣立中學。
作品〈小孩的肖像〉入選第 24 屆「二科會」展，因戰爭原由，人已返回中國，未出席該
展覽。

李寶泉著《中國當代畫家評傳》（南京 · 木下書店出版）中評介李仲生。

1937 年李仲生參加「第 15 屆黑
色洋畫展」作品〈魔術之創造〉。
（圖片提供／李仲生基金會）

1938 **27 歲**

因戰爭需要入伍，在陸軍兩百師政治部擔任少校秘書（1938.06-1939.11）。

1939 **28 歲**

於委員長桂林行營政治部擔任少校教官（1939.12-1940.08）。

1940 **29 歲**

8 月，參加由陳誠主持的中央訓練團留日學生訓練班第 2 期，10 月畢業。

李仲生參加中央訓練團留日學生訓
練班第二期畢業證書。（圖片提供
／李仲生基金會）

1941 **30 歲**

擔任重慶衛戍總司令部政治部中校主任（1941.03-1941.09）。
擔任重慶衛戍總司令部上校編纂專員（1941.09-1942.05）。

1942 **31 歲**

擔任軍委會政治部第三廳上校主任（1942.06-1943.03）。

1943 **32 歲**

於重慶任國立杭州藝專講師（校長陳之佛、李驤），與李可染、關良同事（1943.03.04-1946.07.01）。

1945 **34 歲**

1 月 18 日，參加重慶「現代繪畫聯展」，參展者：丁衍庸、方幹民、林風眠、
林鏞、汪日章、周多、倪貽德、郁風、龐薰琹、趙無極、關良等人，多數是杭
州藝專教授，提倡「中國繪畫藝術與現代世界藝術合流」。

李仲生參加重慶「現代繪畫
聯展」出品目錄（圖片提供
／李仲生基金會）

1945 年李仲生於重慶參加「現
代繪畫聯展」請束及出品目錄。
（圖片提供／李仲生基金會）

1946　35 歲

獲聘任國防部新聞教育專員。

參加重慶「獨立美展」，參展者有朱德群、汪日章、李可染、李東平、林風眠、胡善餘、倪怡德、許太谷、翁元春、趙無極、趙蘊修、關良等人，展覽結果引發「新舊派之爭」。

國立藝專遷回杭州，8月1日續聘為國立杭州藝專教授（校長為潘天壽），至1947年7月31日　因病離職。

1946 年李仲生參加重慶「獨立美展」。
（圖片提供／李仲生基金會）

1948　37 歲

任國防部政工局專員

8月，獲聘廣州市立藝專教授（校長為高劍父），至1949年5月8日止。

續聘廣州市立藝專教授（此為1910年3月1日聘書）。（圖片提供／李仲生基金會）

1949　38 歲

來臺，8月1日，任臺北第二女子中學美術教員，至1951年7月31日止。

1950　39 歲

與黃榮燦、劉獅、朱德群、林聖揚等人合組「美術研究班」，教授「美術概論」。

開始在報章雜誌發表藝術論述，並開始以私人畫室方式從事美術教學工作。

開始在何鐵華創辦的《新藝術雜誌》投稿，並在其創刊號中發表〈國畫的前途〉。

李仲生寫「論傳記文學」刊登於民生報1950年11月18日。（圖片提供／李仲生基金會）

1951　40 歲

與朱德群、劉獅、林聖揚、黃榮燦、趙春翔等，舉行「現代繪畫聯展」，於臺北中山堂展出；韓國大使李範奭收藏李仲生油畫一件。

8月1日，任政工幹部學校美術組兼任教授，（校長為胡偉克、王永樹），至1955年7月31日止。

1951-1955間於臺北市安東街開設畫室，教授油畫、素描、水彩、速寫及理論等，並發表多篇藝術評論與介紹文章。門生有歐陽文苑、霍剛、蕭勤、李元佳、陳道明、吳昊、夏陽及蕭明賢等共8位跟他習畫。

李仲生任政工幹部學校美術組兼任教授聘書。（圖片提供／李仲生基金會）

李仲生安東街畫室招生廣告。（圖片提供／李仲生基金會）

1953　42 歲

獲聘為教育部美育委員會委員（部長為張其昀）。

開始星期天於咖啡館、茶館上課。

於《聯合報》上發表文章，介紹日本畫壇狀況、歐美藝壇思潮、國內畫展及畫家評介、美育等。

 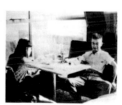 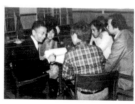

李仲生發表過的報章文稿剪輯（圖片提供／李仲生基金會）

李仲生於咖啡館一對一教學。（圖片提供／李仲生基金會）

李仲生的咖啡廳教學。（圖片提供／李仲生基金會）

1955　44 歲

夏天，辭政工幹校教職，關閉安東街畫室，遷居南下彰化員林。

8 月 1 日，任員林家職教員至 1957 年 7 月 31 日止。

李仲生寫「談畫室」刊登於中華日報 1955 年 3 月 5 日。（圖片提供／李仲生基金會）

1956　45 歲

11 月，門生歐陽文苑、霍剛、蕭勤、李元佳、陳道明、吳昊、夏陽及蕭明賢籌組「東方畫會」。東方畫會的「東方」之名是霍剛提議的，畫會章程則由夏陽起草。

（5 月，另有藝術團體「五月畫會」成立，會員有劉國松、陳景容、郭豫倫、郭東榮、鄭瓊娟、李芳枝等，「五月畫會」與「東方畫會」並稱為臺灣最早的前衛藝術團體，在 60 年代的臺灣藝壇分庭抗禮，將臺灣現代藝術的發展推向一個高峯。）

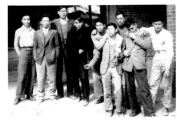

東方畫會成員與李仲生老師，由左至右為歐陽文苑、李仲生、陳道明、李元佳、夏陽、霍剛、吳昊、蕭勤、蕭明賢。（圖片提供／蕭勤基金會）

1957　46 歲

8 月 1 日，仟彰化女中美術教員至 1979 年。

繼續教授前衛藝術，吸引全臺灣各地嚮往當代藝術的學生慕名前來學習，至 1984 年停止。

11 月，學生歐陽文苑、霍剛、蕭勤、李元佳、陳道明、吳昊、夏陽及蕭明賢舉行「第 1 屆東方畫展」，於臺北衡陽路新聞大樓及西班牙巴塞隆那花園畫廊同時展出。《聯合報》副刊的專欄作家何凡戲稱這是「響馬畫展」，意指此參展的 8 位畫家就像中國東北的強盜一樣，是到處掠劫的「響馬」，因此「八大響馬」之名不脛而走，並在當時的藝壇掀起一陣旋風。

西班牙美術史家 J. E. Ciplot 將李氏及門生蕭勤、蕭明賢收錄於其著作《近代世界美術史》之前衛繪畫部分。

（5 月，「五月畫會」在臺北中山堂舉辦畫展。）

1957 年 11 月第 1 屆「東方畫展」於臺北新生報新聞大樓舉辦。（圖片提供／蕭勤基金會）

第 1 屆「東方畫展」畫冊封面。（圖片提供／財團法人蕭勤國際文化藝術基金會）

1957 年 11 月 5、6 日聯合報記者何凡報導－東方畫展八大響馬。（圖片提供／蕭勤基金會）

1958　47 歲

學生江漢東、秦松及李錫奇等人組成「現代版畫會」。

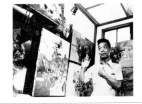

李仲生暢談藝術。（攝影／楊識宏）

1965　54 歲

參加在義大利舉行之「中國現代畫展」。

10 月，應邀擔任第 5 屆「全國美展」西畫部評審委員。

1971　60 歲

「東方畫會」舉行第 15 屆展覽後宣布解散。

1977　66 歲

12 月 3 日，參加臺中第一家私人畫廊「中外畫廊」舉辦首屆「中國當代畫家聯展」，參展者：席德進、劉其偉、顏雲連、賴傳鑑、楊三郎、林玉山、吳昊、朱為白、李錫奇、顧重光、梁奕焚、陳庭詩、楊興生……等人。

後期門生組成「自由畫會」，成員有黃步青、程武昌、謝東山、李錦繡、曲德義等人。

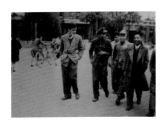

李仲生（右一）與吳昊（右二）等門生談笑風生。（圖片提供／李仲生基金會）

1979　**68 歲**

自彰化女中退休。

擔任第 34 屆「全省美展」油畫部評審委員，提供〈色彩的交響〉油畫作品參展。

接受雄獅美術月刊社專訪，製作「美術家特輯」，刊登於《雄獅美術》11 月號第 105 期。

11 月 20-29 日，舉辦「李仲生個展」，是李氏遷居中部後，23 年來首次集中發表作品，於臺北的版畫家畫廊及龍門畫廊同時展出，且為其生年唯一個展。

李仲生指導彰化女中美術課情景。
（圖片提供／李仲生基金會）

1980　**69 歲**

提供作品〈瑞〉參加「當代畫家聯展」於國軍文藝活動中心展出。

邀擔任第 35 屆「全省美展」油畫部評審委員。

1981　**70 歲**

擔任第 36 屆「全省美展」油畫部評審委員。

後期門生組成「饕餮畫會」，成員有吳梅嵩、郭少宗、許雨仁、姚克洪、謝志商等人。

1982　**71 歲**

獲中華民國畫學會第 19 屆「繪畫教育類」金爵獎。

參加文建會舉辦之「年代美展」，提供〈作品 A〉和〈作品 B〉兩幅油畫作品參展。

後期門生組成「現代眼畫會」，成員有詹學富、黃步青、李錦繡、程延平等人。

1984　**73 歲**

擔任臺北市立美術館「中國現代繪畫新展望」首席評審委員，並撰寫專輯序文〈中國現代繪畫運動的回顧與展望〉。

7 月 21 日，下午 2 時 40 分，因肝硬化及大腸癌，病逝於臺中榮民總醫院，享年 73 歲。

李仲生的長眠之地－彰化花壇李子山公墓，碑上刻字「中國現代繪畫先驅李仲生先生」。（攝影／陶文岳 2009 攝）

李仲生的墓上刻字「這裡安息的是 教師中的教師 藝術家中的藝術家李仲生先生」。（攝影／陶文岳 2009 攝）

1985　12 月 11 日，「財團法人李仲生現代繪畫文教基金會」成立，吳昊擔任基金會董事長，詹學富擔任基金會秘書長。

1987　後期門生組成「龍頭畫會」，成員有程武昌、周世隆、張道燦、張崇芳、鄭憲樺、陳珠櫻、程菊瑛等人。

1989　李仲生基金會主辦第 1 屆「李仲生基金會現代繪畫獎」，成就獎：蕭勤。創作獎：陳幸婉。

第 1 屆李仲生基金會現代繪畫獎頒獎：成就獎蕭勤（右 3）、創作獎陳幸婉（左 2）。
（圖片提供／李仲生基金會）

1991　李仲生基金會開始將部份李仲生作品交予臺灣省立美術館寄藏。

李仲生基金會主辦第 2 屆「李仲生基金會現代繪畫獎」，成就獎：劉國松。創作獎：盧明德。

第 2 屆李仲生基金會現代繪畫獎頒獎會場，該屆成就獎劉國松、創作獎盧明德。（圖片提供／李仲生基金會）

| 1993 | 李仲生基金會主辦第3屆「李仲生基金會現代繪畫獎」，成就獎：夏陽。創作獎：薛保瑕、陳聖頌。 |

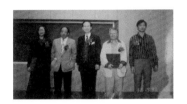

第三屆李仲生基金會現代繪畫獎頒獎會場，
該屆成就獎夏陽、創作獎薛保瑕、陳聖頌。
（圖片提供／李仲生基金會）

| 1998 | 李仲生基金會悉數將李氏作品、手稿、資料捐贈臺灣省立美術館，此為臺灣美術史上最大捐贈案。（1999年3月，正式成為臺灣省立美術館典藏。） |

| 1999 | 5月，臺灣省立美術館舉辦「向李仲生致敬」系列第一項展覽「系譜-李仲生師生展」。
李仲生基金會斥資，由臺北市立美術館出版《美術論叢59—李仲生文集》，蕭瓊瑞編著。 |

| 2014 | 7月，李仲生基金會董事會改選，由黃步青擔任基金會董事長，詹學富續任擔任基金會秘書長。 |

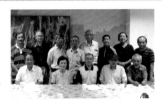

「李仲生現代繪畫文教基金會」董事會議合影。
（圖片提供／李仲生基金會）

| 2017 | 李仲生基金會補助「藝象蒼穹～1950-2018李仲生學生系譜創作研究」，由陶文岳執筆研究案。
李仲生基金會主辦第15屆「李仲生基金會視覺藝術獎」，創作獎：吳東龍、邱建仁。 |

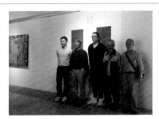

第15屆李仲生基金會視覺藝術獎頒獎會場，
該屆創作獎吳東龍、邱建仁。（圖片提供／
李仲生基金會）

- 李仲生身後遺留臺灣銀行存款274萬餘元，全數移作設立李仲生現代繪化文教基金會之用以推廣現代藝術創作。在其名下、位於板橋的房子（所有權為二樓的34平方公尺），在基金會與國產局訴訟敗訴後，歸屬國產局。
- 李仲生年表綜合參考李仲生遺留資料、手稿、國美館李仲生網站、蕭瓊瑞、曾長生、謝佩霓、陶文岳、陳樹升等相關李仲生著作。
- 在編寫李仲生生平年表時，突然面臨一個極大的屏障，因為參考諸前賢們之前所費心編寫的資料，發覺一些年代上的差異性，這個困難點在於李氏在大陸的資料早已散佚，無從確認比對造成考證上的困難，幸好查閱李氏在彰女教書時其填寫的個人資料，再加上國美館保存的個人資料與手稿。但這並不就代表擁有資料就一定正確無誤，因為包括李氏本人所填寫的資料中或許就有錯誤在先，要不就是因年代已久遠記憶上的偏差誤植，特別是從他出生的年代開始就是一個有趣的謎題，有1910（日本大學藝術文學士畢業證書登記明治43年）、1911（蕭勤、焦士太）、1912（國美館李仲生網站、蕭瓊瑞、曾長生、謝佩霓…等）、1913（李氏身分證登記、彰女個人資料填寫）、1914（日本大學藝術部入學許可證書），還有就讀小學到中學的年代問題，例如：李氏手遺稿寫民國10年（1921）入小學，民國16年（1927）畢業；而包括國美館李仲生網站及多種李仲生集等著作則登記為1924小學畢業，所以再根據這些資料編寫後，當然就會有些誤差的範圍，原則上筆者儘可能的比對考證，某些錯誤也就在所難免，並期待諸賢們不吝指正。

現代藝術發展概略

1905~1907	野獸派	馬諦斯（法）、杜菲（法）、唐元（荷蘭）
1905~1939	巴黎畫派	莫迪里亞尼（義大利）、藤田嗣治（日裔法籍）、蘇丁 Chaïm Soutine（俄裔法籍）
1907~1920 前	立體派	畢卡索（西班牙）、布拉克（法）…
	杜象（法）	杜象（1007~1968）的創作橫跨繪畫、現成物、觀念藝術、裝置，他喜歡獨立思考而不受傳統美學理論的束縛，也很難用各種派別來界定他，很早就以現成物替代繪畫，發展出觀念性思考的創作，最有名的作品是 1917 年在紐約將一件「小便池」命名為〈噴泉〉，以藝術之名公開展出，引發激烈的爭議與藝術論戰。他的繪畫觀念影響「未來主義」的發展，而他的創作觀念影響了「達達主義」的「反藝術」思維與行動，杜象的觀念與創作影響現代藝術深遠，被尊為「觀念藝術之父」。
約 1909~1916	未來派	薄邱尼（義大利）、塞維里尼（義大利）…
1910-1945	抽象藝術	康丁斯基（俄）…
約 1912~1914	奧費主義	德洛內（法）、雷捷（法）…
約 1913~1918	絕對主義	馬勒維奇（俄）
約 1916~1925	達達主義	阿爾普（法）、巴爾（德）…
約 1917~1921	形而上畫派	基里訶（義大利）、卡拉（義大利）…
1919~1933	包浩斯	康丁斯基（俄）、克利（德裔瑞士）…
1920~1942	新造型主義（風格派）	蒙德里安（荷蘭）
約 1924~1947	超現實主義	基里訶（義大利）、馬格利特（比利時）、米羅（西班牙）、恩斯特（德裔法籍）…
1942~1957	抽象表現主義	德庫寧（荷裔美籍）…
1945~1975	原生藝術	杜布菲（法）
1948~1951	眼鏡蛇畫派	阿雷辛斯基（比利時）…
約 1950 中~1970	偶發藝術	約翰・卡吉（美）、亞倫・卡布羅（俄裔美籍）…
約 1950 中~1970 末	表演藝術	吉原治良（日）、克萊因（法）…
約 1951~1957	非形象藝術	杜布菲（法）、達比埃斯（西班牙）
1952~1955	行動繪畫	帕洛克（美）…
1954~1960 末	普普藝術	漢彌爾頓（英）…
1960~1965	最低限藝術	紐曼（美）…
1960~1970	新實物主義	克萊因（法）…
約 1960~1970 末	觀念藝術	柯史士（美）、克萊因（法）
約 1960~1970 末	錄像藝術	白南準（韓）…
約 1960 中~1980 末	貧窮藝術	梅茲（義大利）
1970 中~1980 末	新表現主義	朱利安・施納貝爾（美）、喬治・巴塞利茲（德）、安森・基弗（德）、庫基（義）、克萊門特（義）、恩佐・庫奇（義）、帕拉提諾（義）、羅伯特孔巴斯（法）…
起源於 70 年代，約 80 末~90 年代開始盛行	新媒體藝術（利用現代科技和新媒形式的藝術表現，包含：數位藝術、網路藝術、互動藝術、虛擬藝術…）	比爾・維奧拉（美）、詹姆斯・特瑞爾（美）…

Chronological Table of Li Chun-Shan and His Disciples

Timeline compiled by: Tao Wen-Yuen

1912 Age 1
November 11, Li was born at home at No. 13, Zhongxin Road, Shaoguan City, Renhua County, Guangdong Province (The second year of ROC., in Renhua County, Guangdong Province, according to ROC National Identification Card).
Father Li Ju-mei (courtesy name You-ren) was well educated in law and a well-established calligrapher (the style of Wang Xi-Zhi) and ink painter (the style of Mi Fu). Mother Li Jing-Wen was also well educated. Li was the third of their four children.

1920 Age 8
Entered Catholic SDB Laikwan Elementary School. (Entered elementary school in 1912, "the 10th year of ROC," according to Li's own accounts)

1926 Age 14
Graduated from elementary school. Entered Catholic SDB Laikwan Middle School. (According to his own accounts, he graduated elementary school and entered middle school in the 16th year of ROC, 1927) (Studied ink painting and calligraphy with his father during free time)

1928 Age 17
Enrolled in Guangzhou College of Fine Arts, and studied realistic drawing with Situ Huai, the dean of the college. (Received training in academic classical drawing techniques.)

1930 Age 19
Encouraged by cousin Zan-qin to go to Shanghai, and enrolled in the Department of Western Painting at Affiliated Painting Institute, Shanghai Academy of Fine Arts.
(1930-1932, Li was exposed to and began to learn more about Western neo-classicism, fauvism, cubism, and mechanism.)

1932 Age 21
October, Li participated in the first joint exhibition by "Storm Society (Juelanshe)," the first Chinese art group to promote modern art, at Shanghai's Chinese Arts Students Society, with two works in the style of "mechanism."

1933 Age 22
March, Li entered Nihon University in Tokyo and studied in the Division of Western Painting, Department of Fine Arts. Later in the year, Li enrolled in evening program at "Tokyo Institute of Avant-Garde Fine Arts."

1934 Age 23
Spring, Li's figurative realistic oil painting titled "Containing" was selected to the Shunyo Art Exhibition in Japan.
Autumn, Li's surrealist oil painting titled "Construct" was selected to the 21st "Nikakai."
In Tokyo, Li jointly organized the "Chinese Independence Art Association" with other Chinese painters in Japan, including Leung Sikhung, Fang Ren-Ding, Li Dong-Ping, and Zhao Shou.
(Received training in academic realistic painting at Nihon University in Tokyo)

1935 Age 24
Participated in the 22nd "Nikakai" with exemption status.
Joined avant-garde art group — "Black Western Painting Society" in Tokyo.

1936 Age 25
Work "Fleeing Bird" selected to the 23rd "Nikakai."

1937 Age 26
March, Li graduated from the Division of Western Painting, Department of Fine Arts, Nihon University, and earned a bachelor degree in arts.
August, returned to Guangdong with the outbreak of the Sino-Japanese War. Taught at Renhua County Middle School.

1938 Age 27
Enlisted in the armed forces for the war. Served as Major-Secretary at the Political Department, Army 200 Division. (1938.06-1939.11)

1942 Age 31
Served as Colonel-Director of the Third Office, Political Department, Military Commission (1942.06-1943.03).

1943 Age 32
From March 4 to July 1, 1946, Li served as lecturer at Hangzhou National Academy of Fine Arts of Hangzhou in Chongqing (Presidents Chen Zhi-Fo and Li Xiang).

1945	Age 34
	January 18, Li participated in "Joint Exhibition of Modern Painting" held in Chongqing.
	Tried to create abstract painting.
	Participated in "Independence Art Exhibition" in Chongqing.

1946	Age 35
	Participated in "Independence Art Exhibition" in Chongqing

1948	Age 37
	From August to May 8, 1949, Li was employed as professor by Guangzhou Municipal Academy of Fine Arts (President Kao Chien-Fu).

1949	Age 38
	Came to Taiwan.
	From August 1 to July 31, 1951, Li served as an art teacher at Taipei Second Girls' High School.

1950	Age 39
	Co-founded "Fine Arts Institute" with Huang Jung-Tsan, Liu Shih, Chu The-Chun, and Lin Sheng-Yang, and taught "Introduction to Fine Arts."

1951	Age 40
	Held the "Joint Exhibition of Modern Painting" with Chu Teh-Chun, Liu Shih, Lin Sheng-Yang, Huang Jung-Tsan, and Chao Chung-Hsiang, at Taipei Zhongshan Hall.
	Opened studio on Andong Street in Taipei, where he taught oil painting, drawing, watercolor, quick sketching, and theories, while also publishing many art critiques and articles. Li began holding classes at coffee shops and tea shops on Sundays. His eight disciples, including Oyan Wen-Yuen, Ho Kan, Hsiao Chin, Li Yuan-Chia, Tommy Chen, Wu Hao, Hsia Yang, and Hsiao Ming-Hsien, studied painting under Li.

1953	Age 42
	Penned articles on "United Daily News," introducing latest developments in the Japanese fine arts circles, new ideas and thoughts of European and American fine arts, domestic art exhibitions, critiques of artists and works, and art education.

1955	Age 44
	Summer, Li resigned from position at Fu Hsing Kang College, and closed Andong Street studio. He moved south to Yuanlin, Changhua County.
	From August 1 to July 31, 1957, Li taught at Yuanlin Home-Economics and Commercial Vocational Senior High School.

1956	Age 45
	November, disciples Oyan Wen-Yuen, Ho Kan, Hsiao Chin, Li Yuan-chia, Tommy Chen, Wu Hao, Hsia Yang and Hsiao Ming-Hsien formed the "Tong Fang Painting Association" Ho proposed the name "Tong Fang", and the group's charter was drafted by Hsia Yang.
	(May, another art group, the "Fifth Moon" was founded, and members included: Liu Kuo-sung, Chen Ching-Jung, Kuo Yu-Lun, Kuo Tong-Jong, Cheng Chung-Chuan, and Li Fang-Jhih. The Fifth Moon Group and Tong Fang Painting Association were the earliest avant-garde fine arts groups in Taiwan, and the two groups competed in the 1960s and jointly propelled the development of modern art in Taiwan to a new height.)

1957	Age 46
	From August 1 to 1979, served as art teacher at Changhua Girls' Senior High School.
	Continued to teach avant-garde fine arts, and attracted disciples inspired by contemporary arts from all around Taiwan. Li stopped teaching in 1984.

1958	Age 47
	Disciples Chiang Han-Tung, Wu Hao, Chin Sung, and Lee Shi-Chi co-founded the "Modern Printmaking Association."

1965	Age 54
	Participated in the "Chinese Modern Painting Exhibition" held in Italy.

1971	Age 60
	The "Tong Fang Painting Association" was dismissed after holding the 15th group exhibition.

1977	Age 66
	December 3, Li participated in the First "Joint Exhibition of Chinese Contemporary Painters" held by Chung Wai Gallery, a private art gallery in Taichung.
	Later disciples formed the "Free Painting Association;" members included: Hwang Buh-Ching, Li Jiin-Shiow, Chu Teh-I, Cheng Wu-Chang, Wu Mei-Song, Hsieh Chih-Sun, Chen Meng-Chu, Wang Ching-Cheng, Hwang Way-Jeng, Hsieh Tung-Shan, Chern Shen-Son, Huang Ming-Tsung, Syu Huei-Huang, Cheng Chiung-Ming, Li Mei-Ying, and Chen Chu-Yin.

1979	Age 68 Retired from Changhua Girls' Senior High School. November 20 to 29, Li held the "Li Chun-Shan Solo Exhibition." This was the first major exhibition held by Li in 23 years after moving to central Taiwan. The exhibition was simultaneously held at Printmakers' Gallery and Lung Meng Art Gallery in Taipei. The exhibition was the only solo exhibition Li held when he was alive.
1980	Age 69 Invited to serve as juror of the Oil Painting Category at the 35th Taiwan Provincial Fine Arts Exhibition.
1981	Age 70 Served as juror of the Oil Painting Category at the 36th Taiwan Provincial Fine Arts Exhibition. Later disciples formed the "Tao Tei Painting Association." Members included: Wu Mei-Song, Kuo Shao-Tsung, Hsu Yu-Jen, Yao Keh-Hung, and Hsieh Chih-Sun.
1982	Age 71 Awarded the Golden Knight Award in "Painting Education" by ROC Painting Association. Later disciples formed the "Modern Eyes Group." Members included: Jan Syue-Fu, Hwang Buh-Ching, Li Jiin-Shiow, Cheng Yen-Ping.
1984	Age 73 (Passed Away) Served as the head juror of "Contemporary Trends in Chinese Art" held by Taipei Fine Arts Museum, and wrote the catalogue preface "Review and Outlook of the Chinese Modern Painting Movement." July 21, at 14:10, Li passed away at the age of 73, in Taichung Veterans General Hospital, due to cirrhosis and colorectal cancer.
1985	December 11, Li Chun-Shan Foundation of Contemporary Painting was established. Wu Hao served as the chairperson, and Jan Syue-Fu served as secretary general.
1987	Later disciples formed the "Dragon Head Painting Group." Members included: Cheng Wu-Chang, Choi Shih-Lung, Chang Tao-Chang, Chang Chung-Fang, Cheng Hsien-Hua, Chen Chu-Yin, and Cheng Gi-Yin.
1989	Li Chun-Shan Foundation organized the First "Li Chun-Shan Foundation Modern Painting Awards." Achievement Award: Hsiao Chin. Creative Award: Chen Hsin-Wan.
1991	Li Chun-Shan Foundation began to transfer some of his works to Taiwan Provincial Museum of Fine Arts for archiving. Li Chun-Shan Foundation organized the Second "Li Chun-Shan Foundation Modern Painting Awards." Achievement Award: Liu Kuo-Sung. Creative Award: Lu Ming-Te.
1993	Li Chun-Shan Foundation organized the Third "Li Chun-Shan Foundation Modern Painting Awards." Achievement Award: Hsia Yang. Creative Award: Hsueh Pao-Shia, Chern Shen-Son.
1998	Li Chun-Shan Foundation donated all of his works, manuscripts, and documents, to Taiwan Provincial Museum of Fine Arts. This was the largest donation in the art history of Taiwan. (March 1999, the donated works officially became part of the Provincial Museum of Fine Arts' archive.)
1999	May, Taiwan Provincial Museum of Fine Arts organized the "Homage to Master Li Chun-Shan" Series (1)—"A Mentor & His Pupils." Funded by Li Chun-Shan Foundation, Taipei Fine Arts Museum published "Art Forum 59—A Collection of Articles by Li Chun-Shan Edited by Hsiao Chong-Ray."
2014	July, re-election of Li Chun-Shan Foundation's board directors. Hwang Buh-Ching became the chairperson and Jan Syue-Fu remained secretary general.
2017	Li Chun-Shan Foundation sponsored the "Genealogical Research on Creative Works by Li Chun-Shan's Students, 1950~2018" headed by Tao Wen-Yueh. Li Chun-Shan Foundation organized the 15th "Li Chun-Shan Foundation Visual Arts Awards." Creative Award: Wu Tung-Lung, Chiu Chien-Jen.

藝術家
簡 歷

Artists'
Biographies

朱為白（1926～2018）

1926	出生於中國南京
1953	入李仲生畫室
1988	「中華民國美術發展聯展」，臺灣省立美術館，臺中，臺灣
1999	「臺灣檔案」，薩瓦格薩，西班牙
2000	「首爾亞細亞美術展」，自爾，韓國
2001	「2000亞洲藝術交流展」，香港，中國
	「國際華人抽象畫展」，香港、廣州、深圳，中國
2003	「長流－50年代臺灣美術發展」，臺北市立美術館，臺北，臺灣
2004	「前衛－60年代臺灣美術發展」，臺北市立美術館，臺北，臺灣
2005	「現代與後現代之間－李仲生與臺灣現代藝術」，國立臺灣美術館，臺中，臺灣
	「朱為白回顧展」，臺北市立美術館，臺北，臺灣
2006	「比較沙龍大展」，巴黎大皇宮，巴黎，法國
2011	「現代潮－五〇、六〇年代現代美術」，國立臺灣美術館，臺中，臺灣
2012	「臺灣報刊－臺灣美術雙年展」，國立臺灣美術館，臺中，臺灣
	「非形之形－臺灣抽象藝術展」，臺北市立美術館，臺北，臺灣
2013	「非形之形－臺灣抽象藝術展」，廣東美術館，廣東，中國
2014	「春耕逸境－朱為白個展」，大象藝術空間館，臺中，臺灣
	「抽象‧符碼‧東方情－臺灣現代藝術巨匠大展」，尊彩藝術中心，臺北，臺灣
2018	「朱為白回顧展－破空為白」，亞洲藝術中心，臺北，臺灣

歐陽文苑（1928～2007）

1928	出生於中國廣西
1950	入李仲生畫室
1956	與霍剛、蕭勤、吳昊、李元佳、陳道明、夏陽、蕭明賢等籌組創辦中國第一個現代繪畫團體「東方畫會」
1957	首屆東方畫展在臺北新聞大樓展出，另有西班牙14位現代畫家參展
1958	東方畫會與西班牙及心心多爾畫家臺北聯展
1958-65	參與第2屆至第8屆，「東方畫會」展，臺北，臺灣
1959	「西畫聯合展覽會」，國立臺灣藝術館，臺北，臺灣
1963	「雅苑畫廊聯展」，九龍漆咸道，香港
2012	「藝拓荒原→東方八大響馬」，大象藝術空間館，臺中，臺灣
2015	「意教的藝教－李仲生的創作及其教學」，國立臺北教育大學南海藝廊、中華文化總會，臺北，臺灣
2019	「矗－歐陽文苑、蕭明賢雙個展」，采泥藝術，臺北，臺灣

李元佳（1929～1994）

1929	出生於中國廣西臨桂
1952	入李仲生畫室
1955	臺北師範學校藝術科畢業
1957	第4屆「巴西聖保羅雙年展」，聖保羅，巴西
1959	第5屆「巴西聖保羅雙年展」，聖保羅，巴西
1961	參加蕭勤等人發起的國際龐圖藝術運動「東方」，臺北，臺灣、紐約，美國
1962	「Anno 62」，+'venster，鹿特丹，荷蘭
1963	「龐圖1」，卡代里奧畫廊，米蘭，義大利
1964	「李元佳個展」，哥倫巴畫廊，波隆那，義大利
1966	「3+1：蕭勤、霍剛、李元佳、皮亞‧皮索」，信號畫廊，倫敦，英國
1967	「宇宙點」，李森畫廊，倫敦，英國
1970	「小密森登藝術節」，白金漢郡，英國
1971	「參與式藝術先驅展」，牛津現代藝術館，牛津，英國
1972	「藝術頻譜‧北」，萊恩美術館，紐卡斯爾，英國
1977	「Water + Colour = 56/7 = Li Yuan-Chia」，李元佳美術館，坎布里亞，英國
1989	「另一個故事：戰後英國亞非藝術家作品展」，海沃德畫廊、沃爾漢普頓畫廊，倫敦，英國
	「李元佳」，保羅納利畫廊，波隆那，義大利
2001	「李元佳：可有未盡之言」個展，卡姆登藝術中心和布魯塞爾美術宮，倫敦，英國
2014	「觀‧點－李元佳回顧展」，臺北市立美術館，臺北，臺灣
	「李元佳」，泰特現代美術館，倫敦，英國

焦士太（1929～）

1929	出生於中國江蘇
1953	復興崗學院藝術系文學士
1953	入李仲生畫室
1966	「油畫個展」，臺北文藝中心，臺北，臺灣
1981	「中國當代繪畫展」，多明尼加
1983	「心象世界」，抽象畫展，阿波羅畫廊，臺北，臺灣
1985	「第一屆亞細亞國際藝術年展」，漢城現代美術館，韓國、臺灣
1986	「中國現代繪畫回顧展」，臺北市立美術館，臺北，臺灣
	「中華民國現代繪畫新貌展」，國立歷史博物館，臺北，臺灣
1987	「亞洲國際美展」，國立歷史博物館，臺北，臺灣
1988	「1954～1988焦士太繪畫展」，國立歷史博物館，臺北，臺灣
	「中華民國美術發展展覽」，臺灣省立美術館，臺中，臺灣
1991	「27屆亞細亞現代美術展」，東京，日本
	「焦士太作品展」，臺北縣立文化中心，臺北，臺灣
1993	「抽象在中國聯展」，新光三越文化宮，臺北，臺灣
1994	「臺北國際藝術中心聯展」，臺北，臺灣
1996	「夢幻歲月展」，積禪50藝術空間，高雄，臺灣

1960 「第4屆東方畫展」，新生報新聞大樓，臺北，臺灣、布常拉畫廊，都林，義大利、聖那多爾畫廊，史都戈特，西德、史帝法諾畫廊，威尼斯，義大利、格拉塔西畫廊，磊格都諾，義大利、米丹畫廊，紐約，美國

1961 「第5屆東方畫展」，國立臺灣藝術館，臺北，臺灣

1962 「第6屆東方畫展」，國立臺灣藝術館，臺北，臺灣、發拉色畫廊，義大利

1963~1965 「第7、9屆東方畫展」，國立臺灣藝術館，臺北，臺灣

1981 「東方畫會與五月畫會二十五週年紀念聯展」，歷史博物館，臺北，臺灣

1997 「東方畫會與五月畫會四十週年紀念聯展」，國立臺灣美術館，臺中，臺灣

2012 「藝拓荒原→東方八大響馬」，大象藝術空間館，臺中，臺灣

2015 「陳道明 個展－日出東方，抽象繪畫的潛航者」，臺北國際藝術博覽會 - 誠品畫廊，臺北，臺灣
　　　「意教的藝教－李仲生的創作及其教學」，國立臺北教育大學南海藝廊、中華文化總會，臺北，臺灣

蕭勤（1935~）

1935 出生於上海，原籍廣東中山

1951 臺灣省立臺北師範學校藝術科（今國立臺北教育大學）

1952 入李仲生畫室

1957 「蕭勤個展」，馬達洛美術館，西班牙
　　　「東方畫展」，臺北新生報新聞大樓、巴塞隆納花園畫廊（Galleria Jardin）

1959 「蕭勤個展」，數字畫廊，佛羅倫斯，義大利

1961 「蕭勤個展」，阿農查德沙龍畫廊，米蘭

1963 「中國當代藝展」，萊凡庫森美術館，德國

1964 「蕭勤個展」，當代藝術畫廊，巴黎，法國

1978 「蕭勤個展」，國立歷史博物館，臺北，臺灣

1981 「東方與五月畫會成立二十五週年聯展」，臺北市省立博物館，臺北，臺灣

1989~1993, 1990~1995, 1991, 1994 「國際SHAKTI聯展」，哥本哈根、奧魯斯、伽拉拉代、米蘭

1991 「東方與五月畫會成立三十五週年聯展」，臺北時代畫廊，臺北，臺灣

1995 「蕭勤的歷程：1953 - 1994」，臺北市立美術館，臺北，臺灣

1997 「東方現代備忘錄－穿越彩色防空洞」聯展，帝門藝術中心，臺北，臺灣

2000 「榮源－蕭勤七十回顧展 1955 - 2005」，中國美術館舉行，北京

2010 「大炁之境－向大師致敬系列：蕭勤75回顧展」，高雄市立美術館，高雄，臺灣

2013 「蕭勤－大能量」，大未來林舍畫廊，臺北，臺灣

2014 「蕭勤－永恆能量」，荷軒新藝空間，高雄，臺灣

2015 「八十能量－蕭勤回顧‧展望」個展，國立臺灣美術館，臺北，臺灣

2016 「蕭勤－無盡能量2016」，3812畫廊，香港

2017 「永恆序章－蕭勤創作展」，高雄國際機場中央藝廊，高雄，臺灣

2018 「禪‧藝術：明光－向昇華致敬」，慈山寺，香港
　　　「蕭勤－回家個展」，中華藝術宮，上海，中國

（財團法人蕭勤國際文化藝術基金會 提供）

蕭明賢（1936~）

1936 出生於臺灣南投

1952 入李仲生畫室

1955 臺灣省立臺北師範學校藝術科畢業

1960 翠梅諾二畫廊，米蘭，義大利
　　　第1屆香港國際現代藝術沙龍展，香港

1968 格林畫廊，紐約州橘郡，美國

1971 法國銀行畫廊，紐約州橘郡，美國
　　　史丹福羅克斯米爾畫廊，紐約州史丹福，美國

1999 「向李仲生致敬(一)系譜－李仲生師生展」，國立臺灣美術館，臺中，臺灣
　　　「東方畫會紀念展」，上海美術館，上海

2007 「藝域長流－臺灣美術溯源」，國立臺灣美術館，臺中，臺灣

2012 「藝拓荒原 ~ 東方八大響馬」，大象藝術空間館，臺中，臺灣

2013 「刺客列傳」二年級生，國立臺灣美術館，臺中，臺灣

2017 「從中國到臺灣：前衛抽象藝術先驅 1955-1985」特展，布魯塞爾依克塞爾美術館，比利時

2019 「驫－歐陽文苑、蕭明賢雙個展」，采泥藝術，臺北，臺灣

李錫奇（1936~）

1936 出生於臺灣金門

1958 臺北師範學校藝術科（今臺北教育大學藝術系）

1967 入李仲生畫室

1982 「中國現代繪畫展」，韓國漢城現代美術館，漢城，韓國

1994 「鬱黑之旅系列個展」，乙畫廊，紐約，美國

1996 「李錫奇個展」，四方畫廊，首爾，韓國
　　　「李錫奇創作歷程展」，臺北市立美術館，臺北，臺灣

2002 「浮生十帖－錯位‧變置‧李錫奇個展」，歷史博物館，臺北，臺灣

2004 「金門碉堡藝術館 ~18個個展」，「戰爭‧賭‧和平」，金門，臺灣

2005 「李錫奇北京畫展」，中國美術館，北京，中國

2006 「七十‧本位‧李錫奇－走過臺灣現代藝術50年」，國父紀念館，臺北，臺灣

2009 「淬鋒‧本位‧李錫奇」，廣東美術館，廣東，中國
　　　「亞洲藝術雙年展」，國立臺灣美術館，臺中，臺灣

2011 「ONE PIECE ROOM 李錫奇個展」，關渡美術館，臺北，臺灣

2012 「非形之形－臺灣抽象藝術聯展」，臺北市立美術館，臺北，臺灣
「臺灣報到－臺灣美術雙年展」，國立臺灣美術館，臺中，臺灣

2013 「越界創新 李錫奇的繪畫世界」，創價學會藝文中心，桃園，臺灣

2014 「游藝志道：李錫奇的藝術世界」，國立臺灣藝術大學，臺北，臺灣

2016 「本位・色焰－李錫奇八十回顧展」，國立歷史博物館，臺北，臺灣

2017 「本位／粹煉／超越－李錫奇的藝術歷程－李錫奇八十回顧展」，中華藝術宮，上海，中國

許輝煌（1937~）

1937 出生於臺灣彰化鹿港
1964 入李仲生畫室
1973 臺中師院畢業
2011 大葉大學造型藝術研究所碩士

1971 「許輝煌個展」，彰化社教館，彰化，臺灣
1988 「許輝煌個展」，彰化文化中心，彰化，臺灣
1991 「許輝煌個展」，臺灣省立美術館，臺中，臺灣
1995 「許輝煌作品風格演變過程展」，臺灣省立美術館，臺中，臺灣
1996-2012 連續入選法國春季沙龍及秋季沙龍 21 次，並在巴黎大皇宮展出
1998 「許輝煌現代畫展」，國立國父紀念館，臺北，臺灣
1999 「許輝煌油畫巡迴展」，佛光緣美術館，臺中，臺灣
2000 「許輝煌油畫展」，水湳美術館，臺中，臺灣
「許輝煌現代畫展」，彰化社教館，彰化，臺灣
2003 「許輝煌現代畫展」，彰化社教館，彰化，臺灣
2009 「心象世界－許輝煌創作展」，鹿港鎮圖書藝文中心，彰化，臺灣
佛光緣美術館，宜蘭，臺灣
2011 「百號百福個展」，彰化生活美學館，彰化，臺灣
2012 「抽象繪畫個展」，鹿港藝文館，彰化，臺灣
2017 「許輝煌教授八十回顧展」，鹿港公會堂，彰化，臺灣

黃潤色（1937 ~ 2013）

1937 出生於臺灣臺北
日本東京 Designers 學院畢業
1960 入李仲生畫室

1984 「國內畫家聯展、第一屆現代畫學會會員作品聯展」，臺北市立美術館，臺北，臺灣
1985 「第二接觸現代畫展」，臺北市立美術館，臺北，臺灣
1986 「中國現代繪畫回顧展」，臺北市立美術館，臺北，臺灣

「中華民國現代繪畫新貌展」，臺北國立歷史博物館，臺北，臺灣
1987 「第 3 屆中韓現代繪畫交流展」，漢城寬勳美術館，漢城，韓國
1988 「中華民國美術發展展覽」，臺灣省立美術館，臺中，臺灣
1996 「東方、五月現代情 40 週年聯展」，積禪 50 藝術空間，高雄，臺灣
1998 「臺灣女性藝術展－意象與美學」，臺北市立美術館，臺北，臺灣
1999 「向李仲生致敬(一)系譜－李仲生師生展」，臺灣省立美術館，臺中，臺灣
2002 「大船入港－現代眼群展」，新濱碼頭藝術空間，高雄，臺灣
2005 「生發與變遷－臺灣美術現代性系列展」，國立臺灣美術館，臺中，臺灣
2006 「李仲生與臺灣現代繪畫之發展」，中國北京美術館，中國
2008 「現在完成進行式－現代眼畫會 27 年展」，國立臺灣美術館，臺中，臺灣
2013 「東方之珠－黃潤色回顧展」，靜宜大學藝術中心，臺中，臺灣

鐘俊雄（1939~）

1939 出生於臺灣臺中
畢業於輔仁大學
1957 入李仲生畫室

1986 「中國現代繪畫回顧展」，臺北市立美術館，臺北，臺灣
1987 「中國現代繪畫新貌展」，國立歷史博物館，臺北，臺灣
1988 「中華民國美術發展展覽」，臺灣省立美術館，臺中，臺灣
1991 「中韓現代水墨展」，臺灣省立美術館，臺中，臺灣
1992 個展，臺中市立文化局，臺中，臺灣
1993 「上海、臺北現代水墨展」，上海美術館，上海，中國
1994 個展，臺南市立文化局，臺南，臺灣
1996 「臺北現代畫家聯展」，上海美術館，中國
2000 「集集方舟裝置藝術展」，臺灣省立美術館，臺中，臺灣
2004 「現代眼畫會年度展」，臺中市立文化局，臺中，臺灣
2005 個展，臺中港區藝術館，臺中，臺灣
2011 個展，逢甲大學逢甲藝廊，臺中，臺灣
2016 「無所住而生其心」，The 201 Art 順天建築・文化・藝術中心，臺中，臺灣

黃志超（1941~）

1941 出生於中國廈門鼓浪嶼
1960 入李仲生畫室
1972 美國紐約普拉特藝術學院研究所進修

1961 「青年畫家展」，臺北美國新聞處，臺北，臺灣
1971 個展，亞洲藝術協會，舊金山，美國

1972 「中國當代畫家聯展」，東方畫廊，馬德里，西班牙
1973 「中國當代版畫展」，香港博物館，香港
1983 個展，南畫廊，臺北，臺灣
1988 「亞士匹那紮畫廊」，蒙特婁，加拿大
1991 「臺北－紐約：現代藝術」，臺北市立美術館，臺北，臺灣
1994 「色極觀」，謹畫廊，紐約，美國
1997 「散發系列」，美極畫廊，伊士頓，美國
2000 個展，翰藝術中心，蒙特婁，加拿大
2012 「山水絮語　黃志超個展」，非畫廊，臺北，臺灣
2014 「樂可馬－黃志超個展」，非畫廊，臺北，臺灣、上海，中國
2015 「回眸－黃志超個展」，加力畫廊，臺南，臺灣
2016 「仨人展－黃志超、楊世芝、薛保瑕」，赤粒藝術，臺北，臺灣

詹學富 (1942~)

1942 出生於臺灣彰化
1964 入李仲生畫室
1967 國立臺灣師大美術系畢業

1983~2018 現代眼畫會年展
1984.86 「中華民國現代繪畫新展望」，臺北市立美術館，臺北，臺灣
1986 「中華民國現代繪畫回顧展」，臺北市立美術館，臺北，臺灣
1987 「中華民國現代繪畫新貌展」，國立歷史博物館，臺北，臺灣
「中華民國當代繪畫」漢城，韓國
1988 「中華民國美術發展」，臺灣省立美術館，臺中，臺灣
1990 「臺灣美術三百年」，臺灣省立美術館，臺中，臺灣
「異象的女體－詹學富畫展」，帝門藝術中心，臺北，臺灣
1999 「向李仲生致敬(一)系譜－李仲生師生展」，臺灣省立美術館，臺中，臺灣
2004 「開新－80年代臺灣美術發展」，臺北市立美術館，臺北，臺灣
2005 「現代與後現代－李仲生與臺灣現代藝術」，國立臺灣美術館，臺中，臺灣
「詹學富個展」，國立成功大學雲平藝術櫥窗，臺南，臺灣
2006 「李仲生與臺灣現代繪畫之發展」，中國美術學院，杭州、中國美術館，北京，中國
2006 「李仲生師生探索展」，彰化藝術館，彰化，臺灣
「現在完成進行式－現代眼畫會27年展」，國立臺灣美術館，臺中，臺灣
2009 「老當益壯五人聯展」，陳庭詩現代藝術空間，臺中，臺灣
2011 「現代眼三十年展」，成大藝術中心，臺南，臺灣
2013 「風起雲湧－現代眼畫會2013人展」，建國科技大學，彰化，臺灣
2015 「意教的藝教－李仲生的創作及其教學」，國立臺北教育大學南海藝廊、中華文化總會文化空間，臺北，臺灣

謝東山 (1946~)

1946 出生於臺灣彰化二林
1969 入李仲生畫室
1970 臺灣師範大學美術系畢業
1975 文化大學藝術研究所
1991 美國愛荷華大學西洋藝術史碩士
1994 美國德州理工大學藝術批評學博士

1980 個展，大地畫廊，臺北，臺灣
1988 「後現代繪畫展」，高雄市立文化中心，高雄，臺灣
1999 「向李仲生致敬(一)系譜－李仲生師生展」，國立臺灣美術館，臺中，臺灣
2005 「現代與後現代之間－李仲生與現代藝術」，國立臺灣美術館，臺中，臺灣
2006 「情定二月」，南畫廊，臺北，臺灣
「李仲生師生展」，中國美術學院藝術中心，杭州，中國、中國美術館，北京，中國
2006-2014 參展臺中港區藝術中心百號油畫大展
2008 「從現代到後現代－李仲生師生探索展」，彰化藝術館，彰化，臺灣
「夏日」，臺中教育大學藝術中心，臺中，臺灣
2009 「雲－謝東山油畫創作展2009」，彰化藝術館，彰化，臺灣
2009-2012 參展臺中市當代藝術家聯展
2011 「城市神話－謝東山油畫創作個展」，臺中文化中心，臺中，臺灣
個展，南畫廊，臺北，臺灣
「百年百書畫－礁溪當代名家邀請聯展」，彰化縣文化局，彰化，臺灣
2014 「青青河畔草－謝東山油畫展2014」，彰化藝術館，彰化，臺灣

黃步青 (1948~)

1948 出生於臺灣鹿港
1969 入李仲生畫室
1976 國立師範大學美術系畢業
1987 法國巴黎大學造型藝術碩士

1996 臺北雙年展「臺灣藝術主題性」，臺北市立美術館，臺北，臺灣
1999 「大地、生命、記憶」，高雄市立美術館，高雄，臺灣
「創作論壇」，高雄市立美術館，高雄，臺灣
代表臺灣出席第48屆威尼斯雙年展，威尼斯，義大利
2000 「上海國際雙年展－海上，上海」，上海美術館，上海，中國
2001 「雙城記」臺南、魁北克藝術交流展，臺南生活美學館，臺南，臺灣
「飄浪、生命與暗戀－黃步青裝置個展」，臺南成大藝術中心，臺南，臺灣
2010 「天空的故事 黃步青個展」，東門美術館，臺南，臺灣
2012 「國際建築暨設計展－雙凝空間裝置展」，倫敦，英國

2014　「門外家園：荒蕪的邊緣－黃步青個展」，臺北當代藝術館，
　　　臺北，臺灣
　　　「門外家園：荒蕪的邊緣－黃步青個展」，臺東美術館，臺東，
　　　臺灣
2016　「當代臺灣抽象經典展」，耘非凡藝術館，臺南，臺灣
　　　「大地生命與愛戀」，佛光緣美術館，臺中，臺灣
2017　「變材無礙，當代媒材與表現」，高雄市立美術館，高雄，臺
　　　灣
2018　「五月潮」，黃步青 80 藝術空間，臺南，臺灣

鄭瓊銘（1948~）

1948　出生於臺灣臺南新營
1976　國立臺灣師範大學美術系畢業
1979　入李仲生畫室

1991　「實驗與創新公寓展」，臺北市立美術館，臺北，臺灣
1992　「延續與斷裂－宗教、巫術、自然」，臺北市立美術館，臺北，
　　　臺灣
1993　「中華民國第六屆國際版畫及素描雙年展」，臺北市立美術館，
　　　臺北，臺灣
1994　「二號公寓：最後一夜」，臺北市立美術館，臺北，臺灣
1996　「臺灣藝術主體性」，臺北市立美術館，臺北，臺灣
1998　「線的力量－當代國際素描藝術展」，臺北藝廊，紐約，美國
1999　「向李仲生致敬(一)系譜－李仲生師生展」，臺灣省立美術館，
　　　臺中，臺灣
2004　「立異－九十年代臺灣美術發展」，臺北市立美術館，臺北，
　　　臺灣
2005　「2005 關渡英雄誌－臺灣現代美術大展」，國立臺北藝術大學
　　　關渡美術館，臺北，臺灣
2006　「李仲生與臺灣現代繪畫之發展」，中國美術學院美術館，杭
　　　州、中國美術館，北京，中國
2008　「現在完成進行式－現代眼畫會 27 年展」，國立臺灣美術館，
　　　臺中，臺灣
2010　「續－李仲生現代繪畫獎」，國立臺灣美術館，臺中，臺灣
　　　「Beyond Vision 異象典藏抽象繪畫展」，國立臺灣美術館，臺
　　　中，臺灣
2011　「SKY－2011 亞洲版 × 圖展」，關渡美術館，臺北，臺灣
2015　「意教的藝教－李仲生的創作及其教學」，國立臺北教育大學
　　　南海藝廊、中華文化總會，臺北，臺灣
　　　「再現代－現代眼畫會 2015 聯展」，大墩藝廊，臺中，臺灣
2016　「轉換－現代眼畫會聯展」，大墩藝廊，臺中，臺灣
2017　「版薈風華－2017 中華民國版畫學會現代版畫大展」，嘉義
　　　市政府文化局展覽室，嘉義，臺灣
2018　「同心‧圓－2018 現代眼畫會聯展」，大墩藝廊，臺中，臺
　　　灣

王慶成（1948~）

1948　出生於臺灣彰化鹿港
1976　入李仲生畫室

1980　「第 3 屆自由畫會聯展」，臺灣省立博物館，臺北，臺灣
1982　「現代畫大展」，高雄，臺灣
1993　「龍頭畫會聯展」，維納斯畫廊，臺中，臺灣
1996　「李仲生師生聯展」，國立臺灣美術館，臺中，臺灣
1999　「向李仲生致敬(一)系譜－李仲生師生展」，國立臺灣美術館，
　　　臺中，臺灣
2005　「李仲生與臺灣現代畫聯展」，國立臺灣美術館，臺中，臺灣
　　　「半線藝術季」，彰化縣政府，彰化，臺灣
2008　「當代畫展」，彰化縣文化局，彰化，臺灣
2009　「李仲生師生聯展」，彰化文化局，彰化，臺灣
2011　「百年百書畫邀請展」，彰化藝術館，彰化，臺灣
2012　「百年百書畫鹿港籍當代畫家邀請展」，鹿港，彰化，臺灣

程武昌（1949~）

1949　出生於臺灣彰化鹿港
1969　入李仲生畫室

1985　入選巴西聖保羅國際素描藝術展
1996　「李仲生師生展」，臺灣省立美術館，臺中，臺灣
1999　「向李仲生致敬(一)系譜－李仲生師生展」，臺灣省立美術館，
　　　臺中，臺灣
2001　個展，高雄中正文化中心，高雄，臺灣
2002　個展，彰化縣政府文化局，彰化，臺灣
2005　「李仲生與臺灣現代繪畫聯展」，國立臺灣美術館，臺中，臺
　　　灣
　　　個展，臺南成大藝術中心，臺南，臺灣
2006　「李仲生與臺灣現代繪畫聯展」，中國美術學院美術館，杭州、
　　　中國美術館，北京，中國
2009　「臺南 102 藝術館個展」、「李仲生師生展聯展」，彰化文化
　　　局，彰化，臺灣
2010　「磺溪美展聯展」，彰化文化局，彰化，臺灣
　　　個展，鹿港藝文中心，彰化，臺灣
2013　「創作 50 年歷程回顧展」，鹿港藝文館，彰化，臺灣
2014　個展，彰化藝術館，彰化，臺灣
2015　「意教的藝教－李仲生的創作及其教學」，國立臺北教育大學
　　　南海藝廊、中華文化總會，臺北，臺灣

郭振昌 (1949~)

1949	出生於臺灣彰化鹿港
1968	入李仲生畫室
1973	畢業於中國文化學院美術系

1989	「臺北訊息展」，原美術館，東京，日本
1992	「K18－相互認識展」，卡塞爾，德國
	「浮動」，鳳甲美術館，臺北，臺灣
1993	「神話時代現象展」，龍門畫廊，臺北，臺灣
1995	「臺灣當代藝術展」，當代美術館，雪梨，澳洲
1997	「意象臺灣－當代藝術展」，西法蘭德斯省省立美術館，比利時
2000	「從當下切入(1996~2000)郭振昌聖臺灣個展」，誠品畫廊，臺北，臺灣
2008	「圖騰與禁忌」，臺北市立美術館，臺北，臺灣
	「泡沫紅茶：臺灣藝術・當代演繹」，國立摩拉維亞美術館，捷克
2009	「2008 年前後－浮動」，亞洲藝術中心，臺北，臺灣
	「講・述－2009 海峽兩岸當代藝術展」，國立臺灣美術館，臺中，臺灣、中國美術館，北京，中國
2010	「複語・腹語－臺灣當代藝術展」，光州市立美術館，韓國
2012	「臺灣當代・玩古喻今」，臺北市立美術館，臺北，臺灣
2013	「美麗臺灣－臺灣近現代名家經典作品展」，中國美術館，北京，中國
	「轉動藝臺灣」，首爾市立美術館，首爾，韓國
2015	「與時代共舞－《藝術家》40 年 × 臺灣當代美術」，高雄市立美術館，高雄，臺灣
2016	「圖騰臺灣」，國立彰化生活美學館，彰化，臺灣

許雨仁 (1951~)

1951	出生於臺灣臺南
1973	入李仲生畫室
1975	畢業於國立臺灣藝術專科學校

1979	許雨仁個展，美國文化中心，臺北，臺灣
1991	「個人運動」聯展，香港藝術中心，香港
1995	「人與土地～臺灣當代繪畫」，臺北市立美術館，臺北，臺灣
1997	「臺灣探究～當代紙上作品」，臺北市立美術館，臺北，臺灣
2000	水墨個展，漢雅軒，香港
2003	「當代水墨與水墨當代」水墨聯展，臺北市立美術館，臺北，臺灣
2004	「黃盒子－臺灣當代書畫展」水墨聯展，臺北市立美術館，臺北，臺灣
2005	「2005 水墨桃花源教育展」，臺北市立美術館，臺北，臺灣
	「Through Masters' Eyes」水墨聯展，東亞美術館，科隆，德國
2006	「北京新作展」個展，長店基地，北京，中國
	「水墨再生－2006 上海新水墨藝術大展」，多倫現代美術館，上海，中國

2007	「透明的天光」個展，漢雅軒，香港
2008	「靜無言」個展，奕源莊藝術空間，北京，中國
	「溫室」個展，東家畫廊，臺北，臺灣
2012	「索卡視界」，索卡藝術中心，臺南，臺灣
2013	「許雨仁個展－粗細間境」，關渡美術館，臺北，臺灣
2014	「臺灣報到－2014 臺灣美術雙年展」，國立臺灣美術館，臺中，臺灣
2015	「言與物」，漢雅軒，香港
2016	「當代臺灣 抽象藝術經典展」，薪非凡美術館，臺南，臺灣
2017	「墨若是－許雨仁個展」，朵泥藝術，臺北，臺灣
	「水墨曼陀羅」，高雄市立美術館，高雄，臺灣
	「似重若輕」，M+ 美術館，香港

陳幸婉 (1951~2004)

1951	出生於臺灣臺中
1972	國立藝專美術科西畫組畢業
1981	入李仲生畫室

1987	個展，龍門畫廊，臺北，臺灣
	個展，臺灣省立美術館，臺中，臺灣
1993	個展，金磚畫廊，臺中，臺灣
	個展，金水畫廊，巴黎，法國
1997	「從原型的探求到大地之歌」，臺北市立美術館，臺北，臺灣
2000	「悠遊之境」，科元藝術中心，臺中，臺灣
2001	「雕刻時光」，科元藝術中心，臺中，臺灣
2002	「陳幸婉、蔡志賢雙個展」，科元藝術中心，臺中，臺灣
2003	「清淨歡喜」，科元藝術中心，臺中，臺灣
2004	「陳幸婉紀念展」，科元藝術中心，臺中，臺灣
2006	「陳幸婉 1980-2001 複合媒材」，科元藝術中心，臺中，臺灣
2007	「陳幸婉 1990-1992 水墨作品」，科元藝術中心，臺中，臺灣
2008	「陳幸婉 1994-1999 水墨回顧展」，科元藝術中心，臺中，臺灣
	「開闔之間－陳幸婉的『原型』探求」，靜宜大學藝術中心，臺中，臺灣
2014	「陳幸婉逝世十週年紀念展」，科元藝術中心，臺中，臺灣

曲德義 (1952~)

1952	出生於韓國井邑
1974	入李仲生畫室
1976	國立師範大學美術系學士
1983	法國國立高等設計學院美術設計碩士
1984	法國國立高等美術學院造型美術碩士

2004	「開新－80 年代臺灣美術發展」，臺北市立美術館，臺北，臺灣
	「幾何・抽象・詩情」，臺北市立美術館，臺北，臺灣
2005	「現代與後現代之間－李仲生與臺灣現代藝術」，國立臺灣美術館，臺中，臺灣

2011 「四方之外」個展，塔石藝文館，澳門，中國
「異象－典藏抽象繪畫展」，國立臺灣美術館，臺中，臺灣
2012 「形形色色－曲德義個展」，國立臺灣美術館，臺中，臺灣
「美麗臺灣－臺灣近現代名家經典作品展」，中國美術館，北京，中國
「並生為一」個展，大趨勢畫廊，臺北，臺灣
「幻想空間的先行者－曲德義抽象繪畫展」個展，隱岩美術館，光州，韓國
「人與物：記憶的穿越－蘇州金雞湖美術館開館展」，金雞湖美術館，蘇州，中國
2015 「2015亞洲現代藝術展」，全羅北道立美術館，全羅北道，韓國
「意教的藝教－李仲生的創作及其教學」，國立臺北教育大學南海藝廊、中華文化總會，臺北，臺灣
2016 「生活帶來的種種愉快與不安之間」，光州市立美術，光州，韓國
2017 「居間的維度」個展，双方藝廊，臺北，臺灣
「版藝新象」，關渡美術館，臺北，臺灣

李錦繡（1953~2003）

1953 出生於臺灣嘉義
1974 入李仲生畫室
1976 臺灣師大美術系畢業
1986 法國國立巴黎高等裝飾藝術學院畢業

1077 「自由畫會聯展」，元儿畫廊，臺北，臺灣
1987 「旅法藝術家聯展」，貝納諾畫廊，巴黎，法國
「新青年繪畫沙龍展」，大皇宮，巴黎，法國
1989 「全國現代畫展」，高雄，臺灣
1990 「李錦繡個展」，串門藝術中心，高雄，臺灣
1991 「李錦繡個展」，二號公寓，臺北，臺灣
「女我展」，帝門藝術中心，臺北，臺灣
1992 「本土性特展」，二號公寓，臺北，臺灣
「黃步青、李錦繡」雙個展，新生態藝術環境，臺南，臺灣
1993 「邁向巔峰：臺灣現代藝術大展」，積禪50藝術空間，高雄，臺灣
「李錦繡個展」，臺北市立美術館，臺北，臺灣
「李錦繡個展」，臺南市立文化中心，臺南，臺灣
1995 「李錦繡個展」，杜象藝術中心，高雄，臺灣
1999 「李錦繡個展」，臺灣省立美術館，臺中，臺灣
2001 「前鋒藝術追緝令－臺南當代藝術風貌聯展」，臺南知事官邸，臺南，臺灣
2003 「南臺灣新風格雙年展」，臺南市立文化局，臺南，臺灣
2005 「李仲生與臺灣藝術展」，國立臺灣美術館，臺中，臺灣
「竹凳的移動－李錦繡紀念展」，臺北市立美術館，臺北，臺灣
2013 「現當代女性藝術五部曲，1930-1983」，臺北市立美術館，臺北，臺灣
2016 「自我鏡像的凝視與再現－李錦繡的生命藝術」，水色藝術工坊，臺南，臺灣

姚克洪（1953~）

1953 出生於臺灣雲林
1973 入李仲生畫室
1976 國立臺灣藝專美術科
1990 紐約市立大學市立學院藝術研究所 MFA

1985 「前衛、裝置、空間展」，臺北市立美術館，臺北，臺灣
1993 「臺灣土話個展」，逸清藝術中心，臺北，臺灣
1994 「臺灣當代陶藝聯展」，巴黎臺北文化中心，巴黎，法國
1995 「臺灣現代陶的人文省思」，臺北市立美術館，臺北，臺灣
「土加炎陶藝展」，淡水藝文中心，新北，臺灣
1998 「黑色博物誌個展」，臺北縣立文化中心，臺北，臺灣
2002 「土・臺灣・當代陶藝／臺灣當代陶藝家歐洲巡迴展」，鶯歌陶瓷博物館，新北，臺灣
2005 「非想 關於意像與隨筆個展」，典藏淡水藝術館、淡水文化基金會，新北，臺灣
2006 「現代陶藝邀請展」，國立歷史博物館，臺北，臺灣
2009 「疆域的凝視…臺灣當代陶藝特展」，當代國際陶藝博覽會，亞拉岡，西班牙
2010 「形・無形／臺灣中堅輩陶藝家聯展」，鶯歌陶瓷博物館，新北，臺灣
2012 「五行25人雕塑展」，伊通藝術空間，臺北，臺灣
2015 「意教的藝教－李仲生的創作及其教學」，國立臺北教育大學南海藝廊、中華文化總會，臺北，臺灣
2018 「臺灣國際陶藝雙年展」，鶯歌陶瓷博物館，新北，臺灣

楊茂林（1953~）

1953 出生於臺灣彰化
1973 入李仲生畫室
1979 中國文化大學美術系畢業

2009 「婆娑之廟－臺灣製造」個展，第53屆威尼斯雙年展平行展，聖紀凡尼和保羅教堂，聖托馬索廳，威尼斯，義大利
「觀點與『觀』點：2009亞洲藝術雙年展」，國立臺灣美術館，臺中，臺灣
2010 「Taiwan Calling －臺灣響起：超隱自由」，布達佩斯藝術館，布達佩斯，匈牙利
2011 「後民國－沒人共和國」，高雄市立美術館，高雄，臺灣
2012 「臺灣當代・玩古喻今」，臺北市立美術館，臺北，臺灣
2013 「轉動藝臺灣」，首爾市立美術館，首爾，韓國
2014 「界：臺灣當代藝術展1995-2013」，美國康乃爾大學強生美術館，紐約，美國
「臺灣美術家『刺客列傳』1951～1960－四年級生」，國立臺灣美術館，臺中，臺灣
2015 「與時代共舞－《藝術家》40年 × 臺灣當代美術」，高雄市立美術館，高雄，臺灣
2016 「MADE IN TAIWAN：楊茂林回顧展」，臺北市立美術館，臺北，臺灣

2017	「硬蕊／悍圖」，國立臺灣美術館，臺中，臺灣	
2018	「Awakenings: Art in Society in Asia 1960s-1990s」，東京國立近代美術館，東京，日本、國立現代美術館，首爾，韓國	
2019	「Asia in Asia – Close by Far Away Drums」，慶南道立美術館，昌原，韓國	
	「黯黑的放浪者 II －幽遊之域」個展，耿畫廊，臺北，臺灣	

陳聖頌 (1954~)

1954	出生於臺灣雲林
1976	國立臺灣師範大學美術系西畫組畢業
	入李仲生畫室
1988	義大利國立羅馬藝術學院繪畫系畢業
1987	「第 2 屆國際青年展」，布達佩斯，匈牙利
1989	「十五國外籍藝術家聯展」，范倫個尼大廈，羅馬，義大利
1990	個展，實驗藝術空間個展，葉迅可拉，羅馬，義大利
1991	個展，串門藝術中心，高雄、金石藝廊，臺中，臺灣
1002	個展，串門藝術中心，高雄、金石藝廊，臺中，臺灣
1993	「Agrigento 國際藝術家聯展」，阿格里讚市，西西里島，義大利
	第 3 屆李仲生基金會現代繪畫創作獎
1994	個展，臺北市立美術館，臺北，臺灣
1997	個展，臺灣省立美術館，臺中，臺灣
2000	「天與地」個展，福華沙龍，高雄，臺灣
2003	「天地之間」創作論壇，高雄市立美術館，高雄，臺灣
2005	「實境－化境」，新思惟人文空間，高雄，臺灣
2007	「域－域」，亞帝畫廊，臺南，臺灣
2008	「過渡－渡過」，高苑藝文中心，高雄，臺灣
2009	「陳聖頌個展」，東門美術館，臺南，臺灣
2010	「南國的浪漫與豪情」陳聖頌、李俊賢雙個展，京城圓頂藝廊，高雄，臺灣
2013	「陳聖頌常設展」，白屋藝廊，高雄，臺灣
2015	「意教的藝教－李仲生的創作及其教學」，國立臺北教育大學南海藝廊、中華文化總會，臺北，臺灣
2016	「畫靜、畫境、化境」陳聖頌個展，大趨勢畫廊，臺北，臺灣
	「當代臺灣抽象藝術經典展」，耘非凡美術館，臺南，臺灣
2018	「風影‧季節」李光裕‧陳聖頌雙個展，藝非凡藝術空間，臺南，臺灣

曲德華 (1954~)

1954	出生於韓國
1977	國立臺灣師範大學美術系學士
1977	入李仲生畫室
2000	澳洲國立大學坎培拉藝術學院視覺藝術碩士
1988	「建築空間和雕塑」，雪梨科技大學，雪梨，澳洲
1989	Works 畫廊，雪梨，澳洲

1993	「曲德華雕塑個展」，二號公寓，臺北，臺灣
1995	「曲德華雕塑個展」，美國文化中心，臺北，臺灣
1996	「虛實空間」，淡水藝文中心，新北市，臺灣
1997	「空間遊戲」，國立中央大學藝文中心，中壢，臺灣
1999	「向李仲生致敬－李仲生師生展」，國立臺灣美術館，臺中，臺灣
	「不確定空間」，澳洲國立大學藝文中心，坎培拉，澳洲
2007	「錯置空間」，國立臺灣美術館，臺中，臺灣
2010	「自在‧2010 現代眼畫會」，高雄應用科技大學藝文中心，高雄，臺灣
2012	「漾影，苡樂藝術空間」，臺中，臺灣
2017	「凝視的幻化」，大象藝術空間館，臺中，臺灣

吳梅嵩 (1955~)

1955	出生於臺灣高雄
1973	入李仲生畫室
1975	國立臺灣藝術專科學校美術科西畫組畢業（現為國立臺灣藝術大學）
1990	英國倫敦大學斯雷德美術學院繪畫研究所畢業
1983	「中華民國第一屆全國現代畫展」，臺北市立美術館，臺北，臺灣
1984	「中華民國第一屆國際版畫展」，臺北市立美術館，臺北，臺灣
1985	「當代版畫邀請展」，臺北市立美術館，臺北，臺灣
1989	「吳梅嵩個展」，英國倫敦大學斯雷德美術學院，倫敦，英國
1993	「熟悉與陌生」，新生態藝術環境，臺南，臺灣
	策展「發現愛河裝置藝術」，高雄，臺灣
	「吳梅嵩個展」，臻品畫廊，臺中，臺灣
1995	「桌‧椅‧語錄」，杜象藝術空間，高雄，臺灣
2000	「旅行紀念 VS. 風景原鄉」，高雄市立美術館，高雄，臺灣
2005	「現代與後現代之間－李仲生與臺灣現代藝術」，國立臺灣美術館，臺中，臺灣
2015	「異聲共振－高雄市現代畫學會研究展」，高雄市立美術館，高雄，臺灣
2017	「新浜貳拾 x 南方游擊」，新浜碼頭藝術空間，高雄，臺灣

黃位政 (1955~)

1955	出生於臺灣南投鹿谷
1974	入李仲生畫室
1975	國立臺中師院畢業
1986	法國國立巴黎高等美術學院畢業
1986	「大畫幅素描展」，Maison des Beaux-Arts，巴黎，法國
1987	「黃位政 1984-1986 作品展」，臺北市立美術館，臺北，臺灣
1991	「前衛與實驗，1991－公寓」，臺北市立美術館，臺北，臺灣
	「黃位政個展 1986~1990」，臺北市立美術館，臺北，臺灣
1995	「1995 黃位政個展」，彩田藝術空間，臺北，臺灣
1996	「臺北雙年展－臺灣藝術主體性」，臺北市立美術館，臺北，臺灣
	「1996 黃位政個展」，新樂園藝術空間，臺北，臺灣

1997	「黃位政個展 1991~1997」，臺北市立美術館，臺北，臺灣
2001	「2001 黃位政個展 身體／圖象」，飛元藝術中心，臺北，臺灣
2004	「開新－80 年代臺灣美術發展」，臺北市立美術館，臺北，臺灣
2007	「慾之探 黃位政 2007 個展」，東門美術館，臺南，臺灣
	「BODY－黃位政 2009 創作邀請展」，土城藝文館，臺北，臺灣
2014	「話身體－2014 黃位政個展」，A-7958 當代藝術藝廊，臺中，臺灣
2015	「身體語境－黃位政個展」，國立高雄師範大學藝術中心，高雄，臺灣
2017	「聚合 × 綻放－臺灣美術團體與美術發展」，國立臺灣美術館，臺中，臺灣
2018	「閾限之光－2018 黃位政創作個展」，中友時尚藝廊，臺中，臺灣

林鴻銘 (1956~)

1956	出生於臺灣彰化
1974	入李仲生畫室
2001	國立臺南藝術學院造型研究所碩士畢業

1986	個展，臺北市立文化中心，臺北，臺灣
1988	個展，臺北美國文化中心，臺北，臺灣
1989	個展，臺中市立文化中心，臺中、彰化縣立文化中心，彰化，臺灣
1993	個展，臺灣省立美術館，臺中，臺灣
1994	個展，高雄市立中正文化中心，高雄，臺灣
1997	個展，彰化縣立文化中心，彰化，臺灣
2000	個展，臻品畫廊，臺中，臺灣
2002	個展，臺中市立文化局，臺中，臺灣
2004	「意象山水－林鴻銘油畫創作展」，彰化縣政府藝文廣場，彰化，臺灣
	「迷失系列－林鴻銘創作個展」，20 號倉庫 26A，臺中，臺灣
2005	「林鴻銘個展」，彰化文化局，彰化，臺灣
2006	「山水系列－林鴻銘個展」，新竹文化局，新竹，臺灣
2007	個展，臺北立法院藝廊，臺北，臺灣
2008	「陳庭詩藝術中心紀念個展」，陳庭詩藝術中心紀念館，臺中，臺灣
2009	「新竹縣立文化局個展」，新竹縣立文化局，新竹，臺灣
2011	「林鴻銘創作展－畫我想像」，國立臺灣美術館，臺中，臺灣
2013	「鏡花娑婆」，山城美館，新北，臺灣
2014	「心境」，大墩文化中心，臺中，臺灣
2016	「面相」，彰化縣立美術館，彰化，臺灣
2017	「山水情」，尼頌詩藝術，臺中，臺灣

陳珠櫻 (1962~)

1962	出生於臺灣臺中
1983	新竹師專美術科畢業
1980	入李仲生畫室
1991	巴黎高等美術學院畢業
1995	法國巴黎第八大學－藝術與科技影像碩士
2001	法國巴黎第八大學－美學與藝術科技 博士

2000	「電子動物園馬戲團－阿果拉藝術節」，拉維特科學城，巴黎，法國
2002	「從『有機藝術』到『人工生命』」，國際圈外藝術節及歐洲攝影之家，巴黎，法國
2004	「科學與藝術之研究實驗室聯展」，國際數位文化與資產研討會，柏林，德國
2010	「臺灣報到－2010 臺灣美術雙年展」，國立臺灣美術館，臺中，臺灣
2011	「曼陀羅響樂」，國立臺灣美術館，臺中，臺灣
2012	「人工智能改－AI Plus」，國立臺灣美術館，臺中，臺灣
2013	「不二法門 · 陳珠櫻科藝之旅」個展，清華大學藝術中心，新竹市，臺灣
2014	「新媒體年代學展」，四川美院，重慶，中國
2015	「榮譽校園展」，2015 林茲電子藝術節，林茲，奧地利
	「意教的藝教－李仲生的創作及其教學」，國立臺北教育大學南海藝廊、中華文化總會，臺北，臺灣
2016	「數位視野」國際藝術節，列日市，比利時
2017	「無限軀體」，華德里尼馬戲學院，大巴黎聖德尼，巴黎，法國
2018	「後自然：美術館作為一個生態系統－臺北雙年展」，臺北市立美術館，臺北，臺灣
	「拉瓦爾 · 虛擬」國際藝術節，拉瓦爾市，法國

Chu Wei-Bor (1926~2018)

1926 Born in Nanjing, China
1953 Studied painting at Li Chun-Shan Studio

1988 "The Group Exhibition of Art Development in ROC", Taiwan Provincial Museum of Fine Arts, Taichung, Taiwan
1999 "Taiwan's File", Zaragoza, Spain
2000 "Seoul ASIA Invitation Art Exhibition", Seoul, Korea
2001 "Asian Art 2000 - A Vision of Change", Hong Kong
"Exhibition of International Chinese Abstract Paintings", Hong Kong, Guangdong, Shenzhen, China
2003 "From the Ground Up-Artist Association in 1950s Taiwan", Taipei Fine Arts Museum, Taipei, Taiwan
2004 "The Experimental Sixties: Avant-Garde Art in Taiwan", Taipei Fine Arts Museum, Taipei, Taiwan
2005 "Between Modern and Postmodern - Master Li Chun-Shan and Modern Art in Taiwan", National Taiwan Museum of Fine Arts, Taichung, Taiwan
"Retrospective Exhibition: Chu Wei-Bor", Taipei Fine Arts Museum, Taipei, Taiwan
2006 "Le Salon du Collectionneur", Grand Palais, Paris, France
2011 "The Modernist Wave: Taiwan Art in the 1950s and 1960s", National Taiwan Museum of Fine Arts, Taichung, Taiwan
2012 "YES! TAIWAN-2012 TAIWAN BIENNIAL", National Taiwan Museum of Fine Arts, Taichung, Taiwan
"Formless Form: Taiwanese Abstract Art", Taipei Fine Arts Museum, Taipei, Taiwan
2013 "Formless Form: Taiwanese Abstract Art", Guangdong Museum of Art, China
2014 "Tilling a Spring Paradise - Chu Wei-Bor Solo Exhibition", Da Xiang Art Space, Taichung, Taiwan
"Walking by Taiwanese Art: 1927-2014", Liang Gallery, Taipei, Taiwan
2018 "Chu Wei-Bor Retrospective: Śūnyatā", Asia Art Center, Taipei, Taiwan

Oyan Wen-Yuen (1928~2007)

1928 Born in Guangxi, China
1950 Studied painting at Li Chun-Shan Studio

1956 Co-founds Tong Fang Painting Association, the first Chinese modern painting collective, with Ho Kan, Wu Hao, Li Yuan-Chia, Tommy Chen, Hsia Yang, and Hsiao Ming-Hsien
1957 "The 1st Tong Fang Painting Association Exhibition", Taipei Press Building, Taipei, Taiwan, with 14 Spanish modern painters also presented in the exhibition
1958 "Tong Fang Painting Association group exhibition with artists from Spain and Ecuador, Taipei, Taiwan
1958~65 Participates in the 2nd ~ 9th "Tong Fang Painting Association Painting Exhibition", Taipei, Taiwan
1959 "Western Painting Group Exhibition", National Taiwan Arts Education Center, Taipei, Taiwan
1963 "Chatham Gallery Group Exhibition", Chatham Road, Kowloon, Hong Kong
2012 "Exploring the Wasteland - The Eight Highwaymen of the East", Da Xiang Art Space, Taichung, Taiwan
2015 "Art of Consciousness-Works and Teaching of Li Chun-Shan", Nanhai Gallery, National Taipei University of Education, Taipei, Taiwan; General Association of Chinese Culture, Taipei, Taiwan
2019 "Oyan Wen-Yuen & Hsiao Ming-Hsien Dual Exhibition", Chini Gallery, Taipei, Taiwan

Li Yuan-Chia (1929~1994)

1929 Born in Guilin City, Guangxi, China
1952 Studied painting at Li Chun-Shan Studio
1955 Graduated from the Art Department of Taiwan Provincial School

1957 "4th São Paulo Biennale", São Paulo, Brazil
1959 "5h São Paulo Biennale", São Paulo, Brazil
1961 "Ton-Fan", Taipei, Taiwan; New York, USA; a part of the international Punto Art Movement initiated by Hsiao Chin and others
1962 "Anno 62", +'venster, Rotterdam, Netherlands
1963 "Punto 1", Galleria Cadario, Milan, Italy
1964 Solo exhibition, Galleria La Colomba, Bologna, Italy
1966 "3 + 1 Hsiao Chin, Ho Kan, Li Yuan-Chia, Pia Pizzo", Signals Gallery, London, UK
1967 "Cosmic Point", Lisson Gallery, London, UK
1970 "Little Missenden Festival", Buckinghamshire, UK
1971 "Popa at Moma - Pioneers of Participation-Art", MOMA, Oxford, UK
Buys an old farmhouse, where he lives in and founds the LYC Museum and Art Gallery
1972 "Art Spectrum North", Laing Gallery, Newcastle, UK
1977 "Water + Colour = 56/7 = Li Yuan-Chia", LYC Museum, Banks, UK
1989 "The Other Story: Afro-Asian Artists in Post-war Britain", Hayward Gallery, Wolverhampton Art Gallery, London, UK
1998 "Li Yuan-Chia", Galleria Paolo Nanni, Bologna, Italy
2001 "Li Yuan-Chia", Camden Arts Centre, London, UK; Palais des Beaux Arts, Brussels
2014 "Viewpoint: A Retrospective of Li Yuan-Chia", Taipei Fine Arts Museum, Taipei, Taiwan.
"Li Yuan-Chia", Tate Modern, London, UK

Chiao Shih-Tai (1929~)

1929 Born in Jiangsu, China
1953 Graduated from Fu Hsing Kang College, majoring in art
1953 Studied painting at Li Chun-Shan Studio

1966 "Solo Exhibition of oil Painting", Taipei Art Center, Taipei, Taiwan
1981 "Chinese Contemporary Painting ", Dominicana
1983 "World of Mental Imagery", exhibition of abstract paintings, Apollo Art Gallery, Taipei, Taiwan
1985 "1st Asian International Art Exhibition", National Museum of Modern and Contemporary, Seoul, Korea; Taiwan
1986 "Retrospective Exhibition of Modern Chinese Painting", Taipei Fine Arts Museum, Taipei, Taiwan
1987 "Asian International Art Exhibition", National History Museum, Taipei, Taiwan
1988 "Chiao Shih-Tai Painting Exhibition 1954-1988", National Gallery, National Museum of History Taipei, Taiwan
"Exhibition of Art Development in the Republic of China", Taiwan Provincial Museum of Fine Arts, Taichung, Taiwan
1991 "27th Asia Modern Art Exhibition", Tokyo, Japan

1993	"Abstract in China", Palace of Culture of Shin Kong Mitsukoshi Department Store, Taipei, Taiwan
1994	"Taipei International Art Center Group Exhibition", Taipei, Taiwan
1996	"The Dream Year", Chi-Chan 50 Art Space, Kaohsiung, Taiwan
1999	"The Group Exhibition of Chinese Calligraphy", Overseas Chinese Center in Paris, France
2005	"Years of Dream and Fantasy", Soochow University, Taipei, Taiwan
2010	"Artistic Beauty", cross-strait art exhibition, Zhejiang Art Museum, Hangzhou, China
2016	"World of Emotions", Jimmy's Garden, Taipei, Taiwan
2017	"Chasing Dreams: Painting Dreams - Chiao Shih-Tai 88th Year Retrospective", Chungshan National Gallery, National Dr. Sun Yat-Sen Memorial Hall, Taipei, Taiwan
2017	"Ink Painting Prose – Chiao Shih–Tai Solo Exhibition", Jimmy's Garden, Taipei, Taiwan
2018	"90 Years Old Boy Contemporary Exhibition", 99° Art Center, Taipei, Taiwan
2019	"Chiao Shih–Tai 90th Year Retrospective", National Defense University, National Defense Art Museum, Taipei, Taiwan

Wu Hao (1932~)

1932	Born in Nanjing, China
1948	Attends preparatory courses at Suzhou Provincial Vocational High School
1951	Studied painting at Li Chun-Shan Studio

1959	"5th São Paulo Biennale", São Paulo, Brazil
1964	"International Youth Biennale", Paris, France
1970	"1st International Print Exhibition", Lima, Peru
1971	"Wu Hao Solo Exhibition of Prints", Cornucopia Gallery, Taipei, Taiwan
1973	"Wu Hao Solo Exhibition of Prints and Sketches", Germany
1975	"Wu Hao Solo Exhibition of Prints", Chinese University of Hong Kong, Hong Kong
1976	"Wu Hao Solo Exhibition of Prints", Che Art Gallery, Hong Kong,
1979	"First Solo Exhibition of Oil Paintings", Print Maker's Gallery, Taipei, Taiwan
1983	"Grand Opening Exhibition", Taipei Fine Arts Museum, Taipei, Taiwan
1994	"Wu Hao - Works in 40 years", Taipei Fine Arts Museum, Taipei, Taiwan
1997	"Wu Hao's Painting Journey", Taiwan Provincial Museum of Fine Arts, Taichung, Taiwan
2002	"Dancing Butterflies Blooming the Paths - Wu Hao's Oil Painting Exhibition", Metaphysical Art Gallery, Taipei, Taiwan
2006	"Blooming Season", Metaphysical Art Gallery, Taipei, Taiwan
2010	"Blooming", Metaphysical Art Gallery, Taipei, Taiwan
2013	"The Prints of Wu Hao", Kuandu Museum of Fine Arts, Taipei, Taiwan
2017	"Ala Aureus", Metaphysical Art Gallery, Taipei, Taiwan

Hsia Yang (1932~)

1932	Born in Xiangxiang City of Hunan Province, China
1948	Graduated from Nanjing Normal College, Nanjing, China
1951	Studied painting at Li Chun-Shan Studio
1967	Graduated from Ecole des Beaux-Arts de Paris

1980	Print Maker's Gallery, Taipei, Taiwan
1982	O.K. Harris Gallery, New York, USA
1989	Solo exhibition, Eslite Gallery, Taipei, Taiwan

1991	"Hsia Yan Solo Exhibition - Chinese Gods Series", Eslite Gallery, Taipei, Taiwan
1993	Solo exhibition, Eslite Gallery, Taipei, Taiwan
1994	"Hsia Yan: Continuation and Rejuvenation. A Retrospective of His Works From 1954-1994", Taipei Fine Arts Museum, Taipei, Taiwan
1995	"Hsia Yan Solo Exhibition - Sword in Lion's Mouth Series", Eslite Gallery, Taipei, Taiwan
1996	"Hsia Yan Solo Exhibition - 100 Faces Series", Eslite Gallery, Taipei, Taiwan
1998	"Hsia Yan: A Retrospective Exhibition", Taiwan Provincial Museum of Fine Arts, Taichung, Taiwan
2000	Solo exhibition, Eslite Gallery, Taipei, Taiwan
2003	Solo exhibition, Eslite Gallery, Taipei, Taiwan
2005	"Return of the Stars - Hsia Yan Solo Exhibition", Eye Level Gallery, Shanghai, China
2006	"Solo Exhibition of Hsia Yang", Eslite Gallery, Taipei, Taiwan; Eye Level Gallery, Shanghai, China; Shanghai Art Museum, Shanghai, China
2008	"Hsia Yan Sculpture Exhibition", Eye Level Gallery, Shanghai, China
2011	"Hsia Yan", Lin & Lin Gallery, Beijing, China
2013	"Return to Simplicity - An Exhibition of Hsia Yan's New Art", Eye Level Gallery, Shanghai, China
2014	"Yan Hsia", Lin & Lin Gallery, Taipei, Taiwan
2018	"Hsia Yan: Journey to Art ", Taipei Fine Arts Museum, Taipei, Taiwan

Ho Kan (1932 ~)

1932	Born in Nanjing, China
1950	Studied painting at Li Chun-Shan Studio
1953	Graduated from Taipei Teacher's School/Department of Art

1976	Galleria Artecentro, Milan, Italy
1979	Galleria Fluoart, Venice, Italy
1981	"Ton Fan Art Group and Fifth Moon Group: the 25th Anniversary Painting Exhibition", Taiwan Province Museum of Fine Arts, Taichung, Taiwan
1984	Galleria Artecentro, Milan, Italy
1985	Galleria Toni Brechbuhl, Switzerland
1988	Galleria Artecentro, Milan, Italy
1994	Taiwan Province Museum of Fine Arts, Taichung, Taiwan
1999	"Li Chun-Shan and His Pupils Exhibition", Taiwan Province Museum of Fine Arts, Taichung, Taiwan
2012	"Formless Form - Taiwanese Abstract Art", Taipei Fine Arts Museum, Taipei, Taiwan
2013	"Ho Kan: Time in Between", STARTS Studio, Taipei, Taiwan
2014	"Ho Kan Solo Exhibition", Moon 12 Art, Taipei, Taiwan
	"Walking by Taiwanese Art: 1927-2014" Liang Gallery, Taipei, Taiwan
2015	"Ho Kan Solo Exhibition", Moon 12 Art Taipei, Taiwan
2016	"Reverberations · HO KAN", Taipei Fine Arts Museum, Taipei, Taiwan
	"Contemplating the Original Point-The Oriental Abstract Language of HO Kan", Chini Gallery, Taipei, Taiwan
2018	"Minimalism · Cold Abstraction - Contemporary Abstract Art in Taiwan", Remarkable Art Gallery, Tainan, Taiwan
	"Beyond Colors and Shapes: A Retrospective of HO Kan", The Villa Reale of Monza, Italy
	"Beyond Colors and Shapes: A Retrospective of HO Kan: A Synchronous Exhibition in Taiwan", Chini Gallery, Taiwan
2019	"Taipei Dangdai-Ho Kan Solo Exhibition", Taipei Nangang Exhibition Center, Taipei, Taiwan

Tommy Chen (1931~2017)

1931　Born in, Jinan, Shandong, China

1951　Studied painting at Li Chun-Shan Studio

1959　"5th Sao Paulo Art Biennial", Sao Paulo, Brazil

　　　"International Youth Biennale", Paris, France

1960　"4th Tong Fang Painting Exhibition", Shin Sheng News Daily Press News Building, Taipei, Taiwan; Galleria La Bussola, Torino, Italy; Galerie Senatore, Stuttgart, Germany; Galleria S. Stefano, Venice, Italy; Galleria Grattacielo, Legnano, Italy; Mi Chou Gallery, New York, US

1961　"5th Tong Fang Painting Exhibition", National Taiwan Art Centre, Taipei, Taiwan

1962　"6th Tong Fang Painting Exhibition", National Taiwan Art Centre, Taipei, Taiwan

1963-1965 "7th-9th Tong Fang Painting Exhibition", National Taiwan Art Centre, Taipei, Taiwan

1981　"Tong Fang and Fifth Moon Group 25th Anniversary Exhibition", National History Museum, Taipei, Taiwan

1997　"Tong Fang and Fifth Moon Group 40th Anniversary Exhibition", National Taiwan Museum of Fine Arts, Taichung, Taiwan

2012　"Exploring the Wasteland - The Eight Highwaymen of the Easy", Da Xiang Art Space, Taichung, Taiwan

2015　"Tommy CHEN - Rising from the East, Diver of Abstract Art", ART TAIPEI 2015 EOLITE GALLERY, Taipei, Taiwan

　　　"Art of Consciousness-Works and Teaching of Li Chun-Shan", Nanhai Gallery, National Taipei University of Education, Taipei, Taiwan; General Association of Chinese Culture, Taipei, Taiwan

Hsiao Chin (1935~)

1935　Born in Shanghai, China

　　　Family originated from Zhongshan City in Guangdong Province, China,

1951　Alumnus of the Art Department of Taiwan Provincial Normal School (now National Taipei University of Education)

1952　Studied painting at Li Chun-Shan Studio

1957　Solo exhibition, Mataro Fine Arts Museum, Madrid, Spain

　　　"Tong Fang Painting Association Exhibition", Taipei Press Building, Taipei, Taiwan; Galleria Jardin, Barcelona, Spain

1959　Solo exhibition, Galleria Numero, Florence, Italy

1961　Solo exhibition, Salone Annunciata, Milan, Italy

1963　"Chinese Modern Art", Städtisches Museum, Leverkusen, Germany

1964　Solo exhibition, International Gallery of Contemporary Art, Paris, France

1978　Solo exhibition, National Museum of History,

1981　"Tong Fang and Fifth Moon Group 25th Anniversary Exhibition", National History Museum, Taipei, Taiwan

1989~1993, 1990~1995, 1991, 1994 "International Shakti Group Exhibition", Copenhagen, Aarhus, Denmark; Gallarate, Milan, Italy

1991　"Tong Fang and Fifth Moon Group 35th Anniversary Exhibition", Shi-Dai Gallery, Taipei, Taiwan

1995　"Hsiao Chin: the Odyssey, 1953-1994", Taipei Fine Arts Museum, Taipei, Taiwan

1997　"The Memo of Ton Fan", Dimensions Art Gallery, Taipei, Taiwan

2006　"Glory to the Source, Hsiao Chin 1955-2005", National Art Museum of China, Beijing, China

2010　"Infinity of Chi: Retrospective of Hsiao Chin", Kaohsiung Museum of Fine Arts, Kaohsiung, Taiwan

2013　"Great All", Lin & Lin Gallery, Taipei, Taiwan.

2014　"Hsiao Chin Eternal Energy", Lotus Art Gallery, Kaohsiung Taiwan.

2015　"Eighty Years of Energy: Hsiao Chin's Retrospect & Prospect", National Taiwan Museum of Fine Arts, Taichung, Taiwan

2016　"Endless Energy", 3812 Gallery, Hong Kong.

2017　"Eternity Preface: Hsiao Chin's Solo Exhibition", Kaohsiung International Airport Art Gallery, Kaohsiung, Taiwan

2018　"Bright Light - Homage to Ascendance, Hsiao Chin Solo Exhibition", Tsz Shan Monastery, Hong Kong

　　　"Hsiao Chin Coming Home Retrospective Exhibition", China Art Museum, Shanghai, China

(Courtesy of Hsiao Chin International Art Foundation)

Hsiao Ming-Hsien (1936~)

1936　Born in Nantou, Taiwan

1952　Studied painting at Li Chun-Shan Studio

1955　Graduated from Art Department of Taiwan Provincial Normal School

1960　Galleria 'Numero' 2, Milan, Italy

　　　"1st International Modern Arts Salon", Hong Kong

1968　Green Gallery, New York Orange County, USA

1971　Gallery of Empire National Bank Offices, New York Orange County, USA

　　　Rexmere Gallery – Stamford, New York Stanford, United States

1999　"Homage to Master Li Chun-Shan: A Mentor & His Pupils", National Taiwan Museum of Fine Arts, Taichung, Taiwan

　　　"The Momentum of the Group Ton-Fan Marked in Shanghai", Shanghai Art Museum, Shanghai, China

2007　"The River of Art Meanders - Tracing the Origin of Taiwan Art from 1736-1969", National Taiwan Museum of Fine Arts, Taichung, Taiwan

2012　"Exploring the Wasteland - The Eight Highwaymen of the East", Da Xiang Art Space, Taichung, Taiwan

2013　"The Pioneers of Taiwanese Artists, 1931-1940", National Taiwan Museum of Fine Arts, Taichung, Taiwan

2017　"FROM CHINA TO TAIWAN: Pioneers of Abstraction 1955-1985", Museum of Ixelles, Brussels, Belgium

2019　"The Outlaws – OYAN Wen-Yuen & HSIAO Ming-Hsien Dual Exhibition" Chini Gallery Taipei, Taiwan

Lee Shi-Chi (1936~)

1936　Born in Kinmen, Taiwan

1958　Alumnus of the Art Department of Taiwan Provincial Normal School (now National Taipei University of Education)

1967　Studied painting at Li Chun-Shan Studio

1982　"Exhibition of Modern Painting", Seoul Museum of Modern Art, Seoul, Korea

1994　"Deep Black Series", solo exhibition, Z Gallery, New York, USA

1996　Solo exhibition, Square Gallery, Seoul, Korea

　　　"The Odyssey of Lee Shi-Chi", Taipei Fine Arts Museum, Taipei, Taiwan

2002　"Ten Aspects of My Artistic Life-Transposition, Variation", National Museum of History, Taipei, Taiwan

2004 "Bunker Museum of Contemporary Art-18 Solo Exhibition", Kinmen, Taiwan (artwork shown: "War, Gambling, Peace")

2005 "Lee Shi-Chi Exhibition in Beijing", National Art Museum of China, Beijing, China

2006 "70 · Orientation · Lee Shi-Chi-Modern Art in Taiwan Through the Past 50 Years", National Dr. Sun Yat-Sen Memorial Hall, Taipei, Taiwan

2009 "Orientation · Tempered · Edge · Lee Shi-Chi", Guangdong Museum of Art, China

2011 "One Piece Room - Solo Exhibition of Lee Shi-Chi", Kuandu Museum of Fine Arts, Taipei, Taiwan

2012 "Formless Form - Taiwanese Abstract Art", Taipei Fine Arts Museum, Taipei, Taiwan

"2012 Taiwan Biennial", National Taiwan Museum of Fine Arts, Taichung, Taiwan

2013 "Innovation Beyond the Boundaries: The Art World of Lee Shi-Chi", Taiwan Soka Association, Taoyuan, Taiwan

2014 "Immersed in Art: Lee Shi-Chi's Creative Horizons", National Taiwan University of Arts, Taipei, Taiwan

2016 "Orientation · Splendor of Flame · A Retrospective Exhibition of Lee Shi-Chi at 80", National Museum of History, Taipei, Taiwan

2017 "Orientation · Quenching · Transcend · Art History of Lee Shi-Chi", China Art Museum, Shanghai, China

Syu Huei-Huang (1937~)

1937 Born in Lukang Township of Changhua County, Taiwan
1964 Studied painting at Li Chun-Shan Studio
1973 Graduated from Taiwan Provincial Taichung Normal School
2011 Gained MFA from the Department of Plastic Arts, Da-Yeh University

1971 Solo Exhibition, National Changhua Living Art Center, Changhua, Taiwan
1988 Solo exhibition, Culture Center of Changhua, Changhua, Taiwan
1991 Solo exhibition, Taiwan Provincial Museum of Fine Arts, Taichung, Taiwan
1995 "The Exhibition of the Evolution of Syu Huei-Huang", Taiwan Museum of Art, Taichung, Taiwan
1996-2012 Selected in Salon des Artistes Français and Le Salon d'Automne for twenty one times, and had exhibited at the Grand Palais
1998 Solo modern painting exhibition, National Dr. Sun Yat-Sen Memorial Hall, Taipei, Taiwan
1999 Solo oil painting touring exhibition, Fo Guang Yuan Museum of Art, Taichung, Taiwan
2000 Solo oil painting exhibition, Shui Nan Arts Museum, Taichung, Taiwan
Solo modern painting exhibition, National Changhua Living Art Center, Changhua, Taiwan
2008 Solo modern painting exhibition, National Changhua Living Art Center, Taiwan
2009 "World of Mental Image- Syu Huei-Huang Solo exhibition", Lukang Library, Changhua, Taiwan
Fo Guang Yuan Museum of Art, Yilan, Taiwan
2011 Solo exhibition of large-size paintings, National Changhua Living Art Center, Changhua, Taiwan
2012 Solo exhibition, Lugang Museum, Changhua, Taiwan
2017 "Syu Huei-Huang 80's Retrospective Exhibition", Lukang Assembly Hall, Changhua, Taiwan

Huang Run-Se (1937 ~ 2013)

1937 Born in Taipei, Taiwan
Alumna of Tokyo Designer Gakuin College, Japan
1960 Studied painting at Li Chun-Shan Studio

1984 "Taiwanese Painters Group Exhibition, 1st Group Exhibition with Paintings by Members of the Modern Painting Association", Taipei Fine Arts Museum, Taipei, Taiwan

1985 "Second Contact Modern Painting Exhibition", Taipei Fine Arts Museum, Taipei, Taiwan

1986 "Retrospective Exhibition of Modern Chinese Painting", Taipei Fine Arts Museum, Taipei, Taiwan
"New Modern Chinese Painting", National Museum of History, Taipei, Taiwan

1987 "3rd Sino-Korean Modern Painting Exchange Exhibition", Kyung-In Museum of Fine Art, Seoul, Korea

1988 "Exhibition of Art Development in the Republic of China", (inaugural exhibition), Taiwan Provincial Museum of Fine Arts, Taichung, Taiwan

1996 "Modern Spirit: Tong Fang Painting Association and The Fifth Moon Group 40th Anniversary Painting Exhibition", Chi-Chan 50 Art Space, Kaohsiung, Taiwan

1998 "Mind and Spirit: Women's Art in Taiwan", Taipei Fine Arts Museum, Taipei, Taiwan

1999 "Homage to Master Li Chun Shan: A Mentor & His Pupils", Taiwan Provincial Museum of Fine Arts, Taichung, Taiwan

2002 "Modern Eyes Painting Association Exhibition", Sin Pin Pier Absolutely Art Space, Kaohsiung, Taiwan

2005 "Collision and Action: Development of Modern Art in Post-war Taiwan", National Taiwan Museum of Fine Arts, Taichung, Taiwan

2006 "Li Chun-Shan and Development of Modern Painting in Taiwan", National Art Museum of China, Beijing, China

2008 "Present Perfect Progressive - Modern Eyes 27 Years Exhibition", National Taiwan Museum of Fine Arts, Taichung, Taiwan

2013 "Retrospective Exhibition of Huang Run-Se", Art Center of Providence University, Taichung, Taiwan

Chung Chun-Hsiung (1939~)

1939 Born in Taichung, Taiwan
Alumnus of Fu Jen Catholic University
1957 Studied painting at Li Chun-Shan Studio

1986 "Retrospective Exhibition of Modern Chinese Painting", Taipei Fine Arts Museum, Taipei, Taiwan

1987 "New Modern Chinese Painting", National Museum of History, Taipei, Taiwan

1988 Inaugural exhibition, Taiwan Provincial Museum of Fine Arts, Taichung, Taiwan

1991 "Exchange Exhibition of Sino-Korean Ink Art", Taiwan Provincial Museum of Fine Arts, Taichung, Taiwan

1992 Solo exhibition, Taichung Cultural Center, Taichung, Taiwan

1993 "The Contemporary Calligraphy Exhibition in Shanghai and Taipei", Shanghai Art Museum, Shanghai, China

1994 Solo Exhibition, Cultural Affairs Bureau, Tainan City Government, Tainan, Taiwan

1996 "Modern Taipei Painter Group Exhibition", Shanghai Art Museum, Shanghai, China

2000 "The Chichi Ark Installation Art Exhibition", Taiwan Provincial Museum of Fine Arts, Taichung, Taiwan

2004 "Modern Eyes Society Annual Exhibition", Taichung Cultural Center, Taichung, Taiwan

2011 Solo Exhibition, Feng-Chia University Center for General Education Art Center, Taichung, Taiwan

2016 Solo Exhibition, The 201 ART, Taichung, Taiwan

Dennis Hwang (1941~)

1941 Born in Gulangyu of Xiamen, China
1960 Studied painting at Li Chun-Shan Studio
1972 Studies at the Graduate School of Art, Pratt Institute, New York, USA

1961 "Young Artists Group Exhibition", United States Information Service in Taiwan, Taipei, Taiwan
1971 Solo exhibition, Asian Art Society, San Francisco, USA
1972 "Contemporary Chinese Painters", Oriental Gallery Madrid, Spain
1973 "Contemporary Prints by Chinese Artists", City Museum Art Gallery, Hong Kong
1983 Solo exhibition, Nan Gallery, Taipei, Taiwan
1988 Solo exhibition, Galerie Esperanza, Montreal, Canada
1991 "Taipei - New York: Modern Art", Taipei Fine Art Museum, Taipei, Taiwan
1994 "Color, Extreme", Jin Gallery, New York, USA
1997 "Transpiration", Maggie Gallery, Easton, Pennsylvania, USA
2000 Solo exhibition, Hanks Art Center. Montreal, Canada
2012 "Scenic Chatter-Dennis Hwang Solo Exhibition", Beyond Gallery, Taipei, Taiwan
2014 "Galloping Horse-Dennis Hwang's Solo Exhibition", Beyond Gallery, Taipei, Taiwan; Shanghai, China
2015 "A Glance: Dennis Hwang Solo Exhibition", InART Space, Tainan, Taiwan
2016 "The Troika: Dennis Hwang, Emily Yang, Ava Hsueh", Red Gold Fine Art, Taipei, Taiwan

Jan Syue-Fu (1942~)

1942 Born in Changhua County, Taiwan
1964 Studied painting at Li Chun-Shan Studio
1967 Graduated from the Department of Fine Arts, National Taiwan Normal University

1983~2018 "Modern Eyes Society Annual Exhibition"
1984.86 "New Modern Chinese Painting", Taipei Fine Arts Museum, Taipei, Taiwan
1986 "New Modern Chinese Painting", Taipei Fine Arts Museum, Taipei, Taiwan
1987 "New Modern Chinese Painting", National Museum of History, Taipei, Taiwan
"Chinese Contemporary Arts Exhibition", Seoul, Korea
1988 "Exhibition of Art Development in the Republic of China", Taiwan Provincial Museum of Fine Arts, Taichung, Taiwan
1990 "300 Years of Fine Arts in Taiwan", Taiwan Provincial Museum of Fine Arts, Taichung, Taiwan
"Jan Syue-Fu Painting Exhibition", Dimensions Art Gallery, Taipei, Taiwan

1999 "Homage to Master Li Chun-Shan: A Mentor & His Pupils", Provincial Museum of Fine Arts, Taichung, Taiwan
2004 "The Transitional Eighties – Taiwan's Art Breaks New Ground", Taipei Fine Arts Museum, Taipei Fine, Taiwan
2005 "Between Modern and Postmodern – Master Li Chun–Shan and Modern Art in Taiwan", National Taiwan Museum of Fine Arts, Taichung, Taiwan
"Jan Syue–Fu Solo exhibition", Art Center Window of National Cheng Kung University Tainan, Taiwan
2006 "Li Chun–Shan and Development of Modern Painting in Taiwan", China Academy of Art, Hangzhou; National Art Museum of China, Beijing, China
2008 Exhibition with Li Chun-Shan and his pupils, Changhua Arts Hall, Changhua, Taiwan
"Present Perfect Progressive - Modern Eyes 27 Years Exhibition", National Taiwan Museum of Fine Arts, Taichung, Taiwan
2009 Joint exhibition with 5 veteran artists, Chen Ting-Shih Memorial Art Museum, Taichung, Taiwan
2011 "30th Anniversary Exhibition of Modern Eyes Society", National Cheng Kung University Art Center, Tainan, Taiwan
2013 "Modern Eyes Society 2013", Chienkuo Technology University, Changhua, Taiwan
2015 "Art of Consciousness-Works and Teaching of Li Chun-Shan", Nanhai Gallery, National Taipei University of Education, Taipei, Taiwan; General Association of Chinese Culture, Taipei, Taiwan

Hsieh Tung-Shan (1946~)

1946 Born in Erlin Township, Changhua County, Taiwan
1969 Studied painting at Li Chun-Shan Studio
1970 Graduated from the Department of Fine Arts, National Taiwan Normal University
1975 Gained MFA from Chinese Culture University, Taiwan
1991 Gained MA from Art History, University of Iowa, USA
1994 Gained PhD in Art Criticism, Texas Tech University, USA

1980 First Solo exhibition, Dadi Gallery, Taipei, Taiwan
1988 "Post-Modern Painting Exhibition", Kaohsiung Cultural Center, Kaohsiung, Taiwan
1999 "Homage to Master Li Chun-Shan: A Mentor & His Pupils", National Taiwan Museum of Fine Arts, Taichung, Taiwan
2005 "Between Modern and Postmodern - Master Li Chun-Shan and Modern Art in Taiwan", National Taiwan Museum of Fine Arts, Taichung, Taiwan
2006 "Emotions in February", Nan Gallery, Taipei, Taiwan
"Homage to Master Li Chun-Shan: A Mentor & His Pupils", China Academy of Art, Hangzhou; National Art Museum of China, Beijing, China
2006-2014 Participates in the annual large-size oil painting exhibition presented at the Taichung City Seaport Art Center
2008 Exhibition with Li Chun-Shan and his pupils, Changhua Arts Hall, Changhua, Taiwan
"Summer", solo exhibition, National Taichung University of Education Art Center, Taichung, Taiwan
2009 "Clouds - Hsieh Tung-Shan Oil Painting Exhibition", Changhua Arts Hall, Changhua, Taiwan
2009-2012 Participates in the annual "Exhibition of Contemporary Artists of Taichung City"
2011 "Urban Myths: Hsieh Tung-Shan Oil Paintings Exhibition", Taichung Cultural Center, Taichung, Taiwan

Solo exhibition, Nan Gallery, Taipei, Taiwan

"A Hundred Years of Painting and Calligraphy", Changhua County Cultural Affairs Bureau, Changhua, Taiwan

2014 "Green Grass on the Riverbank - Hsieh Tung–Shan Oil Painting Exhibition 2014", Changhua Arts Hall, Changhua, Taiwan

Hwang Buh-Ching (1948~)

1948 Born in Lukang, Taiwan

1969 Studied painting at Li Chun-Shan Studio

1976 Graduated from the Department of Fine Arts, National Taiwan Normal University

1987 MFA, Department of Plastic Art, University of Paris St-Denis, France

1996 "Taipei Biennial: The Quest For Identity", Taipei Fine Arts Museum, Taipei, Taiwan

1999 "Earth, Life, Memory", Kaohsiung Museum of Fine Arts, Kaohsiung, Taiwan
"Forum for Creativity in Art", Kaohsiung Museum of Fine Arts, Kaohsiung, Taiwan
Represented Taiwan in the 48th Venice Biennial, Venice, Italy

2000 "Shanghai Biennale: Shanghai Spirit", Shanghai Art Museum, Shanghai, China

2001 Tainan and Quebec art exchange exhibition, National Tainan Living Art Center, Tainan, Taiwan
"Drifting Wave, Life and Secret Love - Hwang Buh-Ching Solo Exhibition", National Cheng Kung University Art Center, Tainan, Taiwan

2010 Solo exhibition, License Art Gallery, Tainan, Taiwan

2012 "Gaze, A Site-Specific Installation - International Architecture and Design Exhibition", London, UK

2014 "Homeland: Edge of Desolation-Hwang Buh-Ching Solo Exhibition", Museum of Contemporary Art, Taipei, Taiwan; Taitung Art Museum, Taitung, Taiwan

2016 "Contemporary Taiwan: An Exhibition of Abstract Art Classics", Remarkable Cultivation Art Museum, Tainan, Taiwan
"Land, Life & Love", Fo Guang Yuan Museum of Art, Taichung, Taiwan

2017 "Transformations: Contemporary Media and Manifestations", Kaohsiung Museum of Fine Arts, Kaohsiung, Taiwan

2018 "Marée de mai", 80 Art Space, Tainan, Taiwan

Cheng Chiung-Ming (1948~)

1948 Born in Xinying District of Tainan City, Taiwan.

1976 Graduated from the Department of Fine Arts, National Taiwan Normal University

1979 Studied painting at Li Chun-Shan Studio

1991 "Avant garde and Experimental Apartment Exhibition", Taipei Fine Arts Museum, Taipei, Taiwan

1992 "Dis/ continuity: Religion, Shamanism, Nature", Taipei Fine Arts Museum, Taipei, Taiwan

1993 "6th International Biennial Print and Drawing Exhibition, ROC", Taipei Fine Arts Museum, Taipei, Taiwan, Received bronze prize for the drawing category

1994 "Apartment No. 2: Final Evening", Taipei Fine Arts Museum, Taipei, Taiwan

1996 "Taipei Biennial: The Quest For Identity", Taipei Fine Arts Museum, Taipei, Taiwan

1998 "The Power of Line - Drawings by Contemporary Artists", Taipei Gallery, New York, USA

1999 "Homage to Master Li Chun-Shan: A Mentor & His Pupils", Taiwan Provincial Museum of Fine Arts, Taichung, Taiwan

2004 "The Multiform Nineties: Taiwan's Art Branches Out", Taipei Fine Arts Museum, Taipei, Taiwan

2005 "Kuandu Extravaganza Exhibition of Modern Art in Taiwan", Kuandu Museum of Fine Arts, Taipei, Taiwan

2006 "Li Chun-Shan and Development of Modern Painting in Taiwan", Beijing, Hangzhou, China

2008 "Present Perfect Progressive - Modern Eyes 27 Years Exhibition", National Taiwan Museum of Fine Arts, Taichung, Taiwan

2010 "Continuation - Special Exhibition of Li Chun-Shan Modern Painting Award Winners", National Taiwan Museum of Fine Arts, Taichung, Taiwan
"Beyond Vision: Highlights of Abstract Paintings from the National Taiwan Museum of Fine Arts Collection", National Taiwan Museum of Fine Arts, Taichung, Taiwan

2011 "SKY - 2011 Asia Plate & Print Exhibition", Kuandu Museum of Fine Arts, Taipei, Taiwan

2015 "Art of Consciousness-Works and Teaching of Li Chun-Shan", Nanhai Gallery, National Taipei University of Education, Taipei, Taiwan; General Association of Chinese Culture, Taipei, Taiwan

2016 "Change -- Modern Eyes Society Group Exhibition", Dadun Gallery, Taichung, Taiwan

2017 "Printmaking Association of Taiwan Modern Print Exhibition", Chiayi Cultural Affairs Bureau, Chiayi, Taiwan

2018 "Concentric Round - 2018 Modern Eyes Society Group Exhibition", Dadun Gallery, Taichung, Taiwan

Wang Ching-Cheng (1948~)

1948 Born in Lukang Township of Changhua County, Taiwan

1976 Studied painting at Li Chun-Shan Studio

1980 "3rd "Free Painting Society Group Exhibition", Taiwan Provincial Museum, Taipei, Taiwan

1982 Modern art painting exhibition, Kaohsiung, Taiwan

1993 Longtou Painting Society group exhibition, Venus Art, Taichung, Taiwan

1996 "Homage to Master Li Chun-Shan: A Mentor & His Pupils", National Taiwan Museum of Fine Arts, Taichung, Taiwan

1999 "Homage to Master Li Chun-Shan: A Mentor & His Pupils", National Taiwan Museum of Fine Arts, Taichung, Taiwan

2005 "Between Modern and Postmodern - Mentor Li Chun-Shan and Modern Art in Taiwan", National Taiwan Museum of Fine Arts, Taichung, Taiwan

2005 "Paseo Arts Festival", Changhua County Government, Changhua, Taiwan

2008 Contemporary painting exhibition, Changhua County Government, Changhua, Taiwan

2009 "Homage to Master Li Chun-Shan: A Mentor & His Pupils", Changhua County Cultural Affairs Bureau, Changhua, Taiwan

2011 "A Hundred Years of Painting and Calligraphy", invitational exhibition, Changhua County Cultural Affairs Bureau, Changhua, Taiwan

2012 "A Hundred Years of Painting and Calligraphy", invitational exhibition with contemporary painters from Lukang, Changhua, Taiwan

Cheng Wu-Chang (1949~)

1949	Born in Lukang Township of Changhua County, Taiwan
1969	Studied painting at Li Chun-Shan Studio
1985	Selected for an international drawing exhibition at São Paulo, Brazil
1996	"Homage to Master Li Chun-Shan: A Mentor & His Pupils", National Taiwan Museum of Fine Arts, Taichung, Taiwan
1999	"Homage to Master Li Chun-Shan: A Mentor & His Pupils", National Taiwan Museum of Fine Arts, Taichung, Taiwan
2001	Solo exhibition, Kaohsiung Cultural Center, Kaohsiung, Taiwan
2002	Solo exhibition, Changhua County Cultural Affairs Bureau, Changhua, Taiwan
2005	"Between Modern and Postmodern - Master Li Chun-Shan and Modern Art in Taiwan", National Taiwan Museum of Fine Arts, Taichung, Taiwan
	Solo exhibition, National Cheng Kung University Art Center, Tainan, Taiwan
2006	"Li Chun-Shan and Development of Modern Painting in Taiwan", China Academy of Art, Hangzhou; National Art Museum of China, Beijing, China
2009	Solo exhibition, 102 Art Gallery, Tainan, Taiwan
	"Homage to Master Li Chun-Shan: A Mentor & His Pupils", Changhua County Cultural Affairs Bureau, Changhua, Taiwan
2010	"Huang Xi Art Exhibition", Changhua County Cultural Affairs Bureau, Changhua, Taiwan
	Solo exhibition, Lukang Art Center, Changhua, Taiwan
2013	"50-Year Retrospective", Lukang Art Center, Changhua, Taiwan
2014	Solo exhibition, Changhua Arts Hall, Changhua, Taiwan
2015	"Art of Consciousness-Works and Teaching of Li Chun-Shan", Nanhai Gallery, National Taipei University of Education, Taipei, Taiwan; General Association of Chinese Culture, Taipei, Taiwan

J.C. Kuo (1949~)

1949	Born in Lu kang, Taiwan
1968	Studied painting at Li Chun-Shan Studio
1973	Graduated from the Fine Arts Department of College of Chinese Culture
1989	"Message From Taipei", Hara Museum ARC, Tokyo, Japan
1992	"To Encounter Others", Exhibition Hall K-18, Kassel, Germany
1993	"The Phenomena of the Mythical Age", Lung Men Art Gallery, Taipei, Taiwan
1995	"ART TAIWAN - The Contemporary Art of Taiwan", Museum of Contemporary Art, Sydney, Australia
1997	"Portrait de L' _le Art Contemporain de Taiwan", PMMK-Oostende, Belgium
2000	"St. TAIWAN 1996~2000", CHERNG PIN Gallery, Taipei, Taiwan
2008	"Bubble Tea: Art of Taiwan and its Contemporary Mutations", The Moravian Gallery in Brno, (National Taiwan Museum of Fine Arts.)
	"Float", Hong-Gah Museum, Taipei, Taiwan
2009	"DESCRIBE SPEAK-2009 Cross-Strait Contemporary Art", National Taiwan Museum of Fine Arts, Taichung, Taiwan; National Art Museum of China, Beijing, China
2010	"Ventriloquized Voice", Contemporary Art from Taiwan, National Taiwan Museum of Fine Arts, Taiwan; Gwangiu Museum of Art, Korea
2012	"GAMES TIME-CONTEMPORARY APPROPRIATIONS OF THE PAST", Taipei Fine Arts Museum, Taipei, Taiwan.
2013	"Majestic Island-The Development of Modern Art in Taiwan", National Art Museum of China, Beijing, China.
	"Rolling! Visual Art in Taiwan", Seoul Museum of Art, Korea

2015	"Dance with the Times-40 Years of ARTIST and Contemporary Art in Taiwan", Kaohsiung Museum of Fine Art, Kaohsiung Taiwan.
2016	"Totem Taiwan", National Changhua Living Art Center, Changhua, Taiwan

Hsu Yu-Jen (1951~)

1951	Born in Jiali District of Tainan, Taiwan
1973	Studied painting at Li Chun-Shan Studio
1975	Graduated from National Taiwan Academy of Arts
1979	Solo exhibition, American Cultural Center, Taipei, Taiwan
1991	"Individualist Movement", group exhibition, Hong Kong Arts Center, Hong Kong
1995	"Man and Land - Taiwan Contemporary Painting Exhibition", Taipei Fine ArtsMuseum, Taipei, Taiwan
1997	"Tracing Taiwan: Contemporary Works on Paper", Taipei Fine Arts Museum,Taipei, Taiwan
2000	Solo exhibition of ink paintings, Hanart TZ Gallery, Hong Kong
2001	Driftwood installation exhibition, Hualien, Taiwan
2003	"Contemporary Ink Painting and the state of the Ink", Taipei Fine ArtsMuseum, Taipei, Taiwan
2004	"The Yellow Box: Contemporary Calligraphy and Painting in Taiwan", Taipei Fine Arts Museum, Taipei, Taiwan
2005	"Educational Ink Painting Exhibition", Taipei Fine Arts Museum, Taipei, Taiwan
	"Through Masters' Eyes", Museum für Ostasiatische Kunst (Museum of East Asian Art), Köln, Germany
2006	Solo exhibition, Changdian Base, Beijing, China
	"Revival: New Ink Art Shanghai 2006", Shanghai Duolun Museum of Modern Art, Shanghai, China
2007	"A Translucent Sky", solo exhibition,, Hanart TZ Gallery, Hong Kong
2008	"Worldless in Tranquility", solo exhibition,, Expol-Sources Art Space, Beijing, China
	"Warmish Interior", solo exhibition, Jia Art Gallery, Taipei, Taiwan
2012	"Vision", Soka Art Center, Tainan, Taiwan
2013	"Hsu Yu-Jen Solo Exhibition – Between Coarse and Fine Brushworks", Kuandu Museum of Fine Arts, Taipei, Taiwan
2014	"Yes! Taiwan - Taiwan Biennial", National Taiwan Museum of Fine Arts, Taichung, Taiwan
2015	"Grids and Stones: Landscape as Cultural Self-portrait", Hanart TZ Gallery, Hong Kong
2016	"Contemporary Taiwan: An Exhibition of Abstract Art Classics", Remarkable Cultivation Art Gallery, Tainan, Taiwan
2017	"The Variation of Ink", solo exhibition, Chini Gallery, Taipei, Taiwan
	"Mandala of Ink Art", Kaohsiung Museum of Fine Arts, Kaohsiung, Taiwan
	"The Weight of Lightness", M+ , Hong Kong

Chen Hsing-Wan (1951~2004)

1951	Born in Taichung, Taiwan
1972	Graduated from the Western Painting Division of National Taiwan Academy of Arts
1981	Studied painting at Li Chun-Shan Studio
1987	Solo exhibition, Lung Men Art Gallery, Taipei, Taiwan
1987	Solo exhibition, Taiwan Museum of Art, Taichung, Taiwan

1993 Solo exhibition, Golden Brick Gallery, Taichung, Taiwan
Solo exhibition, L'Eau Métallique Gallery, Paris, France
1997 "From Exploring the Original Form to the Song of the Land", Taipei Fine Arts Museum, Taipei, Taiwan
2000 "Journey of A Stroller", Ke-Yuan Gallery, Taichung, Taiwan
2001 "Sculpting Time", Ke-Yuan Gallery, Taichung, Taiwan
2002 "Chen Hsin-Wan & Tsai Chih-Hsien Duo Solo Exhibitions", Ke-Yuan Gallery, Taichung, Taiwan
2003 "Calm and Joy", Ke-Yuan Gallery, Taichung, Taiwan
2004-2019 "Memorial Exhibition of Chen Hsing-Wan", Ke-Yuan Gallery, Taichung, Taiwan
2006 "Chen Hsing-Wan: Mixed Media 1980-2001", Ke-Yuan Gallery, Taichung, Taiwan
2007 "Chen Hsing-Wan: Ink Painting 1990-1992", Ke-Yuan Gallery, Taichung, Taiwan
2008 "Chen Hsing-Wan: Ink Painting 1994-1999", Ke-Yuan Gallery, Taichung, Taiwan
"Between the Open and the Closed: Chen Hsing-Wan's Quest for 'The Archetype'", Art Center of Providence University, Taichung, Taiwan
2014 "Tenth Anniversary Memorial Exhibition of Chen Hsing-Wan", Ke-Yuan Gallery, Taichung, Taiwan

Chu Teh-I (1952~)

1952 Born in Jeongeup, Korea
1974 Studied painting at Li Chun-Shan Studio
1976 Graduated from The National Taiwan Normal University
1983 L'Ecole Nationale Supérieure Des Arts-Decoratifs De Paris,France. (Diplôme de Decorateur- Specialisation Arts-Plastiques Peinture.)
1984 L'Ecole Nationale Supérieure Des Beaux-Arts De Paris,France. (Diplôme Supérieure D'art Plastique.)

2004 The Transitional Eighties - Taiwan's Art Breaks New Ground, Taipei Fine Arts Museum, Taipei Fine, Taiwan
2004 "The Lyricism of Form Geometric Abstraction", Taipei Fine Arts Museum, Taipei, Taiwan
2005 "Between Modern and Postmodern - Master Li Chun-Shan and Modern Art in Taiwan", National Taiwan Museum of Fine Arts, Taichung, Taiwan
2011 "Beyond Space", Tap Seac Gallery, Macau
"Beyond Vision- Highlights of Abstract Paintings from the National Taiwan Museum of Fine Arts Collection", National Taiwan Museum of Fine Arts, Taichung, Taiwan
2012 "Colors/Forms-CHU The-I Solo Exhibition", National Taiwan Museum of Fine Arts, Taichung, Taiwan
"Majestic Island- The Development of Modern Art in Taiwan", National Art Museum of China, Beijing, China
"Integrate Into One", Main Trend Gallery, Taipei, Taiwan
"A Pioneer of Illusory Space. Chu Teh-I's Abstract Painting", Eunam Museum of Art, Gwangju, Korea
"Passing Through Memory - Suzhou Jinji Lake Art Museum Opening Exhibition", Suzhou Jinji Lake Art Museum, China
2015 "Asia Contemporary Art Exhibition 2015", Jeonbuk Museum of Art , Jeonbuk, Korea
"Art of Consciousness-Works and Teaching of Li Chun-Shan", Nanhai Gallery, National Taipei University of Education, Taipei, Taiwan; General Association of Chinese Culture, Taipei, Taiwan
2016 "LIFE IN BETWEEN DELIGHT AND DISCOMFORT", Gwangju Museum of Art, Gwangju, Korea

2017 "A space between Dimensions", Double Square Gallery, Taipei, Taiwan
"A New Vision of Printmaking", Kuandu Museum of Fine Arts, Taipei, Taiwan

Li Jiin-Shiow (1953~2003)

1953 Born in Chiayi City, Taiwan
1974 Studied painting at Li Chun-Shan Studio
1976 Graduated from the Department of Fine Arts, National Taiwan Normal University
1986 Graduated from École nationale supérieure des Arts Décoratifs, Paris, France, majoring in painting, printmaking, and sculpture

1977 "Free association group exhibition", Yuan Jiu Gallery, Taipei, Taiwan
1987 "Young Chinese Painters in Paris Group Exhibition", Galerie Bernanos, Paris, France
"Salon of Young Painters", Grand Palais, Paris, France
1989 Co-founds Apartment No.2 (1989-1991), Taipei, Taiwan
"National Modern Painting Exhibition", Kaohsiung, Taiwan
1990 Solo exhibition, Chatting Man Gallery, Kaohsiung, Taiwan
1991 Solo exhibition, Apartment No.2, Taipei, Taiwan
"Dialogue between Woman Art and Contemporary Art", Dimension Art Gallery, Taipei, Taiwan
1992 "Localism", Apartment No.2, Taipei, Taiwan
"Duo solo exhibitions of Hwang Buh-Ching and Li Jin-Xiu", New Phase Art Space, Tainan, Taiwan
1993 "Toward Apex: Taiwan Modern Art Exhibition, Chi-chan 50 Art Space, Kaohsiung, Taiwan
Solo exhibition, Taipei Fine Arts Museum, Taipei, Taiwan
Solo exhibition, Tainan Cultural Center, Tainan, Taiwan
1995 Solo exhibition, Duchamp Art, Kaohsiung, Taiwan
1999 Solo exhibition, Taiwan Provincial Museum of Fine Arts, Taichung, Taiwan
2001 "The Scenario of Taiwanese Contemporary Art in Tainan", Old Tainan Magistrate Residence, Tainan, Taiwan
2003 "New Style Art Biennial, Southern Taiwan", Cultural Affairs Bureau, Tainan City Government, Tainan, Taiwan
2005 "Between Modern and Postmodern - Master Li Chun-Shan and Modern Art in Taiwan", National Taiwan Museum of Fine Arts, Taichung, Taiwan
"The Movement of the Bamboo Stool - A Memorial Exhibition of Li Jin-Xiu", Taipei Fine Arts Museum, Taipei, Taiwan
2013 "Women Adventurers: Five Eras of Taiwanese Art, 1930-1983", Taipei Fine Arts Museum, Taipei, Taiwan
2016 "The Gaze and Reproduction of Self-mirroring- Life Art of Lii Jiin-shiow", Mizuiro Workshop, Tainan, Taiwan

Yao Keh-Hong (1953~)

1953 Born in Yunlin, Taiwan
1973 Studied painting at Li Chun-Shan Studio
1976 Alumnus of the Art Division of National Taiwan Academy of Arts
1990 MFA from City University of New York

1985 "Avant-garde, Installation, Space", Taipei Fine Arts Museum, Taipei, Taiwan
1993 "Dialect of Taiwan", Yi-Chin Art Center, Taipei, Taiwan

1994 Exhibition of contemporary ceramic art from Taiwan, Centre Culturel de Taïwan à Paris, Paris, France

1995 Exhibition of modern Ceramic art in Taiwan, Taipei Fine Arts Museum, Taipei, Taiwan

1995 Ceramic art exhibition, Tamsui Center of Arts and Culture, New Taipei City, Taiwan

1998 "Black Museum Chronicle", solo exhibition, Taipei County Cultural Center, Taipei, Taiwan

2002 "Taiwan et sa Terre", contemporary Taiwanese ceramic artists touring exhibition in Europe, Yingge Ceramics Museum, New Taipei City, Taiwan

2005 "Non-Thought: Imagery and Casual Jotting", solo exhibition, Tamsui Tien Tsang Art Museum, Tamsui Culture Foundation, New Taipei City, Taiwan

2006 Invitational exhibition of modern Ceramic art, National Museum of History, Taipei, Taiwan

2009 "Mirando Fijamente en los Territorios", an exhibition of contemporary ceramic art from Taiwan, CERCO - Cerámica Contemporánea, Zaragoza, Spain

2010 "Form, No Signifier - An Exhibition of Established Ceramics in Taiwan", Yingge Ceramics Museum, New Taipei City, Taiwan

2012 "5 Elements with 25 Artists", sculpture exhibition, IT Park, Taipei, Taiwan

2015 "Art of Consciousness-Works and Teaching of Li Chun-Shan", Nanhai Gallery, National Taipei University of Education, Taipei, Taiwan; General Association of Chinese Culture, Taipei, Taiwan

2018 "Taiwan Ceramics Biennale", Yingge Ceramics Museum, New Taipei City, Taiwan

Yang Mao-Lin (1953~)

1953 Born in Changhua

1973 Studied painting at Li Chun-Shan Studio

1979 Graduated from Department of Fine Arts, Chinese Culture University, Taipei, Taiwan

2009 "Temple of Sublime Beauty - Hallelujah", Museum of Contemporary Art Taipei, Taipei, Taiwan

2010 "Taiwan Calling: The Phantom of Liberty", Műcsarnok - Kunsthalle, Budapest, Hungary

2011 "Republic of China - Republic without People", Kaohsiung Museum of Fine Arts, Kaohsiung, Taiwan

2012 "Time Games: Contemporary Appropriations of the Past", Taipei Fine Arts Museum, Taipei, Taiwan

2013 "Rolling! Visual Art in Taiwan", Seoul Museum of Art, Seoul, Korea

2014 "Jie: Boundaries of Self in Contemporary Art from Taiwan 1995-2013", Herbert F. Johnson Museum of Art, Cornell University, New York, USA
 "The Pioneers of Taiwanese Artists, 1951-1960", National Taiwan Museum of Fine Arts, Taichung, Taiwan

2015 "40 Years of Artist and Contemporary Art in Taiwan", Kaohsiung Museum of Fine Arts, Kaohsiung, Taiwan

2016 "YANG MAO-LIN: A Retrospective", Taipei Fine Arts Museum, Taipei, Taiwan

2017 "Hardcore Rally with Hantoo Art Group", National Taiwan Museum of Fine Arts, Taichung, Taiwan

2018 "Awakenings: Art in Society in Asia 1960s-1990s", The National Museum of Modern Art, Tokyo, Japan

2019 "Asia in Asia - Close by Far Away Drums", Gyeongnam Art Museum, Changwon, Korea
 "Wanderers of the Abyssal Darkness II - Somber Seas", Tina Keng Gallery, Taipei, Taiwan

Chern Shen-Son (1954~)

1954 Born in Yunlin, Taiwan

1976 Graduated from the Division of Western Painting, Department of Fine Arts, National Taiwan Normal University
 Studied painting at Li Chun-Shan Studio

1988 Graduated from the Department of Painting, Accademia di Bele Arti of Rome, Italy

1987 "2nd International Youth Exhibition", Budapest, Hungary

1989 Group exhibition of 15 artists from overseas, Palazzo Valentini, Rome, Italy

1990 Solo exhibition, Edicola, Rome, Italy

1991 Solo exhibition, , Doors Art Space, Kaohsiung, Taiwan, King Stone Gallery, Taichung, Taiwan

1992 Solo exhibition, , Doors Art Space, Kaohsiung, Taiwan, King Stone Gallery, Taichung, Taiwan

1993 Group exhibition of international artists, Agrigento, Sicily, Italy

1994 Solo exhibition, Taipei Fine Arts Museum, Taipei, Taiwan

1997 Solo exhibition, Taiwan Provincial Museum of Fine Arts, Taichung, Taiwan

2000 "Sky and Land", solo exhibition, Howard Salon, Kaohsiung, Taiwan

2003 "Between the Sky and the Earth- Chern Shenson ", Kaohsiung Museum of Fine Arts, Kaohsiung, Taiwan

2005 "Reality - Sublimity", Sincewell Gallery, Kaohsiung, Taiwan

2007 "Area - Area", Yadi Gallery, Tainan, Taiwan

2008 "Transition - Cross over", Kao Yuan University Art Space, Kaohsiung, Taiwan

2009 Solo exhibition, Licence Art Gallery, Tainan, Taiwan

2010 "The romance and pride of the South" Shen-Son Chern and Jiun–Shyan Lee Group Exhibition, Acro Gallery of King's Group, Kaohsiung, Taiwan

2015 "Art of Consciousness-Works and Teaching of Li Chun-Shan", Nanhai Gallery, National Taipei University of Education, Taipei, Taiwan; General Association of Chinese Culture, Taipei, Taiwan

2016 "Painting, Picturesque Scene and Sublimity" Solo exhibition, Main Trend Gallery, Taipei, Taiwan
 "Contemporary Taiwan: An Exhibition of Abstract Art Classics", Remarkable Cultivation Art Museum, Tainan, Taiwan

2018 "Wind Shadow and Season" Lee Kuang–Yu and Chern Shen–Son Group Exhibition, Mezzo Art Gallery, Tainan, Taiwan

Chu Teh-Huah (1954~)

1954 Born in Korea

1977 Graduated from the Department of Fine Arts, National Taiwan Normal University
 Studied painting at Li Chun-Shan Studio

2000 MFA from Australian National University, Canberra, Australia

1988 "Exhibition of Architectural Space and Sculpture", University of Technology Sydney, Sydney, Australia

1989 Works Gallery, Sydney, Australia

1993 Solo sculpture exhibition, Apartment No.2, Taipei, Taiwan

1995 Solo sculpture exhibition, American Cultural Center, Taipei, Taiwan

1996 "Elusive and Realistic Space", Tamsui Center of Arts & Culture, New Taipei City, Taiwan

1997 "Spatial Games", National Central University Art Center, Zhongli, Taiwan

1999 "Homage to Master Li Chun-Shan: A Mentor & His Pupils", National Taiwan Museum of Fine Arts, Taichung, Taiwan

"Uncertain Spaces", Australian National University, Canberra, Australia

2007 "Displaced Spaces", National Taiwan Museum of Fine Arts, Taichung, Taiwan

2010 "At East - Modern Eyes Society Exhibition", National Kaohsiung University of Applied Sciences Art Center Kaohsiung, Taiwan

2012 "Moving Shadows", Art Ile, Taichung, Taiwan

2017 "A Gaze into the Illusion Transformation", Da Xiang Art Space, Taichung, Taiwan

Wu Mei-Song (1955~)

1955 Born in Kaohsiung, Taiwan

1973 Studied painting at Li Chun-Shan Studio

1975 Graduated from the Western Painting Division of National Taiwan Academy of Arts (now National Taiwan University of Arts)

1990 MFA in Painting from Slade School of Fine Art, London, UK

1983 "1st National Modern Art Exhibition of the Republic of China", Taipei Fine Arts Museum, Taipei, Taiwan

1984 "1st International Biennial Print Exhibit, Republic of China", Taipei Fine Arts Museum, Taipei, Taiwan

1985 Contemporary prints invitational exhibition of contemporary prints, Taipei Fine Arts Museum , Taipei, Taiwan

1989 Solo exhibition, Slade School of Fine Art, London, UK

1993 "Familiar and Foreign", Solo exhibition, New Phase Art Space, Tainan, Taiwan

"Discover Love River Installation Art", curatorial project, Kaohsiung, Taiwan

Solo exhibition, Galerie Pierre, Taichung, Taiwan

1995 "Tables, Chairs, and Imprints", Duchamp Art, Kaohsiung, Taiwan

2000 "Memories of Travel vs. the Scenic Homeland", Kaohsiung Museum of Fine Arts, Kaohsiung, Taiwan

2005 "Between Modern and Postmodern - Master Li Chun-Shan and Modern Art in Taiwan", National Taiwan Museum of Fine Arts, Taichung, Taiwan

2015 "Resonance of Heteroglossia - On the Modern Art Association of Kaohsiung", Kaohsiung Museum of Fine Arts, Kaohsiung, Taiwan

2017 "Sin Pin TWENTY x Southern Guerilla", Sin Pin Pier Absolutely Art Space, Kaohsiung, Taiwan

Hwang Wey-Jeng (1955~)

1955 Born in Lugu Township, Nantou County

1974 Studied painting at Li Chun-Shan Studio

1975 Graduated from National Taichung Normal School

1986 Graduated from ECOLE NATIONALE SUPERIEURE DE BEAUX-ARTS

1986 "Large Dessin Exhibition", Maison des Beaux-Arts, Paris, France

1987 "Hwang Wey-Jeng retrospective exhibition, 1984-1986", Taipei Fine Art Museum, Taipei, Taiwan

1991 "Avant Garde and Experimental Loft Exhibition", Taipei Fine Arts Museum, Taipei, Taiwan

"Solo exhibition (1986-1990)", Taipei Fine Arts Museum, Taipei, Taiwan

1995 "Solo exhibition (1995)", Pan Pan Gallery, Taipei, Taiwan

1996 "Taipei Biennial: The Quest For Identity", Taipei Fine Arts Museum, Taipei, Taiwan

"Solo exhibition (1996)", Shin Len Yuan Art Space., Taipei, Taiwan

1997 "Solo exhibition (1991-1997)", Taipei Fine Arts Museum, Taipei, Taiwan

2001 "Body/Image", solo exhibition, Fairmate Art Gallery, Taipei, Taiwan

2004 "The Transitional Eighties: Taiwan's Art Breaks New Ground", Taipei Fine Arts Museum, Taipei, Taiwan

2007 "Exploring Desires", solo exhibition, Lee Gallery, Taipei, Taiwan; License Art Gallery, Tainan, Taiwan

"BODY", Tucheng Art Hall, Taipei, Taiwan

2014 "Body Talk", solo exhibition, A-7958 Gallery, Taichung, Taiwan

2015 "Body Context", solo exhibition, National Kaohsiung Normal University Art Center, Kaohsiung, Taiwan

2017 "Aggregation & Blooming: Artists Groups and the Development of Fine Arts in Taiwan", National Taiwan Museum of Fine Arts, Taichung, Taiwan

2018 "Sensory Threshold of Light", solo exhibition, Chungyo Gallery, Taichung, Taiwan

Lin Hung-Ming (1956~)

1956 Born in Changhua, Taiwan

1974 Studied painting at Li Chun-Shan Studio

2001 Graduated from Department of Plastic Arts, Tainan National University of the Arts

1986 Solo exhibition, Taipei Cultural Center, Taipei, Taiwan

1988 Solo exhibition, American Cultural Center, Taipei, Taiwan

1989 Solo exhibition, Taichung Cultural Center, Taichung, Taiwan; Changhua Cultural Center, Changhua, Taiwan

1993 Solo exhibition, Taiwan Provincial Museum of Fine Arts, Taichung, Taiwan

1994 Solo exhibition, Kaohsiung Cultural Center, Kaohsiung, Taiwan

1997 Solo exhibition, Changhua Cultural Center, Changhua, Taiwan

2000 Solo exhibition, Galerie Pierre, Taichung, Taiwan

2002 Solo exhibition, Taichung Cultural Center, Taichung, Taiwan

2004 "Lin Hung-Ming Oil Painting Exhibition", Changhua County Government Art Plaza, Changhua, Taiwan

"Lost Series", solo exhibition, stock20 - 26A, Taichung, Taiwan

2005 Solo exhibition, Changhua County Cultural Affairs Bureau, Changhua, Taiwan

2006 "Landscape Series", solo exhibition, Cultural Affairs Bureau of Hsinchu City, Hsinchu, Taiwan

2007 Solo exhibition, Legislative Yuan Gallery, Taipei, Taiwan

2008 Solo exhibition, Chen Ting-Shih Memorial Art Museum, Taichung, Taiwan

2009 Solo exhibition, Cultural Affairs Bureau of Hsinchu County Government, Hsinchu, Taiwan

2011 "Painting My Imagination", National Taiwan Museum of Fine Arts, Taichung, Taiwan

2013 "Through provident eyes of a Painter", Mountain City Art Museum, New Taipei City, Taipei

2014 "Mind", Da-Dun Cultural Center, Taichung, Taiwan

2016 "Physiognomy", Changhua County Art Museum, Changhua, Taiwan

2017 "Feelings of mountains and waters", Galerie Naissance, Taichung, Taiwan

Chen Chu-Yin (1962~)

1962 Born in Taichung, Taiwan
1983 Graduated from Hsinchu Junior Teachers College
1980 Studied painting at Li Chun-Shan Studio
1991 Graduated from ECOLE NATIONALE SUPERIEURE DE BEAUX-ARTS
1995 MA in Department of Arts and Technologies, University Paris 8
2001 PHD in Aesthetics, Science and Technologies of Arts, University Paris 8

2000 "Electronic Zoo&Circus- Agora festival",Parc de la Villette, Paris
2002 "Bio-Art&Vie Artificielle-@rt Outsiders Festival International", Maison Européenne de la Photographie, Paris
2004 "Sciences & Arts Research Lab Exhibition", International Cultural Heritage Informatics Meetings, Berlin, Germany
2010 "YES! TAIWAN-Taiwan Biennial 2010", National Taiwan Museum of Fine Arts, Taichung, Taiwan
2011 "Singing Mandala", National Taiwan Museum of Fine Arts, Taichung, Taiwan
2012 "AI Plus", National Taiwan Museum of Fine Arts, Taichung, Taiwan
2013 "Second Order · Chen Chu-Yin Exhibition", Solo Exhibition, Arts Center, Tsing Hua College, Hsinchu, Taiwan
2014 "New Media Art Exhibition", Sichuan Fine Art University, Chongqing, China
2015 "Campus Exhibition-Arts Electronica Festival 2015", Linz, Autricho
 "Art of Consciousness-Works and Teaching of Li Chun-Shan", Nanhai Gallery, National Taipei University of Education, Taipei, Taiwan; General Association of Chinese Culture, Taipei, Taiwan
2016 Horizons Numériques International Festival, Transcultures Médiarive, Liège, Belgique
2017 "The Infinite Body" Académie Fratellini, St-Denis IDF, Paris, France
2018 "Post-Nature-A Museum as an Ecosystem", Taipei Fine Arts Museum, Taipei, Taiwan
 Recto-Vrso-in Laval Virtual Festival, Laval, France

感謝誌

我們對於下列個人、機構團體以及本展所有未具名之收藏家們表達誠摯的謝意，因為他們的慷慨支持及合作促使本展得以圓滿且順利的完成。

感謝單位／個人

財團法人李仲生現代繪畫文教基金會、臺北市立美術館、形而上畫廊、采泥藝術、誠品畫廊、科元藝術中心、李錫奇藝術中心、藝非凡美術館、耿畫廊、財團法人蕭勤國際文化藝術基金會、蕭璋瑞、林宏璋、霍剛、鐘俊雄、黃步青、詹學富、曲德義、程武昌、楊識宏、朱光宇、王飛雄、徐寶銀、李恬忻、劉玉雪等，以及所有提供藏品未具名藏家。

Acknowledgements

We would like to thank the following individual and institutions for their generous assistance to the realization of this exhibition. We also want to express our sincere gratitude to those anonymous private collectors who have kindly lent their art to this exhibition.

Special Thanks

Li Chun-Shan Cultural and Education Foundation for Modern Painting, Taipei Fine Arts Museum, Metaphysical Art Gallery, Chini Gallery, Eslite Gallery, Ke-Yuan Gallery, Shi Chi Lee Gallery, Mezzo Art Gallery, Tina Keng Gallery, Hsiao Chin Art Foundation, Hsiao Chong Ray, Lin Hong-John, Ho Kan, Chung Chun-Hsiung, Hwang Buh Ching, Jan Syue-fu, Chu Teh-I, Cheng Wu-Chang, Yang Chi-Hung, Chu Kuang-Yu, Wang Fei Hsiung, Hsu Pao-Yin, Li Tien-Hsin, Liu Yu-Hsueh and the anonymous collectors.

國家圖書館出版品預行編目（CIP）資料

李仲生與臺灣現代藝術發展 / 蔡昭儀主編. --
臺北市：藝術家；臺中市：臺灣美術館, 2019.05
236面；27.5 x 23 公分
ISBN 978-986-282-235-7(精裝)

1.繪畫 2.抽象藝術 3.作品集

947.5　　　　　　　　　　108007897

藝時代崛起－
李仲生與臺灣現代藝術發展

Pioneers of the Avant-Garde Movement in Taiwan:
From Li Chun-Shan to His Disciples

指 導 單 位｜文化部
主 辦 單 位｜國立臺灣美術館
發 行 人｜林志明
編 輯 委 員｜陳昭榮、汪佳政、蔡昭儀、林明賢、
　　　　　　薛燕玲、葉雅純、林晉仲、周益宏、
　　　　　　張智傑、楊媚姿、劉木鎮
策 展 人｜陶文岳
主 　 編｜蔡昭儀
執 行 編 輯｜謝珮敏、黃盈
美 術 編 輯｜郭美魚
校 稿 協 助｜黃昭文、杜依玲、修天容
翻 　 譯｜王聖智、廖蕙芬、馬思揚、韡藝術工作室

出 版 單 位｜國立臺灣美術館、藝術家出版社
地 　 址｜臺中市 40359 西區五權西路一段 2 號
電 　 話｜(04) 23723552

印 製 單 位｜藝術家出版社
地 　 址｜106 台北市金山南路（藝術家路）二段 165 號 6 樓
電 　 話｜(02) 23886715
傳 　 真｜(02) 23965707、23965708
網 　 址｜http://www.artist-magazine.com

總 經 銷｜時報文化出版企業股份有限公司
倉 　 庫｜桃園市龜山區萬壽路二段 351 號
電 　 話｜(02) 2306-6842

南部區代理｜台南市西門路一段 223 巷 10 弄 26 號
　　　　　　電話：(06) 261-7268
　　　　　　傳真：(06) 263-7698

出 版 日 期｜2019 年 5 月
I S B N｜978-986-282-235-7（精裝）
定 　 價｜新臺幣 800 元

Supervisor | Ministry of Culture
Organizer | National Taiwan Museum of Fine Arts
Publisher | Lin Chi-Ming
Editorial Committee | Chen Chu-Jung, Wang Chia-Cheng, Tsai Chao-Yi, Lin Ming-Hsien, Hsueh Yen-Ling, Tsai Ya-Chuen, Lin Chin-Chung, Chow I-Houng, Chang Chih-Chieh, Yang Mei-Tzu, Liu Mu-Chun
Curator | Tao Wen-Yuen
Chief Editor | Tsai Chao-Yi
Executive Editors | Hsieh Pei-Min, Huang Ying
Graphic Designer | Kuo Emily
Proofreading | Huang Chao-Wen, Tu I-Ling, Shiou Tian-Rong
Translator | Wang Sheng-Chih, Liao Hui-Fen Anna, Stephen Ma, Yun Art Translation

Publisher | National Taiwan Museum of Fine Arts, Artist Publishing
Address | No.2, Sec.1 ,Wu-chuan W. Rd., 40359 Taichung Taiwan, R.O.C.
TEL | +886-4-23723552

Produced by | Artist Publishing
Adress | 6F., No. 165, Sec. 2, Jinshan S. Rd. (Artist Rd.), Da' an Dist., Taipei City 106,Taiwan(R.O.C)
TEL | +886-2-23886715
FAX | +886-2-23965707 | +886-2-23965708
Website | http://www.artist-magazine.com
Printer | EPOD Digital Content Co., Ltd.
Publishing Date | May, 2019

General Distributor | China Times Publishing Company
Warehouse | No. 351, Sec. 2, Wanshou Rd., Guishan Dist., Taoyuan City 333, Taiwan (R.O.C.)
TEL: +886-2-2306-6842

Southern Taiwan Division |
No. 26, Aly. 10, Ln. 223, Sec. 1, Ximen Rd., West Central Dist., Tainan City 700, Taiwan
TEL: +886-6-2617268
FAX: +886-6-2637698

Publishing Date | May, 2019
ISBN | 978-986-282-235-7
Price | 800 NTD